Jewelry and Metalwork

in the Arts and Crafts Tradition

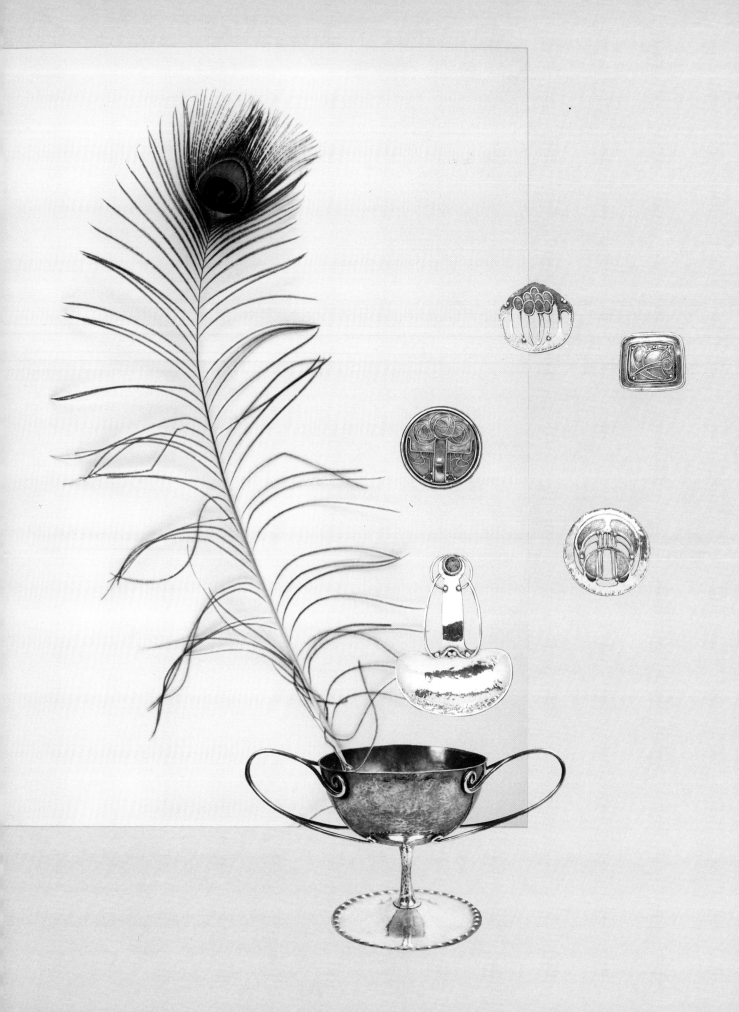

Jewelry and Metalwork in the Arts and Crafts Tradition

Elyse Zorn Karlin

77 Lower Valley Road, Atglen, PA 19310

Dedication

To my husband Andrew who bought me my first piece of English Arts and Crafts jewelry and to my son Harris who helped make my trip to London quite lively.

Published by Schiffer Publishing, Ltd.
77 Lower Valley Road
Atglen, PA 19310
Please write for a free catalog.
This book may be purchased from the publisher.
Please include $2.95 postage.
Try your bookstore first.

We are interested in hearing from authors
with book ideas on related subjects.

Contents

Acknowledgments

The information and photographs that went into this book came from many sources. I am extremely grateful to all the people who shared their time, knowledge and resources with me in the United States, England, Scotland, Ireland, Wales, Germany, Austria and Denmark. Without the help of all the following people this book could not have been written:

There are several people who deserve special mention because they gave so freely of their time and resources, and without them this book would not have been possible: Julia Chambers, John Jesse, London; Didier, Didier Antiques, London; Sarah Hamill, Skinner's Inc., Boston and Bolton; Nicholas Harris and Peter Jeffs, Nicholas Harris, London; Tanya Hunter and Veronica Manussis, Cobra and Bellamy, London; Anthony Hirsch, Hirsch, London; Joyce and Gilbert Jonas, New York; Marilyn Meyers, Asprey, New York; Sonia and David Newell-Smith, Tadema Gallery, London; David Rago, David Rago, Trenton; Leah Roland, Split Personality, Leonia; Peyton Skipwith, Fine Art Society, London; Carole Underwood and Jan Van Den Bosch, Van Den Bosch, London; Nancy Schiffer, my editor, and her assistant Leslie Bockol.

I would like to extend my thanks also to Astri Aasen, Jacqueline Adams, Meg Allen, Professor Bruce A. Austin, James R. Bakker, Roz Balkin, Laura Banchiero, John C. Batzel, Ph.d, Arnold Becker, Gabrielle Becker, Shana Beckett, Brigitte Bednar, Carole Berk, Jonathan Biggs, Sandra Brauns, Shawn Brennan, Claire Brown, Gisela Brown, Veronique Boureuet, Hildegard Buckert, Janet Calderwood, John Davis, Rosalind Dèpas, Louisa DiPietro, Alexandra Eccles-William, Sonia Edard, Nancy Erickson, Patricia Kiley Faber, Dr. Fritz Falk, Victor M. Fleishman, Rosalind Freeman, Diane Freer, Barry Friedman, Elizabeth Gage, Andrew J. N. Gary, Dr. Nina Gockerell, Anne J. Goldberg, Katherine Gottsegen, Margaret Graham-Bell, Ruth Y. Greenbaum, Mark D. Greenbert, Mary Greensted, Katherine Harding, Ian Harris, Kay Harris, Deborah Hunter, Jane Kallir, Dr. Michael Koch, Catherine Kurland, Maria La Lima, Randi Nygaard Lium, Neil Letson, Sarah Levitt, Eva Lindström, Rosa J. Lopez, Jennifer McLaughlin, Karen Otis, Rev. Ousley, Sue Parkes, Roberta Pichler, J.E. Poole, Lieschen A. Potuznik, Simon Ray, Claudia Rigg, Marlene M. Ritchie, Pamela Robertson, Caroline Rogers, Susan Roediger, David Roland, Johanna Scandiffio, Zoe C. Simpson, Jeffrey Solomons, Daisy Spier, Irene Stapleford, Dinah Thompson, John Toomey, Simon Tracy, Peter Trowles, Susan Wachan, Alan Wanzenberg, Martin J. Winter, Vibeke Woldbye, Victoria and Albert Museum, and Janet Zapata.

From top, clockwise: Pin by The Dawsons, c. 1900, sterling with citrine and enamel; pin by C. Horner, c. 1903, sterling with citrine and enamels, marked C.H.; pin by William Haseler, sterling with turquoise cabochons, marked WHH; locket by Murrle Bennett, sterling with enameled coat of arms, marked MB & Co.; pin by Murrle Bennett, sterling with enamels, marked MB; pin by Murrle Bennett with blister pearl and enamel, marked MB; pin by William Haseler, c. 1904, sterling with enamel, marked WHH. *Courtesy of Carole A. Berk, Ltd., Bethesda*

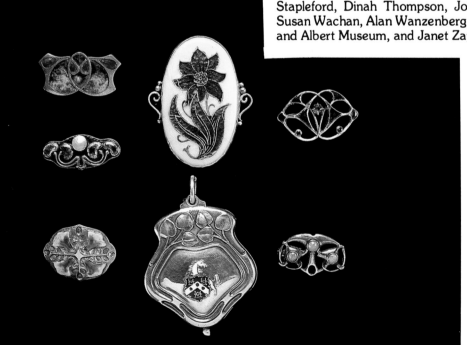

I have been collecting and studying jewelry history for many years—outside of my family it is one of the great passions in my life.

Another passion is Scotland—I am convinced that I was actually born in Scotland in another life which is why I keep persuading my husband that we need to go back there on yet another vacation. The mysteries of the Isle of Skye call to me once a year like some primeval urge I can't explain. (It's healing powers are such that C.R. Ashbee's wife Janet was sent to this area to recuperate from diptheria in 1908, but more about the Ashbees later). So perhaps, it was inevitable that I would fall in love with British Arts and Crafts jewelry.

After years of seeing so much Victorian jewelry which I greatly admired and of which I bought many pieces, the most startling thing about Arts and Crafts period jewelry for me was that it was made in a parallel time frame to late Victorian jewelry. To have forged a style simple in both appearance and materials yet with a distinctive "feel" of its own at this point in time while surrounded by Victorian excess, took courage and foresight by the designers and craftsmen of this new movement.

The fact that I could have studied Victorian jewelry for so long and knew so little about the Arts and Crafts designers who were working at the same time, is testament to the fact that these artisans have not gotten the recognition they deserve. They have been mentioned in survey books, sometimes merely lumped in as a less desirable sub-category of Art Nouveau and receive a few pages dedicated to their work in books on Victorian jewelry, and silver. The one exception is the excellent book *Artists' Jewelry, Pre-Raphaelite to Arts and Crafts*, but this book focuses on only the best known jewelers. Collectors and jewelry historians have over the last two or three decades re-discovered Arts and Crafts jewelry and metalwork and I felt it was time for it to be focused on in a book with a single purpose.

It is my feeling that the British Arts and Crafts designers were *the* catalyst for all of the art jewelry and metalwork in the fresh "new" style that was designed and made beginning around 1890 (give or take a few years) in many countries. I hesitate to put a closure date to this era as I feel that the Arts and Crafts movement is still alive today...the styles may have changed but the men and women who started this movement paved the way for the modern studio jeweler who works today in many countries around the world.

Unlike Art Nouveau designers who worked in a window of no more than about ten years before their movement burned itself out, many British Arts and Crafts jewelers and metalworkers lived and designed well into the second half of the twentieth century.

I started out to write this book solely about jewelry because that is what I know best, but I quickly found it was almost impossible to separate jewelry from metalwork in the Arts and Crafts period for several reasons:

The crossover between the designer/craftsman of this period who created jewelry *and* metalwork is quite high and one influenced the other. Many of the techniques, materials, motifs, influences and designs carried over from jewelry to metalwork and vice versa.

Studying one area may provide clues to the other. For example while in London I mused with one dealer as to whether an unsigned necklace was made by the Guild of Handicraft. This was definitely a possibility because the necklace had links with a "basket" type motif of twisted wire that was quite similar to a wirework finial that appears on silverware made by the Guild.

As you will see, many of the metalwork pieces that came out of the Arts and Crafts period were worked with enamel and set with semi-precious stones which truly made them "jewels".

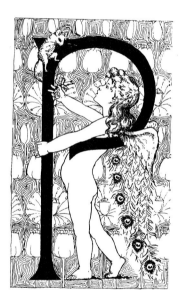

Illustration by Nellie Benson.

My goal in this book was threefold. First, to provide the most comprehensive discussion of the British Arts and Crafts movement in the area of jewelry and metalwork to date. And while doing so to attempt to make these artisans "come alive" by providing as much information about their lives as I could find documented. Finally, to trace how the British movement had a profound effect on the Art Jewelry and Art Metalwork movements in Europe, Scandinavia and the United States. I hope I have accomplished this in some small measure.

Elyse Zorn Karlin
New Rochelle, New York

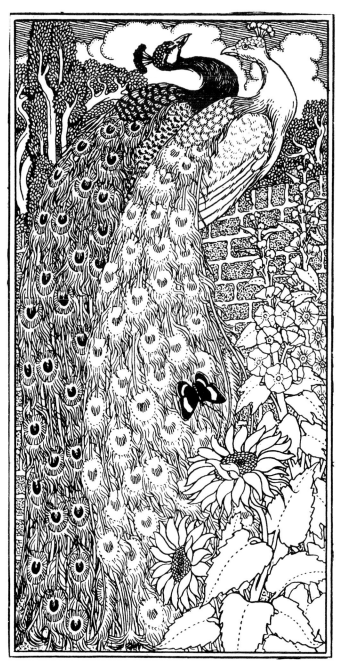

Illustration from *The Studio* by P.J. Billinghurst,
Winter, 1898.

Peacock Motif

The peacock motif is found in almost all of the art jewelry and metalwork movements: English and Scottish Arts and Crafts, American Arts and Crafts, Art Nouveau, the German Jugendstil and turn-of-the-century Scandinavian work. Peacock feathers were an important motif in the earlier Aesthetic movement as well.

Historically, the peacock has several different meanings: it was an ancient protection against the evil eye; a Chinese symbol of beauty and dignity; in Christianity, a symbol of resurrection; and in more modern times, a symbol of Pride.

Louis Comfort Tiffany, the famous turn-of-the-century decorative artist, often created glass with the look of iridescent peacock feathers and in 1914 he gave a famous party with peacock as the main course. His daughters, dressed in classically draped clothing, walked around the dining table with live peacocks on their shoulders to entertain the guests. Among the guests were the painter Childe Hassam, well-known religious leader William Sloan Coffin, and publisher Charles Scribner.

Illustration by E.L. Pattison in *The Studio*, July 1887.

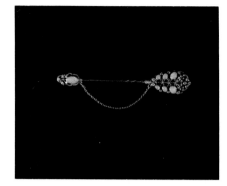

John Paul Cooper **sureté** pin with a peacock feather design. *Courtesy of Leah Roland/Split Personality, Leonia. Photo by Diane Freer.*

Illustration by E.V. Taylor for *The Studio*, August, 1890.

English Arts and Crafts peacock pendant of silver and enamel, c. 1900. *Courtesy of Tadema Gallery, London*

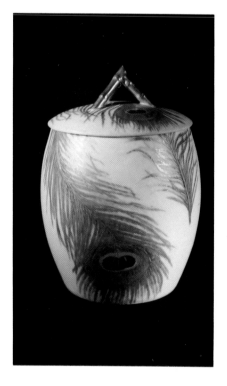

Limoges pot decorated with peacock feather design, c. 1900.

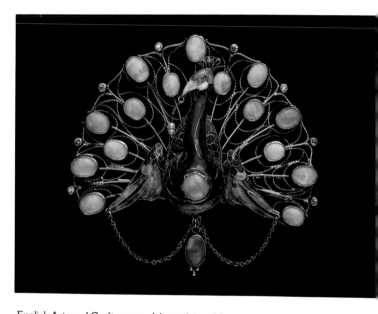

English Arts and Crafts peacock brooch in gold, silver, enamel, opal and diamond, c. 1905. *Courtesy of Tadema Gallery, London*

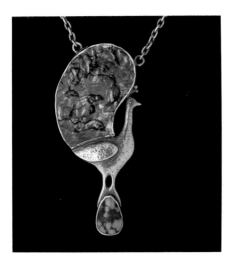

C.R. Ashbee Guild of Handicraft peacock pendant (unsigned), one of a number of peacock jewelry designs by Ashbee. *Courtesy of John Jesse, London*

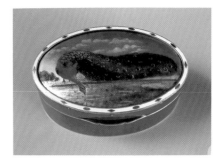

Enamel box with peacock by an unknown English Arts and Crafts artisan. *Courtesy of John Jesse, London*

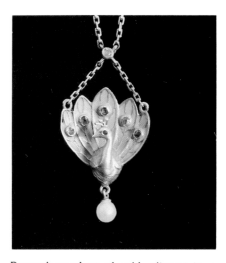

Peacock pendant of gold, plique-à-jour, diamond, sapphire, ruby and pearl drop. Design attributed to Lucien Gautrait c. 1900. *Courtesy of Tadema Gallery, London*

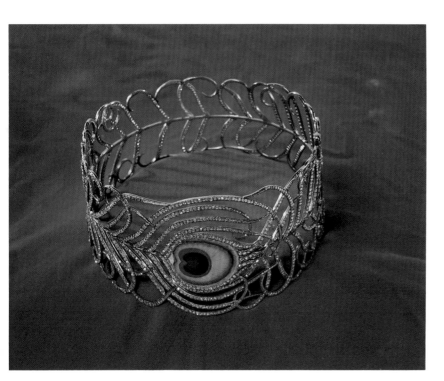

Jewelled collar in the shape of a peacock feather by Mellerio Dites Meller, 1900-05. Gold, diamonds and enamel. *National Museum of American Art, Smithsonian Institution. Gift of Laura Dreyfus Barney*

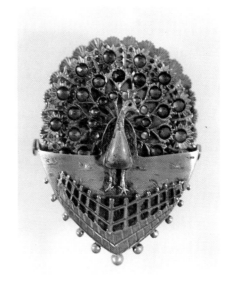

"Clockwork" peacock brooch of silver gilt, enamel and paste. German, c. 1900. *Courtesy of Tadema Gallery, London*

Galleon Motif

One of the common motifs in the Arts and Crafts jewelry is the sailing ship. It can be found in British and American Arts and Crafts as well as in Scandinavian work.

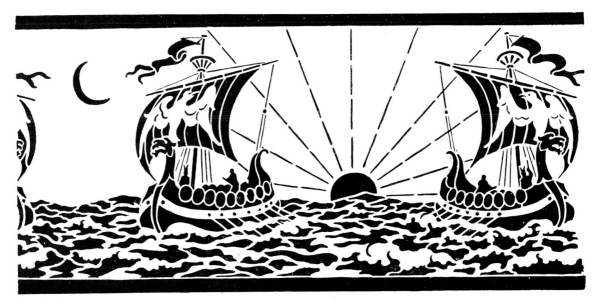

A sailing ship design by A.L. Duthil from Vol. IV, No. 20, Nov. 1884 issue of *The Studio*.

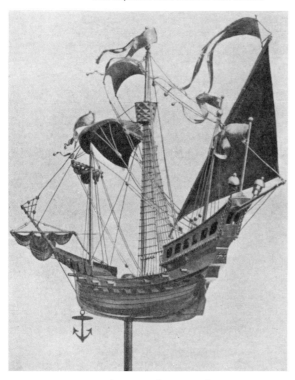

Weathervane in wrought iron and copper gilt designed and executed by W. Bainbridge Reynolds, Ltd.

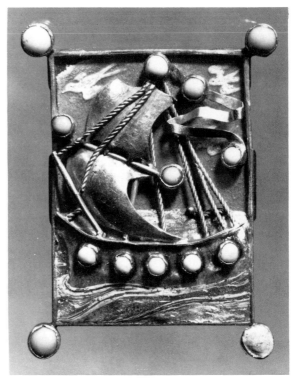

"Craft of the Guild" brooch designed by C.R. Ashbee and made by the Guild of Handicraft. *Courtesy of the Victoria and Albert Museum, London*

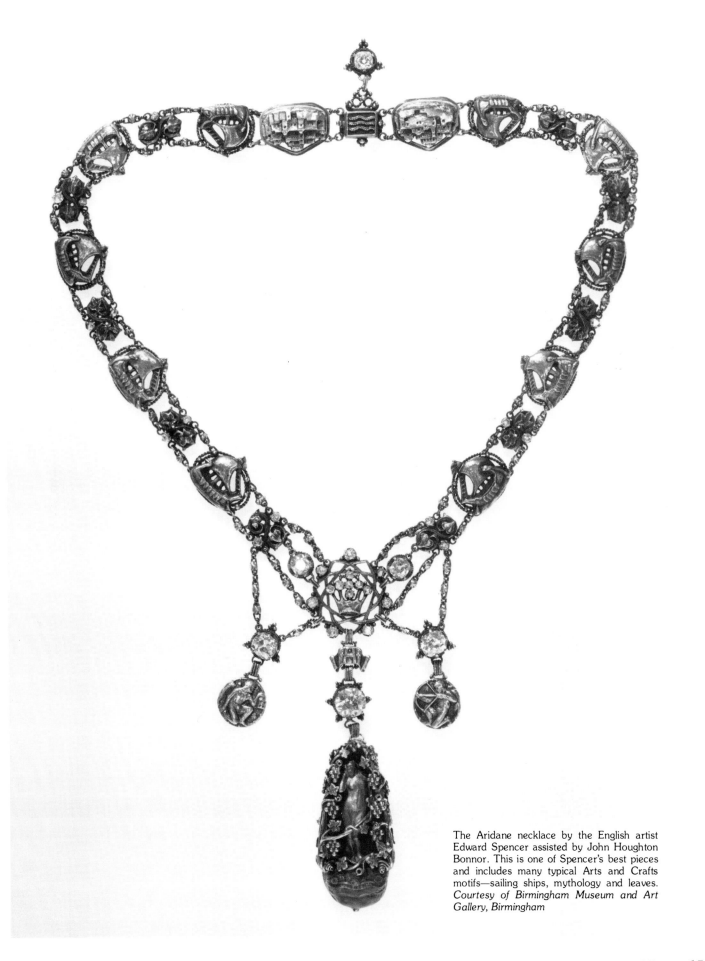

The Aridane necklace by the English artist
Edward Spencer assisted by John Houghton
Bonnor. This is one of Spencer's best pieces
and includes many typical Arts and Crafts
motifs—sailing ships, mythology and leaves.
Courtesy of Birmingham Museum and Art
Gallery, Birmingham

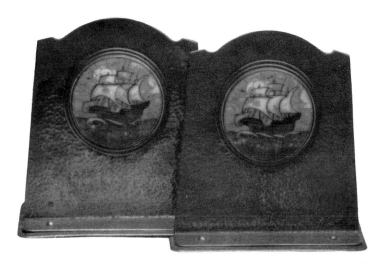

Pair of hammered copper bookends, Boston, early 20th century, enamelled sailing ship medallion mounted on each. 6½″ high, unmarked. *Courtesy of Skinner's, Inc., Boston and Bolton*

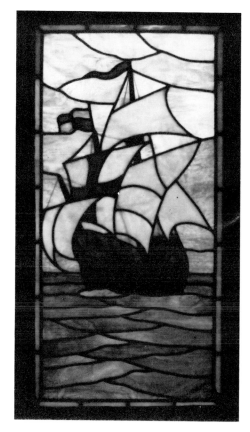

Leaded glass panel—"Sailing Ships"—one of three. Artist unknown, but probably American. *Courtesy of Skinner's Inc., Boston and Bolton*

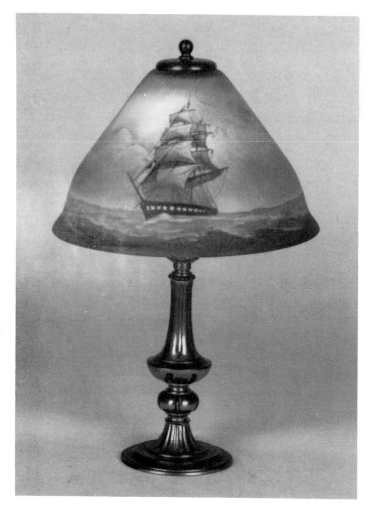

Pairpoint seascape Boudoir lamp with hand-painted interior nautical scene of tall ship. *Courtesy of Skinner's Inc., Boston and Bolton*

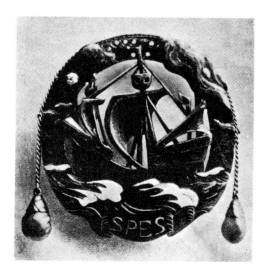

Enamelled brooch in oxidized silver by Harold Slott-Møller.

Determining to which period or country a piece of jewelry or metalwork belongs is not an exact science. Styles often overlap or are combined, particularly during the transitional stage where one style is waning and another growing in popularity. We offer these examples to illustrate what a tough call this can be.

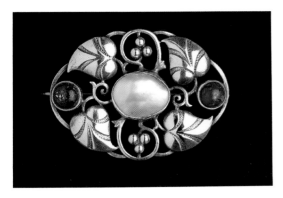

Is It Art Nouveau or Arts and Crafts? European brooch of sterling with bezel set pearl and lapis lazuli. Stamped "800" and either LB or B. *Collection of John Toomey/Dinah Thompson, Oak Park*

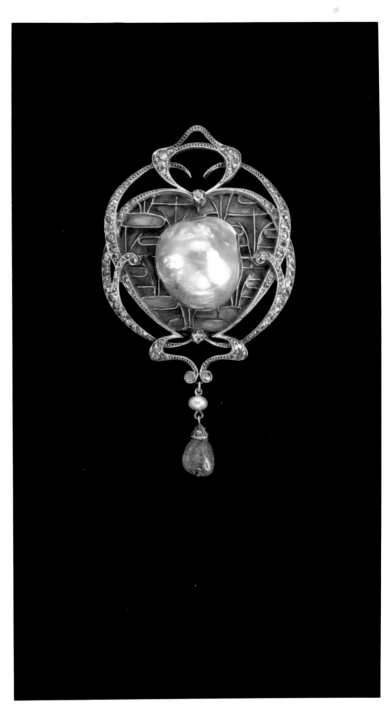

Is It Art Nouveau or Edwardian? An impressive Belle Epoque plique-à-jour enamel and diamond brooch c. 1905, which is attributed to Edward Colonna. *Courtesy of Tadema Gallery, London*

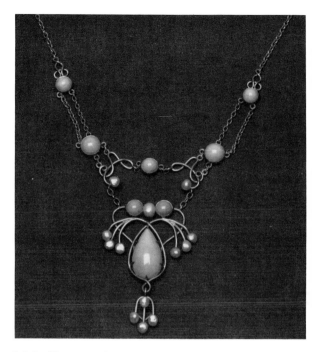

Is It Art Nouveau or Arts and Crafts? Turquoise
and pearl lavaliere containing one pear-shaped
and seven round cabochon turquoise, high-
lighted by thirteen freshwater pearls, set within
a 14 kt. gold wire work front piece with a curb
link chain. *Courtesy of Skinner's Inc., Boston
and Bolton*

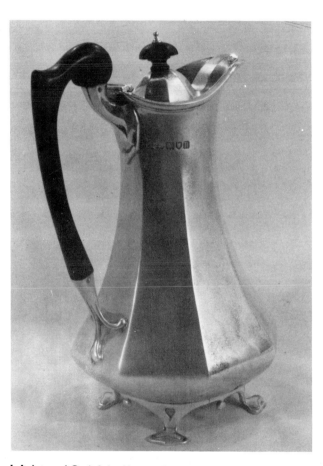

Is It Arts and Crafts? Art Nouveau? Art Deco?
Silver jug designed by Ackroyd Rhodes, 1908,
and executed by Manoah Rhodes & Sons. In
this traditional style, the jug blends elements of
the Art Nouveau with those associated more
closely with the Arts and Crafts movement,
while at the same time clearly presages the
advent of Art Deco. *Courtesy of Lake Forest
Antiquarians, Lake Forest*

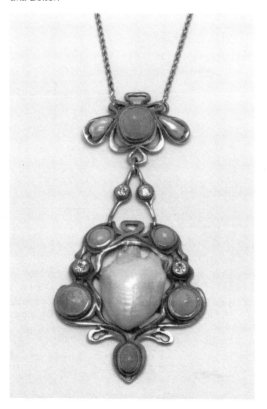

Is It Art Nouveau or Arts and Crafts? An
American necklace of 14 kt. gold with pierced
centerpiece, set with American freshwater
pearls, cabochon turquoise and two round
diamonds with rope chain, highlighted by round
pearls. *Courtesy of Skinner's, Inc., Boston and
Bolton*

Is It Art Nouveau or Edwardian? A transition
piece of platinum with enamel set with
diamonds. *Courtesy of N. Bloom, London*

Is It Art Nouveau or Edwardian? A transitional
piece of platinum, diamonds and pearl.
Unsigned. *Courtesy of N. Bloom, London*

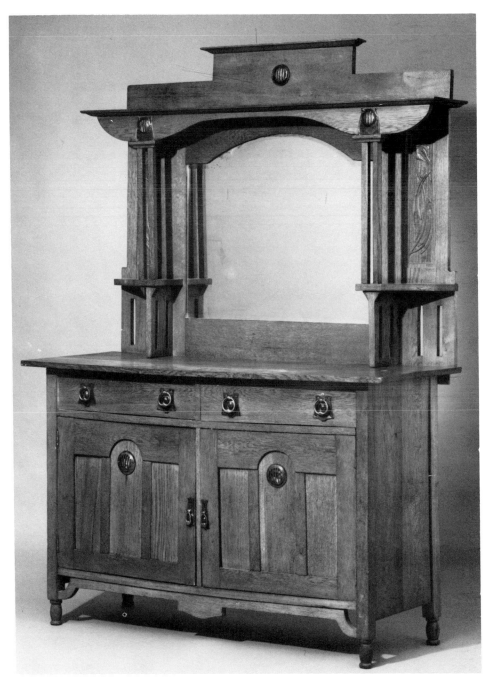

English sideboard. *Courtesy of William Doyle Galleries, New York*

England:

Part I—The Birth of Arts and Crafts

The Arts and Crafts movement in England is seen today as a reaction against the rise of industrialism and the subsequent devaluing of individual craftspeople, as well as a desire to improve English design standards in the last half of the nineteenth century. Even as early as 1836 the Government had issued a report on the decline of British design and how it had been affected by industry, so that by the time the Crystal Palace Exhibition was held in 1851, it was clear that the Victorian output of goods — and indeed jewelry and metalwork — was over-worked, overdone and overly ornate. It is not always clear how extraordinary these Arts and Crafts pieces are for the time in which they were produced. Yet if you view them side by side with mainstream Victorian jewelry and metalwork of the same era you begin to understand. While it is not entirely accurate to say that in the field of jewelry-making and metal-working that the "craft" had been completely taken over by machines, changes were being seen.

Although mass production had insinuated itself into the jewelry trade in nineteenth century England, the better jewelry was still wholly handmade. Even in secondary jewelry, the finishing steps were still mostly executed by hand. Lathes *were* used to make both metalwork and jewelry, and while technology helped the metalwork trade grow—particularly the advances of electro-plating, die sinking, stamping and pressing—the machines were only introduced gradually. In the smaller shops there was less machinery and fine quality silverware, as jewelry was still handmade.[1]

When one studies the Arts and Crafts movement for the purpose of focusing on the jewelry and metalcraft, one would do well to remember that "handmade" was important, but the search for a new English style of design was of equal significance. In this search William Morris, who is considered a catalyst for the Arts and Crafts movement, was influenced heavily by the teaching of John Ruskin and the architect A.W.N. Pugin. Pugin had "fallen in love" with the Gothic period of England's architectural past and almost single-handedly created a Gothic revival; Ruskin supported Pugin and went a step farther to preach the belief in a return to the past when the craftsman was master of his fate—not a nameless face on an assembly line. Ruskin abhorred the use of machinery and spoke of the benefits of returning to the Guild system of the Middle Ages.

Morris forged friendships with members of the Pre-Raphaelite Brotherhood, which was a secret society consisting of the the artists Dante Gabriel Rosetti, Edward Burne-Jones and William Holoman Hunt, with others to be included as they "went public." The Brotherhood disliked most art that was post-Raphael—hence the name—and felt English art was of poor quality. They set out to improve it by using classical, religious, historical and literary themes. Artists in the Brotherhood painted in a romantic Medieval style which added to Morris' nostalgic interest in England's past. Morris had had a fascination for these times even as a young boy. He had grown up in a house with a moat around it, so one can only imagine the childhood fantasies this suggested. By the time he was seven he had already read Ivanhoe,[2] so it's no surprise that he should become the spearhead for a design movement which would bring forth concepts from the past to create something new.

With a family inheritance to take care of his financial needs, Morris was searching for direction in his life. Although he considered entering the Church, he changed his mind and studied architecture. He became one of the founders of Morris, Marshall, Faulkner & Company (later Morris & Company) who produced furnishings in the "new" style which was influenced by a more glorious time in England's artistic history.

Although one of the stated purposes of Morris, Marshall, Faulkner and Company was to produce jewelry, none is known to be extant today and the company never really did produce metalwork. At the International Exhibition of 1862 the firm showed some jewelry, although the designer's identity is not known.

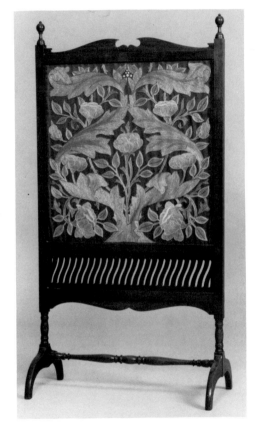

Fire screen with Briar Rose embroidery in colored silks by Morris & Co. *Courtesy of Fisher Fine Art, London*

Mid-Late Victorian jewelry in turquoise and
gold. *Courtesy of Hirsh, London*

Group of charming Late Victorian brooches.
Courtesy of Hirsh, London

Beautiful Victorian butterfly brooch of silver,
gold, ruby and diamonds. *Courtesy of Hirsh,
London*

Beautifully made Late Victorian silver, gold, and
diamond dog's head brooch with ruby eye.
Courtesy of Hirsh, London

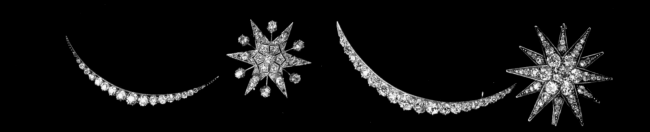

Star and moon brooches in diamonds were quite popular in the Late Victorian period. They were often worn by Queen Alexandra. *Courtesy of Hirsh, London*

Unusual Victorian multi-colored stone fringe necklace. *Courtesy of Hirsh, London*

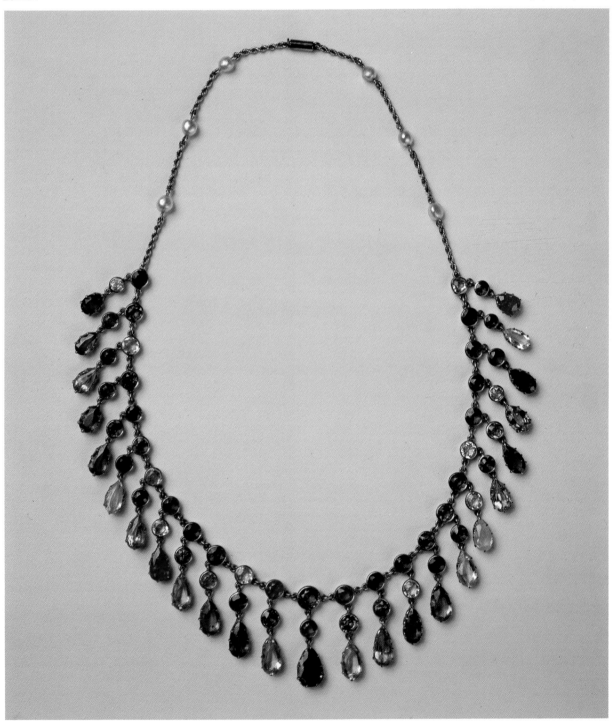

Examples of mid-nineteenth century Birmingham silver by Wilkins & Co. Exhibited at the Crystal Palace Exhibition.

The pieces are believed to have been executed by a jewelry firm located near Morris, Marshall and Faulkner's own. Why the jewelry line was not continued, and why it is not documented, remains a mystery. Although Morris' daughter May did design her own jewelry many years later, it is doubtful she learned this specific skill through her father's company.

Only one piece of jewelry has been attributed to a William Morris design and the attribution is quite likely in error: a necklace made by Margaret Awdry which was exhibited at the Grafton Galleries in 1906 (after Morris' death) was listed as being designed by a William Morris. This William Morris was probably a fellow student of Awdry's at the Birmingham Municipal School of Art, not the William Morris. James Morris was a student at the School who is known for being an assistant to Arthur Gaskin; he had a brother named William who may also have been a student there.

One of the premises espoused by Ruskin and Morris was that an object should be made entirely by one craftsman from start to finish. The Arts and Crafts jewelers and metalworkers embraced this concept theoretically, but in reality did not always keep their work this "pure." The Omar Ramsden/Alwyn Carr partnership and that of Arthur and Georgina Gaskin are two examples where one partner was the jeweler or designer, the other the enameller, and in fact all eventually turned much of their actual work over to their assistants. This principle was hard for Arts and Crafts jewelers/metalworkers to adhere to because most of them were too inexperienced to be adept at all areas of production for a piece of jewelry or metalwork.

Stylistically, it is difficult to describe what a piece of Arts and Crafts jewelry looks like as easily as one can describe some other, more dramatic, styles. Arts and Crafts was more a philosphy of how crafts objects should be made, rather than a specific style, and yet you can easily pick this jewelry out if you are familiar with it. The techniques used in making it, the materials and the feelings of the jewelry somehow says "Arts and Crafts." Arts and Crafts jewelry most often took the form of necklaces with chains, loops, festoons and pendants—often with enamel centers and wirework around them—brooches, belt buckles and cloak clasps. Less prevalent were rings, bracelets and cufflinks; earrings are rare primarily because they were not in style at this time.

While the work of some Arts and Crafts jewelers seems to be clearly recognizable, there are many who have similar stylistic approaches. Identification is made even more difficult by the fact that most pieces are not signed: while the craftsman-as-antidote-to-mechanization was central to the Movement, to identify an individual craftsman as more skilled than another contradicted its egalitarian philosophy. One key to identifying an Arts and Crafts piece is to study one of the favorite design elements of the jewelers—the leaf—which appears over and over again. Arts and Crafts designers used stamp molds to make their metal leaves so those of each designer would be consistent and recognizable.

There were a number of influences on Arts and Crafts jewelry—most prominent was the revival of the Medieval approach to making jewelry as well as the use of Medieval motifs. Ruskin and Morris also believed that design should spring from nature and the Arts and Crafts jewelers agreed—numerous flowers, leaves and animals abound in their jewelry. Celtic jewels were discovered throughout Great Britain in the nineteenth century and led to a Celtic revival in the last few decades—this interest carried over into Arts and Crafts jewelry as well. Most notably, Archibald Knox, designer for Liberty & Co. drew on his own Celtic background by introducing the whiplash or entrelac motif into the jewelry he designed for Liberty's Cymric and Tudric lines.

The Aesthetic movement's Japanese-inspired motifs also spilled over into some of the Arts and Crafts designers' work, and John Paul Cooper adopted the Japanese metalworking technique of mokumé (mixed metal).

Particular designers tended to use certain materials, motifs or techniques which can be clues then to attribution. However, the danger of presuming the origin of an unsigned piece of jewelry is illustrated by an anecdote related by Peyton Skipwith of the Fine Art Society, London. Mr. Skipwith spied a piece of jewelry in a London shop one day that he was certain was made by John Paul Cooper. The shop had identified it as being "probably Austro-Hungarian" in origin. Mr. Skipwith showed the piece to Francis Cooper, the jeweler's son, also a jeweler, who insisted his father would never have designed a piece of jewelry of

that nature. Yet the design for that piece of jewelry was later found in his father's stockbook.[3]

Women in the Movement

An interesting development of the Arts and Crafts jewelry movement was the number of women who emerged as important designers and jewelers. This was really the first time in the history of British jewelry and metalwork that women were permitted to play a serious role as artisans, and many managed to have commercial success. One reason they were able to participate in jewelry and metalwork enterprises is that although the Arts and Crafts movement eventually lifted the decorative arts to the status of the fine arts, "decorative" was still synonymous with "domestic," which clearly meant "feminine."

This was also a movement of untrained craftsmen, so women had an equal chance of excelling through the trial-and-error method. Up until this time, men had the edge in the arts by dint of having formal training which was generally denied to women. Although the men of the Arts and Crafts movement were mostly quite well-educated, they had trained as architects and fine artists, and later taught themselves the craft disciplines.

It was acceptable for a woman to enter into a jewelry-making career for several other reasons as well. For one, it was an occupation directly related to the adornment of women. Second, it was a craft for which they could set up a studio in their home. And last, it was believed, and most unfortunately put by the critic Aymer Vallance in 1903, that "the numerous ladies who have achieved success in jewelry design proves this, indeed to be a craft to which a woman's light and dainty manipulation is peculiarly adapted."

The Pre-Raphaelite movement in painting beginning around 1848 idealized women and used women as the main themes of most paintings. In fact, a number of women painters became a part of the second generation of Pre-Raphaelite painters. As in the Arts and Crafts movement they were primarily sisters, wives and daughters of the male artists. With many cross-relationships between these two circles of artisans the precendent set by these female painters may have helped pave the way for the women of the Arts and Crafts movement.

A further explanation for why there were so many women jewelers and metalworkers during the Art and Crafts period is suggested by Anthea Callen, in her book , "Angels in the Studio". She points out that there were four groups of women who became involved in the Arts and Crafts Movement:

1. Working class women who were part of the craft classes organized throughout the country...nothing on this scale had ever been attempted before.
2. Upper class women who as philanthropists organized these classes and sometimes became successful craftsmen themselves.
3. "Destitute gentlewomen" who were from the middle class but needed a means to support themselves—this strata of women did not really exist in any great number before this time.
4. The women who were married to men in the movement and for the first time became artistic partners with their spouses.[4]

One aspect of the Arts and Crafts jewelry and metalwork movement that is striking is how intricately related these artisans were—they were married to each other, had affairs with each other, did commissions for each other, were teacher and student, sisters, cousins, parent and child, fellow guild members, etc. Study the history of one and you'll no doubt turn up a great deal of information about several others. These relationships make the study of these designers and craftsmen quite fascinating and it is easy to see the synergistic effect they had on each other's work.

This does pose another problem in identifying unsigned pieces—the styles overlap, since the artists influenced each other—was it the teacher or the student who made this necklace? The only rule of thumb to follow here is to look for documented pieces by an artist that are similar to an unsigned piece. If you have a very discerning eye you can try to look at the maturity of the craftsmanship which may help to determine if the teacher or student executed a piece of jewelry, but this is still shaky ground.

Another interesting aspect of the Arts and Crafts movement was the number of husband/wife teams who created jewelry and metalwork. It seems that most of

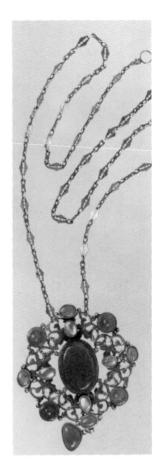

Necklace by unknown maker, c.1915. Silver injected quartz and moonstone. *Cheltenham Art Gallery and Museums, England*

Vinaigrette by the Birmingham firm of Levy and Solomon. *Courtesy of Leah Roland/Split Personality, Leonia. Photo by Diane Freer.*

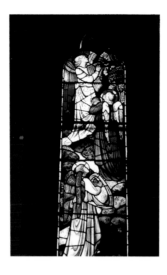

William Morris stained glass window, "Angels of Paradise",1885. *Courtesy of the Church of the Incarnation, New York*

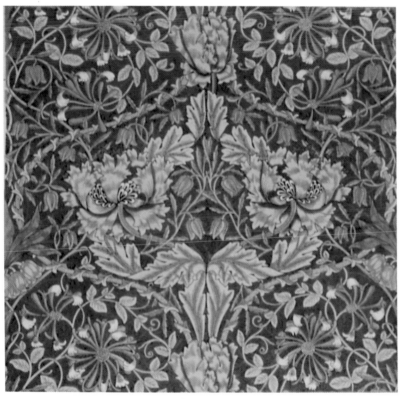

William Morris fabric "Honeysuckle", 1876. *College Museum of Art, Rhode Island College of Design*

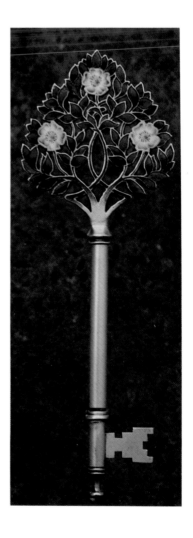

Presentation key of silver gilt, enamel. The decoration is closely associated with William Morris and the Pre-Raphaelite circle, c. 1890. Length 15 cm. *Courtesy of Tadema Gallery, London*

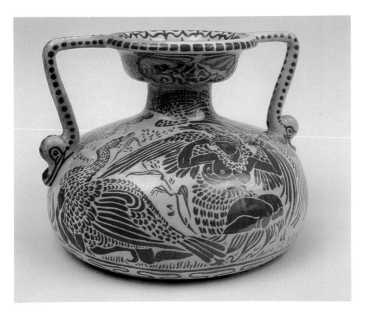

Double-handled vase by Walter Crane.
Courtesy of Barry Friedman, Ltd., New York

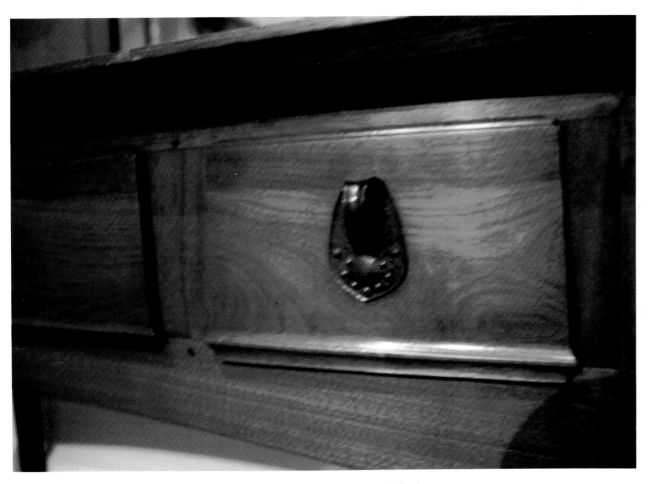

An example of English Arts and Crafts
metalwork fittings for furniture. *Courtesy of
Simon Tracy, London*

Victorian day dresses, 1869 from Godey's Lady's
Book.

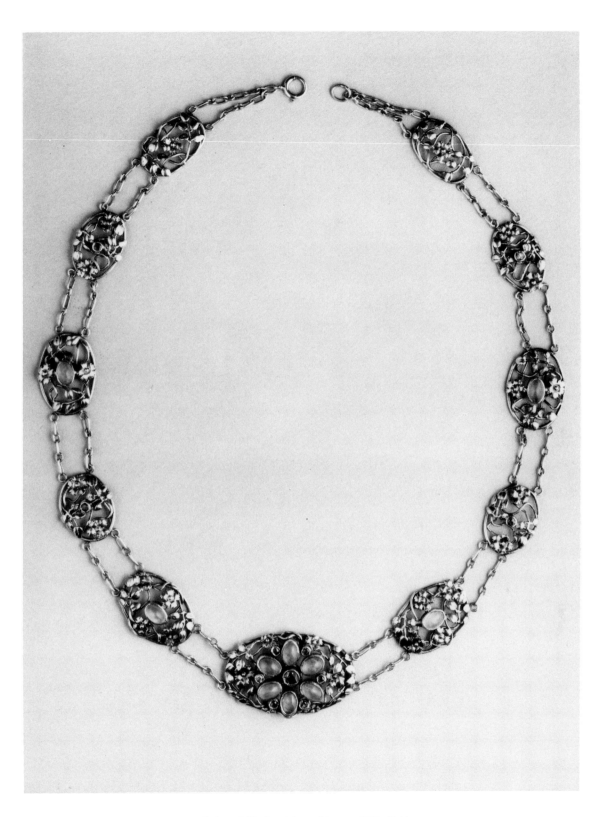

Arts and Crafts style necklace, c.1900. Gold,
opal and demantoid garnets. *Courtesy of N.
Bloom, London*

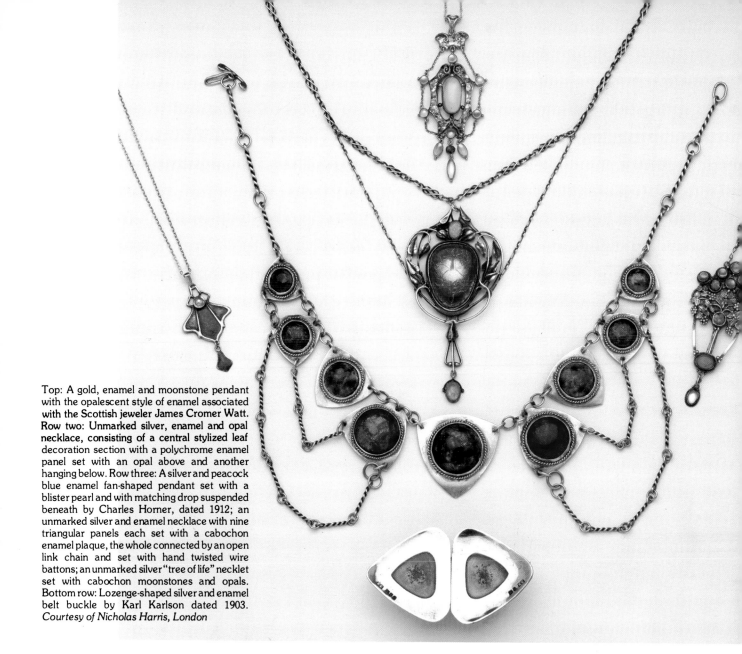

Top: A gold, enamel and moonstone pendant with the opalescent style of enamel associated with the Scottish jeweler James Cromer Watt. Row two: Unmarked silver, enamel and opal necklace, consisting of a central stylized leaf decoration section with a polychrome enamel panel set with an opal above and another hanging below. Row three: A silver and peacock blue enamel fan-shaped pendant set with a blister pearl and with matching drop suspended beneath by Charles Horner, dated 1912; an unmarked silver and enamel necklace with nine triangular panels each set with a cabochon enamel plaque, the whole connected by an open link chain and set with hand twisted wire battons; an unmarked silver "tree of life" necklet set with cabochon moonstones and opals. Bottom row: Lozenge-shaped silver and enamel belt buckle by Karl Karlson dated 1903. *Courtesy of Nicholas Harris, London*

Enamel and silver moonstone necklace by Liberty & Co., c. 1900. *Courtesy of Cobra and Bellamy, London*

the couples met while they were in art school and formed partnerships that crossed over from their personal to their professional lives. For collectors and historians, these collaborations pose a problem to a small extent for it is often difficult to determine if a piece of jewelry or metalwork was really a joint effort or made by one half of the husband/wife team. This is particularly true with people like the Dawsons and the Gaskins who had a sizeable output during their careers.

One should also remember that there were many amateur Arts and Crafts jewelers who account for some of the unsigned works which are out in the marketplace. They were encouraged by the craft schools and were able to afford their hobby because Arts and Crafts jewelry was made from less expensive materials than traditional jewelry. It is even possible to find a "marriage" in Arts and Crafts metal objects—for example, one could buy an enamel plaque made by an accomplished enameller and insert it into an amateur-made box.

The Arts and Crafts designers were on the whole multi-talented people. In addition to producing jewelry and metalwork, the majority of them were successful at other design endeavors as well. Many of the jewelers began as architects and also designed furniture and fabrics, others were painters, illustrators and book designers, while still others did gesso work, embroidery, pottery designs and tapestries. In fact, one would have to say that they were true "Renaissance men and women"—exactly the type of artist they sought to emulate.

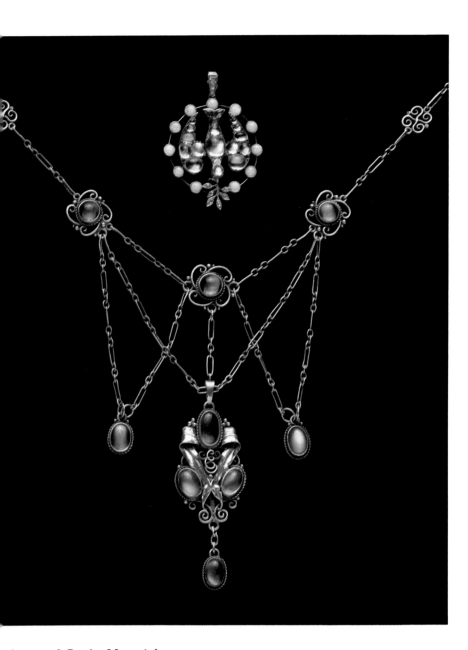

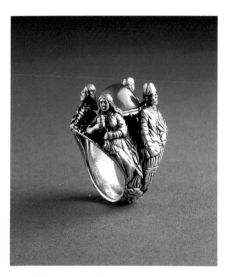

Moonstone and opal pendant and necklace, c. 1900, English. *Courtesy of Van Den Bosch, Georgian Village, London.*

An Episcopal ring in the Gothic style. The central stone is a cabochon blue chalcedony flanked with four figures—St. Augustine of Canterbury, St. Joseph. St. Peter and Mary Magdalene. English. c. 1900. *Courtesy of Spink & Son, Ltd., London*

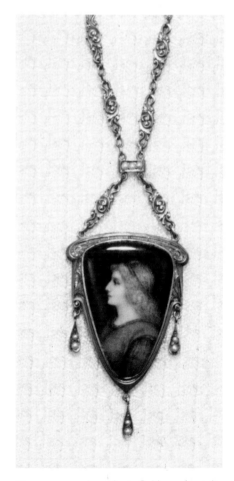

Limoges enamel pendant. Gold, seed pearls, unsigned. *N. Bloom, London.*

Arts and Crafts Materials

In selecting their materials, Arts and Crafts jewelers intentionally chose to work with materials that were less precious than those which were in vogue at the time. Because silver was not nearly as valuable as gold, particularly with all the silver finds made in the late nineteenth century, this was the metal of choice for most designers. Gold was more likely to be used only for decoration or trim since it did not show hammer marks well. These marks were usually left visible on finished pieces of softer metals to serve as a visual sign that the piece of jewelry or metalwork was made by hand. Silver was a more workable metal, and was chased into leaves and flowers; joined by wound wire or flaps of metal inserted through slits and folded back; enamelled; or set with semi-precious stones and other materials.

Also used frequently by Arts and Crafts artisans were copper, brass, aluminum and even base metals—the market value of the metal had no meaning to them. A handful of artisans still preferred to work in gold—15—and 18-karat—for its warm color, but platinum was never used. It is notable that in the October 9, 1992 auction at Christie's in London of the Larner collection of Arts and Crafts jewelry, the majority of the pieces were described simply as being of "white metal" or "yellow metal." It is likely that most of these pieces were silver or gold, but were an impure alloy that could not be labelled appropriately as gold or silver standard.

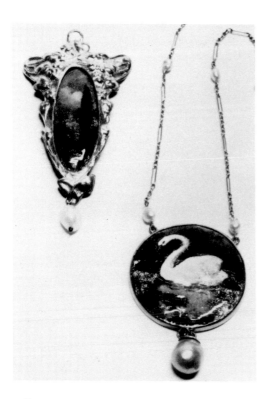

When gemstones were incorporated in jewelry, they appeared mainly as accents. Diamonds—the precious choice of mainstream Victorian jewelry—were almost never used. Stones were chosen for color, not value, hence the popularity of semi-precious stones. If precious stones were used they were likely to be of poor quality, a philosophy consistent with the use of base metals. A dual goal of making the jewelry relatively affordable, while allowing the craftsmanship of the setting to remain the chief focus of the piece, rather than serving as simply the vehicle used to highlight the stone was thereby achieved.

To further highlight the design of a piece of jewelry, most stones were cut *en cabochon*. This practice was encouraged by Ruskin's belief that stones should not be faceted. Ruskin was a collector of gemstones and preferred to keep his own collection uncut. The stones in an Arts and Crafts piece tended to be set in simple collet settings and/or wound with wire.

Pearls received similar treatment: while they were used quite often in Arts and Crafts jewelry, they were not the perfectly formed creamy colored pearls seen in popular jewelry. They were more likely to be elongated river pearls, misshapen, or yellow or gray in color. Turquoise was also popular with Arts and Crafts jewelers. It was often used in a matrix to give a more natural, rough-hewn quality, and was often paler—again, a lower grade—than what was used in standard Victorian jewelry. Opals too, were sometimes used in the matrix. Other "natural" materials were favored by these artisans, including coconut shell, horn, abalone, and mother-of-pearl.

Enamelling, a Renaissance practice, became one of the most important elements of Arts and Crafts jewelry. The undisputed master of enamelling at this time was Alexander Fisher, who had studied in France, and influenced and taught many other contemporary Arts and Crafts jewelers. A number of enamelling methods were used—cloisonné, champlevé, Limoges, and less often plique-à-jour—an important distinction from the Art Nouveau movement artists who used this technique exhaustively. Enamel could be either the main element in a piece of jewelry or used only as a trim. Many of these enamellers learned by trial and error and taught each other.

A New Style of Dress

It is unlikely to see a parure or even a demi-parure in the Arts and Crafts style, and although some jewelry was made for the royal family it was not formal evening jewelry. The exceptions are a few wonderful tiaras that were made, several by Henry Wilson, including one that is in the collection of the Victoria and Albert Museum. That particular piece was composed of crystal and chalcedony. Another of horn and moonstones was one of several designed by Fred Partridge for Liberty and Company which is still in the possession of that firm. May Morris also made a lovely tiara which is now in the collection of the National Museum of Wales.

Two pieces of jewelry by unknown artisans. Pendant at top is c. 1900-1910 and is silver and enamel with a pearl. The enamelling resembles Charles Fleetwood Varley's work. The necklace below is gold and enamel with a pearl. The chain and mount for the pearl are standard commercial fittings. *Cheltenham Art Gallery and Museum, England*

Top left: Sterling silver and blue stone pin, English, early twentieth century and beneath it a sterling silver pin with mounted peridots, c. 1900, probably English. Signed Plantagenet, handwrought. Middle row: Top, enamel and sterling pin by Murrle Bennett & Co. c.1905. Blue and green enamel, marked MB & Co. and 950; center, silver necklace with blue stones, probably English suspended from fine chain, bottom, sterling silver and amethyst pin, early twentieth century with baroque pearls, gold washed highlights, origin unknown (may be American).Right—two decorated silver pins, English, c. 1910. Trefoil pin with blue-green enamel marked 925, the other with applied ribbon border with centered green cabochon, unmarked. *Courtesy of Skinner's Inc., Boston and Bolton*

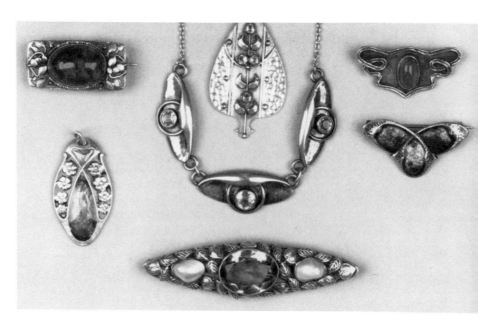

The individual pieces of Arts and Crafts jewelry tend to be larger than other popular styles. The belief was that one significant piece should be worn rather than the excessive amount of jewelry Victorian style called for to complement elaborate dress styles. The Arts and Crafts designs coordinated well with the new style of dressing that was emerging simultaneously. The Rational Dress Society had been formed in the 1870's by enlightened women, and was supported by a number of intellectual and artistic men. The typical Victorian dress at that time trailed to the ground, was heavily ornamented, cinched tightly at the waist and was made of very heavy fabrics.

The Society sought to make women's clothes more sensible rather than the instruments of torture that they were. They opposed corsets and stays, which some claimed caused ill health and even death, and believed in looser, more practical garments. Society members also recommended clothing that was short enough to keep a woman from tripping over it, and the split skirt which allowed a woman to bicycle, play tennis and enter the working world without inhibiting movement.

The women of the Pre-Raphaelite movement—mainly wives of the artists—adopted a new style of dress that met most of the criteria of the Rational Dress Society—flowing gowns with high waists constructed of lightweight, comfortable fabrics that draped loosely. Similar clothing was suggested by the Healthy and Artistic Dress Union founded by sculptor Homer Thorneycroft and his wife. The women of the Arts and Crafts movement also embraced the more fluid style of clothing. Liberty & Co. was quite successful in marketing this type of dress, some in kimono styles, some with smocking and embroidery—a very important Arts and Crafts pursuit—and often worn with a shawl held in place by a brooch. The pendant and necklace, also staples of the Arts and Crafts jewelry designers, suited this costume perfectly.

The dresses were often Medieval in inspiration, a continuation of a style that women of the Pre-Raphaelite circle had become fond of wearing. But the women of this earlier movement had either worn no jewelry, or simple beads, an imported necklace from India, or some other type of ethnic jewelry.

Jewelry for the Masses

It is important to remember that Arts and Crafts jewelry never caught on as a broadly popular style, as more traditional jewelry was thriving at the time. Ironically, although Arts and Crafts jewelry was conceived of as wearable art for the masses, it became a style appreciated and purchased only by an elite portion of the aesthetically oriented middle class who also wore the clothing so compatible with it. Theoretically, materials with little intrinsic value were used to make the jewelry and metalwork affordable to the average person. In reality, it was the middle class, not the working class who appreciated and bought Arts and Crafts jewelry and the cost of hand crafting jewelry made the prices too "dear" for the average woman.

Ironically, the Arts and Crafts movement did reach the "masses" but not through the Arts and Crafts artisans. Retailers and manufacturers such as Liberty & Co., Charles Horner, Murrle Bennett and others became the conduit to the "masses". In many cases this meant that the Arts and Crafts designs became overworked. In its commercial form Arts and Crafts jewelry and

Corset advertisement from Bloomingdale's 1886 catalog.

A metal box with enamel work in the Pre-Raphaelite style. This enamel appears to be of professional quality, but the box itself has an amateur look. It reads, "Wayward as a swallow, shy as a squirrel." *Courtesy of Leah Roland/Split Personality, Leonia. Photo by Diane Freer*

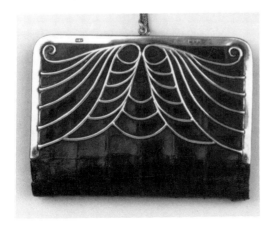

Sterling silver and leather purse, London, c. 1903, interior fitted with a change purse and leather compartments, maker's mark "GHJ" in a rectangular cartouche and a sterling silver belt buckle c.1904 in the form of two angels hallmarked "Birmingham, sterling B1369, copyrighted 1901". *Courtesy of Skinner's Inc., Boston and Bolton*

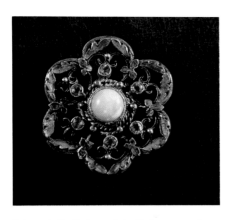

Arts and Crafts brooch in Suffragette colors. Green enamel, amethysts, opal center, green stones set in silver. *Courtesy of Leah Roland/Split Personality. Photo by Diane Freer.*

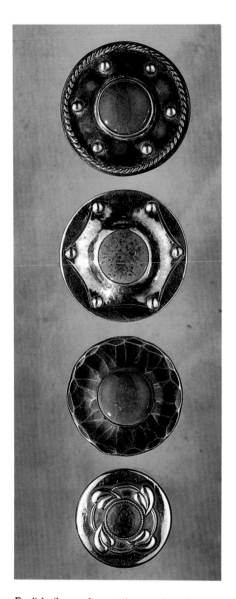

English silver and pewter buttons from the early twentieth century in the Arts and Crafts style. *Reprinted from Buttons by Diana Epstein and Millicent Safro. Published in 1991 by Harry N. Abrams, Inc.: P: John Parnell*

metalwork was an unending flow of silver with a hammered look and mother-of-pearl or moonstones, blue-green enamel on silver, turquoise matrix with gold, and pale amethysts with silver. There was a totally erratic quality to commercially produced jewelry—the quality of design and workmanship varied enormously. In many cases the mass-marketed jewelry hovered somewhere between Arts and Crafts and Art Nouveau stylistically.

The Suffragette movement also helped to create a place for Arts and Crafts jewelry. As women fought to vote, they also began entering professions previously only open to men and adopted a "man-tailored" style of clothing—a simple skirt with a blouse and a belt, and the ever-present jacket became quite popular. The simple brooch to wear at the collar and the belt buckle, cloak clasps and hat pins, became the standard for jewelry with this "uniform," at which the Arts and Crafts jewelers excelled. It may also be noted that several Arts and Crafts jewelry designers often used the colors of the Suffragette movement in their work—green, white and violet (G-Give, W-Women, V-Vote). These were popular colors for this type of jewelry, however, and not all designers may have meant the use of them to signify their political beliefs.

Emmeline Pankhurst, the suffragette leader, supported the Arts and Crafts movement. A watercolor of her daughter wearing jewelry by C. R. Ashbee is in the collection of the Museum of London. In the Scottish National Portrait Gallery a portrait of Flora Drummond, who worked with Mrs. Pankhurst, shows her wearing her suffragette badge and an Arts and Crafts necklace by an unknown designer set with purple, green and blue stones.

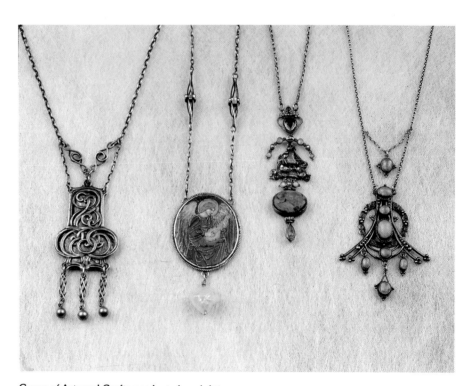

Group of Arts and Crafts pendants from left to right: Omar Ramsden, silver and enamel, c. 1920; unknown artist in Pre-Raphaelite taste, c. 1900; Multi-gem set pendant by Edward Spencer for the Artificer's Guild, c. 1890; opal pendant c. 1900. *Courtesy of Didier Antiques, London*

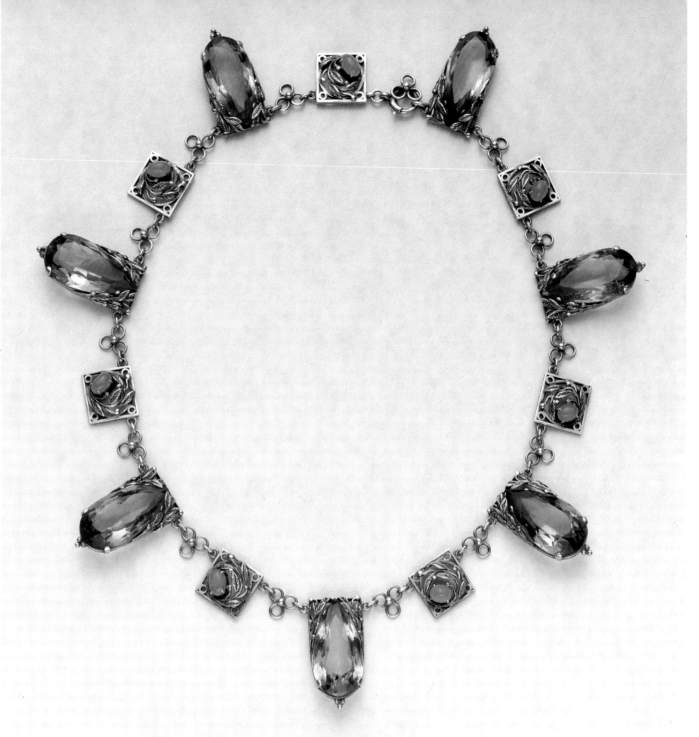

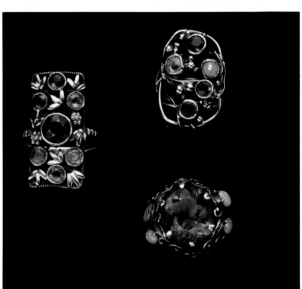

Amethyst and chrysoprase necklace, unsigned. *Courtesy of Van Den Bosch, Georgian Village, London*

Rings by the Gaskins, Sibyl Dunlop, and an unknown artist. *Courtesy of Van Den Bosch, Georgian Village, London*

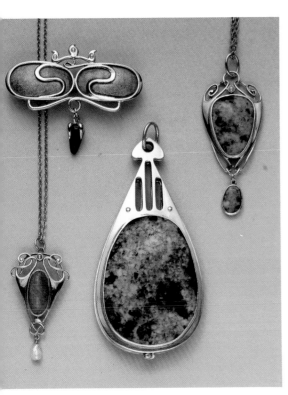

Liberty & Co. enamel brooch, and turquoise and enamel pendants by Murrle Bennett. *Courtesy of Van Den Bosch, Georgian Village, London*

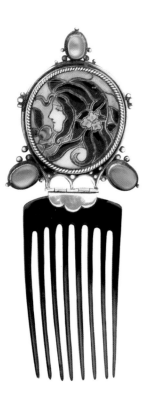

White metal, moonstone and **plique-à-jour** hair comb by an unknown artist. The girl's head in the style of **Art Nouveau** designer Alphonse Mucha and the enameling of the quality of one of the better British Arts and Crafts jewellers. *Courtesy of Christie's, London*

A Marketing Dilemma

One of the problems Arts and Crafts jewelers and metalworkers faced was finding a way to get their work before the public. Joining a Guild was helpful for some artisans but many craftsmen worked on their own. Craft exhibitions were set up in order to help the jewelers and metalworkers with their marketing, but they were not held frequently enough to give artisans continuous exposure to the public—in the end those who were able to succeed financially at their craft were those who got commissions from wealthy patrons.

Another invaluable tool for spreading ideas about the new styles and building the reputations of individual craftsmen was the art magazines that sprung up at this time. A.H. Mackmurdo published the *Hobby Horse* for several years beginning in 1884. This was the first publication to bring British design to the Continent. Most significantly, in 1893 *The Studio* began publication in England and was read not only on the Continent but in the United States as well, and helped provide an exchange of design ideas from many countries.

Arts and Crafts Metalwork

Domestic silver and other metalwork at this time was also incredibly ornate, sometimes to the point of being ridiculous, which only highlights the beauty and integrity of the metalwork by Arts and Crafts artisans. Many of the same principles that applied to Arts and Crafts jewelry applied to the metalwork as well, in good part because many of the craftsmen and women produced both types of work.

Before the Arts and Crafts Movement made copper acceptable for home objects it was used only in the servants quarters and only gold, silver, plate, brass and bronze were fashionable. Copper was favored by Arts and Crafts workers because it was a modest material with a pleasing color and texture and it was affordable. It was also a good medium for hand-hammering, which was meant to be seen as a design element, and it was joined by brazing and riveting, which was also frequently left visible. Silver was carried over from its place of importance in the design of jewelry to do double-duty in the domestic metalwork areas as well. The mechanical properties of both metals made them ideal candidates for hand-crafting by these metalsmiths.[5]

One additional area falls into the realm of Arts and Crafts metalwork. In the change to an industrial society, ironwork became cast, not forged. Forged ironwork was able to make a comeback during the Arts and Crafts period because a great deal of Church restoration was taking place and created a need for hand-wrought iron work. Brass and copper hinges and other decorative metalwork such as andirons, door plates, window fittings are also part of the Arts and Crafts heritage.

Now that we've discussed the social milieu and the working philosophies and materials of the Arts and Crafts designers, we are ready to move onto the discussion of the designers themselves. Metalwork and jewelry making were important aspects of the Arts and Crafts movement and were the outlets for many talented designers and craftsmen in England. As Bernard Cuzner said, "The test of our mastery of our art and craft is to use contours and surfaces as a painter uses colors, a sculptor forms, a writer words, or a musician sounds, to express their own ideals".[6]

Brass tea caddy and spoon by unknown maker. *Courtesy of Leah Roland/Split Personality, Leonia. Photo by Diane Freer.*

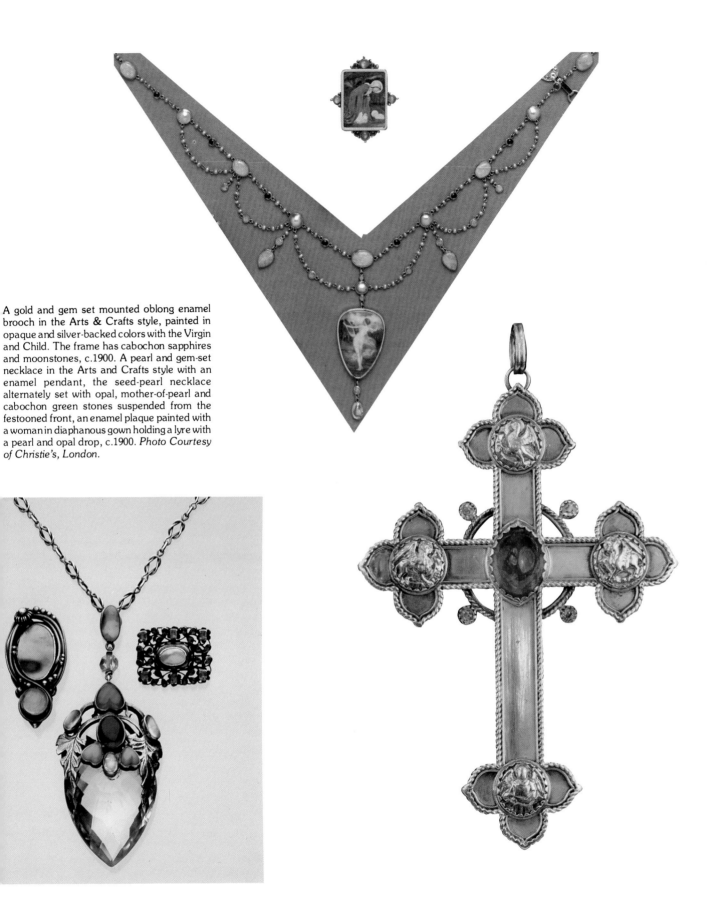

A gold and gem set mounted oblong enamel brooch in the Arts & Crafts style, painted in opaque and silver-backed colors with the Virgin and Child. The frame has cabochon sapphires and moonstones, c.1900. A pearl and gem-set necklace in the Arts and Crafts style with an enamel pendant, the seed-pearl necklace alternately set with opal, mother-of-pearl and cabochon green stones suspended from the festooned front, an enamel plaque painted with a woman in diaphanous gown holding a lyre with a pearl and opal drop, c.1900. *Photo Courtesy of Christie's, London.*

Brooch on left: by unknown artist of tourmaline and blister pearls, center: Sibyl Dunlop crystal pendant c. 1925, and brooch by the Gaskins of tourmaline and green paste c. 1900. *Courtesy of Didier Antiques, London*

Gold, pink tourmaline and diamond cross, attributed to Edward Spencer for the Artificer's Guild, c. 1900. *Courtesy of Tadema Gallery, London*

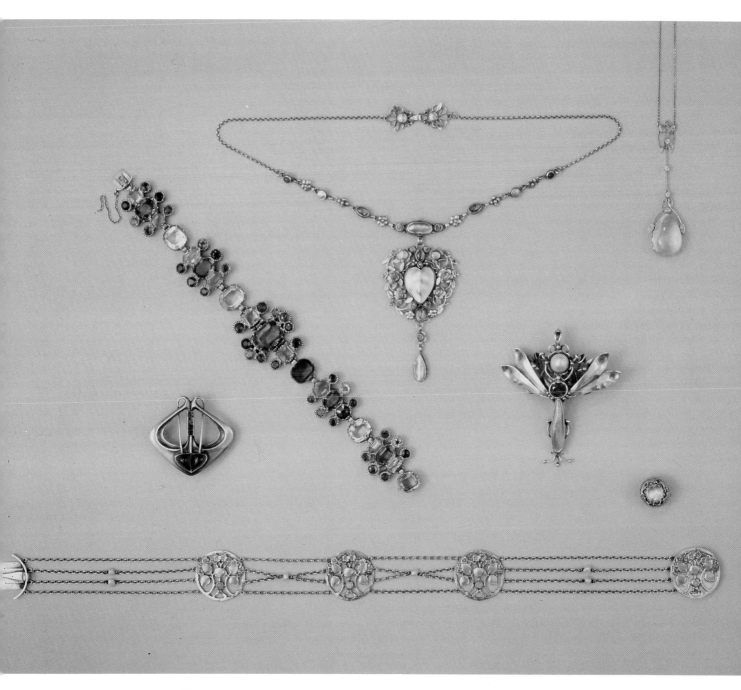

Top row: necklace by the Gaskins; moonstone, platinum and diamond necklace, a later design by Archibald Knox for Liberty & Co. Second row: a brooch designed by Max Gradl for the German manufacturer Theodor Fahrner; a multicolored stone bracelet by Sibyl Dunlop; an insect brooch designed by C.R. Ashbee and made by the Guild of Handicraft; a baby brooch by Liberty & Co. Bottom row: Choker made by unknown English artisan. *Courtesy of Cobra and Bellamy, London*

England:

Part II—Designers and Craftsmen

This section of this book is an attempt to provide as much information as possible about English Arts and Crafts designers of jewelry and metalwork. To do so, an effort was made to include all the designers and craftsmen that were found and not to focus only on the most famous names that are usually mentioned elsewhere. For this reason, there will be a number of artist/craftsmen for whom there are very brief listings; the details of their lives, careers and work have been lost to time. Hopefully their inclusion here will prompt collectors with further information about these craftsmen to share their knowledge.

Secondly, any interesting information about these Arts and Crafts figures' lives that could be uncovered is included to try to help "bring them to life" and to give a feeling for how their lives were intertwined. They are listed in alphabetical order and birth and death dates are given where known. Husband and wife teams are listed together.

Annie Alabaster
Alabaster designed simple silver and gold pieces executed by a Mr. Talbot of Glasgow. Her work included hat pins, brooches and belt buckles with enamel work. The motifs she used included the peacock, thistles and Celtic creatures.

M. Alabaster
This jeweler made silver and enamel work which was featured in *The Studio*.

Cecil Aldin
Aldin was an enameller.

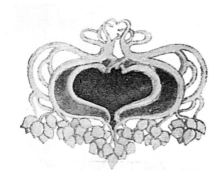

Brooch in gold and emerald by M. Alabaster.

Kate Allen
Allen is primarily known for designing clasps and belt buckles for William Hutton, a jewelry manufacturer. Her buckles had an Art Nouveau flavor and were often made of silver with enamel using a stylized peacock design. Other examples of pieces she designed include a brooch in gold and enamel with a pearl center, watch backs, and a hair comb in silver and translucent enamel. She was probably an independent designer who "freelanced" for Hutton. She often used a Dutch girl motif and other typical Arts and Crafts motifs such as the galleon. Two white metal necklaces stamped "Allen" were offered at Christie's, London in 1992.

Walter Andrews
Andrews was one of Omar Ramsden and Alwyn Carr's original assistants, starting with the workshop in 1899. Hired as an errand boy, he became an accomplished silversmith. After the partnership broke up, he stayed with Ramsden's workshop and became the foreman and chief silversmith, specializing in large and important commissions. Andrews stayed with the workshop until after Ramsden's death in 1939.

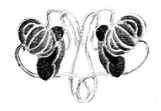

Brooch in silver and enamel by Kate Allen.

Two enamelled silver belt clasps by Kate Allen, one with the popular peacock motif.

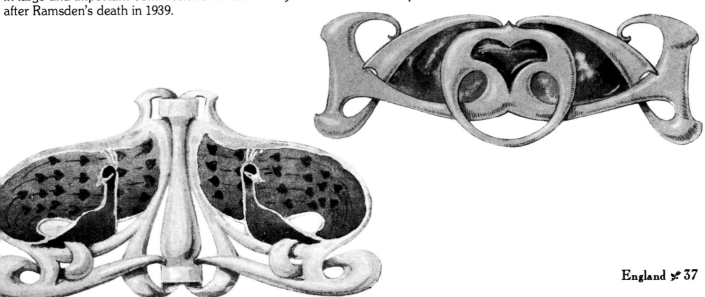

Brooch of silver and enamel by A.E. Arscott.

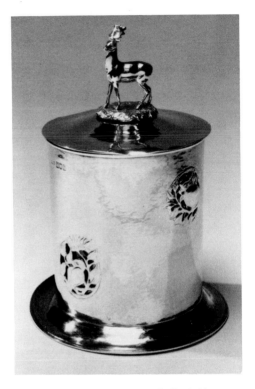

A biscuit barrel designed by C. R. Ashbee, hallmarked in London in 1903, G of H Ltd. The stag is not part of the original design but it is unknown when it was added. *Cheltenham Art Gallery and Museums, England*

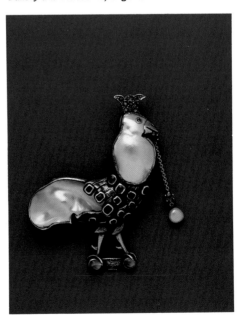

Crowned cockerel brooch designed by C. R. Ashbee and made by the Guild of Handicraft. Made of white and yellow metal set with blister pearls, pearls, sapphires (two are paste replacements), tourmalines and moonstones. *Courtesy of Christie's, London*

A. E. Arscott

Arscott made silver and enamel jewelry that appreared in *The Studio*.

Charles Robert Ashbee (1863-1942)

Architect, designer, silversmith and jeweler, Ashbee was one of the most influential artisans of the Arts and Crafts movement. He is equally important for his design work and as the founder of the Guild of Handicraft. The Guild is significant for the work it turned out as well as for inspiring other artists' communities in a number of countries.

Ashbee attended Wellington and King's College, Cambridge, and was apprenticed as an architect to G.F. Bodley in 1886. During that time he became interested in the philosophies of John Ruskin and William Morris and began a reading class of Ruskin's work which evolved into an art class. At the time he lived at Toynbee Hall, a housing area for students located in the midst of the East End to encourage the students to mix with their working class neighbors.

This class became the basis for the School of Handicraft which in 1888 became the Guild of Handicraft, set up to make furniture, metalwork and jewelry with Ashbee as the chief designer.

The Guild originally was located in London in a Georgian house known as Essex House, with a retail store on Brook Street. In 1902 it moved to Chipping Camden in the country with the intent that a true communal lifestyle be created. That same year they exhibited in the Vienna Secession Exhibition.

During his Guild years Ashbee designed numerous pieces of silver and jewelry which were crafted by Guild members. He was probably the first Arts and Crafts designer to design jewelry. In the early 1890's the Guild made buckles and brooches of copper or silver executed by silversmiths, not jewelers. The pieces were wrought—or cast-silver set with semi-precious stones. As time went on their expertise grew. Some trained jewelers also joined the Guild and Ashbee's designs became more elaborate. Ashbee often favored the use of amethysts, carbuncles, pearls set in silver, and blue and red enamels. Some of his most recognizable pieces are a number of different peacock pendants, and an amorphous combination butterfly/insect/flower that has curves with a slight hint of Art Nouveau to it.

Although in general all of the jewelry produced by the Guild has been assumed to have been designed by Ashbee, some of the pieces may have been designed by others, particularly those at the end of the Guild's existence which were of lower quality and designed to be quick sellers.

Details of Ashbee's life have been unknown for many years. Though he was openly homosexual, all male homosexual acts were illegal in England at this time; Oscar Wilde was imprisoned for being homosexual in the same era. Because of this, Ashbee entered into a heterosexual marriage to Janet Forbes, the daughter of a stockbroker and a supporter of the Guild, when she was just twenty. It appears that the marriage was not consumated for several years, although she eventually gave birth to two children. Ashbee had at least one extramarital relationship with a man later in his marriage, but he did have a very strict moral code. Upon discovering that Guild member Fred Partridge, a very handsome man, was romancing Guild bookbinder Statia Power despite his engagement to May Hart, a jeweler, Ashbee suggested that Partridge give up Power and leave the Guild to save his relationship with Hart. Partridge quit the Guild in great annoyance, but did eventually marry May Hart. Ashbee's wife Janet fell in love with another man and travelled with him during her marriage, but the Ashbees did not separate or divorce.[7]

While Ashbee's early designs were simple, his interest in symbolism is apparent. He frequently used the pink (a flower which became the emblem of the Guild), trees, the sun, a circle, the peacock and winged youths as design motifs. He also used a sailing vessel motif quite often which came to be known as "The Craft of the Guild."

The Guild also made an extensive line of domestic metalware and decorative metalwork of copper and pewter for furniture. Silver pieces designed by Ashbee and produced by the Guild included such items as the well-known double-handled bowls, porringers, cutlery with a wonderful wire-work basket finial, and trays, to name only a few.

Sadly, the cost of supporting members of the Guild and their families in the face of competition with Liberty & Co. and other mass marketers of Arts and Crafts style goods sent the Guild into bankruptcy in 1907. One of the reasons the Guild met its fate is probably stated best by Ashbee's biographer, Alan Crawford: "He had in fact, little interest in the consumer." Ashbee was interested in the "art" and the purity of living and working in a communal style or he probably would have realized the ramifications of moving the Guild out of London. When the Guild failed Ashbee went back to architecture.

In his later years Ashbee was a civic advisor to the British military helping in the restoration of Jerusalem. Although Ashbee's Guild days ended prematurely, the system he pioneered was to have great influence in Austria, the United States, Scandinavia and other countries.

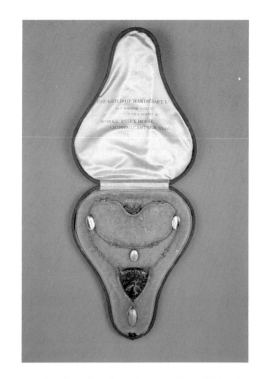

Pendant of mother-of-pearl by C.R. Ashbee for the Guild of Handicraft. *Courtesy of John Jesse, London*

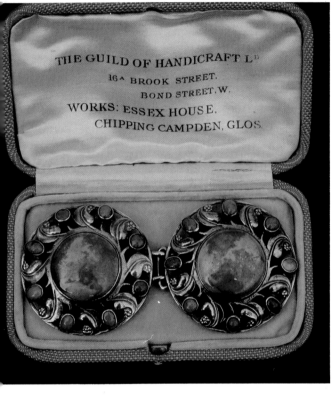

Waist clasp designed by C. R. Ashbee and made by the Guild of the Handicraft. Made of silver, enamel and turquoise, shown in the original box, c. 1900. *Courtesy of Tadema Gallery, London*

"Snowdrop" pendant by C. R. Ashbee for the Guild of the Handicraft. Gold, enamel, citrine and aquamarine with scrolled open work detail. In the original box, c. 1900. *Courtesy of Tadema Gallery, London*

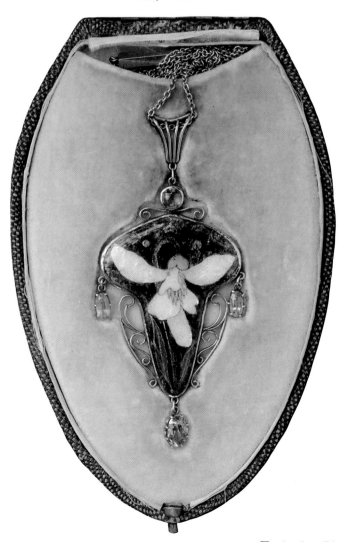

Buttons designed by C.R. Ashbee.
Pierced and chased silver set with
chrysoprase. Executed by the Guild
of the Handicraft c. 1903.
*Cheltenham Art Gallery and
Museums, England*

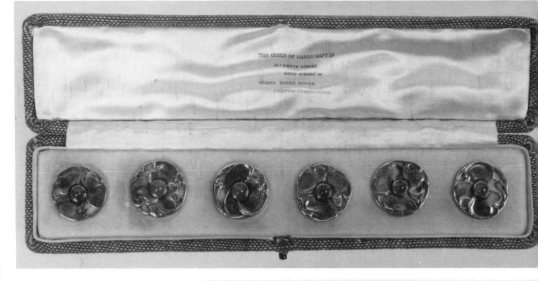

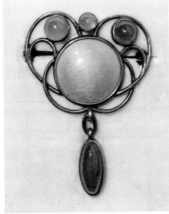

Brooch designed by C.R. Ashbee for the Guild
of Handicraft. Silver, enamel and chrysoprase,
c. 1898. *Courtesy of Tadema Gallery, London*

Silver bowl with looped handles designed by
C.R. Ashbee. Executed by the Guild of
Handicraft and hallmarked 1901. *Courtesy of
Barry Friedman, Ltd, New York*

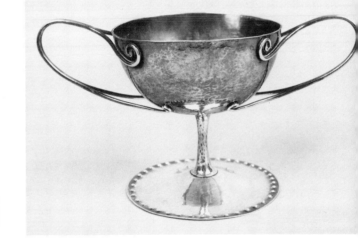

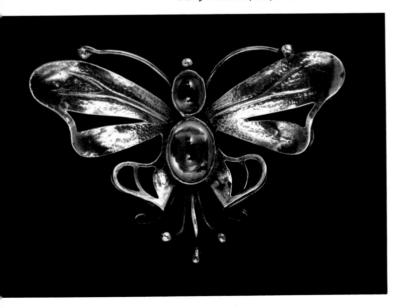

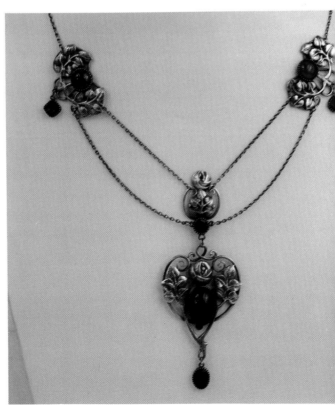

C.R. Ashbee butterfly brooch. Silver and
demantoid garnet. *Courtesy of John Jesse,
London*

A silver and garnet necklace with the design
attributed to C.R. Ashbee and executed by the
Guild of the Handicraft c. 1900. *Courtesy of
Tadema Gallery, London*

Margaret Awdry (Audrey)

A student at the Vittoria Street School under John Paul Cooper, Awdry was a jeweler who is credited with having executed the only piece of jewelry made from a William Morris design. This may have actually been a different William Morris and possibly a fellow student in Birmingham. James Morris is known as a Birmingham student who assisted Arthur Gaskin. James had a brother William who may also have been a student there. Some of her work was illustrated in *The Studio*.

Mackay Hugh Baillie Scott (1865-1941)

A well-known architect and designer, Scott moved to the Isle of Man when he married. He set up an architectural practice there where he met Archibald Knox and they worked together designing and executing iron grates and copper fireplace hoods for the houses Baillie Scott designed. He may have been the person responsible for introducing Knox to Liberty & Co. as he had designed for the firm beginning in 1893.

In 1892 he was hired by the Grand Duke of Hesse (Queen Victoria's grandson) to redecorate several rooms in his palace in Darmstadt. The metalwork Baillie Scott designed for the rooms was made by the Guild of Handicraft and supervised by Charles Robert Ashbee.

Oliver Baker (1856-1939)

Baker was a landscape painter and etcher who also designed jewelry. A brother-in-law of W.H. Haseler, owner of the firm that manufactured much of Liberty & Co.'s metalwork, Baker also designed for Liberty & Co. His pieces for Liberty were usually hammered silver belt buckles set with cabochon turquoise or enamel with the entrelac motif often seen in Liberty pieces.

Baker also designed silver domestic items as well for Liberty including silver bowls, caskets, tankards, salt cellars, and spoons around 1899-1900. He studied at the Birmingham School of Art.

James (Jack) Baily

One of the principal silversmiths with the Guild of Handicraft, Baily continued to make silver in the Ashbee style after the Guild's demise. He remained in Chipping Camden to work.

B.J. Barrie

Barrie's work combined the Arts and Crafts and Art Nouveau styles. He worked in silver with plique-à-jour enamel and semi-precious stones making belt clasps and brooches.

Mabel Bendall

A student of John Paul Cooper at the Birmingham School of Art, Bendall was a jeweler.

William Arthur Smith Benson (1854-1924)

This well-known metalworker and furniture designer grew up in Aylesford near Winchester, the eldest son in a Quaker family. He was educated in Winchester and Oxford where he met William Morris and Edward Burne-Jones. Morris suggested he consider a career in metalwork and after he apprenticed to the architect Basil Chapneys for a short time, he opened his own workshop for metalwork in Fulham in 1880 making household items of copper and brass. His shop stayed open for thirty years, earning him the sobriquet "Brass Benson."

Benson was not a "purist" in his Arts and Crafts ethic as he was not against the use of some machinery. Later in his career he designed metalwork for machine production, and even built a factory in Hammersmith. He had been fascinated by ships and machines as a small boy and this fascination seems to have continued into his adult life.

Examples of pieces by Benson include: both silver—rare—and the more common silverplate hollow-ware such as coffee pots, tea pots and milk pitchers. His output included items of copper and brass—candlesticks, a copper and brass tea kettle and a muffin dish on a stand, chafing dishes and firescreens. He is best known for designing copper and brass lamps and lighting fixtures which often had glass shades from Powells of Whitefriars. He began by designing for gas or oil lamps but switched to electric lamps as they became popular.

Benson was a founding member of the Art Worker's Guild in 1884. He was also active in the Arts and Crafts Exhibition Society and helped start the Design Industries Association (DIA) in 1915. He retired in 1920. Benson also designed

The Manxman Piano designed by M.H. Baillie Scott and made by John Broadwood. Oak with steel hinges and worked steel candleholders inside above keyboard, 1899. *Courtesy of Fischer Fine Arts, London*

Brooch in silver, enamel and precious stones by R. J. Barrie.

Bowl designed by W.A.S. Benson. *Alan Wanzenberg Collection, New York*

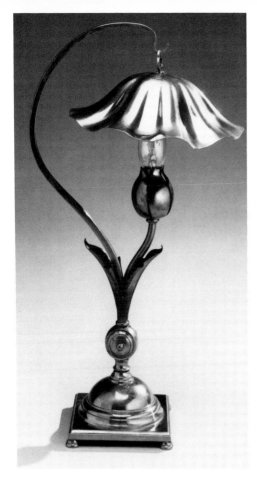

wallpapers and furniture hardware for Morris & Co. and became director of the company when Morris died.

Like so many Arts and Crafts figures he was related to other Arts and Crafts luminaries—R.L.B. Rathbone was his cousin, and Heywood Sumner, the furniture and tapestry designer, was his brother-in-law and childhood friend. His sister Margaret was a favorite pre-Raphaelite model. Benson was married to Venetia Hunt, the daughter of a landscape painter and god-daughter of John Ruskin.

Mrs. Bethune

Mrs. Bethune was a member of the upper class who became a skilled enameller. Jewelry by her is rare.

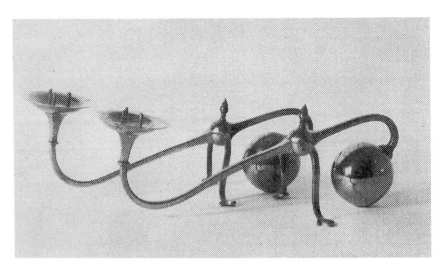

Lamp by W.A.S. Benson stamped W.A.S.B. in shield on the back of the switch. Brass and copper. *Courtesy of Kurland-Zabar, New York*

A candlestand by W.A.S. Benson. *Alan Wanzenberg Collection, New York*

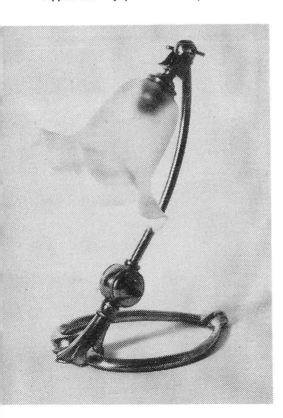

Lamp by W.A.S. Benson. *Alan Wanzenberg Collection, New York*

A necklace by amateur jeweler Mrs. Bethune of silver, enamel and pearl. She exhibited this and another necklace in the 1904 Exhibition of the Royal Amateur Art Society and won a prize for them. *Courtesy of Tadema Gallery, London*

Thomas Birkett

A metalworker with the Birmingham Guild of Handicraft, Birkett executed jewelry designs by Arthur Fowler and others. Birkett left the Guild to become a director of The Faulkner Bronze Company of Birmingham, a firm that made light fittings, fire screens, and other items in brass, copper and bronze. In 1902, the firm bought from R.L.B. Rathbone "the cabinet handles and hinges" portion of his business and then hired one of Rathbone's workmen who was familiar with Rathbone's patination process. At this time they also acquired Rathbone's trademark of "St. Dunstan Raising a Bowl".

The firm was renamed Jesson, Birkett & Co. in 1904 and purchased additional portions of Rathbone's business. At some point A.E. Jones purchased some use of the trademark and the patination process rights, also using Jesson, Birkett's name on some of his work. In 1910 Simplex Conduits Ltd. bought a number of Jesson, Birkett & Cos.' designs and Birkett went to work for them. Birkett was married to Annie Stubbs who designed for both Faulkner Bronze Co. and Jesson, Birkett & Co.[8]

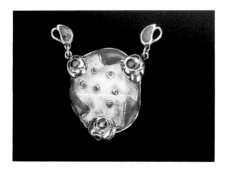

Enamel pendant designed by Sir Frank Brangwyn for La Maison de l'Art Nouveau in Paris. Of four known pieces that were designed, this is the only one accounted for today. Monogram F.B., W.B. *Courtesy of Christie's, London*

W. Thomas (Tommie) Blackband (1885-1945)

One of the craftsman who worked for the Gaskins, Blackband was quite proficient at the technique of applied wire work, a great deal of which turns up in the Gaskin's earlier work as he is known to have collaborated with them. He was first a part-time and then a full-time teacher at the Vittoria St. School in Birmingham with Arthur Gaskin.

Blackband had been apprenticed to a jewelry firm where he became a skilled goldsmith while attending classes at the Vittoria Street School, and he bartered work for the Gaskins in exchange for gold to do his own work. He also worked in the granulation technique, which was unusual for an Arts and Crafts jeweler. He followed Arthur Gaskin as head master at the Vittoria St. School in 1924 and remained there until he retired in 1946.

Constance Blount

Blount was the wife of poet/weaver Godfrey Blount and did enamel work in the 1890's. She was known to consult with C.R. Ashbee on some of his projects.

Albert C. Bonner

A hammered silver spoon by Bonner with London hallmarks for 1909 was offered for sale at Christie's, London in 1992.

John Houghton Maurice Bonnor

Bonnor worked in the architectural department of the London City Council and attended classes at the Central School. He later taught at the Camberwell School of Arts and Crafts. He and Edward Spencer worked on several pieces of jewelry together including the famous "Ariadne" necklace (see Spencer listing). A white metal pendant by Bonnor was offered at auction at Christie's, London in 1992 and bears a resemblance to the Ariadne necklace. It depicts a Viking ship surrounded by sea creatures in enamel with opal and garnet accents. After working for the Artificer's Guild, he opened his own workshop in 1908.

Herbert Borley

Borley worked in Omar Ramsden's workshop in the later years.

Sir Frank Brangwyn (1867-1956)

A painter, etcher, graphic artist and designer, Brangwyn was born to humble circumstances and became so successful he was knighted for his accomplishments in 1941. Born in Bruges, he was a self-taught artist because he couldn't afford art classes. He landed a job with Morris & Co. early in his career.

He is best known for designing stained glass for Samuel Bing's Maison de l'art Nouveau in Paris for which he also designed a few pieces of jewelry, and for his work with Tiffany and Rockefeller Center in New York. Brangwyn also designed furniture, metalwork and jewelry, a series of lamps, rugs, embroideries, pottery and etchings.

In *The Studio* yearbook of 1914 it was stated "Mr. Frank Brangwyn both in his country and aboard is the acknowledged master of modern decoration. His versatility is almost bewildering." An enamelled-silver gilt pendant which was auctioned at Phillips & Co. several years ago featured colors similar to those he used on ceramics.

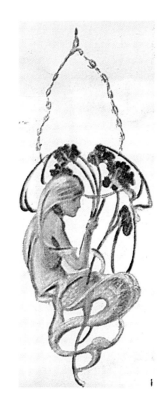

Silver pendant with enamel by E. May Brown.

E. May Brown

Brown made silver and enamel jewelry that appeared in *The Studio*.

Kellock Brown

A member of the Century Guild, Brown executed designs for decorative pieces such as wall sconces and panels in copper. He also is known to have made repoussé silver work from designs by Jessie Newbery, wife of the principal of the Glasgow School of Art during the "Arts and Crafts" period.

Alfred Bucknell

Bucknell was a blacksmith who made andirons, handles, candlesticks, and other implements in iron, brass, polished steel and silver which were designed by the architect Ernest Gimson and other fellow members of the Century Guild.

William Burges (-1881)

A student of the Gothic architect A.W.N. Pugin, William Burges was an architect and designer in the Gothic style with a somewhat eccentric flair, perhaps as a result of his opium addiction. Burges designed silver items that featured mermaids, spiders and other creatures. He designed these pieces to be made with champlevé and en round bosse enamel, ivory and Chinese hard-stone carvings that he collected.

He is also known for the wedding jewelry he designed for Lady Gwendolen Bute. Lady Bute's brooch was gold in the form of a Gothic letter "G" with an heraldic shield in enamel, cabochon gem-stones and pearls. For her bridesmaids he made locket/brooches with enamelled gold shields and featuring rubies and pearls. Lady Bute's husband the 3rd Marquess of Bute was Burges' primary patron. Other pieces designed for the Bute family include a silver dessert service. Burges also designed a badge and chain for the Exeter Corporation, and designs he did for ecclesiastical metalwork still exist.

Andirons (fire dogs) designed by Ernest Gimson and executed by Alfred Bucknell, c. 1905-10. 28" high. *Courtesy of Fischer Fine Art, Limited, London*

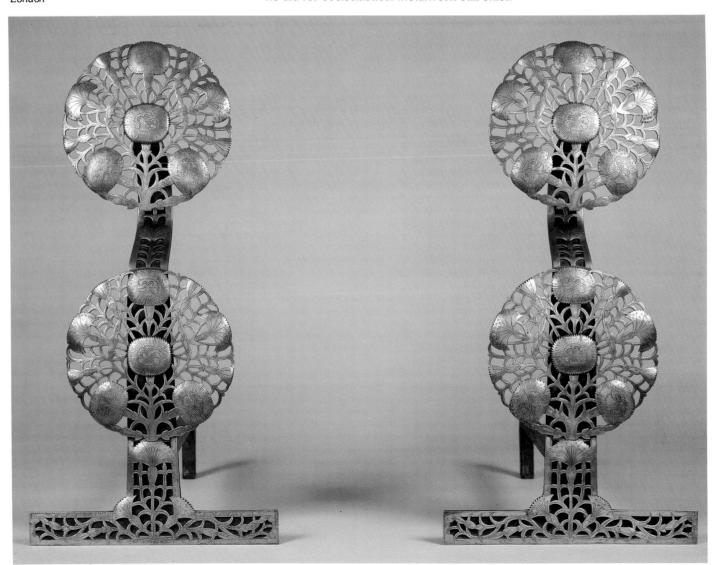

Sir Edward Burne-Jones (1833-1898)

Burne-Jones' mother died of complications during childbirth and his father blamed the boy for her death, delegating his upbringing to a nanny. Young Burne-Jones turned to drawing for comfort, and after attending Oxford, Burne-Jones became a well-known Pre-Raphaelite painter. He was acknowledged by the French Symbolist painters as being one of their inspirations.

A close friend of William Morris, who like Morris had originally planned on entering the Church, Burne-Jones was one of the founders of Morris, Marshall, Faulkner & Co. He designed stained glass, embroidery, mosaics and jewelry from about 1880. His jewelry, which included a series of bird pendants, was primarily designed for family and friends and was executed by the firm of Child and Child and Carlo Giuliano. In 1883 he designed the "Whitelands College Cross," given by John Ruskin each year to a popular student chosen by her peers. His jewelry designs appear in three of his sketchbooks.

William Burroughs

Burroughs joined Omar Ramsden's workshop as an apprentice silversmith and stayed for almost twenty years. He later worked for the Royal Mint.

Leonard W. Burt

Burt was one of the original assistants to join Omar Ramsden and Alwyn Carr. He was successfully trained as a silversmith and stayed with Ramsden after the partnership broke up until Ramsden's death.

Arthur Cameron

Beginning his career inauspiciously as Ashbee's office boy, Cameron became one of the most important jewelers and silversmiths with the Guild of the Handicraft. He was also an enameller learning by trial-and-error.

With the Guild from 1891-1907, Cameron was expelled at one point for using profane language. His nickname was "Chooka Chooka, the Music Hall Ape" referring to a popular song of the time.[9]

Beatrice Cameron

Enamel buttons made by Cameron were offered at auction by Christie's London in 1992.

Florence Camm

A student at the Birmingham School of Art, Camm designed a casket which was to have been presented to J. Thackray Bunce by the City of Birmingham, but he died before the presentation could be made. The casket of repoussé work with enamel was executed by Camm and Violet Holden. It now belongs to the City of Birmingham.

Alice Camwell

Camwell was a student of John Paul Cooper at the Birmingham School of Art who made jewelry.

J.E.C. Carr

Carr was a metalworker. Work by Carr was illustrated in *The Studio*.

Painting by Edward Burne-Jones, "King Copheuto and the Beggar Maid". W.A.S. Benson, the designer of the crown and the base metal armour for the painting, was a very good-looking man and served as one of the models for the work. Robert Catterson Smith had a print of this painting hung over the doorway of the Vittoria St. School. *Courtesy of the Tate Gallery, London*

"Tree of St. Jesse" stained glass window by Edward Burne-Jones. *Published by permission of the Birmingham Museum and Art Gallery*

Chandelier by J.E.C. Carr featured in *The Studio. Courtesy of Leah Roland/Split Personality, Leonia. Photo by Diane Freer*

Design for a metal panel by J.E.C. Carr. *Courtesy of Leah Roland/Split Personality, Leonia. Photo by Diane Freer.*

Gothic revival ring of silver and chalcedony made for the Bishop of Exeter, 1903. Probably executed by Omar Ramsden and Alwyn Carr. *Courtesy of Tadema Gallery, London*

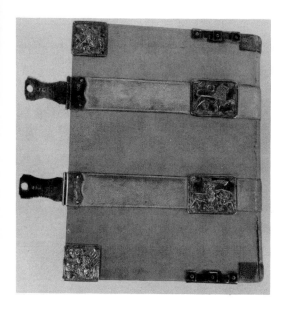

Book mounts by Omar Ramsden and Alwyn Carr. Silver, hallmarked in London,1917. The vellum-bound book is "The History of Reynard the Fox" by F.S. Ellis, illustrated by Walter Crane and published by David Nutt, London, 1897. The mounts depict scenes from the book. *Cheltenham Art Gallery and Museums, England*

Alwyn C. E. Carr (1872-1940)

Alwyn Carr was born into a well-to-do Sheffield family and attended art school there, where he met another student, Omar Ramsden, who was to become his business partner. They both won scholarships to the National Art Training School and spent summers taking courses at the Royal College of Art in London. After graduation they travelled in Europe and then became business partners, producing gold and silverware, in 1898. Ramsden was better known for designing, but Carr also designed and did some enamelling. When Ramsden took first prize in a competition to design a mace for the City of Sheffield, that project became their first commission. They produced very professional work which looked almost too good to be considered Arts and Crafts, and in fact their work was partially machine made. As the business grew they hired many staff members and executed little, if any, work themselves.

Originally Carr financed the business, but it grew steadily on its own. Carr went into the Army in 1914 during World War I, and when he returned he found that Ramsden had developed a relationship with Mr. and Mrs. Downes-Butcher. Ramsden's new alliance came in the way of the original partnership, which dissolved after another year.[10]

Carr, who was never married, continued to make silver pieces on his own along with some wrought iron work. He kept working until some time in the 1920's. (please see Omar Ramsden entry for additional information.)

Robert Catterson Smith

Robert Catterson Smith, a member of the William Morris circle, became headmaster of the Vittoria Street School in Birmingham in 1901. Previously he had studied metalwork at the Chiswick School of Arts and Crafts and worked for William Morris' Kelmscott Press. He was also an inspector for the City of London of art schools and art classes.

Catterson Smith was a skilled respoussé worker and some of his work includes silver plaques derived from Edward Burne-Jones drawings, the execution of a cross designed by Phillip Webb, and a dish executed by London silversmith W.G. Connell which is thought to have been designed by Catterson Smith.

The Kenrick Casket, of silver gilt and enamel with filigree, champlevé and repoussé work in a Medieval style was made by him, and features models of ten Kenrick scholars presenting their work on its top with details of Pre-Raphaelite paintings on the sides. It was given to William Kenrick, an important Birmingham civic leader for twenty-five years of service to the Museum and School of Art committee and is now owned by the City of Birmingham Polytechnic.

Another piece, a mace of silver, silver gilt, enamel and colored gem-stones designed by Phillip Webb and executed by W.H. Haseler in 1902 under Catterson Smith's supervision, is now owned by the City of Birmingham.

A case containing some of William Morris' hair was designed by Catterson Smith and is in the collection of the Victoria and Albert Museum. A similar case was made containing Ruskin's hair and might also be the work of Catterson Smith. Although it is certain he had a greater output than is known, these are among the few pieces that can be documented.

Katherine Cavenagh

This jeweler was a student at the Birmingham School of Art under John Paul Cooper.

Frances Charles Clemens

Clemens studied enamel and silverwork at the Newlyn Industrial Class and his work is not unlike the early Guild of Handicraft jewelry. He made the bulk of the jewelry that came out of the Class including pendants and brooches, utilizing silver wirework and painted enamels with shells, fish and flower motifs.

Maud Coggin

Coggin was a silversmith in Birmingham.

Lorenzo Colarossi

A silversmith, Colarossi went to work for Henry Wilson while still only a boy. When John Paul Cooper was appointed head of the Vittoria Street School he took Colarossi to Birmingham to teach silversmithing and he stayed with Copper when he returned to the south of England. When Cooper died Colarossi continued to work for Cooper's son Francis.

Samuel Coles
A highly qualified silversmith who worked in Omar Ramsden's workshop, Coles was responsible for large, important commissions.

George Colverd
An apprentice silversmith with the Guild of Handicraft in Chipping Camden, Colverd left after a short time because he wanted to return to London to play soccer (British football).

Thomas A. Cook
A jewelry designer from West Ham, Cook created pieces in gold and silver with enamel, mosaics, precious stones and pearls. There are also extant designs he did for silk fans.

Lydia Cooke
A student at the Birmingham School of Art under John Paul Cooper, Cooke made jewelry and did enamel work. She began working for W.H. Lord in 1900. Several pendants and hair combs by Cooke are in the collection of the Birmingham Museum and Art Galleries.

John Paul Cooper (1869-1933)
Cooper was an architect, designer, goldsmith and silversmith and was a protegé of the well-known architect and jeweler Henry Wilson. After attending Bradfield College, Cooper joined the architectural firm of J.D. Sedding where Wilson was the chief assistant. Both men continued with the firm after Sedding died but both became more interested in the decorative arts than architecture. In Cooper's case his early interest was in gesso work, embroidery and silverwork. He attended classes with Wilson at Heatherley's Art School, and when Wilson opened a workshop in Vicarage Gate by 1900, Cooper took jewelry-making lessons there with a Mr. Cowell who specialized in metal raising; Luigi Movio, a jeweler; and Lorenzo Colarossi, a silversmith.

In February of 1900 Cooper's second cousin May Oliver began to work with him on a part-time basis doing gesso work and in December they were married. Within a year or so of his marriage Cooper became head of the Metalwork Department at the Birmingham School of Art. Although quite inexperienced, he was friendly with Joseph Southall, a painter, and Charles Gere, an illustrator, members of the "Birmingham Group" who helped him obtain the position. (The "Birmingham Group" consisted of Gere, Southall, the artist and jeweler Arthur Gaskin, Henry Payne, an artist, Mary Newhill, an embroiderer and stained glass designer, and Sidney Meteyard, a painter and jeweler. They unofficially worked together in Birmingham at this time and received many local commissions.) Cooper held this post for about five years, then resigned to become a full-time craftsman.

With the exception of some designs he created for the Artificer's Guild, Cooper always executed his own designs. His work is known for frequently being made in 15 kt. gold (most Arts and Crafts designers preferred silver) because he liked the warmth of the gold. At times he also used copper and copper gilt. He worked in cloisonné and champlevé enamel, and did repoussé and chasing work. He pioneered the use in Britain of a Japanese style of metalwork called mokumé—a combination of silver and copper which he began to use around 1906. This interest was probably a direct result of attending a series of lectures that Wilson had arranged on Japanese metalworking techniques at the Royal College of Art given by Professor Uno Bisei of Tokoyo University. He was also strongly influenced by the Medieval, as was Wilson, and by Celtic designs.

Cooper liked to use unusual natural materials such as coconut shell, ostrich-egg shell, and narwhal tusk. He often used foliage and flowers as ornaments. Also distinctive were the boxes he began making around 1897 of wood covered with shagreen (finely granulated skin from rays found in waters around China usually dyed green) which were decorated with silver. Cooper is credited with reviving this art, which dates back to the eighteenth century. From 1915-19 Cooper did war work at W.A.S. Benson's metalworks three days per week. His job was to work with R. L. B. Rathbone sorting steel rods and stamping brass labels.

Cooper was an extremely prolific artisan making almost fourteen hundred pieces of jewelry, silverwork, gesso-work and other metalwork. In fact he provided over two hundred pieces for the Artificer's Guild alone and exhibited no less than 84 examples of his work at the Exposition de l'Art Decoratif in Paris.

Thomas Cook brooch.

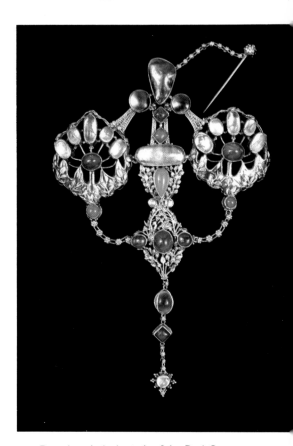

Brooch and cloak pin by John Paul Cooper. *Courtesy of John Jesse, London*

Shagreen box and cover by John Paul Cooper. Silver, grey shagreen and cedar. Silver label stamped J. Paul Cooper pinned inside lid., c. 1905. *Cheltenham Art Gallery and Museums, England*

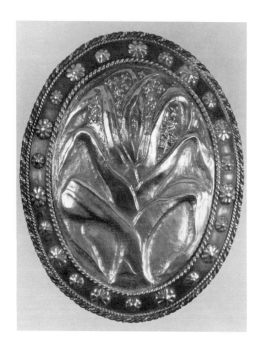

Belt buckle by John Paul Cooper. Chased silver and copper. small card labels attached inscribed J.P.C. 216 and J. Paul Cooper 216 which correspond to the description for this inventory number in his stock book, c. 1905. *Cheltenham Art Gallery and Museums, England*

Cooper's work appeared frequently in *The Studio* and *Art Journal* and is extensively documented in his stock books. The books list almost all of his life's work and are complete with sketches, cost of materials and the price of each piece. As proof of his great output the books list objects in all of the following categories: match boxes, card cases, ring boxes, parasol handles, stamp boxes, brooches, bracelets, work boxes, dispatch boxes, mirrors, candlesticks, vases, buckles, rings, pendants, hat pins, wedding rings, cloak clasps, "safety pins for hair", buttons, hair ornaments, bowls, jewel caskets, cabinet handles, butter knives, napkin rings, cream jugs, chalices, porringers, tea sets and paper knives. Work in 15 and in 18 kt. gold is listed as well as silver, silver gilt, mokumé and shagreen. One listing is for an ashtray for "Princess Louise", one of Queen Victoria's daughters.

Mr. Peyton Skipwith of the Fine Art Society in London related a charming story to me about a visit he made to Cooper's house to see Francis who was by then a quite elderly man. He said that it appeared that John Paul Cooper had a subconscious belief that his children would never grow up, as most parents do. As he designed his own house this was apparent because he placed the door handles very low for any rooms the children were allowed to enter. At the time of Mr. Skipwith's visit, Cooper's son Francis was quite elderly, and the sight of him stooping to open doorways was very touching. After Cooper's death, Francis had completed any outstanding commissions and continued with the business. Leaving his father's workshop intact, he set up his own in the garden shed. Francis died in 1980.

Necklace by John Paul Cooper listed as #498 in his stock book. Set with chrysoprase, a sapphire and ruby, zircons and a green opal, c. 1905. *Courtesy of Tadema Gallery, London*

Necklace attributed to John Paul Cooper. Gold, moonstone, cabochon emeralds and sapphires.

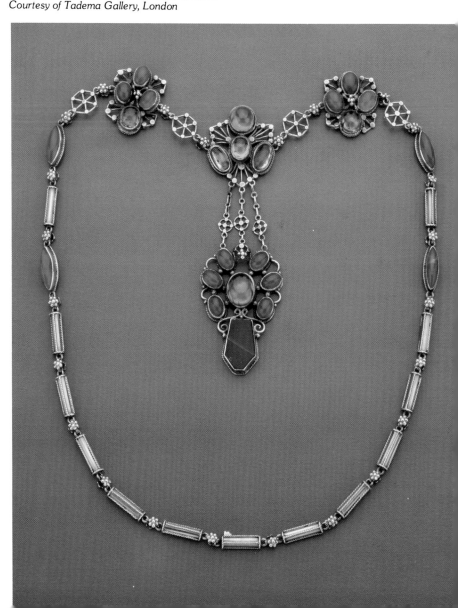

Carrie Copson

Copson was a pupil of Arthur Gaskin at The Vittoria School in Birmingham and worked for Bernard Instone. One of her brooches is in the Victoria and Albert Museum and is made of silver and gold with amethysts and blister pearls. A baroque pearl necklace of her design is displayed there as well.

D. Corbett

A member of the Guild of Handicraft, Corbett was a jeweler.

Thomas Corson

A belt buckle by Corson was illustrated in *The Studio*.

Cowell

Cowell (first name unknown) worked for Henry Wilson and specialized in metal raising. He gave lessons to John Paul Cooper.

Harry C. Craythorn(e)(1881-1949)

A silversmith and designer, Craythorne designed waist buckles for Liberty & Co. during the early stages of the Cymric jewelry line and later became their chief designer in the 1920's when they no longer followed the practice of using freelance designers. Craythorne was a student of Arthur Gaskin and went to work for the W.H. Haseler Company at the age of seventeen.

A silver box designed by Archibald Knox and executed by Craythorne is in the permanent collection of the Museum of Modern Art, New York. The box was made for the Rockefeller family and is proof he was an accomplished craftsman, not only a designer.

Benjamin Criswick

A member of the Bromsgrove Guild in Birmingham, Criswick also had his own metalworking studio. He executed work for the Guild and taught at the Birmingham Municipal School of Art.

S.C. Curtis

Curtis designed jewelry and metal work that appeared in *The Studio*.

Thomas Cuthbertson (1840-1976)

Cuthbertson studied at the Margaret Street School in Birmingham for a number of years and in 1911 he joined the staff of the School and taught metalwork. He worked in enamelled metal of a Gothic style. The Birmingham Museum and Art Gallery has an "architectural" clock case c.1925 which took him three years to make. He was influenced by Louis Josephs, the enamelling instructor at the Margaret Street School. Cuthbertson became headmaster of the Vittoria St. School in Birmingham when Thomas Blackband retired.

Bernard Lionel Cuzner (1877-1956)

One of the better known Arts and Crafts designers, Cuzner studied metalworking at The Vittoria Street School and at the School of Art on Margaret Street, both in Birmingham. He had been trained as a watchmaker but decided not to use his training, and in 1901 began making jewelry with A. Edward Jones. He went on to have his own workshop creating silver and jewelry for most of his life.

Cuzner designed silver pieces for Liberty & Co. which were less traditional than the work he did on his own. His simple pieces had repoussé, embossing and chasing for ornamentation and sometimes incorporated enamel, niello and semi-precious stones. He is especially known for fine engraving work.

Like his silver, his jewelry was simple with birds and vine decorations among the twisted wire work. Cuzner often used enamel and cabochon-cut stones and his work showed a Medieval influence. It has been said that he never repeated a design. Cuzner was a metalworking instructor at the College of Art in Margaret Street from 1910-42. He is usually remembered as a silversmith rather than a jeweler probably because he continued to work successfully at this craft until his death at age 79.

Cuzner's love for his work can probably be best put in his own words, "A true craftsman, one whose work is his own conception and for the execution of which he is directly responsible, puts all his being, body, mind and spirit into his work."[11]

Lily Dale

Dale won a gold medal for a belt design in 1900 and was one of the principal assistants to the Gaskins listed in the 1916 Arts and Crafts Exhibition Society catalogue. She was a student of Arthur Gaskin at the Vittoria Street School in Birmingham.

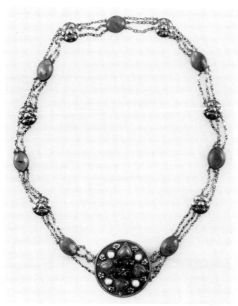

Necklace designed and made by Carrie Copson. Silver and gold openwork with amethysts, blister pearls and a baroque pearl pendant. *Victoria and Albert Museum, London*

Enamel box by S.C. Curtis. *Courtesy of Leah Roland/Split Personality, Leonia. Photo by David Roland*

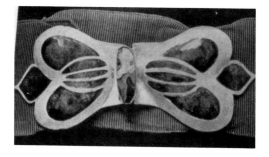

Buckle in silver and mother-of-pearl by S.C. Curtis illustrated in *The Studio. Courtesy of Leah Roland/Split Personality, Leonia. Photo by Diane Freer.*

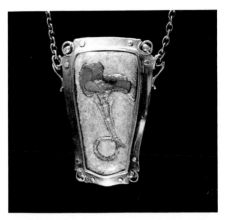

Silver-gilt necklace with garnets and peridots by Bernard Cuzner, 1904. *Courtesy of Tadema Gallery, London*

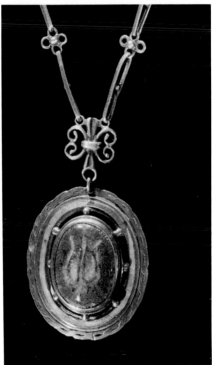

Two enamel pendants by the Dawsons. The smaller pendant has a rose design, the larger pendant an iris. *Courtesy of Leah Roland/Split Personality, Leonia. Photo by Diane Freer.*

Enamel napkin ring by the Edith and Nelson Dawson that reads, "Bon Accord". *Courtesy of Leah Roland/Split Personality, Leonia. Photo by Diane Freer.*

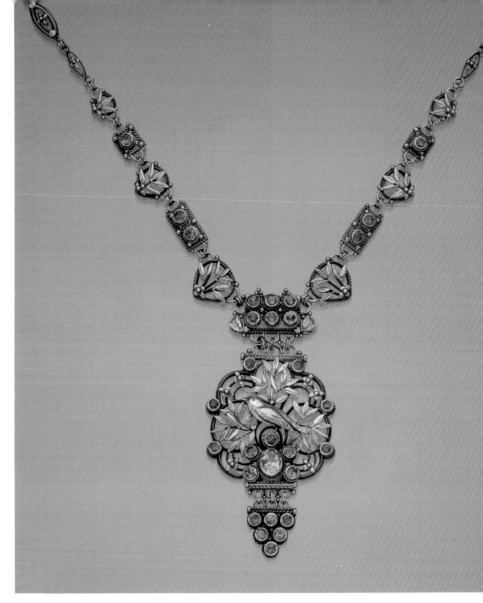

Charles Daniels

Daniels was a jeweler with the Guild of Handicraft.

J. Davis

The "Tree of Life" morse which is in the collection of the Victoria and Albert Museum is described as having being made by the noted enameller Alexander Fisher and J. Davis.

Nelson (1859-1942) and Edith Dawson

The Dawsons are among the best known of the Arts and Crafts jewelers and are one of the many husband and wife teams to emerge in this movement. Nelson Dawson trained as an architect, studied painting and was a watercolorist before he became a jeweler and metalwork artisan. He started to work with metal in 1891 and studied enamelling techniques with Alexander Fisher.

In 1893 Edith Robinson, also a watercolorist, became his bride and they set up a studio in Chiswick. Nelson taught Edith enamelling at which she excelled, perhaps in part due to the fact she was a perfectionist about her work. The Nelsons' designs were primarily inspired by nature, and included very delicate flowers, insects and birds. The deep-colored enamels they created are fairly easy to recognize. Their enamels feature a subdued effect achieved by a dull surface and a grainy texture, which renders them opaque.

In addition to buckles, pendants, necklaces and brooches they produced silver items including candlesticks, silver and copper, caskets, and covered cups. A number of pieces made by the Dawsons are described in issues of *The Studio*, and include jewel caskets—one in particular in copper and steel with enamel panels; a circular bowl on legs with pale opaque enamel of a cyclamen blossom;

the "Kipling Posy Casket" of silver and cloisonné enamel; and a triptych in steel and enamel. Other items mentioned are a wooden box with steel and silver fittings, hair pins in the shape of dragonflies, enamel buttons with a bird design and a fire screen with enamel medallion insets and a dandelion design. A number of metalwork items are attributed to Nelson Dawson, including a beaker and tray in silver and beaten bronze, a large beaten and wrought copper bowl on a pedestal, and an electric light and a wrought iron chandelier with a copper model of a ship which hung in the Dawsons' home.

The Dawsons also made a number of commissioned pieces which include a memorial tablet for the public library in Oxford in repoussé copper and champlevé enamel, a christening casket of wrought steel with enamels, a trowel in silver and enamel with a steel and silver box to hold it for Queen Victoria's use to lay the foundation stone for the Victorian and Albert Museum, and a covered cup on a stand which also belonged to the Queen. Another piece in this category is a presentation casket in silver and enamel which was described in *The Studio* as "conferring the freedom of the city of Carlisle on the Speaker of the House of Commons." One unusual item which was designed by the Dawsons was a leather satchel with metal fittings executed by an S. Cope and C. Ottaway.

Their studio was so successful that it is said that Edith Dawson became ill from exhaustion, not being a very healthy person in the first place. This particular story was disputed by the Dawson's daughter Rhoda Dawson Bieckerdike, who died in 1992, in an article she wrote for *Apollo Magazine* in 1988. Mrs. Bieckerdike said the collapse of her mother had never happened to her knowledge. She did say that her mother had admitted the noxious kiln fumes were unhealthy and never encouraged her daughters to take up the art of enamelling.

Founding the Artificer's Guild in 1901, Nelson Dawson was associated with it for only two years, although he continued to do metalwork until 1914. He then spent the last 25 years of his life devoted to painting.

Set of enamel buttons by the Dawsons. *Courtesy of Leah Roland/Split Personality, Leonia. Photo by Diane Freer.*

A blister pearl bracelet by Nelson and Edith Dawson of yellow metal with an enamelled heart clasp. "D" mark in ivy leaf. *Courtesy of Christie's, London*

Enamel and steel belt buckle by the Dawsons with swan designs in the corners. *Courtesy of Leah Roland/Split Personality, Leonia. Photo by Diane Freer*

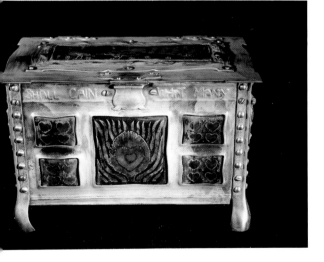

Magnificent enamel peacock box by Nelson and Edith Dawson. Reads "Who Chooses Me Shall Gain What Many Men Desire". *Courtesy of Leah Roland/Split Personality, Leonia. Photo by David Roland*

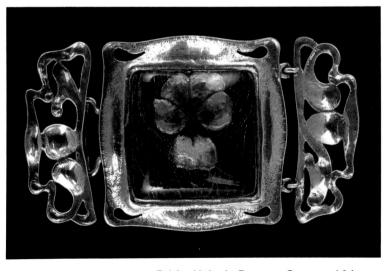

Belt buckle by the Dawsons. *Courtesy of John Jesse, London*

Comb by Joseph M. Doran. *Courtesy of Leah Roland/Split Personality, Leonia. Photo by Diane Freer*

Lily Day

Charlotte Gere in *American & European Jewellery* mentions Lily Day, an enamellist and jeweler who taught at Liverpool University and exhibited with Herbert and Frances McNair (see chapter two). Is it possible that Lily Dale and Lily Day, (an assistant to the Gaskins) are the same person?

Henri de Konnigh

This enamellist was from Belgium and worked for both Sibyl Dunlop and Omar Ramsden in the 1920s and 1930s.

Arthur Stansfield Dixon (1856-1929)

Dixon, an architect, designer and metalworker, was a founding member of the Birmingham Guild of Handicraft. He was the original instructor for the night class which was the origin of the Guild, and was the chief designer for the Guild's brass and copper wares, although he also designed silver objects. Characteristic of Dixon's work are the visible rivets. Owing to Dixon's friendship with William Morris, some of the Guild's work was sold through Morris & Co.

Joseph M. Doran

Several designs for hair combs by Doran appeared in *The Studio*.

Charles Downer

A blacksmith with the Guild of Handicraft, Downer and Bill Thornton continued to run a forge in Chipping Camden after the Guild shut down.

Christopher Dresser (1843-1904)

Dresser's work is not truly of the Arts and Crafts movement, although he is an important almost-contemporary of its designers. Some of Dresser's designs are of the Victorian-Aesthetic period style, and others are incredibly innovative when compared to overblown Victorian designs of his time. This is particularly evident in his metalwork.

He differed from Arts and Crafts designers not so much in his design aesthetics but in his principles—he had no quarrel with industrialization. Widar Halen, author of a book on Christopher Dresser, calls him "one of the first professionally trained designers for machine production," and says that he "may arguably be the first industrial designer in Europe...advocating the equality of the designer and the manufacturer. He was one of the first European designers to imprint his signature next to the maker's mark".

Born in Glasgow, he planned to be a botanist, studied at the Government School of Design (where Owen Jones, author of the *Grammar of Ornament* was one of his mentors) and abandoned botany for design in 1860. In the 1870's he designed silver and silverplate, brass, copper, cast iron and mixed metal pieces including teapots, toast racks, trays, coal boxes, decanters, tureens, cruets and candlesticks. He worked for several companies including Hukin & Heath, James Dixon & Co., Benham & Froud, Elkington & Co., and Richard Perry, Son & Co. He also designed cast iron pieces, textiles, carpets, wallpapers, and ceramics (he helped start several pottery companies).

Dresser's metalwork is often devoid of ornamentation, unlike his pottery and textile designs. He was strongly influenced by Japanese design as many Aesthetic-period designers were, and even visited Japan. In fact, for a brief time he bought Japanese goods for Tiffany & Co. Dresser's work has been compared to that of the Wiener Werkstätte and the later Bauhaus but his work was more organic in shape.

He designed domestic ware items for Liberty and Co. as did so many Arts and Crafts artists. Dresser wrote a number of books including several on botany and design, and lectured on design. He was married to Thirza Perry with whom he had thirteen children, five dying in childhood. One of his sons married a Japanese woman and lived in Japan while another became a designer and worked for Liberty & Co. (with less success than his father). Dresser's importance in design has only truly been recognized in recent times and his pieces have become quite collectible. His sketchbooks are the primary source for identifying his work.

T. Ducrow

The first full-time coppersmith employed by the Birmingham Guild of Handicraft Ducrow did not stay there long. He felt their work was too amateurish.

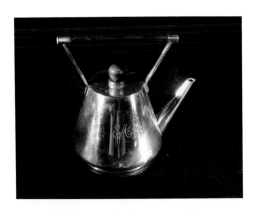

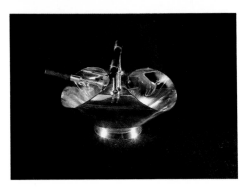

Two items designed by Christopher Dresser, a coffee pot and a sugar bowl and scoop. *Courtesy of Leah Roland/Split Personality, Leonia. Photo by Diane Freer*

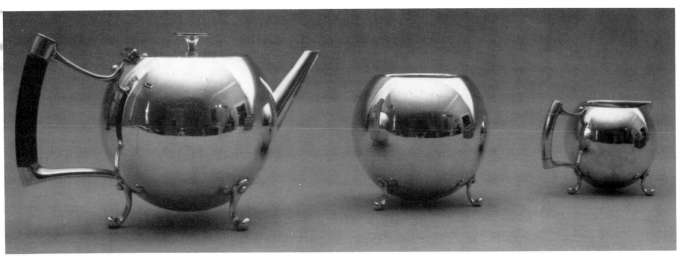

Tea set designed by Christopher Dresser for James Dixon & Sons. Silver with ebony handles, 1880. *Courtesy of Barry Friedman, Ltd., New York*

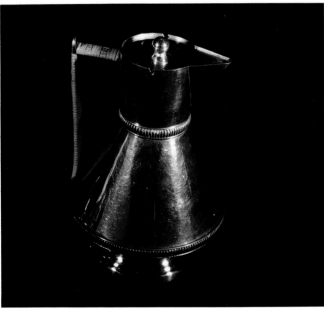

Hot water jug by Christopher Dresser. *Courtesy of Leah Roland/Split Personality, Leonia. Photo by Diane Freer*

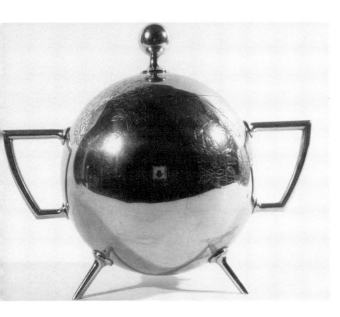

Pot with hinged lid designed by Christopher Dresser dated 1879. *Courtesy of Barry Friedman, Ltd., New York*

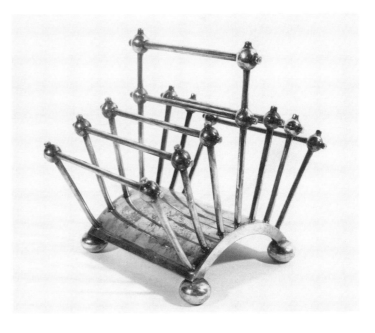

Toast rack designed by Christopher Dresser. *Courtesy of Barry Friedman, Ltd., New York*

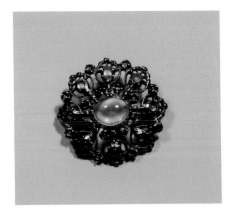

Brooch by Sibyl Dunlop. Chrysoprase,
amethyst and silver. Signed. *Courtesy of Leah
Roland, Split Personality, Leonia. Photo by
Gabrielle Becker.*

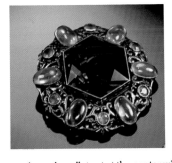

A gem-set brooch, collet set at the center with a
hexagonal-shaped amethyst within a pierced
foliate and scroll border. Decorated with
moonstones alternating with chrysoprase,
marked S.D. for Sibyl Dunlop. *Courtesy of
Sotheby's, London.*

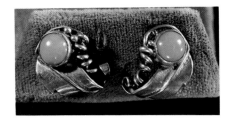

Earrings by Sibyl Dunlop of silver and coral.
*Courtesy of Leah Roland/Split Personality,
Leonia. Photo by Diane Freer.*

Sibyl Dunlop (1889-1968)

A Scot by birth, Sibyl Dunlop was sent to Brussels to learn French and there
she also learned about making jewelry. Her professional career was centered in
London with a workshop in Kensington Church Street being opened around
1920. Her childhood "nanny" kept the books for the business and four craftsmen
worked out in the open where the customers could see them. She was known for
dressing in "artsy clothes," primarily Middle Eastern caftans.

Although the Arts and Crafts movement had peaked by the time Sibyl Dunlop
set up her business she still chose to work in the Arts and Crafts style. Her
jewelry, with tight wire scrolls and stylized leaves includes necklaces, very large
pendants, earrings and brooches, and has a very distinctive look. Dunlop used
stones with very muted colors, often those of the Suffragette movement—green,
white and violet. Her use of many multi-colored stones—often stained agate,
opals and garnets—is referred to as the "carpet of gems." The carefully cut
stones cover a large area and are arranged in a geometric pattern.

Many of Dunlop's stones were cut by lapidaries in Idar-Oberstein, a German
gem-cutting center and her enamel work was done by a Belgian craftsman named
Henri De Konnigh who also worked for Omar Ramsden. W. Nathanson joined
her as manager of the workshop when he was only 16 and it was he who led her
into more modern designs related to the Art Deco movement. They worked
together until 1939 when World War II interrupted and he worked as a fireman
during the blitz. Nathanson resurrected the business after the war (Dunlop was
too ill to work any longer) and continued to work until he retired in 1971.

A controversy regarding Dunlop's jewelry centers around another English
jeweler, Dorrie Nossiter, who worked primarily in the 1930's. It is said that the two
were friends. There are visual similarties in Nossiter's work and Dunlop's carpet
of gems and some believe that many pieces attributed to Dunlop were actually
done by Nossiter. There do appear to be some clues to the work of these two
jewelers although they are by no means definitive: Dunlop tended to use
cabochon-cut stones while Nossiter used faceted stones. However, this is not to
an absolute, as Dunlop did at times use faceted stones as well and Nossiter
cabochon stones. Dunlop's stones tend to be collet-set and Nossiter's claw-set
although again, not always. As Dunlop had no children and as there are no living
relatives to shed light on this mystery, it is unlikely this will ever be resolved.

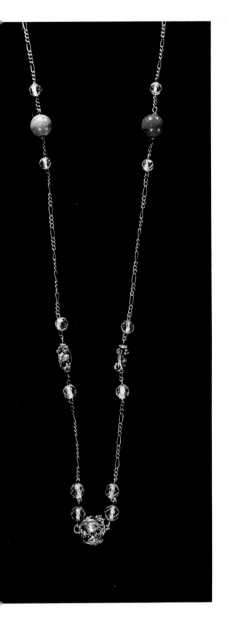

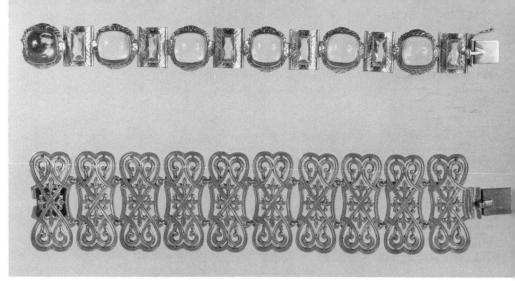

Bracelets by Sibyl Dunlop's workshop. The top is silver-gilt and rock crystal, hallmarked London, 1960, SD. The bottom is cast and engraved silver-gilt, hallmarked London, 1962, SD and stamped S. Dunlop. *Cheltenham Art Gallery and Museums, England*

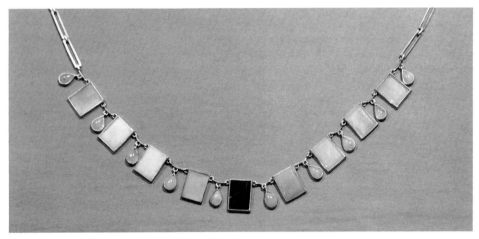

Multi-colored jade Art Deco style necklace attributed to Sibyl Dunlop. *Courtesy of Leah Roland/Split Personality, Leonia. Photo by Gabrielle Becker.*

Sibyl Dunlop necklace of silver and crystal. *Leah Roland/Split Personailty, Leonia, New Jersey. Photo by Diane Freer.*

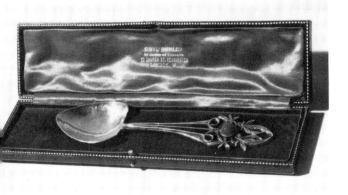

Spoon by Sibyl Dunlop c. 1930. Hammered and cast silver set with cabochon cornelian. Hallmarked in London. *Cheltenham Art Gallery and Museums, England*

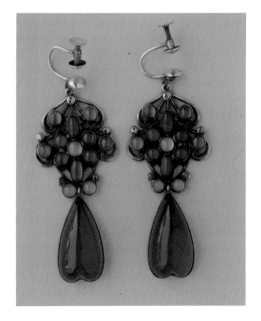

Earrings by Sibyl Dunlop. Silver, cornelian, and various chalcedonies, c. 1920. *Tadema Gallery, London*

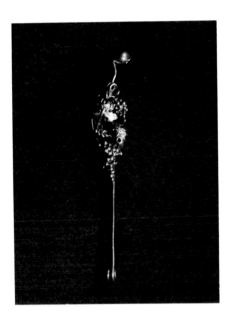

Silver wirework kilt pin attributed to Sibyl
Dunlop. *Courtesy of Leah Roland/Split
Personality, Leonia. Photo by Gabrielle Becker.*

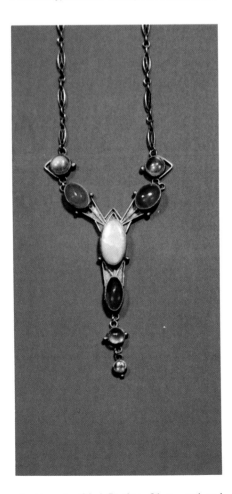

Necklace by Sibyl Dunlop. Silver, opal and
moonstone. *Courtesy of Leah Roland/Split
Personality, Leonia*

Leslie G. Durbin (1913—)

Durbin worked as an engraver in the workshop of Omar Ramsden from
1928-39, where he was trained as a silversmith by Ernest Wright. Durbin left to go
out on his own, served in the R.A.F. during World War II, and then worked with
Leonard Moss, another silversmith from Ramsden's workshop.

Kate Eadie (see Sidney Meteyard)

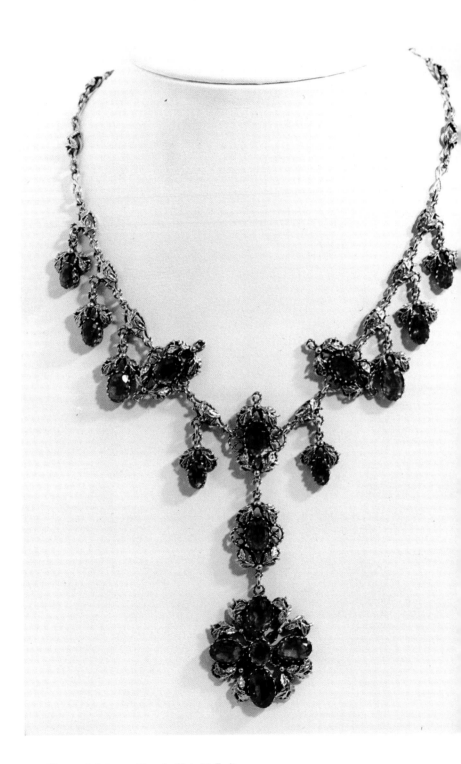

Silver and citrine necklace by Kate M. Eadie, c.
1910. *Courtesy of Tadema Gallery, London*

Maud Mair Eastman

Maud Eastman was a second generation jeweler who might have remained forgotten but for an exhibition of her jewelry by Spink and Son, Ltd., London in 1992. The firm purchased her jewelry from her family.

Eastman attended art school near Croyden and then spent time teaching in Wales. When she returned to London, she married Frank Eastman and began working as a miniaturist. In the 1920s (when she was 50) she began designing and making jewelry, having the stones cut in Idar-Oberstein, Germany much like Sibyl Dunlop. In 1928, she opened her own shop in the Park Lane Hotel and remained open for ten years. She later created jewelry for Asprey, Fortnum and Mason, both in London, and Anne Goddrich, Ltd. in Birmingham. She produced more than 1500 designs and liked to combine smooth and faceted stones. Some of her work is in an Art Deco Style.[12]

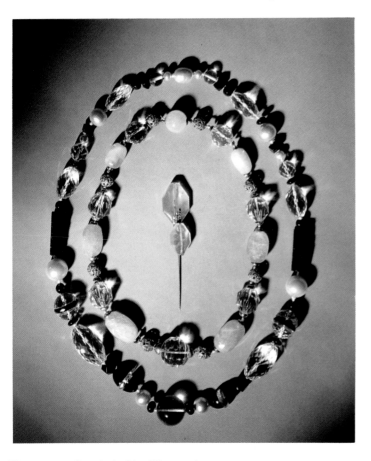

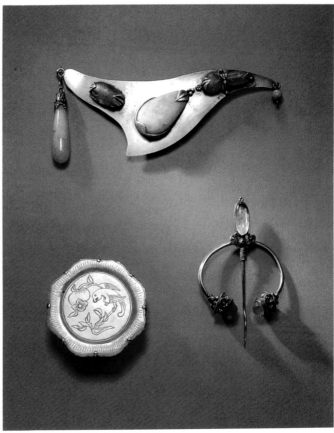

Three pieces of jewelry by Maud Eastman in an Art Deco style: necklace with faceted rock crystal, onyx jet, simulated pearls; smaller necklace of gilt metal, faceted rock crystal, oval-shaped rose quartz; silver dress pin set with rose quartz, marcasite with a silver fitting. All c. 1935. *Courtesy of Spink & Son, Ltd., London*

Three jewels by Maud Eastman in the Arts and Crafts style: a hammered silver triangular-shaped dress clip set with pink tourmalines, and jadeite drops; a carved jadeite plaque mounted in silver and engraved with a parrot perched on the stem of a plant with a large flowerhead growing from a fruit; silver pennanular brooch in the Celtic style set with central moonstone, amethysts, emeralds and carmelians, c. 1935. *Courtesy of Spink & Son, Ltd., London*

Walter Edwards

This silversmith was a member of the Guild of Handicraft. After the Guild disbanded, he continued to work as a silversmith for a time, and then went to work for the Cadbury candy company supervising the making of chocolate molds.

Charlotte E. Elliot

A metalwork designer from Liverpool, Elliot won second prize in a competition sponsored by *The Studio* under the pseudonym "Parnassus." Her tankard design was produced by Liberty & Co.

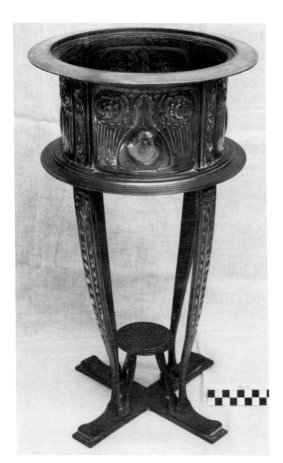

Lamp stand designed by A.H. Mackmurdo and executed by George Esling. *Colchester Museums, Essex, England*

Enamelled brooch in silver by Nora Evers-Swindell.

George Esling

A metalworker for the Century Guild, Esling often did repoussé work which included candlesticks, light fittings, plaques, and dishes. Of several pieces by Esling, one designed by the architect Arthur Heygate Mackmurdo is in the Colchester and Essex Museum, England.

Jeanne Etève

Etève began as a part-time enameller for the workshop of Omar Ramsden and Alwyn Carr. She eventually came on board full-time around 1919. Her work was considered mediocre, and sometime in the 1920s she left the workshop and was replaced by Henri de Konnigh.

Nora Evers-Swindell

An Arts and Crafts jeweler, Evers-Swindell made small items such as hat pins and brooches of silver, enamel and pearls. Her work was featured in *The Studio*.

Alexander Fisher (1864-1936)

One of the top enamellists of the Arts and Crafts movement, Fisher influenced many other designers. A sculptor and silversmith as well, Fisher attended South Kensington school and then studied in Italy on scholarship and in Paris concentrating on enamelling. He had heard the French Limoges enamel expert Louis Dalpayrat speak in London which had piqued his interest.

Fisher taught for four years at the Central School of Arts and Crafts where he met Henry Wilson, with whom he had a brief partnership. He went on to set up a school of enamelling at his own studio in Warwick Gardens where he influenced many other enamellists, including Nelson Dawson to whom he gave private lessons. Fisher also taught a class at the Tinsbury Technical College and exhibited some of his work at the home of one of his students, Mrs. Percy Wyndham. He taught enamel work to her and other members of the aristocracy and London's leisure class in his studio.

Fisher made large complicated enamels using both the cloisonné and Limoges techniques, sometimes using both in one piece. Some of his pieces are done with champlevé, basse taille and plique-à-jour enamelling as well. Vivienne Becker describes the system of enamelling Fisher created himself, utilizing a number of layers of translucent enamels in various colors as being done "to create a dreamlike effect of swirling depth and movement."[13]

Jewelry by Fisher is rare, yet his use of the Limoges technique influenced countless jewelers. Within his small output were a few a few pieces of jewelry he designed for Queen Victoria. Fisher wrote frequently for *The Studio* and was influential in the work of Ernestine Mills, the Gaskins, Kate Eadie and Sidney Meteyard, and Nelson Dawson among others. He exhibited at international exhibits, won the Diploma of Honor in Budapest in 1902, and a silver medal at the Barcelona International Art Exhibit in 1907.

A lighting sconce with a peacock enameled on it by Fisher was shown at the Arts and Crafts Exhibition in 1896. Two other well-known pieces by Fisher are in the Victoria and Albert Museum, London. "The Wagner Girdle" which depicts Tristan and Isolde and is made of steel with enamel plaques. An earlier piece, a "Tristan and Isolde" belt buckle, which was sold at Christie's, London in 1992. Made in 1896 it was of white metal and enamel and set with opals. The "Tree of Life" morse is an enamel that depicts the Crucifixion set in a gold frame backed with silver and set with emeralds. The "Tree of Life" was made in 1906 by Fisher and J. Davis and was shown in 1907, 1913 and 1914. He made a number of enamel triptychs and large caskets which are also well known.

Another important Fisher piece was shown at the Nicholas Harris Gallery in London in 1984. It is a silver travelling icon, and the lid has an applied silver medallion illustrating St. Esprit. Inside is an enamel panel mounted in silver depicting a full-length figure of Christ. The icon was made by Fisher as a gift from Arthur Balfour to Madeline Wyndham in 1897.

Two large pieces designed by Fisher were auctioned by Christie's Glasgow gallery in 1989. One was a 24" high ship mounted on a 50" column representing "The Birth of Aphrodite." This incredible piece was commissioned by Lord Carmichael of Sterling, an arts patron, around 1900 (his wife studied enamelling with Fisher) and is made of silver plate and enamel. "The Birth of Aphrodite" depicts two mermaids beneath a sail which has an enamel medallion inset featuring a flowering rose and the inscription "Aphrodite." Enamel panels

decorate the side of the ship which sits on a green onyx base atop a carved oak column. This ship appeared in the *Studio Magazine* in 1900. The second piece which also belonged to Lord Carmichael is not documented, but is attributed to Fisher. She is Urania, the muse of Astronomy, and is cast in bronze applied with silver plate and enamel. She stands on a bridge with her arms reaching towards a metal globe with enamel panels depicting the Zodiac. The sculpture is 36½" high and is also on an oak column.[14]

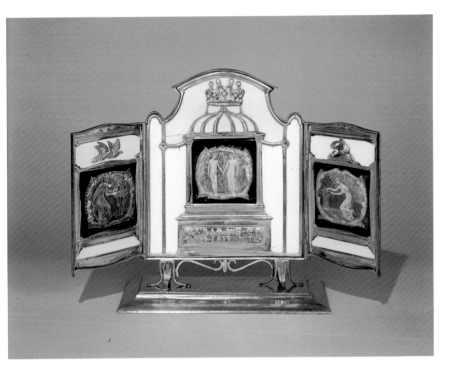

Triptych by Alexander Fisher. Silver gilt and ivory, set with opals and standing on a bronze base, c. 1904. The enamels depict knowledge, life, and the unity of man and woman. Inscribed "Pour la vie et dans l'eternitie." Signed with AF monogram. *Courtesy of Fischer Fine Art Limited, London*

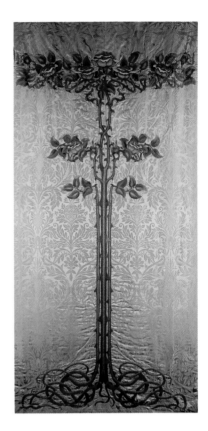

Embroidered hanging of a stylized rose tree in bloom designed by Alexander Fisher, c. 1904. One of four designed by Fisher and executed by the Royal School of Needlework for Fanham's Hall. *Fischer Fine Art Ltd., London*

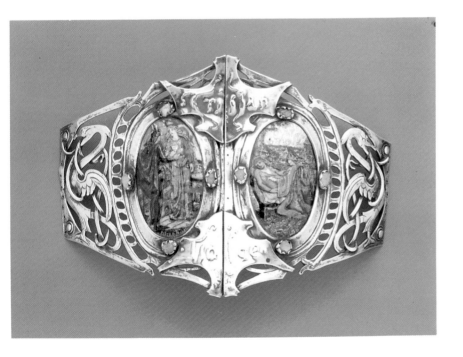

Tristan and Isolde white metal and enamel belt buckle by Alexander Fisher. This piece is clearly related to the Wagner girdle which is in the Victoria and Albert Museum and may have been made earlier. It is set with opals. The clasp depicts stylized griffins and foliage and reads "Tristan and Isolde" in repoussé work. Each enamel panel is signed "Alex Fisher" with the AF monogram and is dated 1896. The metalwork is monogrammed FD. *Courtesy of Christie's, London*

Necklace in gold and enamel by Kate Fisher
(Alexander Fisher's daughter).

Silver and enamel clasp by Kate Fisher.

"The Spielman," silver statuette designed and
executed by Alexander Fisher, 1914

"The Virgin and the Doves" enamel panel
designed and executed by Alexander Fisher,
1913

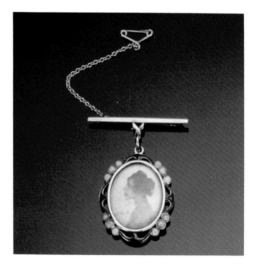

A 15 kt. gold brooch by W. Russell Flint. The
watercolor picture of a maiden is mounted in a
frame set with enamel and opals. Signed W.R.F.
Inscribed "Diana, 1907" on back. *Courtesy of
Christie's, London*

Kate Fisher

The daughter of Alexander Fisher, Kate was a jeweler and enameller who created clasps in silver and enamel. According to Vivienne Becker in her book *Art Nouveau Jewellery*, Fisher designed for Hutton & Co.

W. Russell Flint

A brooch by Flint was sold at Christie's, London in 1902. Dated 1907 it was a titled "Diana" and contained a watercolor of a maiden.

Eleanor Fortescue-Brickdale (1871-1945)

A painter in the later portion of the Pre-Raphaelite movement, illustrator and stained-glass designer Brickdale was an enamel painter as well who did work for Liberty & Co., including a frieze on a silver box designed by Oliver Baker. She studied at the Crystal Palace School of Art and Royal Academy Schools.

Arthur Fowler

A member of the Birmingham Guild of Handicraft, Fowler designed silver jewelry. Four clasps designed by him were exhibited in 1899, and were executed by Thomas Birkett of Birmingham.

H.R. Fowler

Fowler was the chief jewelry designer for Gittin's Craftsmen Ltd., a Birmingham firm that merged with the Birmingham Guild of Handicraft in 1910.

George Frampton (1860-1928)

A sculptor who started his career as a jeweler and metalworker by making jewelry for his wife, Frampton was self-taught. He was an instructor at the Central School in London and opened his own studio in the 1880's to make jewelry. He also designed nine panels of silver relief depicting heroines from the "Morte D'Arthur" for a door in the Aster Estate Office in London.

Frederick Freeman

A student at the Vittoria Street School, Freeman made metalwork decorated with enamel in a Gothic style.

Louis Richard Garbe

Louis Garbe, like John Paul Cooper, designed objects of shagreen. His were mounted with brass and wrought iron whereas Cooper used silver. He was also a sculptor and a member of the Guild of Art.

Bill Gardiner

Gardiner was a silversmith in Omar Ramsden's workshop in the later years.

Arthur Gaskin (1862-1928) and Georgina Cave Gaskin (1866-1934)

The Gaskins were one of the important husband and wife jeweler teams of the Arts and Crafts movement. Arthur Gaskin began his training as a student at the Birmingham School of Art where he studied under E.R. Taylor. In 1902 he became director at the Vittoria Street School for Jewellers and Silversmiths where he stayed until 1925 when he retired to the Cotswolds. He met fellow student and future wife Georgina Cave France (Georgie), an illustrator with a style similar to Kate Greenaway's, there.

Gaskin was part of an informal organization of artists in Birmingham that worked together and were known as "The Birmingham Group." Other members included the artist Joseph Southall; the painter and jeweler Charles Gere; painter Henry Payne; Mary Newhill, an embroiderer and stained glass designer; and Sidney Meteyard, a painter and jeweler.

In 1894 the Gaskins married and five years later they began a business designing and executing silverwork and jewelry. Arthur's first known piece in enamel was a Medieval-inspired copper gilt ecclesiastical clasp fastening—a cope (also known as a morse) for the church he attended. He was a multi-talented artist working also as a woodworker, book illustrator, and painter. This other facet of his career brought the Gaskins within the circle of the Pre-Raphaelites and William Morris. Georgie Gaskin became a close friend of Georgiana Burne-Jones (wife of the Pre-Raphaelite painter) and May Morris (William Morris' daughter)—May even became the godmother to one of the Gaskins' two daughters.

Arthur also did a number of portrait sketches including some of well-known Arts and Crafts metalwork figures Bernard Cuzner, W. T. Blackband and William Catterson Smith. Arthur Gaskin abandoned his art career to make jewelry presumably because it was more lucrative than painting and he had a family to support. But Georgie was the one with the business acumen. In 1899

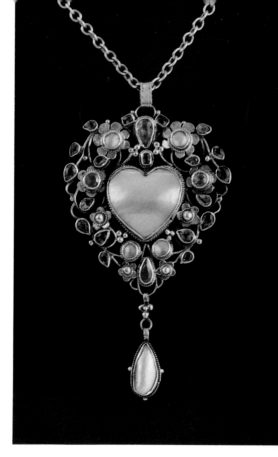

Pendant by the Gaskins of silver, pearl, pink tourmaline and green paste, c. 1910. *Courtesy of Tadema Gallery, London*

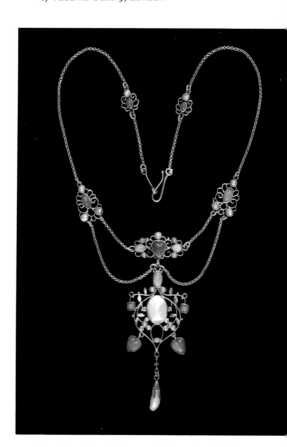

Necklace by Arthur and Georgie Gaskin. *Courtesy of John Jesse, London*

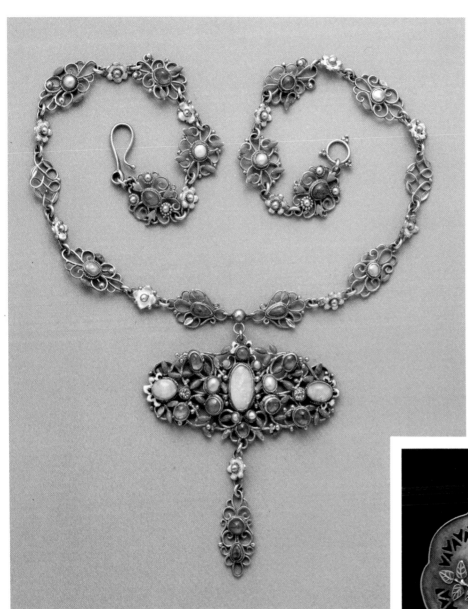

Necklace by the Gaskins. *Courtesy of Fine Art Society, London*

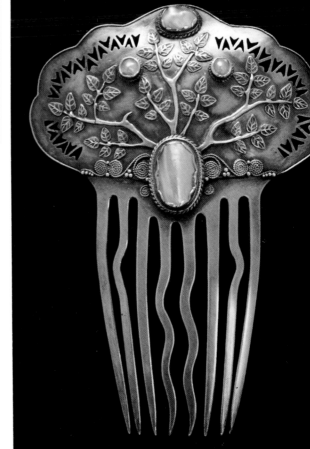

Silver and pearl hair comb attributed to the Gaskins, c. 1910. *Courtesy of Tadema Gallery, London*

when they began making jewelry she was already a mature woman of 32 and she ran their business smoothly.

According to those who were friends of the Gaskins the majority of the jewelry should be attributed to her. They exhibited under both names, but critic Aymer Vallance wrote that Arthur was the enameller and Georgie the jeweler. Actually, many of their designs were executed by their assistants—a number of them were Vittoria St. School students. This was almost a necessity in the beginning because they were quite inexperienced themselves, and later because their success created more work than they could handle personally.

Neither Arthur or Georgie were in the best of health and Georgie suffered ill effects from kiln fumes although she continued to design jewelry until her death. In fact, Georgie's red hair was actually a wig made of her own hair which had fallen out from a youthful illness. Perhaps due to her hair loss, she became known for wearing interesting hats.[15]

At the Vittoria Street School plant drawing was a requirement, and this influence is easily seen in the Gaskins' work. Many of their pieces incorporate flowers and leaves in gold and silver. They are often set with small, colored cabochon stones and opaque enamels in pale colors (which was imitated by many Birmingham jewelers) and the earlier pieces featured coils and tendrils of gold or silver wire. Medieval inspiration can also be seen in their jewelry. Their later jewelry from 1910-15 makes more use of enamel, the foliage is more elaborate, and the pieces are in general more sophisticated.

Other notable elements of the Gaskins' work are borders of a "rope" design and clusters of silver grains. Birds often appear, and a number of pieces have an overall pink and green coloration through the use of colored stones and/or enamelwork. These colors also appeared in Jubilee jewelry made in 1897, often with flower motifs, but this is probably not related to the Gaskins' work.

The Gaskins continued to "grow" as artisans throughout their lives. Later in her career, Georgie made "pebble" jewelry and other items for the wealthy and prominent Cadbury family including several napkin rings utilizing gold wire work wrapped around carnelian. (The "pebbles" were gathered by the Cadbury family.) Arthur took up Limoges enamelling in 1913 and collaborated on the Birmingham Law Society's badge with W. T. Blackband.

Arthur also did metalwork in addition to jewelry including inkwells, spoons, boxes, brass and copper bowls. He and Bernard Cuzner collaborated on a pastoral staff made for the Bishop of Gloucester and he also designed silver objects including a number of badges, presentation caskets, and Christening bowls. A cup for Cheltenham College illustrating Sir Galahad and the Holy Grail and an enamel altar cross were also his handiwork. The cross c.1905 was made with the assistance of James Morris, Lily Dale, Effie Ward and A.E. Jones.

A velvet bound book of the Gaskins' drawings is in the collection of the Victoria and Albert Museum. It includes drawings for necklaces, pendants, brooches, earrings, combs, rings, and lace pins. Most of the drawings are annotated with the type of stone to be used, with the actual color of the stone sometimes shown on the drawing. The stones most frequently indicated are: pearls, opals, pink topaz, turquoise, chrysoprase, moonstone, crystal, amethyst, aquamarine and emerald. Many of the pieces in the sketch book are named—"Bird of Paradise," "The Dove," "Love In A Mist," "The Squirrel Brooch" or they have girls' names or the name of the person the piece was made for is notated. One of the most charming drawings is a pair of earrings which resemble delicate little bells—they are labeled "Tink-a-bell." The sketch books also contain a photograph of a necklace the Gaskins made for Queen Alexandra.

A number of beautiful pieces of the Gaskins' work reside at the Victoria and Albert Museum in London including necklaces, pendants and brooches. These pieces are worked with opals, emerald pastes, enamel, pearls, turquoise, tourmalines, topaz and moonstones and a number of them date from as late at the 1920s.

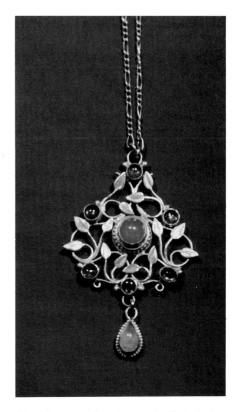

Floral design pendant that is most likely by the Gaskins. Sapphires, tourmaline, chalcedony, 9 kt. gold. *Courtesy of Leah Roland/Split Personality, Leonia. Photo by Gabrielle Becker*

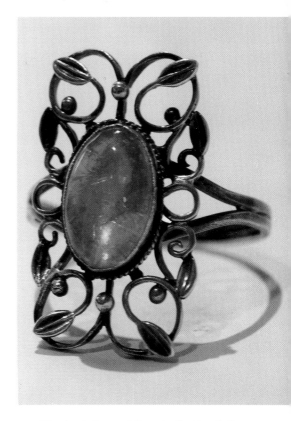

Ring by Arthur and Georgie Gaskin of silver with a fire opal c. 1903. *Courtesy of Tadema Gallery, London*

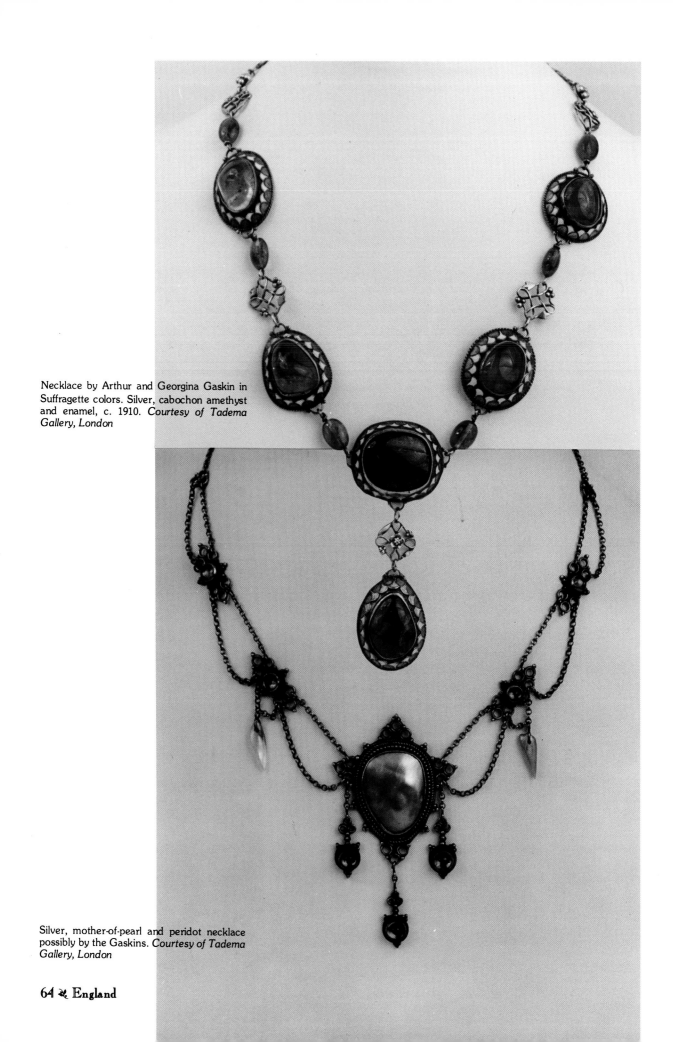

Necklace by Arthur and Georgina Gaskin in Suffragette colors. Silver, cabochon amethyst and enamel, c. 1910. *Courtesy of Tadema Gallery, London*

Silver, mother-of-pearl and peridot necklace possibly by the Gaskins. *Courtesy of Tadema Gallery, London*

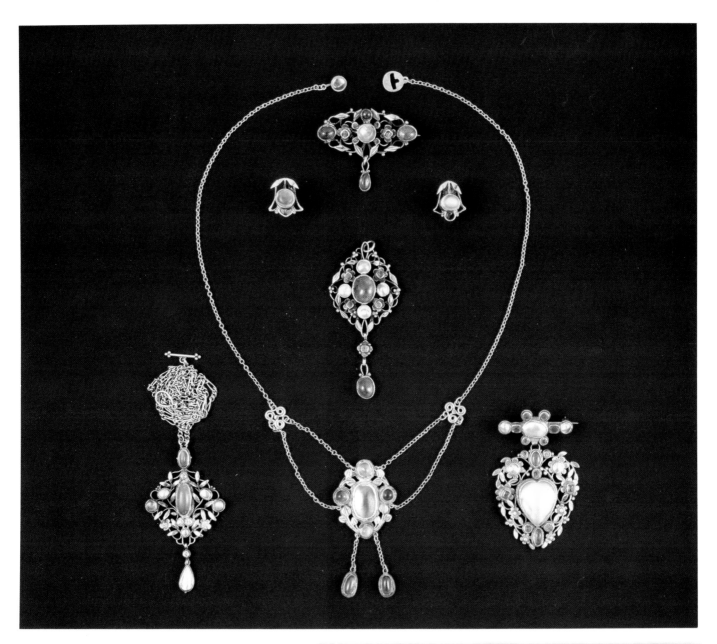

A group of jewelry by the Gaskins including a
pair of earrings which are seen less frequently
than other forms of Arts and Crafts jewelry.
Courtesy of the Fine Art Society, London

Top: Brooch by unknown designer of silver,
gold and opal, 1900-1920. Bears some similarity
to the Gaskins' work. Bottom: Pendant, 1913-20
of gold colored metal with a ceramic insert
impressed "Moorcroft" on back. *Cheltenham
Museum and Art Gallery, England*

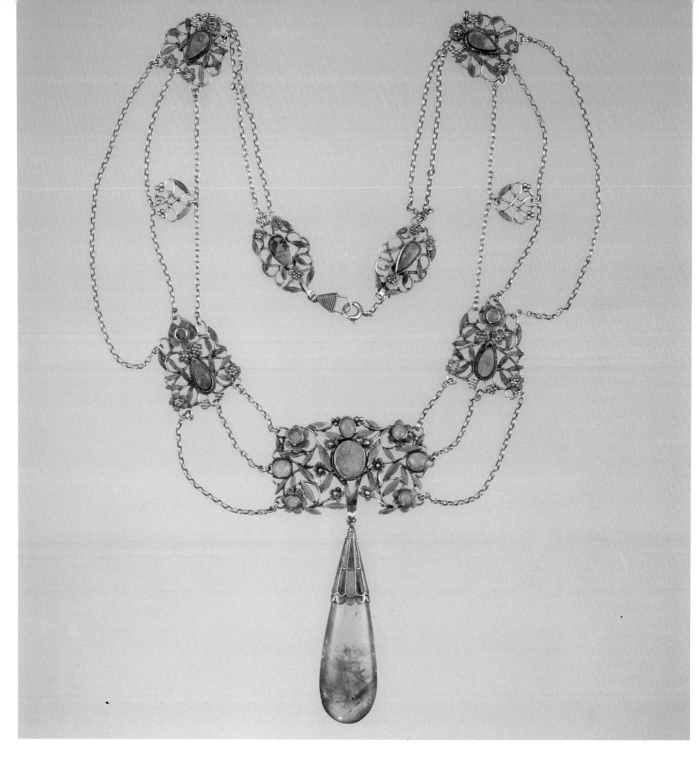

Necklace by the Gaskins. *Courtesy of the Fine Art Society, London*

A. Gebhardt

A jeweler with the Guild of Handicraft, Gebhardt may have been the designer of one of the well-known peacock necklaces although he primarily executed Ashbee's designs.

Charles March Gere

A member of the Birmingham Guild of Handicraft, Gere was an artist who designed some gem-set jewelry. Gere was part of the group of artisans that frequently worked together known as "The Birmingham Group" and also taught at the Birmingham School of Art (see Arthur Gaskin for more detailed information). A gold brooch designed by Gere and executed by Frederick Jones was exhibited at the Arts and Crafts Exhibition of 1896.

The Group received a local commission to revamp the Chapel of Madresfield Court. The mural decoration was done by Payne, the enamel by Gaskin and his assistants, and the altarpiece by Gere.

Jewelry designs for pendants by Sir Alfred Gilbert. *National Museum of Wales, Cardiff*

Wax model of jewelry design by Sir Alfred Gilbert. *National Museum of Wales, Cardiff*

Sir Alfred Gilbert

This well-known sculptor is most famous for designing the Eros Fountain in Picadilly Circus in London. He was also a jewelry designer with one of his most important works being the Preston Mayoral Chain in 1887-88 which is significant because it is not as static as most Arts and Crafts jewelry. The chain is made of banded alloys, a Japanese technique of metalworking, and was described by Herbert Mayron as being "wrought in elaborately chased and pierced high relief repoussé work, in several superimposed layers. The principal links of the chain are gilded and enamelled silver with jewelled devices...in a series of inscribed, rectangular links in laminated metals."[16] The necklace is very strongly related to Art Nouveau in concept although Gilbert professed to dislike Art Nouveau work and would not admit the relationship of his own work to it.

Gilbert also designed necklaces, rings and other personal items by twisting wire into complicated forms and setting pearls and gemstones into it. Some of his jewelry is in the collection of the Victoria and Albert Museum, and drawings for other pieces are in the National Museum of Wales. He designed a silver epergne which was presented to Queen Victoria as a Jubilee gift from officers of the Army, decorated with bronze, ivory, wire and crystal.

Walter Gilbert

Gilbert, a cousin of the sculptor Sir Alfred Gilbert, was a student at the Birmingham School of Art and became a metal designer with the Bromsgrove Guild. A badge of cast and wrought silver Gilbert designed for the Leeds & Yorkshire Architectural Society in 1904 was executed by the Guild, as were many other pieces he designed.

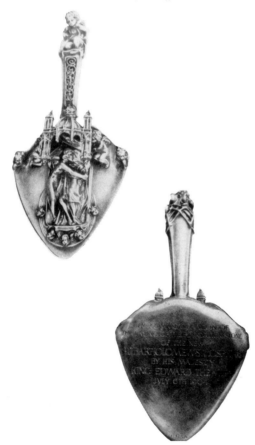

Trowel by Walter Gilbert for the Bromsgrove Guild. Illustrated in *The Studio. Courtesy of Leah Roland/Split Personality, Leonia. Photo by Diane Freer.*

Casket designed by Walter Gilbert for the Bromsgrove Guild. *Courtesy of Leah Roland/Split Personality, Leonia. Photo by Diane Freer.*

Wall sconces designed by Ernest Gimson. Made of reticulated iron and probably made by Alfred Bucknell, c.1910. *Courtesy of Fischer Fine Art Ltd., London*

Mary A. Gilfillian

A necklace and pendant set with stones by Gilfillian were featured in *The Studio* in the 1910 National Competition of Schools of Art. She was a student at the Camden School in Islington.

Ernest Gimson (1864-1919)

An architect, and designer of furniture, Gimson is best known for his venture, the Daneway Workshop, which he founded with Sidney Barnsley and his brother, Ernest Gimson, an architect who had trained with J.D. Sedding. He also designed forged metalwork which was executed by the blacksmith Alfred Bucknell, including andirons (fire dogs), candlesticks, and wall sconces.

R.M.Y. Gleadoe (1878-1944)

A designer of silverwork, but not a silversmith, Gleadoe studied with Henry Wilson and also worked for H.G. Murphy and the silversmithing firms of Wakely and Wheeler of Birmingham and Barnards of London. He opened his own workshop in 1913, taught at the Royal College of Art, and was the first person from the silver discipline to be made principal of the Central School in London. Gleadoe was also an art master at Winchester.

John Green

Green was a jeweler on High Street in Birmingham. He made stamped silver jewelry that was Art Nouveau-influenced.

W. S. Hadaway

A white metal and cloisonné brooch of a Viking ship was auctioned at Christie's London in 1992. A similar piece by W. S. Hadaway was exhibited at the Dress Designer's Exhibition and shown in the *Art Worker's Quarterly* in 1904. A Mrs. Hadaway is mentioned as being a friend of C.R. Ashbee's; presumably, this is the same person.

Dorothy Hager

Hager's work was featured in the *Art Worker's Quarterly* in 1902 and *Art Journal* in 1906. A white metal brooch with wirework and opal was offered at Christie's London in October 1992.

William Hardiman

Hardiman became a principal silversmith who joined the Guild of Handicraft in 1890, after taking classes at the School of Handicraft. Hardiman essentially learned his craft by "on-the-job-training." He worked with Ashbee to produce jewelry using the lost wax-casting method. Although his modelling work was good, Hardiman was not mentally stable, and he suffered from a persecution complex. His personal problems contributed to some of the internal squabbling that occurred in the metalworking department—he believed other members of the Guild were "out to get them." Hardiman stayed with the Guild until close to his death, but in the end he worked alone.[17]

John Hardwicke

An assistant to the Gaskins on their later work, Hardwicke was a student from the Vittoria Street School. He worked under James Morris, another pupil of Arthur Gaskin's.

Lillian May Harper

An enamellist who attended the Aston Manor School of Art, Harper exhibited a copper and enamel sugar bowl and cream jug in the 1910 National Competition of Schools of Art, and the set was favorably reviewed in *The Studio*.

Kate Harris

Silver and enamel belt buckles are the work for which Kate Harris is known. She designed these pieces for the manufacturer William Hutton and Sons, Ltd. and the Goldsmiths and Silversmiths Co. Her designs are strongly Art Nouveau-influenced featuring women's heads with flowing hair. Not much else is known about her.

Dorothy Hart

Dorothy Hart designed and executed her own work which included filigree pendants with enamel and pearls and turquoise.

Gold pendant with pearls, turquoise and champlevé enamel by Dorothy Hart.

Kate Harris designed belt buckle, c. 1900.
Courtesy of Tadema Gallery, London

Silver belt buckle designed by Kate Harris and
hallmarked in London, 1902. Marker's mark
obscured but shows W H (W over H) LD for
William Hutton & Sons. *Cheltenham Art
Gallery and Museums, England*

Silver and velvet lined silk handbag designed by
Kate Harris, c. 1900. *Courtesy of Tadema
Gallery, London*

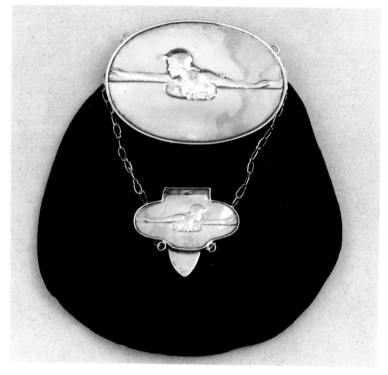

Six silver buttons and case designed by Kate
Harris and made by Hutton and Sons.
Hallmarked in Birmingham 1903, WH & SS LD.
*Cheltenham Art Gallery and Museums,
England*

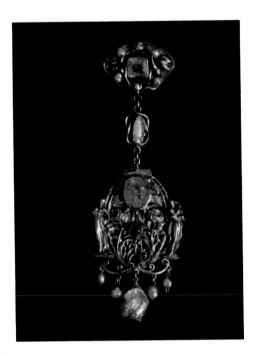

Brooch by Joseph Hodel. Various colored golds mounted with pink tourmaline and baroque pearls. c.1900. *Courtesy of Tadema Gallery, London*

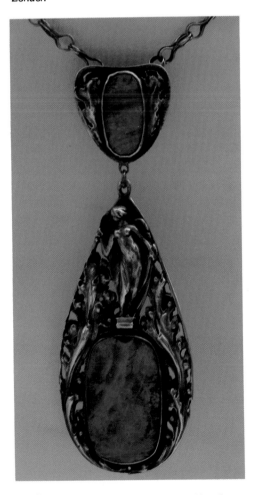

A pendant by Joseph Hodel of silver, gold and opal for the Bromsgrove Guild c. 1906. *Courtesy of Tadema Gallery, London*

George Hart (1882-1973)

One of the early members of the Guild of Handicraft, Hart was a silversmith who continued his trade after the Guild's demise working with Jack Baily, Huish and Warmington, and also his son, much of the work being church plate. Hart continued to use the Guild of Handicraft "G of H" mark after the Guild was disbanded and it is still used today by his grandson, David Hart, who manages the family business. Hart made many pieces based on the Guild's designs, but also did original work in the 1920's and 1930's styles.

Richard Hatton

A silver casket made for Queen Alexandra in 1906 by the Newcastle Handicrafts Co. was designed by Hatton.

Clement John Heaton (1861-1940)

The son of a stained glass manufacturer, Heaton was an artist who at age twenty-one became a member of the Century Guild for which he designed metalwork and light fittings. He went on to specialize in cloisonné enamel, with some pieces executed from designs by the architect Arthur Heygate Mackmurdo. For a time he opened his own business, Heaton's Cloisonné Mosaics, Ltd. before moving to Switzerland in the early 1890's. Heaton did design work for Liberty & Co. even after moving to Switzerland and then in 1912 he moved to the United States.

Tom Hewson

Hewson was a silversmith with the Guild of Handicraft. When the Guild was disbanded he had difficulty finding a job and suffered from alcoholism.

George Hides

Hides was a jeweler who had been a student at the Birmingham School of Art under John Paul Cooper.

Joseph Hodel

Hodel worked with the Bromsgrove Guild and taught at the Municipal School of Art in Liverpool for a number of years. He made jewelry and small architectural metalwork pieces for the Guild. He had a Swiss-born partner, Louis Weingarten, who also joined the Bromsgrove Guild.

A comb in the Victoria and Albert Museum was designed by Hodel in 1905. It was exhibited at the Arts and Crafts Exhibition in 1906 where it was probably acquired by May Morris. The comb with ivory teeth, is of silver, mother-of-pearl, fire opal matrix and sapphires. Other pieces known to be by Hodel are a silver belt clasp with grape leaf cluster design and a central cabochon chrysoprase; a gold pendant with a human form standing on either side of a black opal with a baroque pearl drop; and a belt clasp made for the Guild with a flying fish that has Art Nouveau-like curves.

Thomas Hodgetts

Hodgetts was a Birmingham silversmith who also executed Cymric pieces for Liberty.

Silver cupid buckle by Joseph Hodel shown in *The Studio. Courtesy of Leah Roland/Split Personality, Leonia. Photo by Diane Freer.*

Ethel Hodgkinson

Silver brooches and hat pins set with enamels and precious stones are attributed to Ethel Hodgkinson who may have been related to Winifred Hodgkinson.

Winifred Hodgkinson

Human figures, often nude women, are a feature of Hodgkinson's silver jewelry. Her brooches, belt buckles, hair pins and stick pins are usually enamelled, some with niello work, and stylistically are a combination of Art Nouveau and Arts and Crafts design. She may have been related to Ethel Hodgkinson, another Arts and Crafts jeweler.

Violet Holden

Mentioned as having worked on a repoussé enamel casket with Florence Camm, Holden was probably a fellow student of Camm's at the Birmingham School of Art. The casket was to be presented to J. Thackray Bunce of Birmingham, but he died before this could happen.

Henry George Alexander Holiday (1839-1927)

Holiday was an enamellist who trained at the Royal Academy School where he became influenced by the Pre-Raphaelites. He worked as a stained glass designer for Powells of Whitefriars, but also designed mosaics, enamels, embroidery and did mural painting.

Charles Hopkins

Hopkins taught mounting, carving and setting at the Vittoria Street School and executed a number of pieces of Georgie Gaskin's later jewelry.

Herbert Percy Horne (1864-1916)

Trained as a surveyor, Horne then went to work for A.H. Mackmurdo in 1883 when he was only eighteen. He became a principal designer of the Century Guild designing objects in copper and brass as well as textiles and wallpapers. From 1885-90 he was in partnership with Mackmurdo and then he retired to Italy.

Ted Horwood

Horwood was a jeweler with several years of experience before he joined the Guild of Handicraft. He continued to work as a jeweler in Chipping Camden after his Guild days were over.

Mary Galway Houston (1871-?)

An artist/craftsman, Houston wrote books on costume and design as well as designing metalwork with an Art Nouveau influence. A comb, brush and mirror set of metal are attributed to her. She was also an illustrator whose work appeared in *The Studio*.

Silver brooch with enamel by Ethel M. Hodgkinson.

Enamelled silver brooch by Winifred Hodgkinson.

Illustration by Mary Galway Houston.

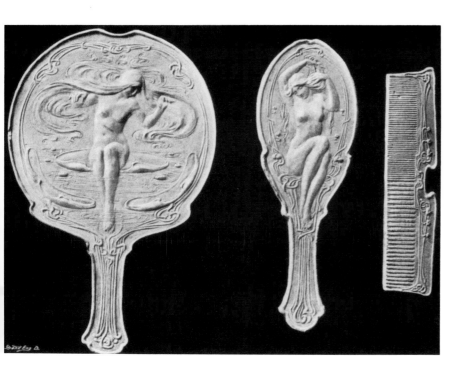

Dresser set by Mary Galway Houston.

Enamel brooch by George Hunt. Signed G.H. *Courtesy of Leah Roland/Split Personality, Leonia. Photo by Gabrielle Becker*

Enamel butterfly brooch by George Hunt of white metal with citrines. Stamped G. Hunt, 1922. *Courtesy of Christie's, London*

Bert Humphries

Humphries was a silversmith with the Guild of Handicraft.

George Edward Hunt (1892-1960)

Born near Birmingham, Hunt was left deaf at the age of five from a bout of diphtheria. At sixteen he won a scholarship to the Margaret Street School in Birmingham where he was exposed to such Arts and Crafts luminaries as Bernard Cuzner and Arthur Gaskin.

In 1912 he opened his own studio in Birmingham and began taking commissions. His is best known for using Limoges enamel, heart-shaped enamel leaves, many different stones in one piece of jewelry, and his frequent use of colored agates, moonstones, and pearls.[18] Hunt also made a number of rings of silver with gold wire work as ornament, and was known to make the same ring or very similar ones with different stones. Many of his surviving rings are of a large ring size and may have been made that way to fit a customer's finger over her gloves.

Hunt's artistic style was very much in the Arts and Crafts mode (later pieces were Art Deco) although he was inspired by a wide variety of influences: other British Arts and Crafts designers, Josef Hoffman, Lalique, Egyptian jewelry and other ancient pieces. He designed and executed all of his own work, sometimes making several versions of a piece of jewelry with similar enamelling.

Some of his jewelry is unmarked and earlier pieces are considered by some to be of a better quality than his later work. A number of his pieces designed as late at the 1930's are in the collection of the Victoria and Albert Museum including the Sheba Regina brooch of gold and silver with a carved ivory head of Sheba, and mother-of-pearl, pearls, opals, tourmalines, crystals, other stones and enamel c. 1936. His "Medusa" brooch (illustrated in this book) recently became part of the collection of the Toledo Museum in Toledo, Ohio. Another "Medusa" brooch by Hunt has a carved ivory face with blue-green enamel and is set with opals and pearls.

Medusa brooch by George Hunt c. 1935. Silver and gold set with sapphires, pearls, garnets, crystals and pink topaz with central carved citrine Medusa head. *Courtesy of Tadema Gallery, London and Toledo Museum of Art*

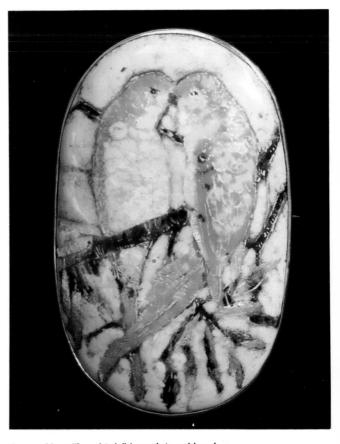

George Hunt "Lovebirds" brooch in gold and enamel, dated 1924. *Courtesy of Tadema Gallery, London*

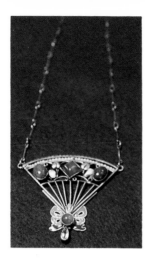

George Hunt necklace of lapis, enamel, green stones, glass pearls and silver. *Courtesy of Van Den Bosch, Georgian Village, London*

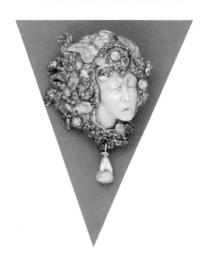

Another Medusa brooch by George Hunt of blue-green enamel, yellow metal, ivory, opals and pearls. Stamped Medusa, G.H. *Courtesy of Christie's, London*

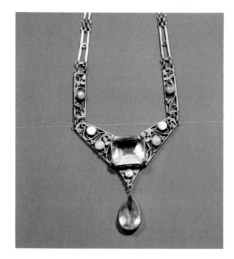

George Hunt necklace of silver, pale amethysts which Hunt seemed to favor, and opals. *Courtesy of Leah Roland/Split Personality, Leonia. Photo by Gabrielle Becker*

Samuel Hunt
Hunt was the first enamelling instructor at the Vittoria Street School

Madeline Hutchins
M. Hutchins was a metalworker who studied at the Birmingham School of Art winning a silver medal there and then worked at Queen's College. A dress ornament by Hutchins was exhibited at the City Museum and Art Gallery in Birmingham, England in 1973. Hutchins married and became Mrs. Taylor.

Emile Icguy
Jewelry by Icguy was featured in *The Studio*. It is believed he worked in England.

Selwyn Image
Image was a founding member of the Century Guild with A. H. Mackmurdo. He designed a small number of metal items for the Guild including an enamelled metal tray in 1882.

Bernard Instone (1891-1987)
A designer, jeweler, and silversmith, Instone was only twelve when he won a scholarship to the Central School of Art in London. He later became a student of Arthur Gaskin at the Vittoria Street School where he learned silversmithing. The Gaskins' influence can be seen in his work which is often quite delicate and done in the cloisonné enamel technique. He also received training with the prestigious German Court Goldsmith Emil Lettre in Berlin.

Instone worked for John Paul Cooper for a time before opening Langstone Silver Works in Digbeth in 1920. He was strongly inspired by nature. In addition to jewelry he produced domestic items such as candlesticks and flatware.

Enamel brooch signed by George Hunt, 1932. Hunt did a number of these brooches with portraits or flowers in Limoges enamel. The wirework is quite recognizable as his style. *Courtesy of Van Den Bosch, Georgian Village, London*

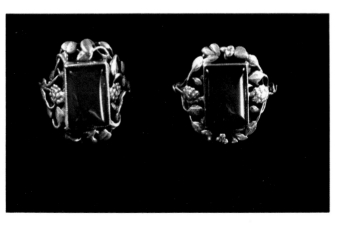

Two rings by Bernard Instone of very similar design. *Courtesy of Leah Roland/Split Personality, Leonia. Photo by Diane Freer.*

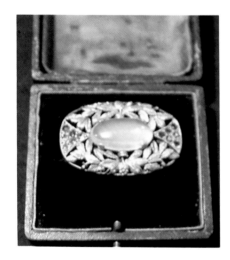

Brooch attributed to Bernard Instone of silver, moonstone and sapphires. *Courtesy of Van Den Bosch, Georgian Village, London*

Silver preserves jar c. 1920 by A.E. Jones. *Courtesy of Leah Roland/Split Personality, Leonia. Photo by Diane Freer*

Lewis Instone

The older brother of Bernard Instone, Lewis was also a talented silversmith who joined his brother to study with Emil Lettre in Berlin. He met a premature death in an accident there.

Ruth A. Isaac

Several pieces in Limoges enamel c. 1925 with Birmingham hallmarks by Isaac were auctioned at Christie's, London in 1992.

George Jack

A metalwork designer, Jack designed steel andirons (fire dogs) for Longden & Co., an established metalworking manufacturer. He became chief designer for Morris & Co. in 1890.

A.C. Jahn

Jahn was the principal of the Wolverhampton School of Art. His jewelry designs were influenced by the Art Nouveau movement and Dante Gabriel Rossetti's paintings, and featured female figures. Several pieces of Jahn's work on display at the Victoria and Albert Museum include a silver pendant with the profile of a girl's head in ivory with pearls, and a gold ring with a mermaid clasping an opal mirror. He made a number of pieces in gold, some in a neo-Renaissance style. His beaten steel and chased silver belt buckles incorporate entrelac motifs.

Gertrude Jekyll (1874-1932)

A renowned garden designer, Jekyll was also a self-taught painter, embroiderer, wood carver, gilder, designer of illumination and metal worker. She designed over four hundred gardens, and wrote fifteen books and two thousand articles. Jekyll knew William Morris and John Ruskin and was a follower of their principles. She collaborated on many projects with the architect Sir Edwin Lutyens, and received commissions from Sir Edward Burne-Jones. A believer in natural beauty she used the same motifs in her embroidery and her metalwork: pomegranates, dandelions, periwinkles, mistletoe, and fishes were among her favorites. Her metalwork consisted of silver repoussé work in the form of plates, trays and boxes.

A. Edward Jones (1879-1954)

From Birmingham, where he studied at the Vittoria Street School, Jones was a silversmith and jewelry designer who went from his father's blacksmithing to his own workshop in 1902. His style was similar to the Birmingham Guild of Handicraft for which he worked for about one year, and his work was often set with turquoise. Some of his work is also reminiscent of Charles Robert Ashbee's work.

In 1905 Jones bought from Jesson, Birkett & Co. partial use of the "St. Dunstan Raising a Bowl" trademark, St. Dustan being the patron saint of silversmiths. He also secured from them the use of a patination process for copper and bronze, which R.L. Rathbone had developed and sold to Jesson, Birkett. He also began to use some designs by Annie Stubbs, the wife of Thomas Birkett, a director of the Jesson, Birkett Company.[19]

Jones also made mounts for brooches that held William Howson Taylor's pottery "jewels" (from the Ruskin Pottery) and designed for Liberty & Co. (These pottery buttons can also be found in mirror frames sold by Liberty & Co.) Some of the jewelry he made was done in conjunction with Bernard Cuzner and he did commissioned work for the Birmingham and Bromsgrove Guilds with the Gaskins enamelling some of his silver pieces.

His beaten silver and bronze work included items such as silver bowls, tea sets, dessert stands and sugar tongs and received positive notice at the London Jeweler's Exhibition of 1912. Examples of his work that survive include items such as silver bowls, copper pots, a silver sugar caster and a copper pot with a silver lid. His firm is still in business today making church plate and executing commissioned work.

Frederick Jones

A Birmingham goldsmith, Frederick Jones executed some jewelry for the Birmingham Guild of Handicraft.

Jessie Jones

Jones was a Birmingham silversmith who executed Cymric pieces for Liberty. She had been at student of the Vittoria Street School.

Candlesticks by A. Edward Jones. Hallmarked in Birmingham, 1908, A.E.J. Near the foot is a chased band of decoration of bats and the legend "Now is the witching hour of the night". *Cheltenham Art Gallery and Museum, England*

Louis Josephs

As an enamelling teacher at the Margaret Street School, Josephs was very influential on a number of students who passed through the school. Swiss-born, he probably learned his craft there which included expertise in Limoges enamelling.

Prince Bojidar Karageorgvitch

An Art Nouveau-style gilt buckle by this gentleman was sold at Christie's, London in 1992. The catalog states that it originally had a label reading "This buckle made by Prince Bojidar Karageorgvitch, cousin of the King of Serbia." It also states that similar pieces were exhibited at the Leicester Gallery in 1906.

John Illingsworth Kay

Kay a watercolorist, became a designer for the Silver Studio. Although many designs for Liberty of belt buckles and cloak clasps are signed "Rex Silver," they may have been made by Kay or Harry Napper, another designer with the Silver Studio. In addition to designing metalwork for the studio, he also designed book covers, wallpapers and textiles. When he left the studio in 1900 he worked for Essex & Co., a wallpaper manufacturer, and taught at the Central School of Arts and Crafts.

Stanley Keeley

A local boy from Chipping Camden, Keeley was a metalworker with the Guild of Handicraft, joining while he was still a teenager.

Cyril Kelsey

Kelsey was a silversmith who worked for the Guild of Handicraft. He was nicknamed "the professor." He left the Guild to join the British Army in South Africa and later became a broker's clerk.[20]

Ethel Kirkpatrick

A jeweler and enamellist Kirkpatrick work was shown in *The Studio*. A white metal necklace decorated with mother-of-pearl and agate was featured in *The Studio* in 1905.

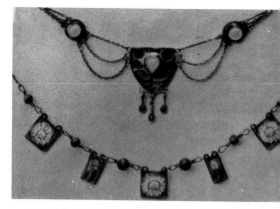

Necklace on top by unknown designer and the one on the bottom by Ethel Kirkpatrick. Silver, chrysoprase, mother-of-pearl "daisy chain" in champlevé enamel with malachite. Buckle in champlevé enamel and silver by Kirkpatrick. *Courtesy of Leah Roland/Split Personality, Leonia. Photo by Diane Freer.*

A silver necklace by Ethel Kirkpatrick with a mother-of-pearl background set with agate. This necklace was featured in *The Studio* in January, 1905, vol. 33, pg. 353. *Courtesy of Tadema Gallery, London*

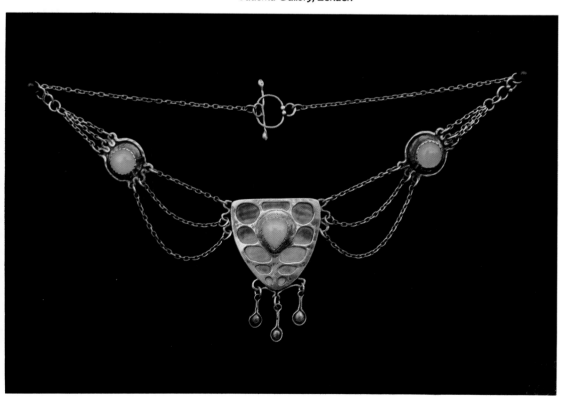

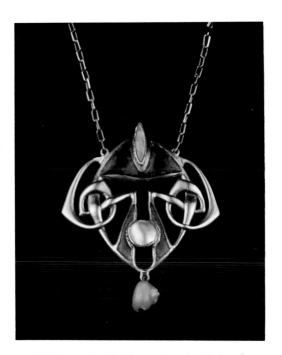

Gold, enamel and blister pearl pendant designed by Archibald Knox for Liberty & Co. *Didier Antiques, London*

Archibald Knox (1864-1933)

The most famous of all the Liberty & Co. Arts and Crafts style designers, Knox was born on the Isle of Man and studied at the Douglas School of Art where he later taught, specializing in Celtic designs.

In the late 1890's he moved to London after accepting a teaching position. There he eventually came in contact with Liberty & Co., possibly through an introduction by the architect M.H. Bailie Scott with whom he had worked on the Isle of Man. It has also been said he worked for the Silver Studio and Christopher Dresser's studio before working for Liberty and both had Liberty connections.

He began designing wallpapers and fabrics for Liberty and in 1899 became the major force in the launch of the Cymric (silver) and Tudric (pewter) lines of household items and jewelry with his Celtic-inspired designs (please see Liberty & Co. for a further discussion).

Knox continued to work for Liberty until 1912 even while returning to the Isle of Man from 1900-04. In 1904 he moved back to London and taught at the Kingston School of Art in London. In 1912 he left for the United States because the school was unhappy with his teaching methods. When he left several of his students were quite upset and founded the "Knox Guild of Craft & Design" while continuing to correspond with him. One of these students was Denise Tuckfield who herself became a Liberty & Co. designer in 1913.[21]

Knox taught briefly at the Pennsylvania School of Industrial Arts before moving to New York, but unable to make a suitable living he returned to the Isle of Man for the remainder of his life.

Knox's use of Celtic-inspired designs probably derived from several sources. His parents were Scots-born and he may have been influenced through them. Also, Celtic motifs were in evidence on the Isle of Man, particularly on old gravestones. In 1856 Owen Jones published *The Grammar of Ornament* which had Celtic designs in it, and which Knox probably studied. His earlier pieces were close to traditional Celtic designs but became more of Knox's own invention as his work matured.

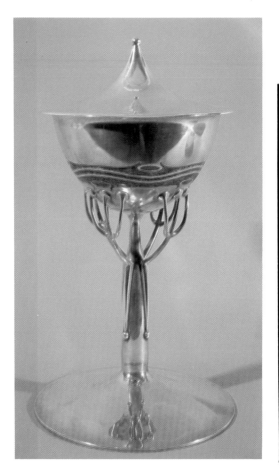

Presentation cup with cover designed by Archibald Knox for Liberty & Co. Hallmarked in Birmingham, 1901, CYMRIC/L & Co. *Courtesy of Barry Friedman, Ltd., New York*

Belt buckle by Archibald Knox for Liberty & Co., silver and enamel, c. 1910. *Courtesy of Tadema Gallery, London*

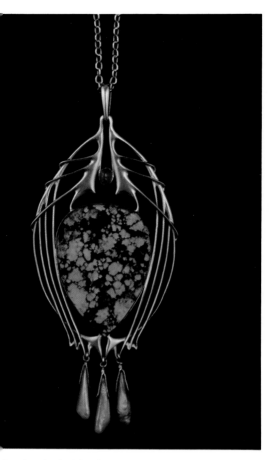

Pendant by Archibald Knox for Liberty & Co.,
c. 1900. Turquoise matrix set in 15 k. gold,
garnet and Mississippi pearl drops. *Courtesy of
Cobra & Bellamy, London*

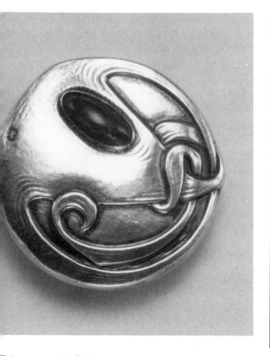

Silver, round Celtic brooch designed by
Archibald Knox c. 1901. Set with green
turquoise, hallmarked in Birmingham, 1904.
Marked L & Co. and CYMRIC. *Courtesy of
Kurland-Zabar, New York*

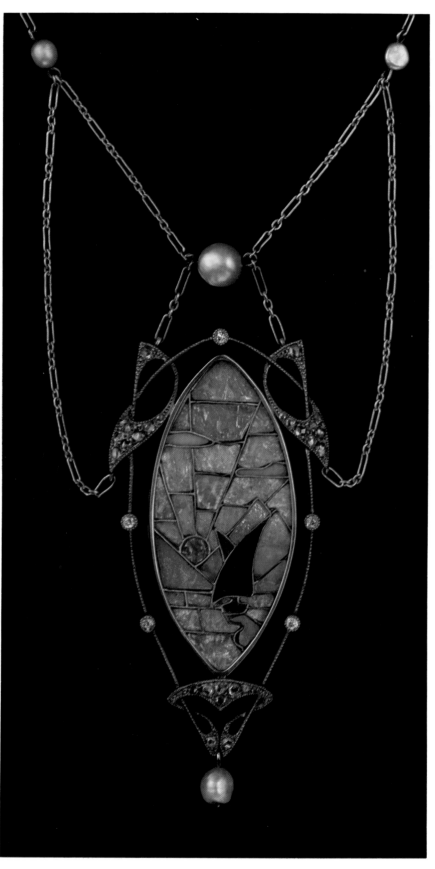

An unusual necklace by Archibald Knox for
Liberty & Co. Opal mosaic, white gold, diamond
and pearl, c.1900. *Courtesy of Cobra &
Bellamy, London*

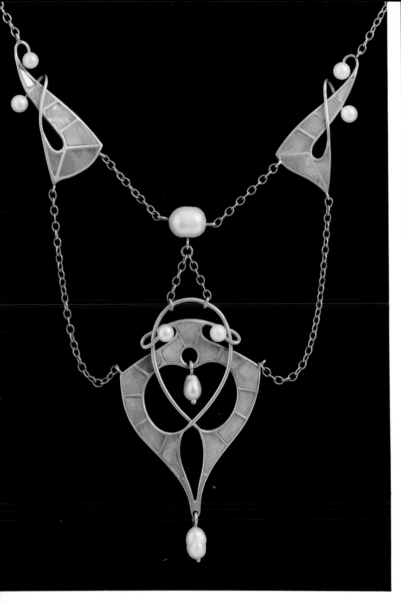

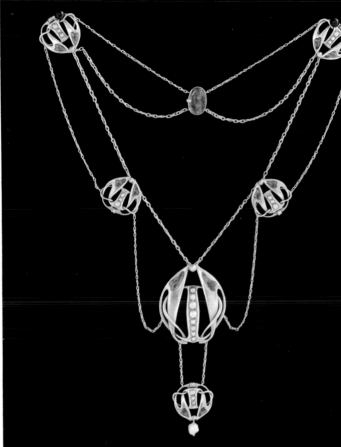

Necklace designed by Archibald Knox of gold, pearls and enamel, prior to 1900, made for Liberty & Co. Illustrated on pg. 209, #858 of the Liberty Catalogue of 1898. *Courtesy of Tadema Gallery, London*

Pendant designed by Archibald Knox of gold, opal, diamonds, and pearl drop, for Liberty & Co. c. 1900. In his sketchbook this is no. 8931, pg. 298. *Courtesy of Tadema Gallery, London*

Necklace designed by Archibald Knox for Liberty & Co. Gold, opals and pearl, c.1900. *Courtesy of Tadema Gallery, London*

Necklace designed by Archibald Knox for Liberty & Co. *Courtesy of John Jesse, London*

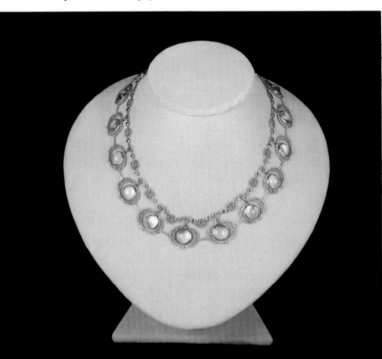

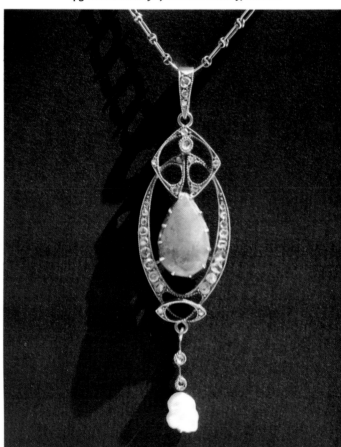

Ethel Larcombe

Larcombe designed jewelry and fans using human figures similar to those of the Art Nouveau style. A gold pendant with enamel is shown in *Art Nouveau Jewellery and Fans,* a special edition of *The Studio* published in 1902.

W. R. Lethaby (1857-1931)

At least one piece of jewelry designed by this well-known architect is known, a necklace he designed as a wedding present for his wife in 1901 which was executed by Henry Wilson. Made of gold, the pendant is designed to look like the facade of a church and is set with an amethyst, emerald, sapphire and rubies.

Celia Levetus

A white metal and enamel cloak clasp by Levetus was sold at Christie's, London in 1992. Her work was featured in *The Artist* in 1896.

Edith Linnell

Linnel was a jeweler who worked in the Arts and Crafts style.

Sir Edwin Lutyens

A well-known architect who worked in the Gothic style of Pugin, Lutyens designed at least one piece of jewelry which was a silver and ebony crucifix set with pearls made by Child and Child. It was given to Lady Emily Lytton while he was courting her.

John D. Mackenzie

A painter who started the Newlyn Industrial Class, Mackenzie designed many copper and other metal objects executed by the class. There is a strong similarity between his work and John Pearson's, who was associated with the Newlyn Class at one point. (see Newlyn Industrial Class under Schools.)

Arthur Heygate Mackmurdo (1851-1942)

Mackmurdo was an important British architect and one of the founders and principal designers of the Century Guild with other members including metalworkers George Esling, Kellock Brown and enamellist Clement Heaton. He was a friend of John Ruskin's and knew William Morris.

Mackmurdo designed objects in copper and brass repoussé for the Guild and was instrumental in publishing *The Hobby Horse* magazine.

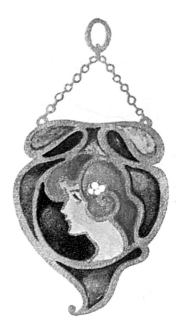

Gold pendant with enamel by Ethel Larcombe.

Pair of wall sconces by Sir Edwin Lutyens. Silver, bronze, and vitreous enamel work by the Japanese enamellist Kato, who also did work for the Stablers. c.1924. *Courtesy of Fischer Fine Art Limited, London*

Sconce designed by A.H. Mackmurdo and executed by Kellock Brown. *Colchester Museums, Essex, England*

Silver cup by Gilbert Marks. Hallmarked in London, 1900. *Cheltenham Art Gallery and Museums, England*

Necklace by Sarah Madeline Martineau. *Courtesy of Leah Roland/Split Personality, Leonia. Photo by Jessica S. Roland*

Silver brooch set with red coral by Isabel McBean.

William Maggs

Maggs joined the workshop of Omar Ramsden around 1920. Previously a designer of Chintz fabrics, he did chased decorations as well as designing pieces with Ramsden.

William Mark

Mark was an Australian enamellist and engraver who was a member of the Guild of Handicraft. Some of the enamel plaques he made for the Guild are signed with his own name. He continued to work in Chipping Camden after the Guild's disbandment and at some point did work for Nelson Dawson. Mark wrote a number of essays about the technique of plique-à-jour enamel.

Gilbert Leigh Marks (1861-1905)

One of the first Arts and Crafts silversmiths, Marks worked as a manufacturing silversmith at Johnson, Walker & Tolhurst before opening his own workshop in 1885 with the intent of doing all his work by hand. Although his work has the characteristic hammer marks it had a highly professional, finished look that almost took it out of the realm of Arts and Crafts.

He frequently used repoussé floral motifs, often poppies, for decoration. He also favored water lilies, cranes, and other Japanese motifs. Producing approximately 750 pieces of silver during his career, he also worked occasionally in pewter.

In 1984 four pieces of Gilbert's work were exhibited at the Nicholas Harris Gallery in London. One was a sterling silver two-handled tazza decorated with repoussé dog roses and applied leaves on the handles dating from 1904. Another was a silver gilt dish with a high relief repoussé border of open poppies, dated 1896. Also shown was another piece with silver repoussé poppy design—a tea tray dated 1901. The remaining piece was a small oval sterling dish with a hammered stylized leaf spine motif.

William Martin

Martin joined the Omar Ramsden/Alwyn Carr workshop in 1914; he apprenticed to Ramsden and became a competent chaser.

Sarah Madeline Martineau

Unfortunately Martineau produced only a small amount of work, because what does exist is quite lovely. A jeweler and a silversmith of Huguenot background, several pieces by her are known including several necklaces, dangling earrings and an enamelled gold pendant, c. 1910, and a yellow metal brooch with green and red enamel c. 1911. Some of her pieces are done in the colors of the Suffragette Movement and many were of 18 kt. gold with cloisonné enamel. Her work tends to be smaller than usual for Arts and Crafts jewelers.

Martineau studied jewelry at the Liverpool School of Art and possibly at the Sir John Cass Institute as well. She won first prize in *The Studio* magazine's prize competition in 1911. She may have been related to the prominent Martineau family of Birmingham.

Herbert J. Maryon (1874-1965)

Maryon studied enamelling under Alexander Fisher at the Central School and was apprenticed to C.R. Ashbee from 1896-98. He later worked in Henry Wilson's workshop and was an instructor at the Keswick School of Industrial Art, becoming the head of the school in 1902. His work was done in simple shapes and with little ornament. He worked as technical attaché (restorer) at the British Museum for almost twenty years and did reconstruction work on the Sutton Hoo treasure for which he was awarded the Order of the British Empire.

He produced the book *Metalwork & Enamelling* in 1912 which is still being re-issued today. Maryon's belief in the Arts and Crafts ethic is probably best summed up in his own words: "But there will always be a demand for work executed throughout by one man—a man who can both design and carry the work through."[22]

Robert H. Massey

Massey was apprenticed to Omar Ramsden. Massey was an excellent silversmith and for a time was the chief engraver at the shop.

Isabel McBean

McBean worked in silver, designing clasps, brooches and pendants set with semi-precious stones and other materials such as coral and enamel.

Annie McLeish

Hailing from Liverpool, McLeish was influenced by the Art Nouveau movement using human figures often in her pieces. Her pierced metal pieces were of silver or gold with enamel or semi-precious stones and took the form of brooches, pendants, hair pins, belt buckles and clasps, and crosses. In 1903, Aymer Vallance compared her work to the look of the metalwork on a Japanese sword hilt. According to Vivienne Becker, in *Art Nouveau Jewellery*, McLeish designed for the William Hutton Company.

It is believed she and Minnie McLeish, another Arts and Crafts jeweler, were sisters of Phoebe McLeish Stabler.

Minnie McLeish

Several pieces of jewelry by Minnie McLeish are featured in the special edition of *The Studio* entitled *Art Nouveau Jewellery and Fans,* including an enamelled pierced silver brooch and a silver pendant with enamel.

Annie McLeish and Phoebe McLeish Stabler are believed to be her sisters. Phoebe Stabler was jeweler in her own right and married to the jeweler Harold Stabler. A necklace and pendant made by Harold Stabler was given to the Victoria and Albert Museum by a Miss M. McLeish in memory of the Stablers.

Mark Merriman

A member of the Guild of the Handicraft, Merriman was an enameller.

Sidney Meteyard and Kate Eadie Meteyard

These jewelers were influenced by Alexander Fisher and had a close relationship with Arthur Gaskin. Sidney Meteyard, an accomplished painter, was part of the informal group of artisans (including Gaskin) who worked together and were known as "The Birmingham Group". He taught classes in gesso and leatherwork at the Birmingham School of Art and ran the enamelling studio. His enamels were often replications of his paintings.

His wife, Kate Eadie, was a student from 1908-1914 at the Vittoria Street School of Jewelry under Gaskin. A talented artist, Eadie also was a successful enameller and jeweler. She made a number of Limoges enamel plaques which were exhibited in 1906-07 based on paintings by Edward Burne-Jones and other Medieval inspirations. Two white metal necklaces by Eadie were offered at Christie's, London in 1992—one with pearls and aquamarine and the other set with opals.

John Everett Millais (1829-1896)

Millais was a Pre-Raphaelite painter. He had been a child prodigy, and designed jewelry which seemed to predict Art Nouveau fifty years before it happened, although most of his designs were never executed. The jewelry he sketched was usually shown being worn by Effie Gray Ruskin, the Scots-born wife of John Ruskin, and a friend of Millais. In 1855, after seven years of marriage, Effie had her marriage with Ruskin dissolved on the grounds of lack of consummation. She then married Millais, with whom she had eight children.

Millais did have two pieces of jewelry he designed made up—scarf pins with a duck and a goose for his brother and himself. A portrait of him shows him wearing the goose pin was made by the prestigious jewelry firm of Hunt and Roskell.

Alec Miller

Miller arrived from Scotland to become a silversmith with the Guild of Handicraft. In the later years, Miller became the Guild's modeler. He is known to have created small groups of figures and caryatids (a female figure).

Mrs. Ernestine Mills (1871-1959)

Mills studied at the Royal College of Art and the Slade School and lived in Kensington, London. She pursued enamelling with Alexander Fisher and was also strongly influenced by Arthur Gaskin designing and executing enamels and metalwork. She completed pieces including a triptych "Peace, War and Famine;" a morse and other enamels for which she received a gold medal at the Milan Exhibition; and a panel of translucent enamel on copper with a mermaid design. The Cheltenham Art Gallery and Museum owns a copper and enamel plaque in a gilt wood and enamel frame by Mills, who was active in her work right up until her death.

A white metal and enamel brooch with a polychrome foil enamel bird perched on a flowering branch by Mrs. Mills was offered at Christie's, London in 1992.

Silver brooch with enamel by Annie McLeish.

Silver and enamel clasp by Annie McLeish.

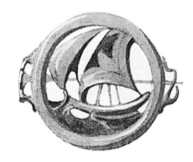

Enamelled silver brooch by Minnie McLeish.

Silver brooch by Ernestine Mills, c. 1905. Polychrome foil enamel depicting a bird on a flowering branch. Signed with EM monogram. *Courtesy of Tadema Gallery, London*

England ❧ 81

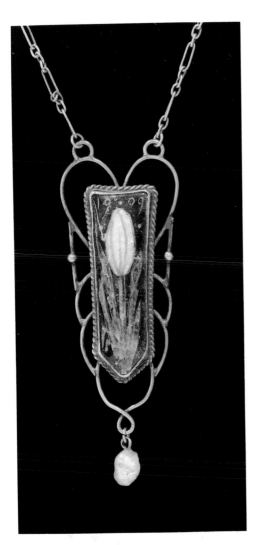

Pendant by Ernestine Mills of silver with enamel and a pearl drop, signed EM and dated 1909. *Courtesy of Tadema Gallery, London*

An enamel and copper plaque set in a silver frame by Ernestine Mills, signed EM c. 1900. (6" x 6"). *Courtesy of Didier Antiques, London*

Florence Milnes

Several necklaces and a purse with a metalwork frame by Milnes were featured in *The Studio*. She was a student at the Bradford School of Art.

E.R. Minns

Minns was a silversmith with the Artificer's Guild. A white metal pendant with moonstones, amethysts and garnets was sold at Christie's in 1992. It was listed as being by a C. Minns, possibly the same person.

William Moorcroft (1872-1945)

This well-known pottery manufacturer produced some jewelry utilizing pieces of ceramics. The Cheltenham Art Gallery and Museum has a pendant of ceramic material in a gold-colored metal frame c. 1913-20 which is impressed "Moorcroft" on the back.

Micky Moran

Moran was a jeweler with the Guild of the Handicraft.

G. Lloyd Morris

Morris was the founder of the Barnstaple Metalworker's Guild which was formed to produce repoussé brass and copper.

James Morris

Morris studied at the Vittoria Street School. He won prizes for enamel work while at school, and worked with Arthur Gaskin on enamels for a private chapel and on the necklace presented to Queen Alexandra in 1909. It is reported that he and Gaskin parted ways after arguing over the use of stamped parts.

May Morris (1862-1938)

The youngest daughter of William Morris, May studied at the South Kensington School of Design. May's career was overshadowed by her father's but she managed to have some success in her own right. Although she designed jewelry, she was best known as an embroiderer and for designing textiles for Morris & Co. In 1886 she began to manage her father's embroidery workshop at Merton Abbey and she was a founding member of the Women's Guild of Arts in 1907, later becoming the chairperson.

May's personal life is as interesting as her jewelry and embroidery. Morris grew up surrounded by all the famous names of the Morris Circle—Edward Burne-Jones, Dante Gabriel Rossetti, Phillip Webb, Ford Madox Brown among them. Her mother Janey, the daughter of a stable hand, and a semi-invalid at a young age, was one of the famous models of the Pre-Raphaelite painters. She married William Morris not out of love but for the life that he offered her. She later became involved in an affair with Rossetti, who was Morris' friend. The affair lasted for several years with Morris' knowledge until Rossetti began suffering from drug addiction and mental illness.

May herself had an unusual marital situation. She married Henry Halliday Sparling in 1890, but Bernard Shaw, one of her father's followers, was also in love with her; he came to live with the married couple for a time. She was divorced in 1898 and lived out her later years with a companion, Vivien Lobb.

Morris specialized in bead necklaces, but also designed other pieces of jewelry. A few examples are: a belt (girdle), c.1905 of silver, river pearls, garnets and chrysoprase; a heart-shaped pendant, c.1903. This pendant was designed after a Rossetti brooch worn as a pendant by his housekeeper, model, one-time mistress and former prostitute Fanny Cornforth in his painting "The Blue Bower." The pendant was made in 1865 of silver with applied rosettes, and is set with amazonite, a turquoise, pearls and lapis-lazuli. Both the original and May's version are in the Victoria and Albert Museum, London.

The painting "Rosa Triplex" by Rossetti shows three portraits of May wearing a number of different pieces of jewelry. It is believed that at least one necklace was probably made by her and the balance was probably either from Rossetti's extensive jewelry collection or May's own collection of ethnic jewelry.

Other pieces in the Victoria and Albert Museum which are believed to be by Morris include: several rings with cabochon stones, a pin in the style of Gaskin with agate, emeralds and pearls, and a pair of gold earrings with sapphires and pearls. Some of these pieces may have been owned by Rossetti and passed down to May through her mother and are not by her hand.

A tiara of pearls, opals and garnets designed and executed by May is in the collection of the National Museum of Wales as well as two necklaces, three rings

Necklace by May Morris. *National Museum of Wales, Cardiff*

and a pair of sleeve clasps. Morris' work was sold in the Fordham Gallery along with the work of John Paul Cooper and Edward Spencer. Although her father never travelled to the United States, May did, and lectured on embroidery and jewelry.

Leonard Moss

Moss was a silversmith in Omar Ramsden's workshop from 1928 to 1939.

L. Movio

A silversmith and jeweler who worked for Henry Wilson, Movio gave lessons to John Paul Cooper. Pieces signed by him are rare and command prices accordingly.

Mrs. Mura

Mrs.Mura was an amateur jeweler who exhibited with the Royal Amateur Art Society in 1904.

Henry (Harry) George Murphy (1884-1939)

Murphy went to work in 1898 at the age of 12 doing errands for Henry Wilson. Wilson encouraged his interest in jewelry and eventually he became an assistant and executed a number of Wilson's pieces. Although his own work was influenced by Wilson he developed his own style doing excellent enamel work.

In 1909 he began teaching at the Royal College of Art with Wilson and in 1912 he went to work for the well-known goldsmith Emil Lettre in Berlin. When he returned from Germany he opened his own workshop working on his own designs and executing some work designed by the sculptor Eric Gill and Arts and Crafts jewelry designer R.M.Y. Gleadowe. He continued to work after the Arts and Crafts period had peaked. Influenced by French styles and the Ballet Russe he designed Art Deco jewelry.

Murphy frequently signed his pieces and often enamelled the backs as well as the fronts. Murphy was principal of the Central School for the last two years of his life.

Ella Champion Naper (1886-1972)

Ella attended the Camberwell School of Arts and Crafts for two years where Fred Partridge was her instructor. In 1906 she opened a workshop with him in Branscombe, Devon where she remained until her marriage to Charles Naper. The couple then moved to Looe, near Lamorna, Cornwall to join an artists' colony.

Naper, like many others, designed for Liberty & Co. and exhibited at Arts and Crafts Exhibitions. She was influenced by Lalique as was Partridge, and often worked in horn, a favorite material of Lalique, producing beautiful hair combs. She also favored dark green enamels. The Lamorna pottery was founded and run by Naper.

Silver and turquoise ring by H.G. Murphy and a close up of his mark. *Courtesy of Tadema Gallery, London*

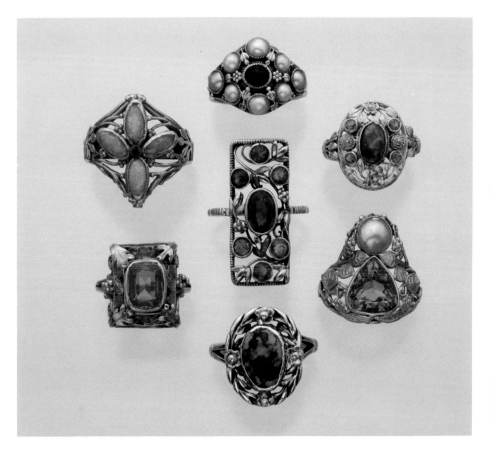

Arts and crafts rings. Starting at the top and moving clockwise: Edward Spencer, gold and sapphire and pearl, c. 1900; Henry Wilson, gold, opal and green garnet, c. 1900; Designer unknown, gold, pink tourmaline and pearl, c. 1910; Ella Naper, silver, gold and turquoise c. 1915; Henry Wilson, gold, pink sapphire and enamel, c. 1900; John Paul Cooper, gold and opal. Center: The Gaskins, silver, gold, garnet, C. 1910. *Courtesy of Tadema Gallery, London*

Claude Napier-Clavering

The managing director of the Birmingham Guild of Handicraft, Napier-Clavering designed most of the Guild's silver output. He had been a student at the Birmingham School of Art and joined the Guild about 1894 where he was influenced by fellow Guild member Arthur Dixon.

In 1897 Napier-Clavering married Millicent Kenrick. Her father invested in the Guild and became a member of the board of directors (the well-known Kenrick Casket, designed by Arthur Gaskin was made for him). At the Arts and Crafts Exhibition of 1896, gold jewelry designed by Napier-Clavering was exhibited by the Guild, but it was not executed by Guild members. None of this jewelry is known to exist today.

Harry Napper

Napper was a well-known watercolorist who became a designer for the Silver Studio. Although many belt buckles and cloak clasp designs for Liberty are inscribed "Rex Silver," some may have been designed by Napper who also designed textiles. When Arthur Silver, founder of *The Studio*, died in 1896, he became head of the design department for two years. He subsequently left to become a freelancer, but continued to design for the studio.

Mrs. Phillip Newman (Charlotte) (1840-1927)

Mrs. Newman was a goldsmith, jeweler and designer who was the assistant to the well-known jeweler John Brogden. They worked primarily in the Victorian archaeological revival style and when Brogden died in 1885 she opened her own workshop to do similar work. Some of her later pieces are closer to the Arts and Crafts style being done in a Celtic motif, although she is not really well known for this type of work. She worked from about 1870-1910.

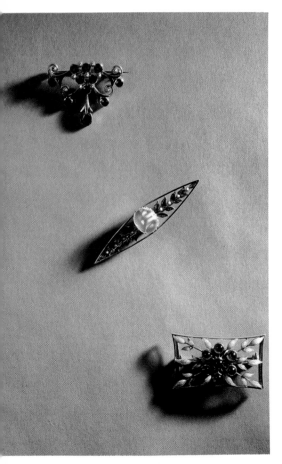

Three brooches by Mrs. Newman. Top: gold brooch with garnets and rose-cut diamonds; center: a gold brooch with a central moonstone surrounded by enamel leaves; bottom: a gold brooch set with cabochon amethysts in gold collets with white enamelled leaves. All signed "Mrs. N" in a rectangle, c. 1890. *Courtesy of Spink & Son, Ltd., London*

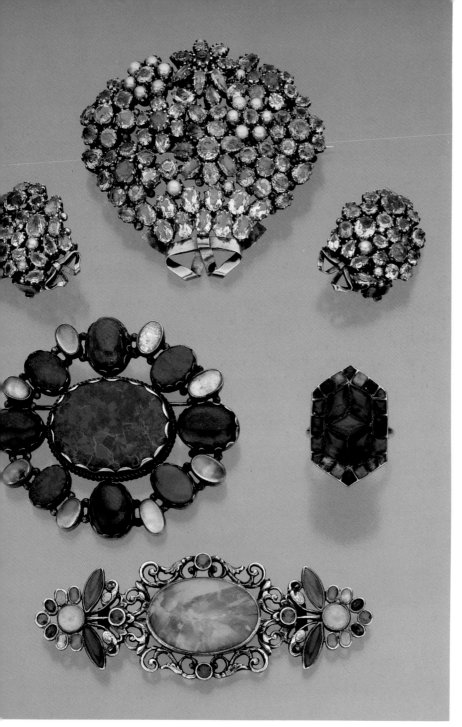

Jewelry by Dorrie Nossiter and Sibyl Dunlop which illustrates how the coloration of their jewelry has a similar effect while their styles are different. Top row: Brooch and earrings of silver, gold, aquamarine, pink tourmaline, peridot, citrine, brown zircon, and chyrsoberyl c. 1930 by Dorrie Nossiter. Note stones are faceted. Center row: Brooch of pink tourmaline, opal doublet and moonstone c. 1920 and ring of silver, chalcedony, amazonite and amethyst, c. 1930 both by Sibyl Dunlop. Bottom row: Brooch by Sibyl Dunlop of silver, opal, sapphire, citrine, amethyst and chrysoprase, c. 1928. Note the stones in the Dunlop pieces are cabochon cut. *Courtesy of Tadema Gallery, London*

Silver, moonstone, and chalcedony clip attributed to Dorrie Nossiter. *Courtesy of Leah Roland/Split Personality, Leonia. Photo by Gabrielle Becker*

Brooch of tourmaline and moonstones attributed to Dorrie Nossiter. *Courtesy of Leah Roland/Split Personality, Leonia. Photo by Gabrielle Becker*

Dorrie Nossiter

Nossiter worked in the 1930's but her jewelry is closer in style to Arts and Crafts than the Art Deco Jewelry being made at this time. Like Sibyl Dunlop, her designs are primarily dependent on a pattern of color from the gems which are set in claw settings. She used topazes, pearls, hematites, peridots, and amethysts frequently and made brooches, earrings, clips and sureté pins. Some controversy exists over whether some of the work she did has been mistakenly attributed to Sibyl Dunlop. It is said that Nossiter was a friend of Dunlop. Dorrie Nossiter worked out of her home. According to a catalog produced by Spink & Son, Ltd., she was a flamboyant figure with a love for champagne. After World War II, she moved to New Zealand.

Brooch and earrings once attributed to Dorrie Nossiter but now believed to be by Sibyl Dunlop, incorporating a variety of semi-precious stones. *Courtesy of John Jesse, London*

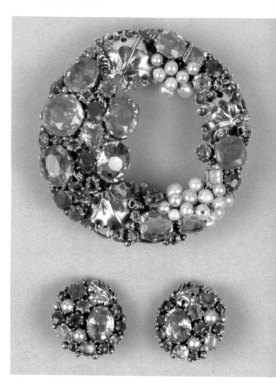

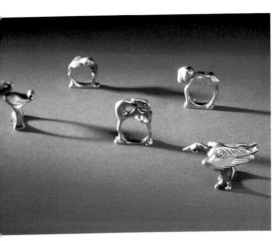

A group of silver animal rings by Sah and/or Mosheh Oved. A swan with gold beak, a silver-gilt dove, a camel, a lamb, and an eagle with a gold beak, c. 1940s. *Courtesy of Spink & Son, Ltd., London*

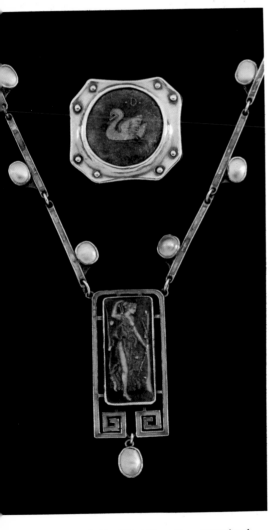

Necklace by Fred Partridge, silver, enamel and pearls, c. 1905. Brooch by Nelson and Edith Dawson of silver and enamel, c. 1905. Note the "G" mark on the enamel. *Courtesy of Tadema Gallery, London*

Sah and Mosheh Oved (1900-1983)

One of the "second generation" Arts and Crafts jewelers, Sah Oved worked under John Paul Cooper for a few years; then in 1924 she started her own workshop. She had studied art briefly in Chichester and took some evening jewelry-making classes.

In 1927 she went to work with Mosheh Oved, her common-law husband, in his shop "Cameo Corner." Oved was a Polish Jew, and although Sah was a Christian her work shows the influence of Jewish folklore, with some of her rings bearing a resemblance to antique Jewish wedding rings. She is also known for jewelry with animal designs made in the thirties and forties. A series of animal rings fashioned in silver have been attributed in some accounts to Sah and in others to Mosheh. In one account, Sah modelled the first ring out of wax while the two were in a bomb shelter during a blitz. By another account, Mosheh created a lamb ring from his own cuff links as a spontaneous act of sympathy for a client whose son was killed during the war. Both are touching stories. Sah used a variety of techniques and materials in her jewelry, which often had designs with allegorical or literary significance. She usually workd in 22 kt. gold, and many pieces are inscribed. One of her rings in the Cheltenham Art Gallery and Museum dates from 1930 and is cast, hammered and engraved silver gilt; work by her is also in the Victoria and Albert Museum.

Sah and Mosheh emigrated to Israel, and from 1934-47 they had a shop in Jerusalem selling antiques and Jewish plates. *The Book of Necklaces* was written by Sah in 1953. In 1965 she married Hugh Hughes, an architect.

Constance M. Paine

A casket set with white carnelian designed and executed by Paine was exhibited at the Exposition des Arts Decoratifs, Paris, 1914.

H. Parker

Parker was a brassworker who worked for the Birmingham Guild of Handicraft.

Frederick James Partridge (1877-1942) and May Partridge (?-1917)

Fred Partridge was a jeweler from Barnstaple who attended the local school of art there. He also studied for two years at the Birmingham School of Art.

In 1891 Partridge went to work at the Barnstaple Guild of Metalwork until 1900 when he joined the Guild of Handicraft at Chipping Camden. Although he was one of the best jewelers the Guild had, he left there after a stay of less than two years due to Ashbee's concern over some indiscretion Partridge had committed with a woman who worked for the Guild (prior to his marriage). Judging from the 1903 drawing by Willie Strang of Partridge, he was an extremely handsome man.[23] Partridge has been described as dressing in an "arty style" with shaggy hair, a flannel shirt and sandals. After leaving the Guild, he returned to the Barnstaple Guild and later taught at the Camberwell School of Arts and Crafts in London.

In 1906, the same year he married his wife, the enamellist May Hart, Partridge set up a studio in Branscombe, Devon with Ella Champion, one of his students. In 1910 Champion married and moved away and Partridge closed up the studio and moved it to Dean Street in Soho. Partridge designed for Liberty & Co. among others and showed a strong Art Nouveau influence in his jewelry. Like Lalique, he often worked in horn and made hair combs in the French style; had he not signed them, they might be mistaken as French in origin. His use of plique-à-jour enamel was notable for an Arts and Crafts jeweler.

Partridge was influenced by many sources including Anglo-Saxon and folk jewelry as well as contemporary works of his time. Jewelry by Partridge in the collection of the Victoria and Albert Museum includes an enamel and gold brooch he made for his daughter Joan's twenty-first birthday with the sign of Virgo engraved on the back, and a ring he designed for her as well. Another well-known piece made in 1905 is "The Mermaid"—a silver and enamel necklace with chrysoprase. He also made several tiaras for Liberty & Co. One lovely tiara with moonstones is still in the company's vault.

May Hart attended the Birmingham School of Art and taught at the Sir John Cass Technical Institute, London. She is known for her gem-like enamel jewelry and enamel plaques with figures of women. The Victoria and Albert Museum has a pendant by her which is silver with plique-à-jour intertwined birds set with a

cabochon amethyst. Like her husband she worked in plique-à-jour enamel which was unusual for an Arts and Crafts jeweler. The Partridges sometimes collaborated on jewelry and May did some enamelling work for C.R. Ashbee. Two pieces of jewelry by May were sold at Christie's in 1992: a white metal pendant with enamel depicting a ballerina, and an enamel brooch of a dancing maiden marked "Flame, 1911."

In 1917 May Partridge committed suicide by hanging herself in the "Thatched House," a weaving school run by Fred Partridge's sister Ethel Mary Mairet, a well-known weaver. It was Ethel who discovered May's body and from then on she could not bring herself to continue running the school. She moved to Ditchling, Sussex where her future second husband, Phillip Mairet, joined her after being released from the Army's stockade where he served time for not obeying orders. Ethel's first marriage to the Anglo-Sinhalese Ananda Coomaraswang, a self-styled anthropologist and writer on Indian religion and art, had ended by then. Ethel and Coomaraswang had been close friends of the Ashbees.

During World War I Partridge did munitions work; after the war and his wife's death he joined his sister in the artists' colony in Ditchling.

Fred Partridge also had another sister, Maud, who was an enamellist.

Maud Partridge

The sister of the talented Fred Partridge, Maud was also an enamellist. There may be some confusion with her work and May Partridge's but it is believed that she signed her work M Partridge, while May used her full name or her initials MHP. A circular enamel pendant with polychrome enamel decoration of an Egyptian in profile signed M. Partridge, was sold at Christie's in 1992.

Edith Gere Payne (1875-1959)

The half sister of Charles Gere, the painter and sometimes jewelry designer, Edith designed metalwork, gesso work, was a watercolorist and did gilding work. She was married to the painter Henry Payne in 1903. Both she and her husband along with her half-brother were part of the so-called "Birmingham Group", an informal circle of Birmingham artists and artisans including Arthur Gaskin who worked together on projects.

Alfred Pearce

A student at the Vittoria Street School, Pearce did metalwork and enamel in the Gothic style.

John Pearson

The chief designer for the Guild of Handicraft and one of the original founding members, Pearson is believed to have previously worked for the well-known potter William de Morgan. Many of his motifs were similar to de Morgan's— peacocks, galleons, and stylized flowers, animals and trees. Pearson also used the stag, a common Arts and Crafts motif. He seems to have learned copper work by studying pieces in the British Museum as his work is related to Renaissance metalwork.

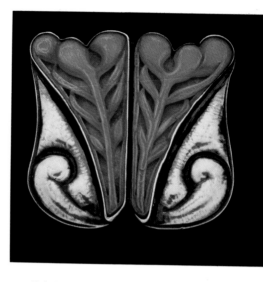

Belt buckle designed by Fred Partridge for Liberty & Co. Silver, carved horn and enamel c. 1905. *Courtesy of Tadema Gallery, London*

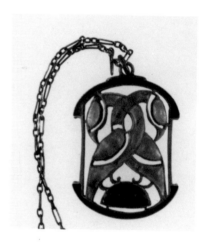

Pendant designed and made by May Partridge. Silver, plique-à-jour enamel and a cabochon amethyst. *Victoria and Albert Museum, London*

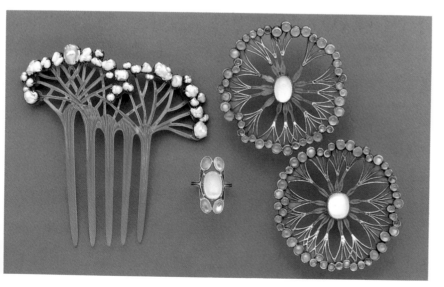

Hair adornments of horn by Fred Partridge consisting of a hair comb set with baroque pearls and two ornaments set with moonstones. Also a ring of white metal and enamel set with moonstones. All signed "Partridge." *Courtesy of Christie's, London*

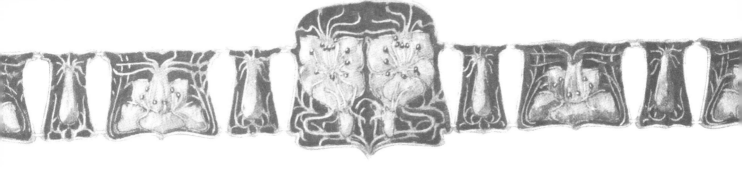

Belt in silver and enamel by Edith Pickett.

Hair pin by Edith Pickett.

Pearson was one of the few Guild members who joined as an already accomplished craftsman, and mostly did his own work unlike most of the Guild who executed others designs by other people (primarily Ashbee's). In 1892 Ashbee asked him to leave the Guild because he had been doing work outside the Guild. He was allowed to rejoin but before long then quit to go to Cornwall and join the Newlyn Industrial Class, founded by the painter John D. MacKenzie. The Class produced objects in copper and other inexpensive metals with repoussé. decoration, many designed by MacKenzie.

In 1892 Pearson opened his own shop. He is known for his large copper repoussé plates and beaten copper dishes he made for Liberty & Co.

Arthur Penny

A silversmith who worked for the Guild of Handicraft, Penny was known as a good modeler. Penny was deaf, and died while he was employed by the Guild.

Mrs. J.W. Peyton

Mrs. Peyton was an amateur jeweler who exhibited at the Royal Amateur Art Society Exhibition.

William Pick

Work by William Pick was featured in the *Art Worker's Quarterly* in 1907. A heart-shaped pendant of wire work set with turquoise and blister pearls made by him was auctioned at Christie's, London in 1992. In 1912 Pick co-founded the Dryad Metalworks, a firm that made architectural metalwork (see listing).

Edith Pickett

Pickett made silver jewelry with colored enamel surfaces. Her work includes belt buckles and clasps, brooches and hair pins and exhibits an Art Nouveau influence.

Charles Povey

Povey was a Birmingham craftsman who executed Cymric (silver) pieces for Liberty & Co.

R.J. Price

Price was a jeweler who had his work featured in *The Studio*. A brooch of cast white metal designed as an angel set with citrine was offered at Christie's, London in 1992.

Augustus Welby Northmore Pugin (1812-1852)

This well-known architect was responsible for the Gothic revival in architecture in England and for espousing principles upon which the Arts and Crafts movement was partially founded.

Pugin began designing silverware for the firm Bridge and Rundell when he was only 15. He also designed metalwork and jewelry in a Gothic style which was executed by John Hardman & Co. His jewelry was enamelled and set with semi-precious stones.

A staunch Catholic, Pugin designed ecclesiastical pieces as well as gold crosses with rubies and pearls to be worn as pendants. These were also executed by John Hardman. In the Victoria and Albert Museum are three pieces of a full parure—an enamelled necklace, pendant cross and brooch in the Gothic style—that Pugin designed for a woman he asked to be his third wife. She refused him and he gave the parure to the woman he actually married. The jewelry is c.1848 and was also made by Hardman.

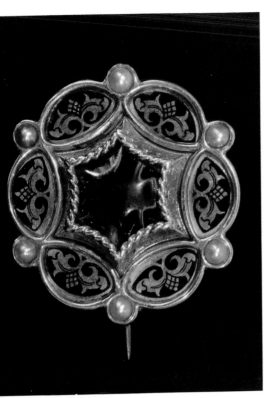

Gothic Revival brooch of gold, crystal, pearl, enamel c. 1880 by John Hardman & Co. A similar brooch is pictured in the book "Artist's Jewelry—Pre-Raphaelite to Arts and Crafts" by Charlotte Gere and Geoffrey Munn. *Courtesy of Tadema Gallery, London*

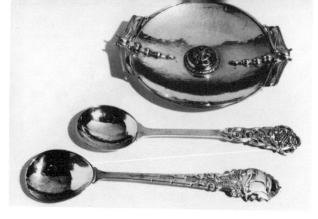

Top: Silver and enamel dish by Omar Ramsden. Hallmarked in London, 1937, OR, and engraved OMAR RAMSDEN ME FECIT. Middle: A silver spoon hallmarked 1923 RN (Upper) and CR (upper). Bottom: A silver spoon, hallmarked 1928, London, OR. *Cheltenham Museum and Art Galleries, England*

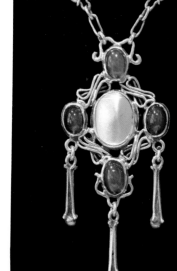

Silver chrysoprase and pearl pendant by Omar Ramsden, c. 1905. *Courtesy of Tadema Gallery, London*

Omar Ramsden (1873-1939)

Omar Ramsden began his career working for a silversmith in Sheffield and attending the Sheffield School of Art. At that school he became friendly with another student, Alwyn Carr, who was a year older and came from a well-to-do family.

In 1896, Ramsden and Carr both won scholarships and took summer courses at the Royal College of Art in London. After they completed their schooling and a trip to Europe, they formed a partnership to produce items of gold and silverware which lasted until 1919. Ramsden and Carr both designed, and Carr did some enamelling.

The pair produced good quality jewelry and tableware which sometimes borders on the Art Nouveau in design. Many of their pieces look almost too professional to be considered Arts and Crafts, in part because the two had industrial design backgrounds but also because lesser pieces were partially machine-made.

Silverwork by Ramsden and Carr includes: silver tea caddies, silver candlesticks, napkin rings, ceremonial pieces and wooden drinking bowls mounted in silver that are in the Medieval fashion and silver and enamel buckles. Both being Catholic, they often did work that was religious in nature, though they also did a number of important, large scale commissions.

Ramsden and Carr had many workers on their staff, and it is probable that both stopped executing metalwork for much of the time they were in business; it is likely that they also relinquished most of the design work to their staff as well. Carr served in World War I, returning to the business in 1918, but within a year the partnership was no longer working and Carr left. A relationship that Ramsden had developed with a Mr. and Mrs. Downes-Butcher was one of the causes of the partnership's dissolution. Ramsden continued to run the workshop through the 1930's. Carr worked on his own making silver and wrought iron pieces until the 1920's.

Ramdsen had a flair for the dramatic, often signing his pieces with the Latin "Me fecit Omar Ramsden" (I was made by Omar Ramsden). For example, a silver cup by Ramsden auctioned at Sotheby's in Scotland in 1992 was inscribed "I was wrought for David William Hope Jebb by Command of His Grandmother Marta Jebb, nee MacLeod 1938," while a pair of silver salvers (circa 1929) sold by Sotheby's in 1991 were engraved "I was wrought by Omar Ramsden by command of John William Coe in the year of our Lord MCMXXIX." A silver ship created by Omar Ramsden in 1922 for Mr. and Mrs. Henry Ford recently sold at Christie's, New York for an astounding $154,000! When sold in 1951 as part of Mrs. Ford's estate, it brought only $625.

Ramsden, who bicycled to work everyday, married Annie Emily Berriffe, the widow of Mr. Downes-Butcher, in 1927. A waist girdle (belt) with twenty-two heraldic shields designed by Ramsden is in the collection of the British Museum and is said to have been made for Annie. Peter Canon-Brooks in the 1973 Exhibition Catalogue of Omar Ramsden's work shown at the City Museum and Art Gallery of Birmingham described Mrs. Ramsden this way: "...Madame (as she was known to the workshop staff) was a formidable woman who would be seen striding down the streets of South Kensington clasping a tall cane and wearing a long silver chain decorated with scenes from *The Canterbury Tales*."[24]

Ramsden was a founder of the Art Worker's Guild and Chairman of the Church Crafts League.

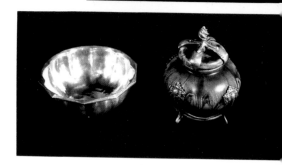

Small silver bowl by Omar Ramsden and Monaco pottery pot with silver mounts by Omar Ramsden and Alwyn Carr. *Courtesy of Leah Roland/Split Personality, Leonia. Photo by Diane Freer*

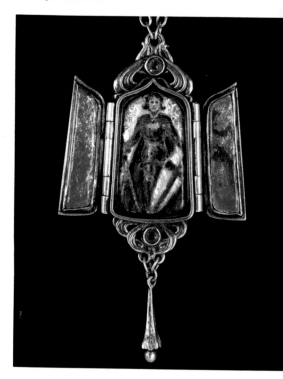

Omar Ramsden designed silver and enamel pendant. *Courtesy of John Jesse, London*

England ❦ 89

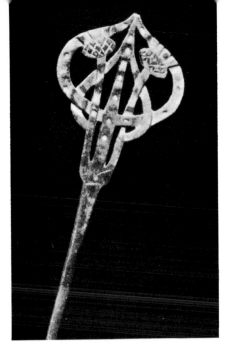

Silver hat pin designed by Arabella Rankin and executed by J.M. Talbot.

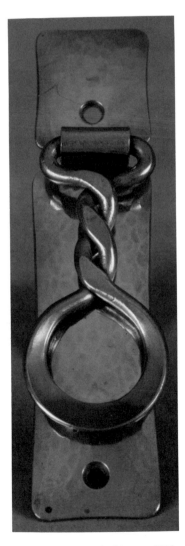

Brass doorplate by R.L. Rathbone, 1906. *Nordenfjelske Kunstindustrimuseum, Trondheim, Norway*

Arabella Rankin
Rankin was an Arts and Crafts jewelry designer who had her work executed by the jeweller J.M. Talbot of Edinburgh.

Richard Llewellyn Benson Rathbone (1864-1939)
A designer and metalworker, Rathbone was from an important Liverpool family, and a relative to other Arts and Crafts figures. His cousin Harold ran Del Robbia pottery and he was also related to the metalworker W.A.S. Benson. Although designing only a small quantity of jewelry, he wrote two books on the subject, *Simple Jewellery* and *Unit Jewellery*.

Rathbone's metalwork consisted of producing metal fittings for other designers and executing copper and brass utensils from designs by C.F.A. Voysey, A. H. Mackmurdo, Heywood Sumner and others. He worked in hammered copper and brass, plain, embossed or punched.

His first workshop was in Liverpool established in 1890 where he worked with Harold Stabler around 1900. In 1902 he moved to London but later had workshops in Wales and London making copper and brass objects. When Rathbone left Liverpool he sold portions of his business to Faulkner Bronze Co. (which later became Jesson, Birkett & Co.), including a special patination process he developed for copper and bronze and his trademark "St. Dunstan Raising a Bowl."

Rathbone attended Cambridge University and taught in the Applied Art division at Liverpool University School of Architecture and the Central School and served as director of the Art School of the Sir John Cass Technical Institute. After 1905 he began to move away from the Arts and Crafts style.[25]

John Sydney Reeve
A member of the Guild of Handicraft for a time, Reeve was already a veteran silversmith when he joined having been an art master in Bewdley, Worcestershire. He later taught silversmithing and metalwork at the Leicester School of Art and designed art metal for the Dryad Works.

Charles de Sousy Ricketts (1866-1931)
Born in Geneva, Ricketts' jewelry designs were not entirely of the Arts and Crafts style—they were a blend of Art Nouveau and a Neo-Renaissance style. He had been educated in France and came to England when he was 13. Most of the jewelry he designed was for friends and made around 1899-1900. He had many of these pieces crafted by Carlo and Arthur Giuliano, and some pieces were executed by May Morris. It is believed that H.G. Murphy may also have made some of his jewelry.

In 1896 Ricketts was co-founder of the Vale Press, but his primary interest was in theatre design. Ricketts designed jewelry made of brass, copper, gilded leather, colored beads and other materials for a production of "Attila" in 1907 which were executed by Gwendolen Bishop.

A number of pieces of his jewelry are in the Fitzwilliam Museum in Cambridge, England including the "Sabbatai" ring. It was designed in 1904 for Katherine Bradley, a poet and close friend of Ricketts, and is made of gold (or gold on copper) and decorated with the model of a Byzantine church surrounding a star sapphire. It has a small loose emerald inside and was once filled with ambergris, the purpose being to stimulate the senses of hearing and smelling.

Katherine sometimes wore it hung from a black cord and even wrote a sonnet about it "On Beholding a Ring Set With A Star Sapphire." There is also some evidence the ring was shown in 1906 to Frances Koehler, an American Arts and Crafts socialite jewelry designer from Chicago who often visited London and studied enamelling with Alexander Fisher.[26] The Ashmolean Museum in Cambridge, England also has some of his jewelry and Ricketts' albums with his designs are in the collection of the British Museum.

Florence M. Rimmington
A set of six silver coffee spoons by Rimmington set with amethysts were sold at Christie's, London in 1992. They were hallmarked 1907.

Fred Robinson
Robinson made jewelry in silver set with semi-precious stones, often bent wire open-work pendants.

C.A. Llewellyn Roberts
Roberts studied architecture and metalwork at the Birmingham School of Art.

He worked with the Bromsgrove Guild and then with Gittins Craftsman Ltd. as chief designer, a firm that later merged with the Birmingham Guild of Handicraft. Roberts is best known for having designed the cast brass elevator grilles for Selfridge's department store in London.

Dante Gabriel Rossetti (1828-82)

One of the original members of Pre-Raphaelite Brotherhood of painters, Rossetti was known for using women as allegories in his paintings. Rossetti was also a part of the William Morris circle and in fact had an affair with Morris' wife Janey after his own wife, the painter Elizabeth Siddell, committed suicide from an overdose of laudanum, a form of opium. Janey was frequently his model wearing jewelry he collected wherever he could find it. He designed two pieces of jewelry, both watch cases, but only one was actually made.

Gordon Russell

A metalworker, Russell made steel fireplace tools, among other utensils.

F.W. Salthouse

Salthouse worked for R.L.B. Rathbone in Liverpool and was an expert in executing Rathbone's special patination method for copper and bronze. In 1902 he went to work for Faulkner Bronze Co. of Birmingham, which had purchased Rathbone's metalworking business. Around 1905-06 A.E. Jones purchased rights to the patination process and Salthouse went to work for him.

A. Schonwerk

Schonwerk was a trade jeweler who set stones for the Guild of Handicraft.

Robert Weir Schultz (1860-1957)

An architect known for being part of the Byzantine Revival movement, Schultz also designed metalwork including lamps. He knew Ernest Gimson who executed some of his designs.

Bill Schurr

Schurr was a jeweler with the Guild of Handicraft.

Alice Scott

Scott designed jewelry and silverwork in the Arts and Crafts style, and was a student at the Bradford School of Art. Her work was featured a number of times in *The Studio.* In 1910 a silver-mounted sugar basin set with stones appeared; in 1913 a silver pendant set with pearls; and in another issue a pendant and chain, along with a bookbinding.

John Dando Sedding (J.D.) (1838-1891)

An architect who was also a fine designer of metalwork, wallpaper and embroidery, Sedding's work was done primarily before the Arts and Crafts movement began. He is an important figure nonetheless, because Henry Wilson and John Paul Cooper both worked in his architectural office.

After practicing architecture only a few years, he turned to decorative arts design for several years, before going into partnership with his brother Edmond, also an architect. He designed objects such as a chalice of silver gilt set with cabochon garnets, opals and pearls, which was featured in a 1986 exhibit at Fischer Fine Arts, London.

After his brother's death he moved first to Bristol and then to London where he met John Ruskin and was influenced by his belief of nature in design.

Wilson, his chief assistant in his architectural firm took over when Sedding died in 1891. He had been working on a large commission at the time of his death—the Holy Trinity Church. Designers and craftsmen he hired to work on the church included Edward Burne-Jones, William Morris, and Nelson Dawson.

George Elton Sedding (1882-1915)

George Sedding was J. D. Sedding's son. In an ironic twist, he was apprenticed to Henry Wilson who had been his father's apprentice. In 1907 he opened his own workshop, where he made jewelry of silver and copper with semi-precious stones which showed Wilson's influence. His work became more elaborate later in his career, and like Wilson he executed ecclesiastical commissions.

Hugh Seebohm

Two pieces of jewelry made by the Guild of Handicraft may have been designed by Seebohm. In Margaret Flower's book *Victorian Jewellery* she credits him with that distinction. One piece is a necklace of moonstones, black and white enamel, gold and silver with the enamel signed by William Mack.[27] The other is a silver chain set with moonstones, both c. 1896. Seebohm was a wealthy friend of C.R.

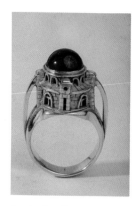

Ring believed to be by Charles Ricketts which bears a striking resemblance to the "Sabbatai" ring. Gold and amethyst, c. 1905. *Courtesy of Tadema Gallery, London*

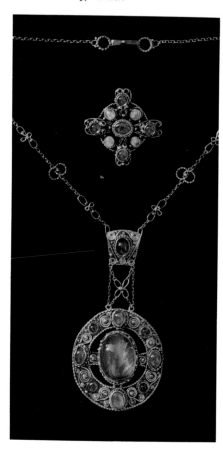

Alice Scott necklace and brooch with pink tourmaline and amethyst, c. 1910. *Courtesy of Tadema Gallery, London*

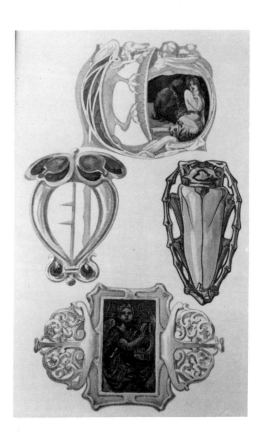

Four buckles that appeared in *The Studio*. The top by John Thirtle; middle row, left: Gertrude M. Siddall; right, Emile Icguy; bottom: Thomas Corson. *Courtesy of Leah Roland/Split Personality, Leonia. Photo by Diane Freer.*

Ashbee's and a supporter of the Guild. When the Guild fell into financial troub in 1905 Seebohm was called in for advice, along with the Guild directors.

Cyril James Shiner (1908—?)

A silversmith and instructor at the Vittoria Street School, Shiner studied und Bernard Cuzner. He had his own workshop where he made large presentatio pieces and later did freelance design work in an Art Deco style for Wakely an Wheeler.

Gertrude M. Siddall

Jewelry by Siddall was shown in *The Studio*.

Arthur Silver (1853-1896)

Founder of the Silver Studio, Arthur was friendly with Christopher Dresse and C.F.A. Voysey. The studio designed metalwork, wallpapers, textiles, carpet and linoleum for Liberty and Co. The Silver Studio remained open until 196 Many of its designs were influenced by WIlliam Morris. There is also som speculation that Archibald Knox may have worked there for a time.

Reginald (Rex) Silver (1879-1955)

Silver took over the Silver Studio when his father died, interrupting his trainin as a painter to do so. His company supplied silver and pewter designs to Libert & Co.

Edgar Simpson

A jeweler from Nottingham, Simpson worked between 1896-1910 in a simpl style, somewhat similar to C.R. Ashbee. His work, some of which was exhibite in 1902 at the Vienna Secession exhibit, often took the form of curved wirewor (whiplash) pendants with enamel. Other pieces by Simpson include: silver cloa clasps, gold pendants set with opal and amethysts, silver pendants, brooches buttons with enamel, and a pendant with an opal in matrix. Dolphins and othe marine animals were familiar motifs in his work.

Simpson designed for Charles Horner and other firms. He designed som pieces in the Glasgow style which were exhibited in Vienna. Charles Renni Mackintosh had recommended him to Josef Hoffmann of the Wiener Werkstätt when Mackintosh was unable to fill a request himself.

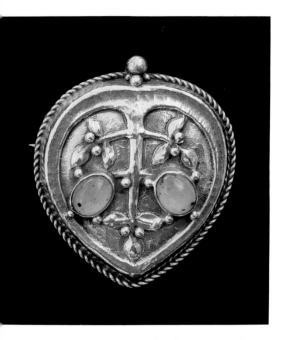

Silver and bowenite brooch with repoussé work by Edgar Simpson. Stamped E. S., c. 1903. *Courtesy of Tadema Gallery, London*

Necklace and pendant by Edgar Simpson. Silver, enamel and chrysoprase, c. 1900. *Courtesy of Tadema Gallery, London*

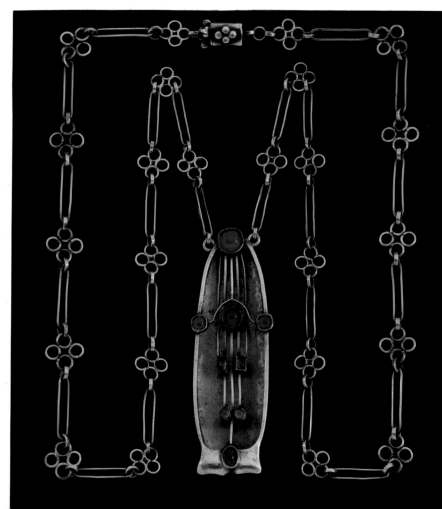

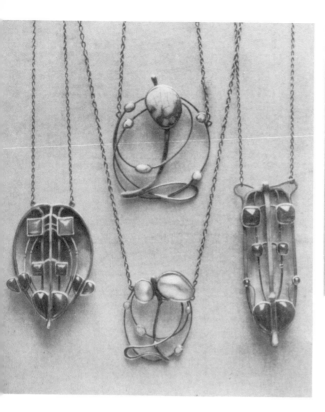

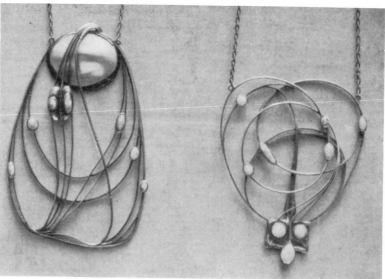

Pendants by Edgar Simpson, c. 1900.

Belt buckle by Edgar Simpson. Silver, enamel and pearls, c. 1902. It is similar to several designs by C.R. Ashbee. *Cheltenham Art Gallery and Museums, England*

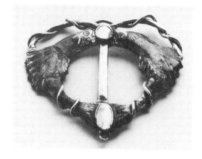

M. Lillian Simpson

In 1894, Simpson won an award for designing silver-plated copper book mounts in a national competition of art schools.

Gertrude Smith

Smith designed jewelry, including a silver and enamel waist buckle "Echo and Narcissus" in 1900.

Edward Napier Hitchcock Spencer (1872-1938)

A protegé of Nelson Dawson, Spencer was a metalworker and designer. When Dawson founded the Artificer's Guild in 1901 he became a junior designer and was elevated to chief designer when the Guild was sold to Montague Fordham two years later.

After the Guild was sold it was moved to the Fordham Gallery. There, John Paul Cooper was an important exhibitor and his work had a profound influence on Spencer's work. Like Cooper he worked with unusual materials—shagreen, ostrich egg, gourds, mother-of-pearl, wood and ivory. He produced simple iron and copper hand wrought items also from Cooper's example. Spencer's work was to some extent based on that of Charles Robert Ashbee. His metalwork included items such as a silver claret jug set with stones (1905), candlesticks, sconces, andirons, a wrought iron table with a brass tray, a silver casket with enamels, an ivory and silver box, a tea caddy and spoon in copper and silver, a silver flagon set with rubies and moonstones and as well as many others. He also worked in copper and bronze, sometimes mounted with silver.

A copper cup with gilt interior, a hexagonal foot, applied floral enamels, silver bellflowers and silver pine cones along the rim is attributed to Spencer in *Reflection: Arts and Crafts Metalwork in England and the United States,*[28] dating the piece around 1905.

Book mounts by M. Lilian Simpson c. 1894. The book won Simpson a gold medal. The book is of blank paper and has been used as a sketchbook. *Cheltenham Art Gallery and Museums, England*

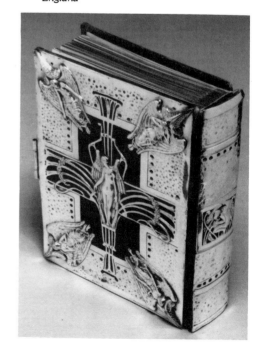

Spencer designed jewelry for the Artificer's Guild, some of which was reminiscent of May Morris' jewelry—various colored stones on chains. One of his most famous pieces is the "Ariadne Necklace" with silver and diamond leaves, links of ships and blue enamel work now in the collection of the Birmingham Museum and Art Gallery designed with John Houghton Bonner. Another, the "Tree of Life" necklace also shows his tendency to work in allegorical subjects. It depicts a Phoenix rising from opal flames. The Tree is of gold, silver, diamonds and opals. In the 1914 *Studio Yearbook* Spencer was described as a "clever and versatile artist."

Spencer, in the true spirit of the Art and Crafts movement benefiting all men, employed orphaned boys as apprentices.

Silver necklace with opals, blister pearls by Edward Spencer. *Courtesy of Leah Roland/ Split Personality, Leonia. Photo by Gabrielle Becker.*

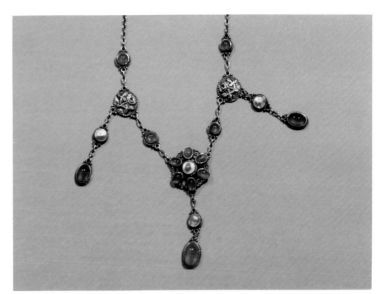

Pendant by Edward Spencer for the Artificer's Guild in suffragette colors. Silver, pearls, moonstone over white enamel, emeralds and amethysts. *Courtesy of Leah Roland/Split Personality. Photo by Diane Freer.*

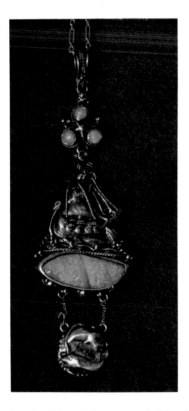

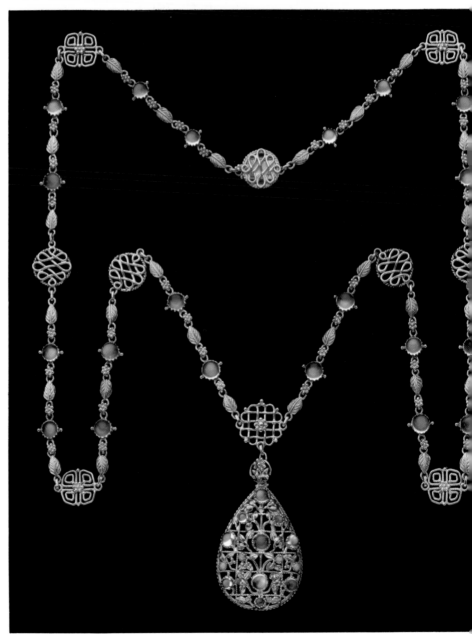

Pendant by Edward Spencer and John H. Bonner. Silver, gold, opal and enamel, c. 1905. *Courtesy of Tadema Gallery, London*

Gold and moonstone necklace by Edward Spencer for the Artificer's Guild, c. 1905. *Courtesy of Tadema Gallery, London*

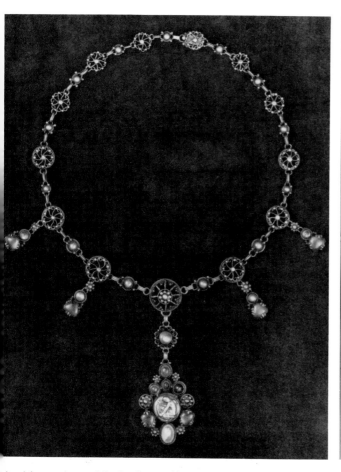

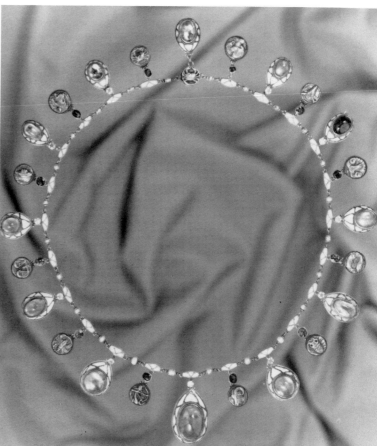

An elaborate Arts and Crafts silver necklace set with aquamarines, moonstones, rubies and opal and emerald designed by Edward Spencer and John Houghton Bonnor for the Artificer's Guild c. 1900. Set with a central gold disc representing a star sign. *Courtesy of Didier Antiques, London*

The "Zodiac Necklace" by Edward Spencer and John Houghton Bonnor for the Artificer's Guild c. 1900. A specially commissioned piece set with twelve star sapphires and twelve faceted sapphires, white enamel on silver. *Courtesy of Didier Antiques, London*

Walter Spencer

Spencer was a blacksmith who did work for the firm Dawson & Spencer.

Harold (1872-1945) and Phoebe McLeish Stabler (?-1955)

In addition to being an accomplished silversmith and enamellist, Harold Stabler was also an artist and a potter. From Westmoreland, he attended the Kendal school of Art, where he studied woodwork and stone carving. He spent a year as the head of the Keswick School of Industrial Art and then moved on to the Liverpool University Art School where he worked with R. Llewellyn Rathbone in 1899. They both left to go to the John Cass Technical Institute six or seven years later, with Stabler following Rathbone as the head of the school.

Stabler was a founder of the Carter, Stabler, Adams pottery which produced designs he and his wife created, and he was a founding member in 1915 of the Design and Industries Association (DIA).

Phoebe McLeish Stabler, his wife, studied with the Scottish designer Herbert McNair while he was teaching in Liverpool. Together Harold and Phoebe designed cloisonné work. Some pieces were designed by Phoebe and executed by Harold, but they were also aided in the executing by a Japanese craftsman named Kato. Their pieces were done in opaque colors and were very large; although they were made as jewelry they often could not really be worn (though some later pieces in the Art Deco style were mounted as pendants). They also designed ceramic figures and plaques.

Silver teapot designed and executed by Harold Stabler, 1913, from *The Studio*,

The multi-talented Harold Stabler designed and executed his own silverwork as well as designing for the firms of Wakely & Wheeler and the Goldsmith's and Silvermith's Company, London and Adie Brothers of Birmingham. He is also known for having designed a cast iron panel for the Hyde Park Corner underground station in London.

Chest by H. Hughes Stanton as illustrated in *The Studio. Courtesy of Leah Roland/Split Personality, Leonia. Photo by Diane Freer.*

Gas, oil and electric pendant lighting devices designed by Annie G. Stubbs, executed by Jesson, Birkett and Co., Ltd., 1908, from *The Studio.*

Two other Arts & Crafts jewelers are believed to have been Phoebe's sisters—Minnie and Annie MacLeish. Several pieces of jewelry in the collection of the Victoria and Albert Museum were donated in memory of the Stablers by Miss M. McLeish.

Edith F. Stewart

A white metal haircomb with plique-à-jour enamel by Stewart was offered at Christie's, London in 1992. Her work was also shown in *The Studio* in 1914.

H. Hughes Stanton

A chest with metal strap work and painted panels of a religious nature by Hughes appeared in *The Studio.*

Annie Grisdale Stubbs (1889-1975)

A student at the Birmingham School of Art, Annie Stubbs exhibited her propensity for success early on by winning a medal for a carved ivory casket with silver mountings.

After school, she designed light fittings for a Birmingham firm of which Thomas A. Birkett, a member of the Birmingham Guild of Handicraft, was a director and they eventually married. Together they produced light fittings and fire screens with repoussé ornament and bought part of R.L.B. Rathbone's metalworking business when he left Liverpool, also acquiring his trade mark of "St. Dunstan."

The firm became known in 1904 as Jesson Birkett & Co. and Stubbs did the bulk of the designing. Although difficult to puzzle out today, at some point A.E. Jones acquired partial use of the St. Dunstan's trademark and Rathbone's special coloring method for patination of copper and bronze. Jones used some of Stubbs' designs as well, and some of his pieces carry the Jesson Birkett name.

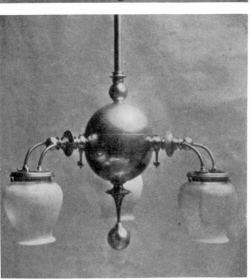

F.L. Temple

Temple was a student at the Vittoria Street School in Birmingham and worked for A. E. Jones.

John Thirtle

John Thirtle designed jewelry that appeared in *The Studio.*

Charles Thomas (1833—?)

A silversmith who taught at the Vittoria Street School, Thomas also had his own studio. His work often included large presentation pieces.

William Thornton

Thornton was a blacksmith with the Guild of Handicraft. He and Charles Downer continued to run a blacksmithing shop in Chipping Camden when the Guild of Handicraft shut down.

James Tissot

A painter by profession, Tissot also designed cloisonné pieces which were critically acclaimed. Twenty of these were exhibited at an exhibition at the Dudley Gallery in London in 1882.

A. Toy

Toy was a jeweler who worked with the Guild of Handicraft.

Arthur Tuckey

The Guild of Handicraft shop in London was run by Tuckey and there is some evidence he may also have designed some silver items for the Guild.

A.E. Ulyett

Ulyett was an assistant in the workshop of Omar Ramsden and Alwyn Carr. He was the senior chaser in the shop as well as a modeller. Between World War I and World War II after Carr's departure he managed the workshop as well, but focused on high quality repoussé work and the modelling of elaborate finials.

R. Underhill

An independent craftsman who worked in wrought iron, Underhill did work for the Guild of Handicraft.

Charles Fleetwood Varley

A craftsman with the Guild of Handicraft, Varley was a quality enameller who specialized in pictorial enamel landscapes often set in early evening for both jewelry and household items. For example, a beaten copper, enamel and boxwood lined cigar box, exhibited at the Nicholas Harris Gallery in 1984 was signed as being Guild of Handicraft designed and executed by Varley. After the Guild's demise he did work for Liberty & Co. His enamels were used for box decorations for the Tudric line and occasionally in jewelry.

Enamel and silver brooch by David Veasey.

Liberty & Co. box with enamel signed by Charles Fleetwood Varley and a Liberty silver wirework brooch with enamel attributed to Varley. *Courtesy of Van Den Bosch, Georgian Village, London*

David Veasey

A jeweler, Veasey's work shows Art Nouveau influence. His pieces included brooches, clasps, hair combs, and hair pins of silver and enamel. In 1899, Veasey working under the pseudonym "Tramp," designed a silver tea caddy that won a competition in *The Studio*. It is known that at least this design, and possibly others, was produced by Liberty & Co. A white metal brooch set with opals by Veasey was sold at Christie's, London in 1992.

S. Viner

Viner was a jeweler with the Guild of Handicraft.

Hubert Von Herkomer (1840-1914)

Von Herkomer was a painter who became interested in enamel work in the 1890's and studied the techniques of Limoges enamellists. He set out to stretch the limitations of the art which he did in many of his plaques set with semi-precious stones. In 1897 he made a badge of enamel for the Royal Society of Watercolorists and the same year he executed a very large enamelling project known as the Herkomer shield or "The Triumph of the Hour," which depicted a Celtic shield. Only four panels remain from this piece (there were originally twelve) which were exhibited at the Nicholas Harris Gallery in London in 1984. The shield when intact was approximately 5½′ x 3½′ and was first exhibited at the Royal Academy in 1899.

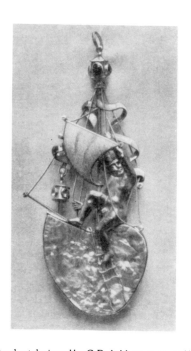

Pendant designed by C.R. Ashbee, executed by E. Viner for the Guild of Handicraft, and shown at the Arts and Crafts Exhibition in London , 1903.

Von Herkomer may have learned enamelling from Constance Blount—her husband Godfrey attended an art school with Von Herkomer. He was knighted in 1907.

Charles Frances Annesley Vosey (1857-1941)

Although primarily known as an architect, designer of fabrics and Arts and Crafts carpets, Vosey also designed metalwork—handles, keys, bolts, hooks, letterboxes, a beaten brass inkstand, fireplace tools, toast racks, jugs, cruet sets and table silver among other objects. He is also known to have made some jewelry designs. It has been suggested that Voysey's work influenced Charles Rennie Mackintosh, the important Scottish designer and architect.

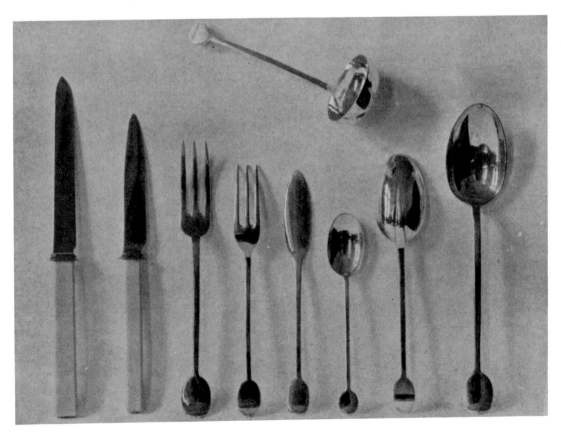

Toast rack, jug, cruet and table silver designed
by C.F.A. Voysey, 1908, from *The Studio*

Lamps and door hardware designed by C.F.A.
Voysey and executed by W. Bainbridge
Reynolds, Ltd., 1908, from *The Studio*

Designs for metalwork by John Wadsworth. *Courtesy of Phillips, London*

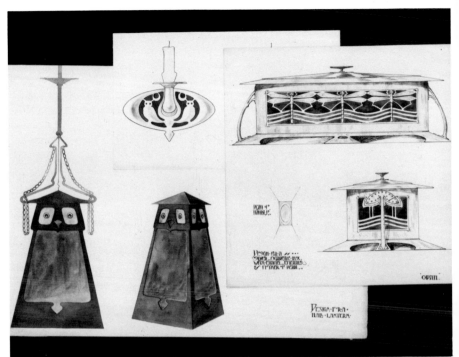

Necklace design attributed to Effie Ward. Silver and enamel moonstone necklace, c. 1900. *Courtesy of Tadema Gallery, London*

Henry Wilson stag brooch of rock crystal and jade. *Courtesy of John Jesse, London*

John William Wadsworth (1879-1955)

Wadsworth was the art director of the Minton porcelain factory for most of his adult life, as well as a watercolorist. A friend of W. R. Lethaby, he studied in France where he was exposed to Art Nouveau. As a student he was interested in metalwork and a number of his metalwork designs are extant. For a time he worked in an ornamental metal foundry before joining Minton in 1900. [29]

Colbran Joseph Wainwright (1867-1948)

Wainwright was a jeweler and silversmith who worked for his father's firm primarily making jewelry in the archaeological style but also producing some work in the Arts and Crafts style. He was a believer in William Morris' teachings and bought shares in the Birmingham Guild of Handicraft which he held for over twenty years.

Effie Ward

A neighbor of the Gaskins in Acocks Green, Ward was a one of Arthur's best students and an excellent enameller. She may have helped him enamel the Galahad Cup with a frieze of champlevé enamel in 1902.

Ward has been given credit for having done the enamelling for some jewelry and mirror cases for the Gaskins in the Arts and Crafts Exhibition Society's Catalog for 1903, and one example does have her initials on it. She also worked with Arthur Gaskin to make enamels for a private chapel and she made jewelry on her own as well.

Phillip Webb (1831-1915)

This well-known architect met William Morris at the offices of G.E. Street where he was an apprentice and Morris a student for a few months. He designed Morris' home, "The Red House," and a home for the Hon. Percy Wyndham. Wyndham was a patron of Arts and Crafts designers including the enamellist Alexander Fisher who taught Mrs. Wyndam to do enamel work. Webb also designed furniture for Morris & Co. and metalwork including copper candlesticks. Webb designed a cross pendant that was executed by Robert Catterson Smith.

J. Webster

Webster was the first silversmith to join the Birmingham Guild of Handicraft.

Louis Weingartner

Joseph Hodel's Swiss-born partner, this modeler joined the Bromsgrove Guild in 1903 with Hodel. Weingartner made castings for small items for the Guild.

W.A. White

A jeweler and silversmith with the Guild of Handicraft (he joined in 1890 and remained for six years), White had no previous experience before attending metalworking classes at the School of Handicraft. Prior to this time he had been working in a bookshop.

Although most designs executed by the Guild of Handicraft are attributed to Ashbee, some were done by White. A few pieces in the Arts and Crafts Exhibition catalogs of 1893-96 are attributed specifically to him.

White became a foreman at the Guild, but did not get along well with the men who worked for him—they nicknamed him the "The Whale" and "The Old Man."[30]

Norman Wilkinson

A student at the Vittoria Street School, Wilkinson worked in enamel and metalwork in a Gothic style.

A.E. Williams

Williams was a metalworker with the Birmingham Guild of Handicraft.

John Williams

Williams was one of the two original metalworkers with the Guild of Handicraft when it was founded, and taught metalworking classes as well as clay modelling, wood carving and plaster casting. He left the Guild in 1892 and later was involved in several other craft groups including classes at Newton, Cambridgeshire and Fivemiletown, County Tyron, Ireland.

Henry Wilson (1864-1934)

Henry Wilson was a trained architect who became the chief assistant to the architect J. D. Sedding. After Sedding's death in 1881 Wilson continued his practice, but about the same time he became interested in metalwork. Eventually metalwork became the vocation he gave most of his time, particularly after he set up his own workshop in 1885. For a short time he was in partnership with the enameller, Alexander Fisher, and later he worked alone. His architectural background is quite evident in the fine structuring of his jewelry and metalwork.

One of his assistants from Sedding's office, John Paul Cooper, studied jewelry at his studio, and his jewelry and metalwork was greatly influenced by Wilson's work. Cooper was to become an important Arts and Crafts jeweler in his own right.

Author of the book, *Silverwork and Jewellery* in 1903, Wilson also taught at the Central School in London and at the Royal College of Arts. In 1914 and 1925 Wilson was responsible for selecting British jewelry to go to the Paris Exhibitions.

Wilson's jewelry was of the Arts and Crafts style, being very Medieval in influence and most of the silverwork he did was ecclesiastical—such as a chalice in silver, ivory and enamel in 1898. Wilson made a number of religiously-oriented pieces of jewelry including a silver cross c. 1890 and a shrine ring which opens to show an enamelled panel of the Madonna and Child. The Victoria and Albert Museum owns a Wilson pendant/brooch with embossed relief of Christ on the cross in the form of a tree as well as non-religious pieces including a winged tiara of crystal, chalcedony, gold and enamel mounted with a silver figure of Cupid in a shell. He worked in both gold and silver, and sometimes in pewter. In addition to Medieval and religious themes he used stylized nature motifs such as roses, figs, pomegranates, stags and human figures and Oriental and Celtic influences can be seen in his work as well.

Wilson did stray from Arts and Crafts ideals in two ways—he made gemstones to fit his designs, rather than the reverse, and he used trained jewelers to manufacture his jewelry. His pieces were finished with great care and the backs are as beautiful as the fronts in the true Renaissance tradition. He even went as far as to conceal joints with a small gold discs or several tiny balls of gold. Wilson had a number of craftsman working for him who included: John Innocent, his foreman; Luigi Movio, a silversmith and jeweler; Lorenzo Colarossi, a silversmith; Felice Signorelli, and a goldsmith with the last name of Cowell.

Although known primarily for his jewelry, Wilson designed the bronze doors of the Anglican Cathedral of St. John the Divine in New York City and the doors for the Salada Tea Company in Boston. After World War I Wilson made architectural sculpture and from 1922 on he lived in France.

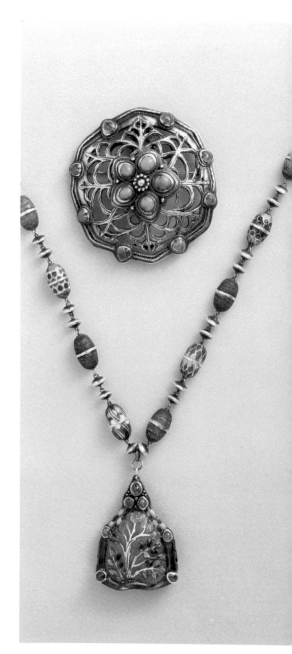

An enamel and gemset pendant suspended from a baluster link necklace, the links alternately bound with wirework or enamelled in blue, red, green and white. The hinged doors to the pendant are decorated on either side with a branching tree with flame-coloured flowers bound by translucent green enamel borders set with cabochon gems, the interior enamelled in green, c. 1900 and a brooch, both by Henry Wilson. *Courtesy of Christie's, London*

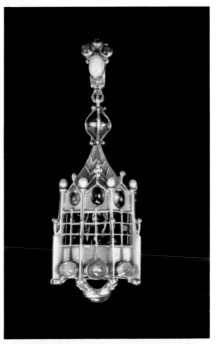

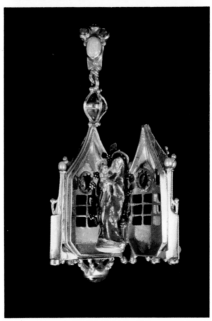

Two views of a pendant by Henry Wilson, with the "doors" opened and closed. *Courtesy of the Fine Art Society, London*

A group of jewelry by Henry Wilson with the exception of the brooch in the lower left corner believed to be by either Henry Wilson or Henry George Murphy. Top starting from the left: yellow metal ring with the figure of Pan kneeling on a pearl; a yellow metal brooch with openwork rose sprays and a child's profile in the medallion, the heart-shaped drop is set with an emerald; a yellow metal and sapphire ring with a rose spray and forget-me-not flowerheads. Bottom left: a yellow metal, enamel and rock crystal brooch set with opals and a cabochon garnet. Bottom right: a white metal brooch with turquoise enamel central flowerhead. *Courtesy of Christie's, London*

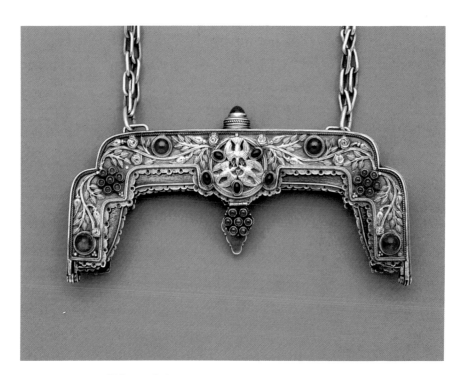

Yellow and white metal evening bag frame done in the Henry Wilson workshop. Decorated with an eagle, doves, serpents, vines and roses and set with garnets, lapis lazuli, amethysts and moonstones. *Courtesy of Christie's, London*

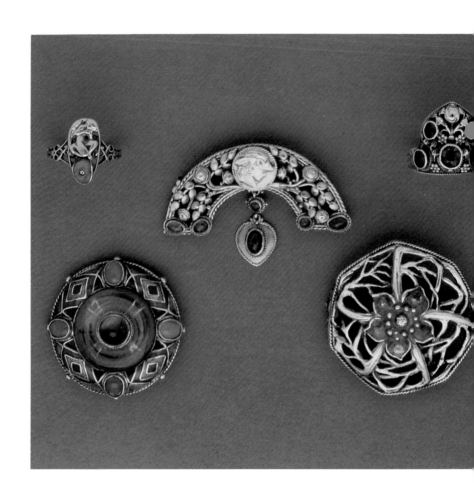

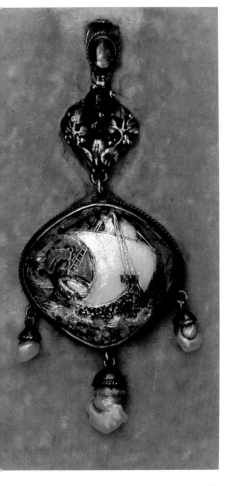

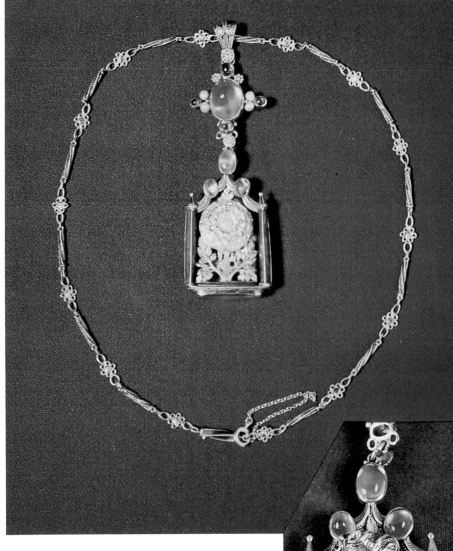

Galleon brooch in silver, gold, enamel and pearl c. 1900, probably by Henry Wilson. *Courtesy of Tadema Gallery, London*

Mary Wintour
Wintour made enamel jewelry in the Arts and Crafts style.

Sydney Wiseman
A craftsman who executed jewelry for Henry Wilson, Wiseman was married to the nurse of Henry Wilson's children.

Joseph Wray
A Birmingham jeweler, Wray made some items in the Arts and Crafts style.

Ernest Wright
A graduate of the Central School, Wright became the chief engraver in Omar Ramsden's workshop in the later years. He taught engraving to Leslie Durbin, who also worked there for a time; after World War II the two men became partners.

Madeline Wyndam (Mrs. Percy)
Mrs. Wyndam studied under Alexander Fisher and was an amateur enamellist (and embroiderer). She was a member of "The Souls," an artistic and religious "clique" within the aristocracy. Those within this coterie primarily assuaged their artistic urges by becoming patrons of the arts rather than artists themselves. Mrs. Wyndam was a founder of the Royal School of Needlework and had her home decorated by Morris and Co. as a result of her friendship with Edward Burne-Jones.

Front and back of pendant and necklace of gold, enamel, opals and pearls by Henry Wilson c. 1910. The detail on the back of the pendant is very characteristic of Wilson's work. A piece similar to this was made by Wilson for David Strachan, the stained glass artist. The pendant has probably lost a swivelling joint in the center. The necklace and pendant are in the collection of the Cheltenham Art Gallery and Museums in a green leather case with a label that reads: THE ARTIFICER'S GUILD LTD, 9, MADDOX ST. LONDON W HENRY WILSON. *Cheltenham Art Gallery and Museums, England*

To call the following manufacturing retail jewelers and metalwork firms makers of Arts and Crafts objects is not entirely correct—by definition Arts and Crafts jewelry and metalwork is handmade and more often than not was one-of-a-kind. However, the jewelry and metalwork made by these firms was clearly based on Arts and Crafts designs and motifs and actually succeeded where the true Arts and Crafts designers did not—bringing affordable jewelry and domestic items in the "new" style to a wider section of the public.

Child and Child

This prestigious jeweler primarily sold traditional Victorian jewelry and later Edwardian jewelry in their retail store in London. Owned by Walter and Harold Child from 1891-1915 they counted Queen Victoria and her son and daughter-in-law, the future King Edward and Queen Alexandra, among their customers. The Pre-Raphaelite painters William Holoman Hunt and Edward Burne-Jones were also customers and the firm executed a number of pieces Burne-Jones designed.

Child and Child's "Arts and Crafts" style pieces were mainly silver with guilloché enamel—they did especially nice buckles. They are known for their "wings" motif which appears in many different types of jewelry such as brooches and hat pins, and pendants—also for the use of peacocks.

The design of this silver, enamel and pearl brooch is attributed to Henry Wilson, c. 1900. It is similar to a pendant in Wilson's book *Silverwork and Jewellery. Courtesy of Tadema Gallery, London*

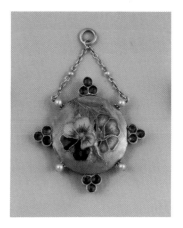

Child and Child Arts and Crafts circular amethyst, pearl and enamelled gold pendant painted in translucent colors with two pansies on a mauve ground and three stone clusters with pearls and amethyst. The reverse is engraved "Hugh Grosvenor, 8th Oct., 1869-6th August, 1900". The interior of the hinged back with dedicatory verse and glazed memorial compartment, Pearl-set suspension chain, c. 1900. Hugh Grosvenor was a diplomat and the son of the 2nd Baron Ebury. *Courtesy of Christie's, London*

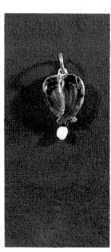

Magnificent casket made by Henry Wilson for Nevil Chamberlain in 1903. Several Arts and Crafts motifs can be found in this piece—the architectonic which is quintessential Wilson and sailing ships. *Published by permission of the Birmingham Museum and Art Gallery, England*

Two pieces of jewelry by Child and Child. The blue enamel winged pendant opens to reveal a locket. The brooch is of blue guilloché enamel with a shamrock in enamel and a crown with small jewels atop in its original box, it was probably a royal presentation piece. Both pieces are signed. *Courtesy of Leah Roland/Split Personality, Leonia. Photo by Diane Freer.*

Collins and Co.

A Birmingham firm, Collins & Co. manufactured some jewelry. A 1908 white metal pendant and a silver waist clasp designed by R. J. Emerson were offered in by Christie's, London in 1992.

William Comyns

A manufacturer of fine silver Comyns made belt buckles and other items with an Art Nouveau persuasion around 1900. The company manufactured Arts and Crafts style products with spot hammering to give the appearance of being handmade. The Comyns company was founded in 1848 and at one point the company occupied the building that had been the Italian painter Canaletto's studio while he was living in England. Comyns made die-stamped wares of thin sheet metal and sold some of their products to the Goldsmith's and Silversmith's Company and to Tiffany & Co. The firm is still in business today.

Belt by William Comyns & Sons. Cast silver, hallmarked in London, 1901, WC. Stamped with register numbers as well. *Cheltenham Art Gallery and Museums, England*

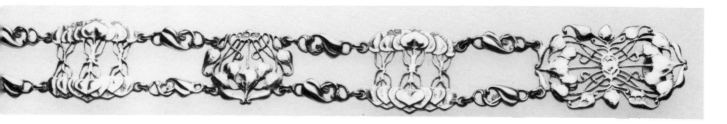

Connell & Co.

Connell was a competitor to Liberty & Co. and appears to have used some of Liberty & Co.'s designs with Liberty's knowledge—it has been documented that Liberty sold them some pewter designs at the very least. Primarily a wholesaler, some of their jewelry was sold through the Goldsmiths' and Silversmiths' Co. although they sold directly to the public as well.

Calling their line "Modern Artist's Jewelry and Silverware," they advertised such pieces as: a 15 kt. gold and opal pendant; gold and silver rings set with opals, opal matrix, turquoise matrix or chrysoprase; a 15 kt. gold and pearl brooch; a solid gold and turquoise matrix bracelet also available with opal (this bracelet also appeared in the Murrle Bennett catalog); an art silver jardinière with green glass liner (19" long) and a beaten silver fruit dish.

James Dixon and Sons

Founded in 1806, this Sheffield firm was among the first in Britain to produce Britannia metal and Old Sheffield plate as well as sterling silver. They were manufacturing silver and silver plate items around the turn of the century including some in the Arts and Crafts and Art Nouveau style. A number of their pieces were also executed from designs by Christopher Dresser.

Dryad Metal Works

Harry Peach and William Pick founded this company in 1912, and in 1917 they began manufacturing art metalwork. The designs they executed had very little decoration and were provided by John Sydney Reeve and other instructors at the Leicester School of Art. The Dryad Works produced domestic items including bronze bowls, candlesticks, copper hot water jugs, as well as silver and jewelry.

Goldsmiths and Silversmiths Co., Ltd.

This firm was established as a retail and manufacturing jeweler in the 1890's by William Gibson to manufacture household items of silver and gold. They also sold work made by other artisans. In 1952 they acquired Garrad's and took that name. Harold Stabler designed a series of blue enamel boxes for the company.

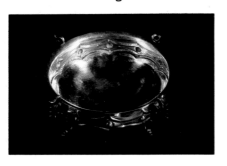

Small silver bowl by the Goldsmiths' and Silversmiths' Company. *Courtesy of Leah Roland/Split Personality, Leonia. Photo by Diane Freer.*

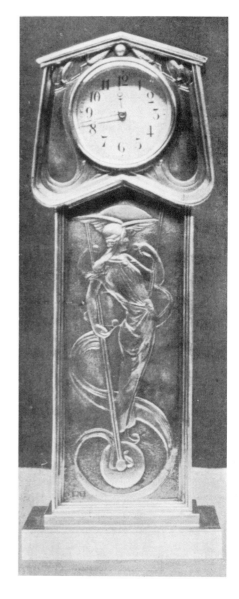

Clock by Goldsmiths' and Silversmiths' Company.

Two small enamel boxes. The one on the left by W. H. Haseler & Co., the one on the right by an unknown maker. *Courtesy of Leah Roland/Split Personality, Leonia. Photo by Diane Freer.*

Thistle pin by the firm of Charles Horner with a faceted "amethyst", the stone is probably glass.

Two Charles Horner sterling silver brooches. Circa 1910. *Courtesy of Skinner's, Inc., Boston and Bolton.*

Three silver and enamel picture frames by William Hutton & Sons. London hallmarks for 1903 and 1904. *Courtesy of Christie's, London*

W.H. Haseler & Sons

Founded by William Hair Haseler and then run by his sons, this Birmingham manufacturer of silverware and pewter made the bulk of Liberty's Cymric and Tudric line, even registering the Cymric name together with Liberty in 1901. They did most of their manufacturing with machinery while simulating a handmade look. The firm's name changed to Haseler and Restall Ltd. in the 1930's and then became an associated company of Marples and Beasely Ltd. in 1963.

T. Hayes

Hayes was a Birmingham silversmithing firm that produced Art Nouveau style items. The firm's mark was registered in 1893.

Charles H. Horner

This Halifax firm produced jewelry with motifs that had both Arts and Crafts and Art Nouveau influences and were unique because all stages of manufacturing were done under one roof. There was a wide range in quality of their pieces. Although Edgar Simpson may have designed some jewelry for them most of it was designed by Charles Henry Horner himself. Working mostly in silver with a hand-beaten look and some gold, many of the pieces were of blue, green and yellow enamel. The pendants, brooches and hat pins by Horner featured openwork borders, Celtic designs and stylized leaves. Knot brooches and hat pins with a imitation amethyst thistle (a Scottish symbol) were common as were winged scarabs with enamel.

The hatpins were mostly silver with enamel, pearls or precious stones and sometimes mother-of-pearl. A smaller quantity of rings were also produced. Most of Horner's jewelry was assayed and marked in Chester.

William Hutton & Sons

Kate Harris is the designer most associated with the silversmithing firm of William Hutton, and she primarily designed Art Nouveau influenced belt buckles for them. The firm was a Birmingham silversmithing firm that was founded in 1800 and made buckles and clasps and picture frames, some in an Arts and Crafts style between 1900-1910. Their buckles were similar to those done by William Comyns but it is unknown who Comyns' designer may have been. A six-piece silver dressing table set designed by Harris with "Art Nouveau lily maidens" was offered for sale at Christie's, London in October, 1992.

Jones & Compton

This Birmingham silversmithing firm produced items in an Art Nouveau style around 1900.

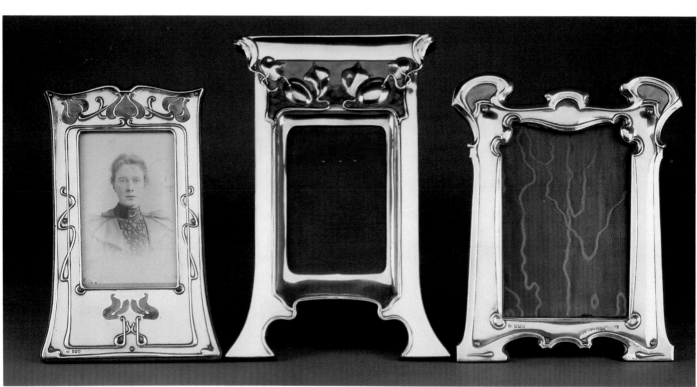

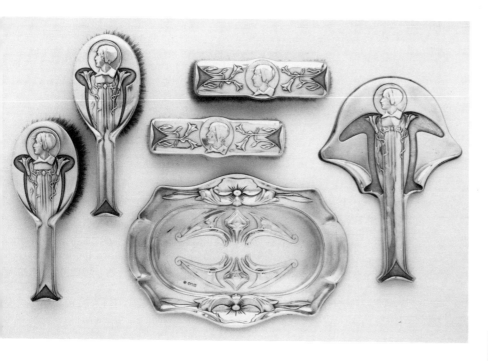

A William Hutton & Sons six-piece dressing set designed by Kate Harris with hand mirror, two clothes brushes, two hair brushes and a tray. Decorated with repoussé Art Nouveau lily maidens and stylized lily flowers, it is stamped with registration number RD 347101, WH & S Ltd., and London hallmarks for 1901 and 1902. *Courtesy of Christie's, London*

Liberty & Co.

Liberty and Co. was founded in 1875 as a purveyor of goods and fabrics from the Orient which fit nicely into the popular Aesthetic style of the time. Nine years later a costume department was opened, and then furnishings and decorating departments. In 1899-1900 silver and pewter lines of jewelry and home items were launched.

As the Arts and Crafts style and the ideal of decorative items being hand-made by artisans became more popular, Arthur Lasenby Liberty, the store's founder, saw an opportunity to capitalize on this movement. He began by importing a number of silver and silver plate items from Germany made by the manufacturer known as WMF (Wurttemburgische Mettalwarenfabrik Company) as well as other companies that fit into the Arts and Crafts style offering, but soon realized it would be more profitable to make his own. Liberty did not have to wrestle with his conscience when it came to the use of machines for production, therefore he was able to produce affordable objects that *looked* handmade but were now available to a wider audience.

Many well-known designer/craftsmen produced designs for Liberty & Co., most notably for jewelry and metalwork. They were: Jessie M. King, Arthur Gaskin, Rex Silver, Bernard Cuzner, Oliver Baker, Harry Craythorne, Ella Naper, A. E. Jones and Archibald Knox. However, the store never allowed designers to sign their names and attribution to specific pieces is not always possible. One reason for this is because Liberty & Co. frequently "mixed and matched" elements from different designers. (Please see individual biographies of these people).

The silver goods made under the banner *Cymric* (after Cymru, Wales) and pewter goods were known as the *Tudric* Line, began being offered to the public in the late 1890s. John Llewellyn was in charge of the production of these metalwork lines and being Welsh, he may have chosen these Celtic names. A majority of the actual manufacturing was done in Birmingham by the firm of W.H. Haseler, which had a limited partnership with Liberty & Co. for a number of years. The success of the Liberty metalwork was so great that in Italy the new art movement became known as "Stile Liberty."

Liberty and Co. had an impact on the Arts and Crafts movement in several ways. While providing more jewelry and silver items for people at an affordable price, the store may have hurt some of original members of the movement. C.R. Ashbee felt that Cymric line was responsible for the downfall of the Guild of Handicraft because it made available to the public a less expensive version of the Guild's work.

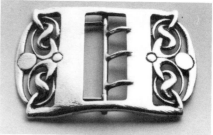

Liberty & Co. belt buckle. Hallmarked in Birmingham, 1901, L & Co., stamped CYMRIC. *Cheltenham Art Gallery and Museums, England*

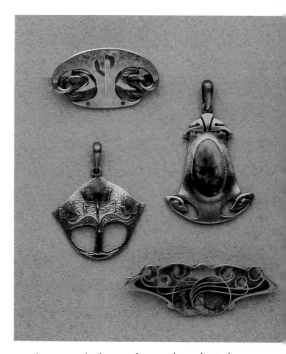

A group of silver and enamel pendants by Liberty & Co. Clockwise: By Archibald Knox, unknown, Jessie M. King, Archibald Knox. *Courtesy of Didier Antiques, London*

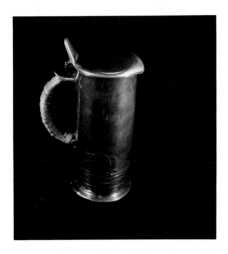

Hot water jug by Liberty & Co., designed by Archibald Knox. *Courtesy of Leah Roland/Split Personality, Leonia. Photo by Diane Freer.*

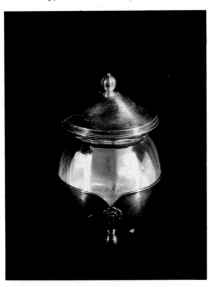

Two pewter humidors by Liberty & Co. One with enamel insert probably by Charles Fleetwood Varley. *Courtesy of Leah Roland/ Split Personality, Leonia. Photo by Diane Freer.*

Liberty and Co. belt buckle hallmarked in Birmingham in 1903. This is no. 127 in the Liberty design book in the Victoria and Albert Museum. *Cheltenham Art Gallery and Museum, England*

Cymric jewelry was made in gold and silver and often enamelled in shades of blue and green. Also incorporated into these pieces were semi-precious stones including garnets, turquoise, mother-of-pearl, opals and pearls. Many of the pieces featured the Celtic Knot or "whiplash motif," particularly those designed by Archibald Knox. But influences other than Celtic can be found in the jewelry including Japanese and a mild version of Art Nouveau.

The early silver pieces were hand-made or at least hand finished whereas the pewter line was always made entirely in molds. Jewelry could be customized to accommodate a customer's choice of materials. Necklaces were often linked sections with a large center pendant of semi-precious stones decorated with enamel. Other popular items were rings, lockets, brooches, belt buckles, cloak clasps, buttons and cufflinks. Some jewelry in an Edwardian style designed by Knox were sold later as well.

Silver objects in the line included: spoons, cake slicers, cigarette boxes, clocks, inkstands, pen trays, claret jugs, wall sconces, powder boxes, beakers, vases, tankards, tea services, decanters, milk jugs, cardcases, biscuit boxes, picture frames, napkin rings, knife rests, mirrors, hair brushes, sugar bowls, salt cellars and pepper pots and many other items too numerous to list. The household items all had names such as vases named Avalon or Cloris and bowls named Maya or Romany, the jewelry had names such as Cyric or Runia.

From 1900-1903 Liberty & Co. had purchased pewter from a German firm, Kayser-Zinn. Then the firm began its own pewter Tudric line which consisted of many items, such as boxes, muffin dishes, inkwells, card trays, biscuit boxes, vases with glass liners, picture frames, candlesticks, crumb scoops, circular dishes, tea services, cake trays, clocks, fruit bowls, flagons, hot water jugs, etc. The green glass liners which appeared in some pieces were made by James Powell & Sons of Whitefriars and Clutha Glass incorporated in others (pale green, yellow or amber with bubble or streaks) was made by James Couper & Sons of Glasgow.

In addition to the Cymric and Tudric lines, Liberty also sold beaten copper and brass items, some designed by Christopher Dresser and John Pearson, cloisonné work by Clement John Heaton, beaten copper items by amateurs, some of it from the Yattendown School.

A number of manufacturers in Birmingham made "knock-offs" of Liberty's metalwork lines in an effort to capitalize on its success. They were often die-stamped to suggest embossing and chasing and often featured flower motifs or Kate Greenaway (a popular children's book illustrator of the time) figures. Vases, bowls, tea sets and vanity sets were among the most commonly produced items by companies such as Nathan and Hayes and Elkington's.

Even today, Liberty & Co., still plays an important role related to the Arts and Crafts. For the last nineteen years the store has held an Arts and Crafts exhibit and sale of furniture, metalwork and other items. The 1992 sale included a painting by Sir Edward Burne-Jones, furniture by C.F.A. Voysey, Liberty pewter, and Arts and Crafts ceramics. The jewelry firm of Cobra and Bellamy, with a concession within Liberty's store sold Cymric jewelry as well.

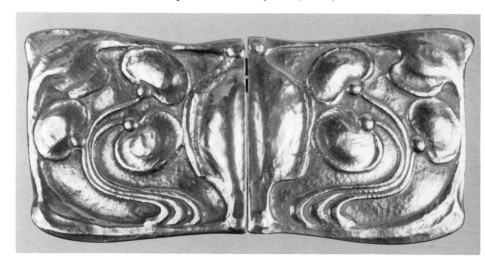

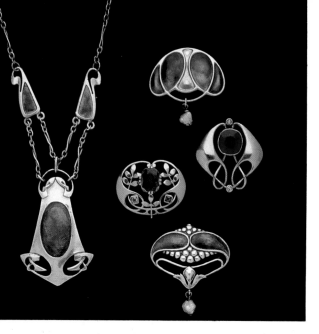

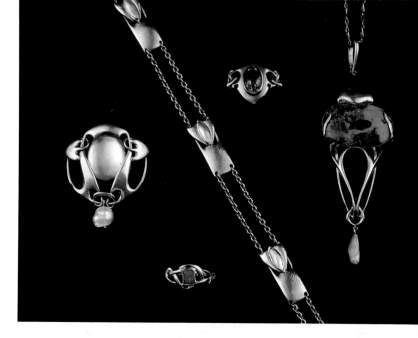

Gold and silver jewelry by Liberty & Co. *Courtesy of Didier Antiques, London*

A collection of Liberty & Co. gold jewelry designed by Archibald Knox. *Courtesy of Didier Antiques, London*

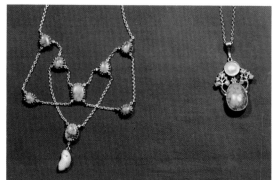

Two Liberty & Co. gold necklaces with turquoise and pearls. The pendant is sketch #8197 in the Liberty & Co. sketchbook from 1900-1912 which is in the Victoria and Albert Museum. *Courtesy of Leah Roland/Split Personality, Leonia. Photo by Gabrielle Becker.*

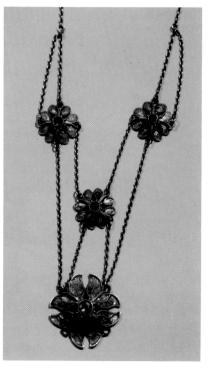

Liberty & Co. enamel necklace which appears in the Liberty sketchbook in the Victoria and Albert Museum as sketch #8968. *Courtesy of Leah Roland/Split Personality, Leonia*

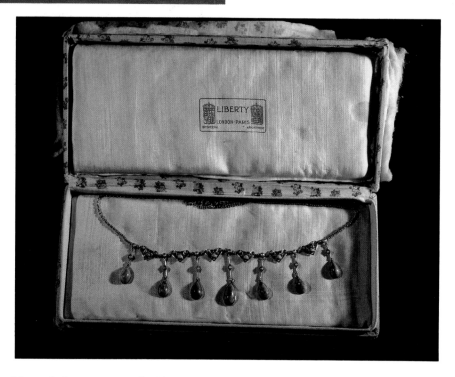

Liberty & Co. turquoise and gold necklace in box. *Courtesy of Leah Roland/Split Personality, Leonia. Photo by Diane Freer*

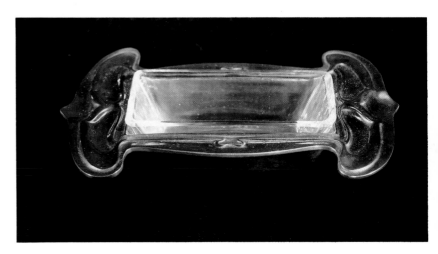

Liberty & Co. butter dish of pewter with Powell glass lining, c. 1906. *Courtesy of Leah Roland/Split Personality, Leonia. Photo by Diane Freer.*

Pewter Liberty & Co. biscuit box attributed to Archibald Knox. *Courtesy of Leah Roland/Split Personality, Leonia. Photo by Diane Freer.*

Silver and enamel match safe by Liberty & Co. *Courtesy of Leah Roland/Split Personality, Leonia. Photo by Diane Freer.*

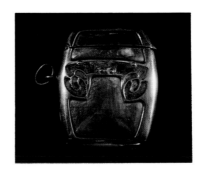

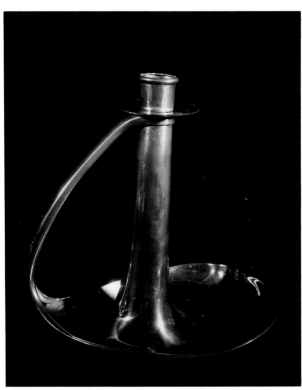

Liberty & Co. pewter candlestick, swirling design probably by Oliver Baker. *Courtesy of Leah Roland/Split Personality, Leonia. Photo by Diane Freer.*

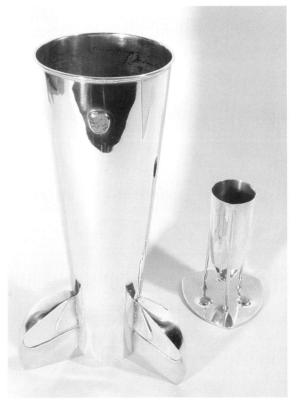

Liberty & Co. silver vases set with cabochon turquoise, 1905. *Courtesy of Barry Friedman, Ltd., New York*

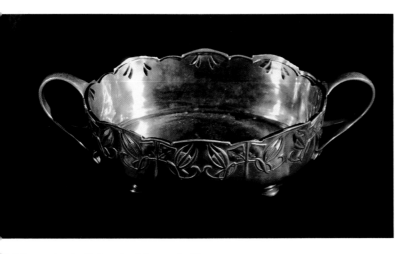

Tudric pewter jardinière by Liberty & Co.
Incised pattern with scallop top, original
matching scalloped green Powell glass liner, c.
1909. *Courtesy of Leah Roland/Split
Personality, Leonia. Photo by Diane Freer.*

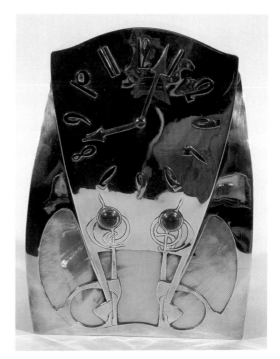

Clock by Liberty & Co. *Courtesy of Barry
Friedman, Ltd., New York*

Liberty & Co. silver cigarette case with enamel
signed by Charles Fleetwood Varley. *Courtesy
of Leah Roland/Split Personality, Leonia. Photo
by Diane Freer.*

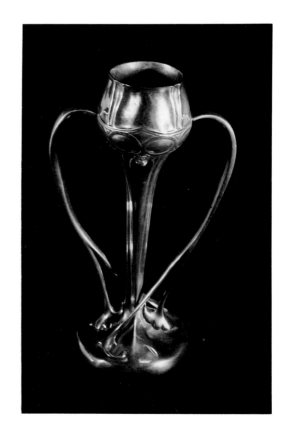

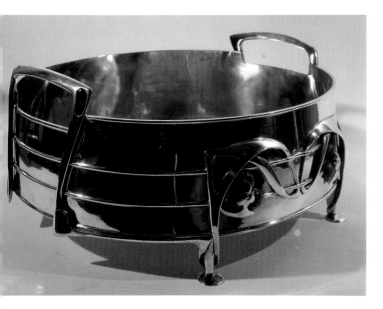

Liberty & Co. footed bowl. *Courtesy of Barry
Friedman, Ltd., New York*

Vase by Liberty & Co. *Courtesy of Leah
Roland/Split Personality, Leonia. Photo by
Diane Freer.*

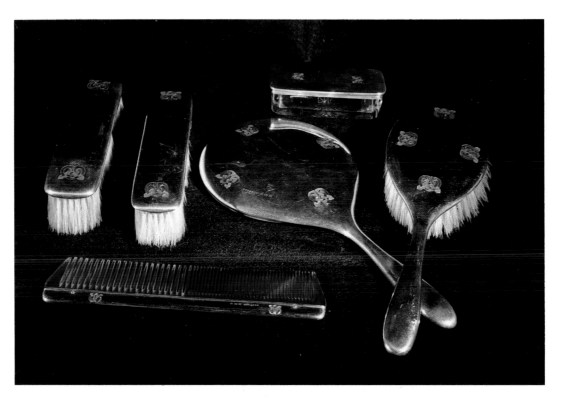

Cymric vanity set of sterling and enamel designed by Archibald Knox for Liberty & Co. *Courtesy of Didier Antiques, London. Photo by Diane Freer*

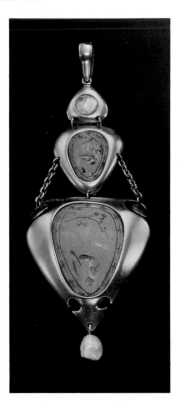

Arts and Crafts pendant believed to be by Murrle Bennett. Gold set with turquoise decorated with gilt Arabic inscriptions. The top inset with mother-of-pearl, anchored by a small freshwater pearl. *Courtesy of Sotheby's, New York*

Mappin and Webb

Still in business today, this London firm manufactured some silver items in an Arts and Crafts and Art Nouveau style.

Murrle, Bennett & Co.

Murrle, Bennett & Co. was a firm owned by the German-born Ernest Murrle. By leaving the umlaut off his name, he gave it a more English appearance, and after entering into partnership with a gentleman name Bennett the transition was complete. Murrle Bennett was primarily a wholesaler who had his goods manufactured in Pforzheim, Germany where he visited several times a year. Some of the jewelry was clearly manufactured by Murrle's friend Theodor Fahrner as pieces can be found marked with Murrle Bennett's mark and TF for Theodor Fahrner.

Murrle Bennett sold goods to Liberty & Co., and some of their advertisements show the identical jewelry that was sold at Liberty & Co. and the Goldsmith's and Silversmith's Company. D. G. Connell & Co. also sold items identical to Murrle Bennett.

Much of the Murrle Bennett jewelry is in a style related to English Arts and Crafts. The silver jewelry has a hand-hammered "look", with visible nail heads. The rest that was sold was of a Jugendstil style (the German form of Art Nouveau).

Murrle Bennett and Co.'s jewelry was made in both gold and silver and is quite attractive. It often features blue/green enamel, amethysts, odd-shaped pearls, mother-of-pearl, turquoise, and opal matrix. Some pieces have gold wire work and pendants and brooches were the most common to find, rings turn up less frequently.

The following descriptions are typical of Murrle Bennett jewelry:
—pendant in 15 kt. gold with turquoise matrix with pearl drop
—brooch—flower design with lapis lazuli
—brooch—hand-chased with opal matrix center
—brooch—hand chased of Celtic character
—brooch—in 15 kt. gold with opal matrix center and pearl drop

Murrle Bennett also made copies of medallion designs. Two examples in the British Museum include a waist clasp of silver with a female profile which is after a medal by Fritz Wolber c. 1900. The other is a brooch of a mother and child after a medal design by Alfred Schmid who worked in Pforzheim and Karlsruhle, Germany c. 1903.

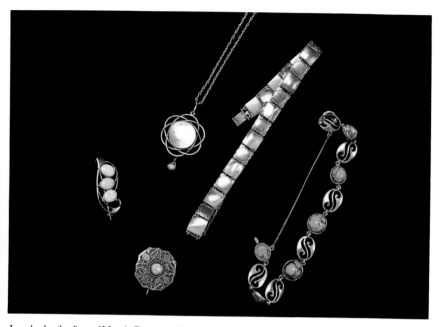

Jewelry by the firm of Murrle Bennett. *Courtesy of Carole Berk Inc., Bethesda*

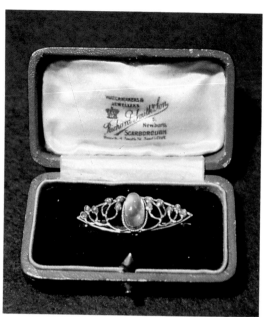

Murrle Bennett & Co. enamel and silver brooch modelled after an Archibald Knox design. *Courtesy of Van Den Bosch, Georgian Village, London*

W. Bainbridge Reynolds

This firm made architectural metalwork including iron and bronze andirons (fire dogs), fire grates and screens, wrought iron hinges, lighting fixtures, and items in brass and copper, iron, and copper gilt. A weathervane in the form of a fully rigged ship was made by this firm for the Royal Naval College on the Isle of Wight and pieces they executed from designs by C.F.A. Vosey were featured in *The Studio.*

Three electric pendant lighting devices executed by W. Bainbridge Reynolds, Ltd., 1908. The center one was designed by C.F.A. Voysey.

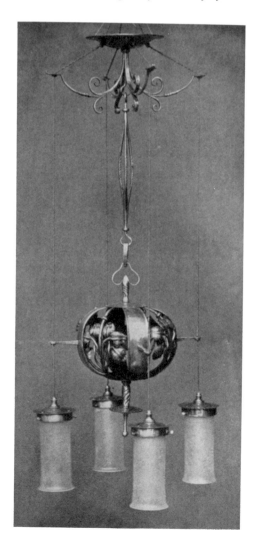

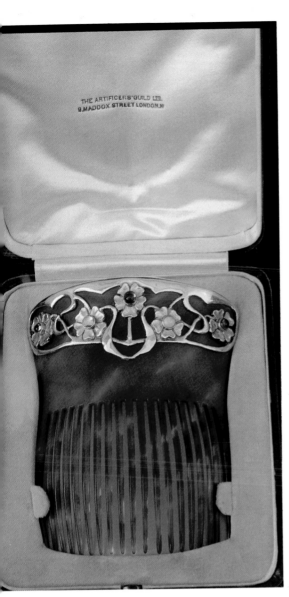

A tortoiseshell hair comb set with amethysts and moonstones by the Artificer's Guild. Original fitted case. *Courtesy of Tadema Gallery, London*

Silver cloak clasp by the Artificer's Guild set with chrysoprase, in the original fitted box, c. 1920. *Courtesy of Tadema Gallery, London*

The Silver Studio

Founded by Arthur Silver (1853-1896) who was a fabric designer, the business was taken over by his son Rex (Reginald) upon his death.

The Silver Studio supplied designs to Liberty & Co. and this tradition continued with Rex designing fabrics and silver for the "Cymric Line" beginning in 1898. His designs featured the Celtic "entrelac" motif and he also designed for the pewter "Tudric" line.

Some of the designers who worked for the studio included Harry Napper who was design manager for a few years and then left to freelance and John Illingsworth Kay. It is also possible that Archibald Knox may have created some designs for the Silver Studio.

Spital & Clark

This Birmingham firm made architectural metalwork.

Wakely and Wheeler, Ltd.

This London firm manufactured some silver items in the Arts and Crafts and Art Nouveau styles in the early 20th century. Both R.M.Y. Gleadowe and Harold Stabler designed for the firm.

Walker & Hall

Items in the Arts and Crafts and Art Nouveau styles were produced by this silver manufacturer around the turn-of-the-century.

Waltham & Hill

This firm made forged iron work.

George Wragge, Ltd.

This London firm made architectural metalwork.

A & J Zimmerman

A Birmingham silversmithing firm, Zimmerman did some work in an Art Nouveau inspired style. A buckle of cast silver of a female head with flowing hair, c. 1903 is in the collection of the British Museum. They also made silver picture frames and other items.

WMF

The Wurttemburgische Mettalwarenfabrik Company of Geislingen, Germany, still in business today, made silverplated ware that was imported by Liberty & Co. and other English companies in great enough quantity to create the need for a separate catalogue for the English trade.

Many of WMF's designs were made by well-known German artists of the time including possibly Peter Behrens, Albin Müller, and the sculptor Albert Mayer. The plated line had an Art Nouveau influence while a line of pewter was "High Jugendstil" and a number of items in their 1906 catalog have a clearly Celtic influence. Items in these styles included: cake baskets, sweet and fruit dishes, vases, cigarette cases and boxes, claret jugs, card trays, desk items, mirrors, picture frames, wall plaques, candelabras, etc.

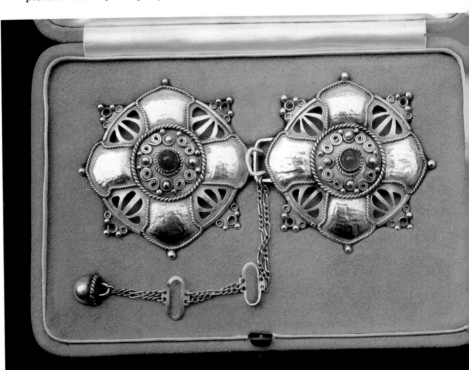

Artificer's Guild

Nelson Dawson and Edward Spencer, one of Dawson's workshop employees, founded the Artificer's Guild in 1901 for the purpose of making a wide range of metalwork. Dawson's design contribution included forged iron work with silver or brass and Spencer also designed items in wrought iron. Walter Spencer, a blacksmith executed their wrought iron work. They made items of copper and bronze mounted with silver—most of these pieces were designed by Spencer.

Two years after it was started, the Guild was purchased by Montague Fordham, an attorney, who was one of the former directors of the Birmingham Guild of Handicraft.

The Guild then moved from Chiswick to the Fordham Gallery on Maddox Street in London; Dawson did not go with the Guild, and Spencer became the chief designer.

One of the leading artists represented at the Gallery was John Paul Cooper and the Guild's style, particularly that of Edward Spencer, was strongly affected by him. The Gallery also represented May Morris and Henry Wilson. In addition to jewelry, items for the home were also offered.

The Guild eventually moved to Conduit Street where it remained until its dissolution in 1942. The Guild was one of the most successful in the Arts and Crafts movement both in the length of time that it survived and financially.

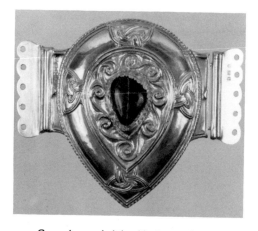

Cope clasp or belt buckle designed by Edward Spencer and made by the Artificer's Guild. Silver and pebble, hallmarked in London, 1928. *Cheltenham Art Gallery and Museums, England*

The Art Worker's Guild and The Arts and Crafts Exhibition Society

The Art Worker's Guild was founded in London in 1884 by a group of artists and architects. Many important designers and craftsmen were members of this group which helped to bring public attention to their cause. C.R. Ashbee was one of the early members, and most of the Arts and Crafts designers belonged to the Guild at some point in their careers. Enamel work was one of the more important interests of Guild members.

In 1887-88 a group of artists who were Guild members, led by W.A.S. Benson formed the Arts and Crafts Exhibition Society to sponsor exhibits of the member's work.

The Arts and Crafts Exhibition Society show became a prestigious place for artists to display their work, so much so that Liberty & Co. even broke the company rule of not putting individual artisans names on their wares. The firm allowed Archibald Knox to exhibit pieces he had done for Liberty & Co. under his own name, the only way Liberty, a retailer, could be included in an Arts and Crafts Exhibition Society show.

Barnstaple Metalworker's Guild

Founded by G. Lloyd Morris in 1900, the Guild produced repoussé copper and brass.

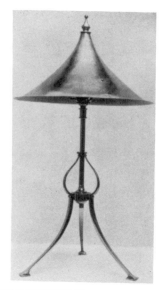

Birmingham Guild of Handicraft

Created in 1890, the Birmingham Guild of Handicraft was based on John Ruskin and William Morris' ideals for the Arts. It began with about twenty craftsmen, and one of the first directors was Montague Fordham, a lawyer who later bought the Artificer's Guild.

The Guild expanded until 1895 when it became a "limited company" with Claude Napier-Clavering as its first Managing Director, he also designed many of the silver items produced by the Guild.

Arthur Dixon, an architect and metalworker, was the chief designer for the brass and copper ware and was also the Managing Director at some point. Although the Guild also made furniture, the copper, brass and silver items for the home and ecclesiastical silver were the Guild's most successful endeavors. Their work included coffee pots, jugs, silver cups, presentation spoons, and a limited quantity of jewelry.

The Guild's style consisted of working with simple lines, using a hammered finish that was unplanished or lightly planished with wire work for handles and finials. Semi-precious stones were often set in pieces for decoration. Rivets were visible in many of the Guild's pieces for dual purposes—as a structural element and as a design feature; they were particularly favored by Arthur Dixon.

In 1910 the Guild joined forces with E & R Gittins Company, makers of fine jewelry and architectural metalwork and evolved into a more commercial venture. Around 1920 the company merged with another company.

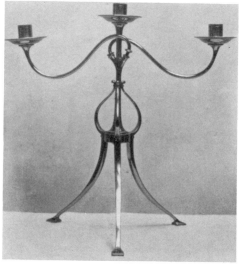

Lighting devices by A.S. Dixon and the Birmingham Guild of Handicraft, c. 1900.

The company survives today continuing to do architectural metalwork as well as well as engineering. The Guild's motto was "By Hammer and Hand" which is also the title of an excellent book by Alan Crawford on the metalsmiths of Birmingham.

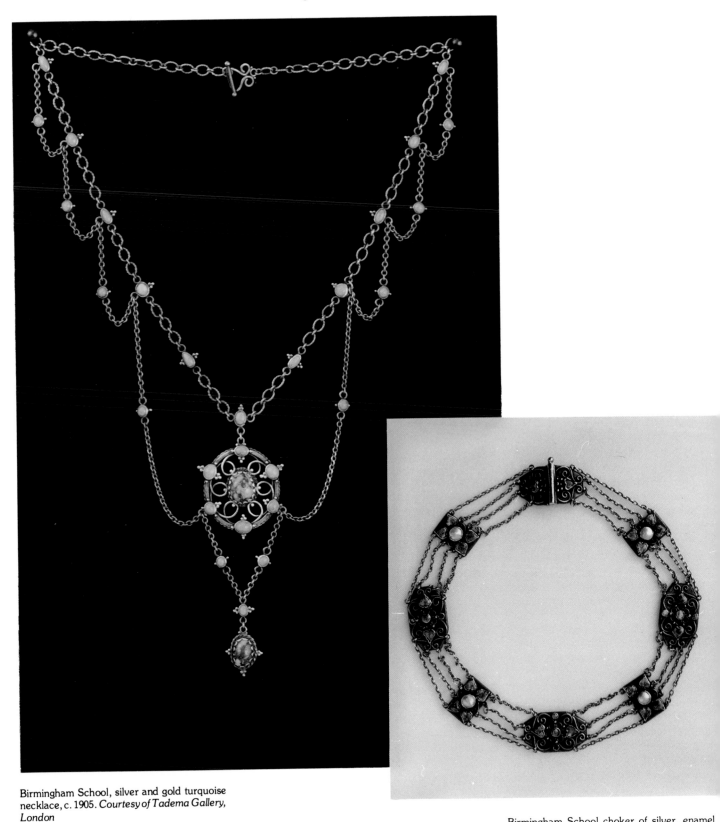

Birmingham School, silver and gold turquoise necklace, c. 1905. *Courtesy of Tadema Gallery, London*

Birmingham School choker of silver, enamel and pearl, c. 1900. *Courtesy of Tadema Gallery, London*

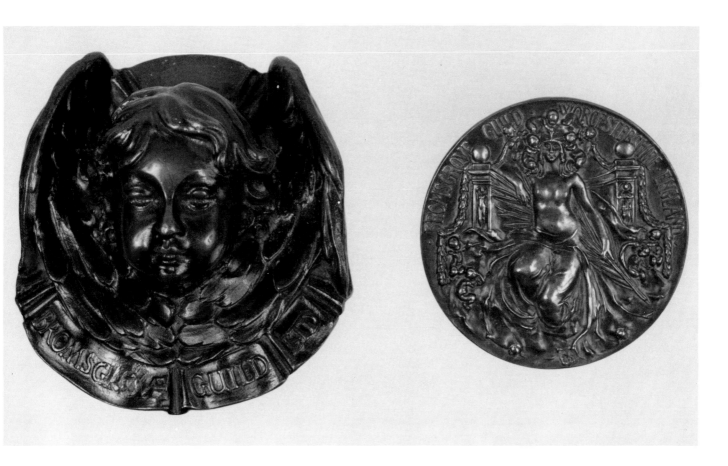

Bromsgrove Guild of Applied Art

Walter Gilbert, the cousin of the sculptor Alfred Gilbert, and others founded this guild in a Birmingham suburb around 1890 to focus on jewelry and metalwork; they also produced embroidery and other items. Well known designers who did work for the Guild included the Gaskins, Joseph Hodel and A. Edward Jones who executed much of the metalwork. The Guild exhibited at the Paris Exhibition in 1900.

An unusual feature of the Guild was that it hired designers as needed and did not have them as full-time workers. This allowed the craftsman to do other work as well without fear of redress.

In later years, the Guild had a royal warrant under King Edward VII and King George V. They were commissioned to make the gates and railings for Buckingham Palace, a good deal of the metal work on the Queen Mary and the Lusitania, and other important work. The Guild went out of business in 1966.

The Century Guild

Founded in 1882 by A. H. Mackmurdo and Selwyn Image, the other Guild members included metalworker and enamellist Clement Heaton, and metalworkers George Esling and Kellock Brown. The bulk of the Guild's work was based on Mackmurdo's designs and they were undertaken as group projects, rather than as individual projects. For this reason, it is often difficult to assign attribution for work which came out of this Guild.

Heaton did enamel work for the group, with some of the cloissoné designed by Mackmurdo.

Examples of work by the Guild include: a repoussé copper sconce designed by Mackmurdo and made by Kellock Brown, a circular brass dish with relief decoration by Esling, and a cast bronze lamp designed by Mackmurdo and executed by Esling.

The Guild was dissolved in 1888 although the members continued to work together on an informal basis.

Two items by the Bromsgrove Guild. On the left, a plaque or paperweight of cast bronze, c. 1900. On the right a plaque of cast bronze, c. 1900. *Cheltenham Art Gallery and Museums, England*

Dish by George Esling for the Century Guild. *Colchester Museums, Essex, England*

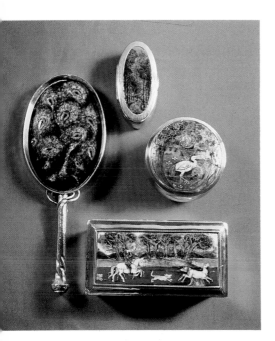

Enamelled silverwork by the Guild of Handicraft, 1901-13. *Cheltenham Art Gallery and Museums, England*

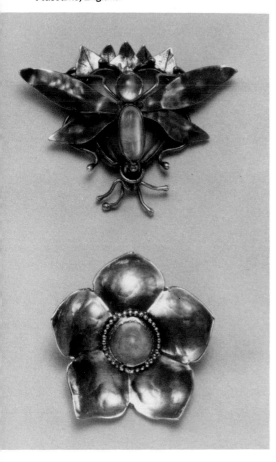

Top: Wirework insect brooch with moonstone head and body and wings of silver resting on large silver-backed moonstone circa 1895. Bottom: Silver flower brooch set with a cabochon amazonite surrounded by applied beaded wire. Circa 1895 by the Guild of Handicraft. *Courtesy of Kurland-Zabar, New York*

Cripples Guild

The Duchess of Sutherland began this Guild to make items of silverware with chased and repoussé work. Silver-plated copper ware and some objects of copper were also produced and sold at a Bond Street shop. Many of the styles of the Guild were based on seventeenth century silver.

Guild of Handicraft

The Guild of Handicraft was founded by the architect Charles Robert Ashbee who was a follower of John Ruskin and William Morris's belief in a return to the Guild system to make workers proud of their work again.

As a student in London, Ashbee lived in Toynbee Hall, a form of experimental student housing to bring students closer in touch with the working class neighborhood in which it was located. There Ashbee founded the School of Handicraft which evolved out of a group of students gathering in the evening for readings of Ruskin's works.

The Guild grew out of the School and its purpose was to return to a system in which domestic and decorative objects were made by hand not machines, and each craftsman did all of his own work rather than being a specialist in one area. Ashbee's interest was in creating an integrated Guild style rather than encouraging the creativity of individual designers.

Beginning in London in 1888 the Guild had workshops for making furniture, textiles and metalwork. Most of the men who began with the Guild had not trained in the crafts they were to work in, and learned by "on the job training", becoming quite skilled over time. It is usually assumed that most of the Guild's designs were Ashbee's own, while the execution was done by the Guild's members, but certainly some of the work must be the handiwork of other designers such as W.A. White, Fred Partridge, John Williams and William Hardiman. It is likely that much of the early metalwork was probably designed by John Pearson.

The metalwork department of the Guild used electrically powered equipment for buffing and polishing but all other work was done by hand. Work included silver objects for the home as well as fittings of copper and pewter for lighting fixtures and jewelry.

The jewelry first began to be created around 1891-92. The early pieces were silver and gold brooches, silver chatelaines and pendants. Employing the lost-wax casting method and using wire work, the jewelry was executed by William Hardiman, A. Schonwerk, Arthur Cameron and W.A. White. Most pieces were set with stones and were quite simple in design as these men were not experienced jewelers and Ashbee himself was a neophyte jewelry designer.

Common motifs used were flowers and leaves and an amorphous flower/insect, sort of a free form shaped butterfly with curves that may have been Art Nouveau influenced. Ships were another popular motif. The Guild produced brooches, necklaces, belt buckles and cloak clasps primarily employing the techniques of repoussé and casting.

Ashbee was probably the first to design Arts and Crafts jewelry, and his talent grew with experience as is evident by the more complicated pieces the Guild produced as it matured. This was also partly due to the fact that more experienced jewelers came on board later in the Guild's history so the quality of craftsmanship improved.

The Guild's jewelry incorporated moonstones, amethysts, garnets, pearls and enamel. Also dating from this earlier period are the many peacock necklaces. Later pieces are more intricate and show a definite Renaissance influence. Garnets were no longer used at this point, and opals and irregular turquoise appeared.

The table items did not begin to be produced in great numbers until the late 1890's and at that point wirework began to be employed. Wires were twisted together to form handles and bowl supports, and color enamels and gemstones were added more frequently for decoration.

Some of the more popular items produced by the Guild included green glass decanters with metal fittings, a circular covered dish (muffin dish) and loop-handled dishes that had many uses—as jam or butter dishes, porringers or "sweet" dishes. Drawings published in Ashbee's book *Modern English Silverwork* in 1909 included among other items: covered cups, tazzas, goblets, beakers, tea and coffee pots, sugar and cream pots, toast racks, toilet sets,

epergnes, pepper casters, salt cellars, spoons, plates, tureens, mustard pots, hot water jugs, menu holders and ladles.

The peacock motif turned up in a number of metalwork pieces as well as in the jewelry. Plate 33 in Ashbee's book illustrates a coffee pot with an ivory handle. The spout is a peacock's head and neck with the plumage chased on the body of the pot. The lid has green enamel with a malachite stone set in the knob and was designed for Mrs. Rudyard Kipling.

In the same book Ashbee featured an illustration for a tureen and cover designed for a Count Minerbi. His annotation for the drawing states that it was melted down before it was completed because the Count changed his mind and desired a piece with Art Nouveau design which Ashbee says, "I was unable to give him."

In 1902 the Guild moved to Chipping Camden in the countryside which proved to be a mistake. For a number of reasons the Guild could not support itself financially in the countryside environment and the Guild went into voluntary liquidation.

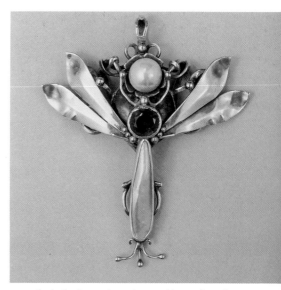

A similar insect brooch set with pearls and an amethyst. *Courtesy of Cobra and Bellamy, London*

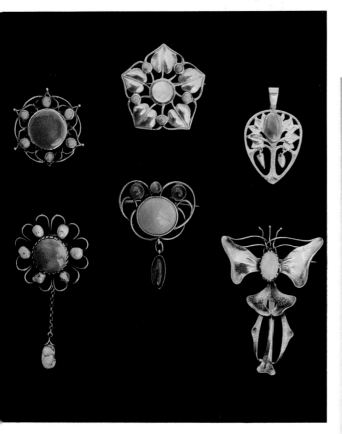

Group of jewelry designed by C. R. Ashbee and made by the Guild of Handicraft (with one exception). From the top, moving clockwise: Brooch set with moonstone and turquoise, c. 1900; "tree" pendant of silver, enamel and baroque pearl drop, c. 1900; winged insect pendant of silver and opal, c. 1900; silver brooch by Bernard Cuzner of heartshaped wirework design with a Ruskin Pottery circular plaque, c. 1900; a Guild of Handicraft silver brooch set with moonstones and turquoise; a silver brooch set with turquoise and turquoise enamel. *Courtesy of Tadema Gallery, London*

Guild of Handicraft pendant in original box. Silver and gold wirework, large blister pearl, chrysoprase. c. 1900. *Courtesy of Kurland-Zaber, New York.*

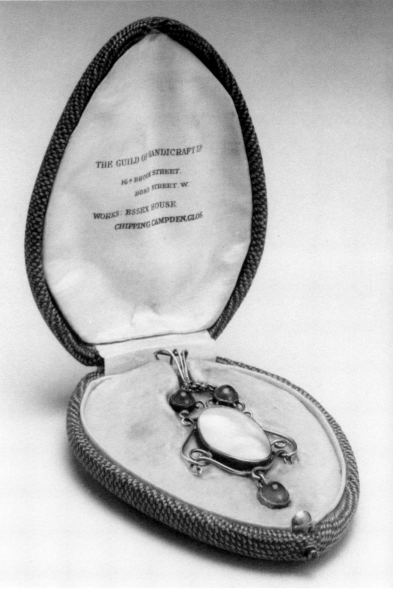

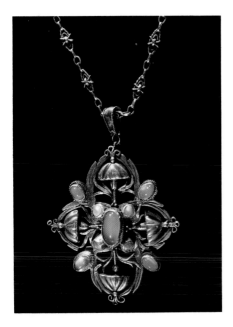

Pendant attributed to the Guild of Handicraft of silver, moonstones and pearls. *Courtesy of Leah Roland, Split Personality, Leonia. Photo by Diane Freer.*

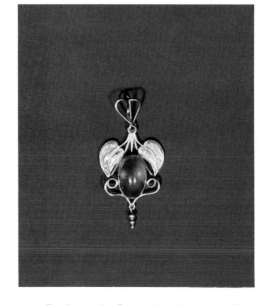

Pendant in the Guild of Handicraft style. Note basket on the "bale" which is similar to the finial on the Guild's silverware. Gold, opal and enamel. *Courtesy of Leah Roland/Split Personality, Leonia. Photo by Gabrielle Becker*

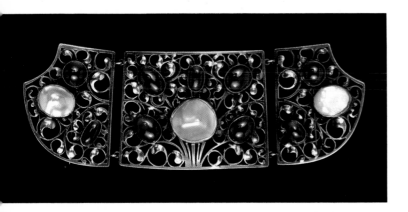

Brooch by the Guild of Handicraft. Blister pearl and garnets. *Courtesy of John Jesse, London*

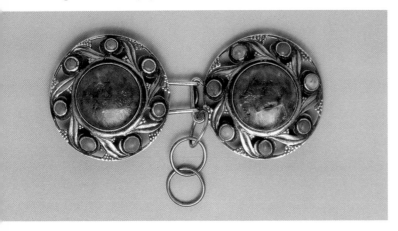

Belt or cloak clasp; one side can also be worn as a brooch. Silver with yellow-green enamel and green turquoise made by the Guild of Handicraft. *Courtesy of Kurland-Zabar, New York*

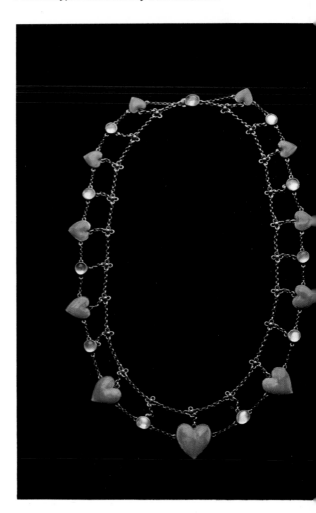

Guild of Handicraft necklace of silver, enamel and moonstone hearts. *Courtesy of Tadema Gallery, London*

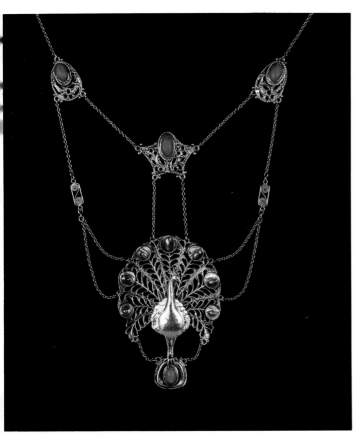

C.R. Ashbee/Guild of Handicraft peacock pendant/necklace. One of many different pieces of jewelry made with a peacock motif. *Courtesy of John Jesse, London*

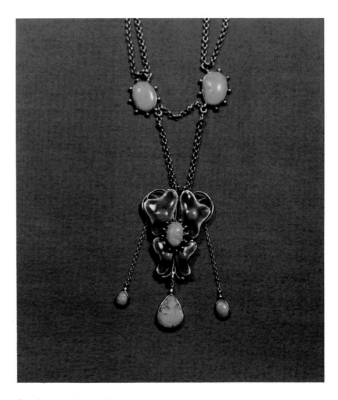

Pendant necklace of blue enamel and turquoise in floral/butterfly design by C.R. Ashbee for the Guild of the Handicraft. *Courtesy of Leah Roland/Split Personality, Leonia*

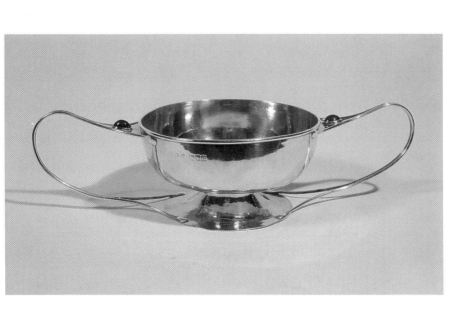

Double-handled bowl by C.R. Ashbee executed by the Guild of Handicraft. *Courtesy of Barry Friedman, Ltd., New York*

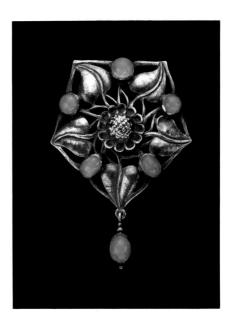

Silver and opal brooch, pendant by the Guild of Handicraft, c. 1904. *Courtesy of Van Den Bosch, Georgian Village, London*

Haslemere Peasant Industries

This group was an "umbrella" organization set up by Godfrey Blount to help local small shops sell their goods in London. The products offered included ironwork.

Home Arts and Industries Association

Begun in 1884 by Mrs. Jebb of Ellsmere in Shropshire, the Association set up art studios at Langham Place, London but also established craft courses all over the country. Staffed by middle-class and aristocratic women, the Association, supported by A.H. Mackmurdo held many exhibitions featuring repoussé copper and brass work done by its students.

The primary goal of the Association was to teach amateurs how to make the above-mentioned work as well as beaten silver and pewter brooches, and provide an outlet for sales of these items.

The Guild provided both an activity for the working class and an outlet for many "isolated" women. Members for the most part remained amateurs.

Woman's Metal Worker's Company

Although not technically a guild, this group made architectural metalwork and wrought iron.

Two necklaces executed by Liberty & Co., c. 1900. The top one of gold, amethyst and pearl is by Archibald Knox; the bottom one of gold, sapphire and enamel is by Jessie M. King. *Courtesy of Tadema Gallery, London*

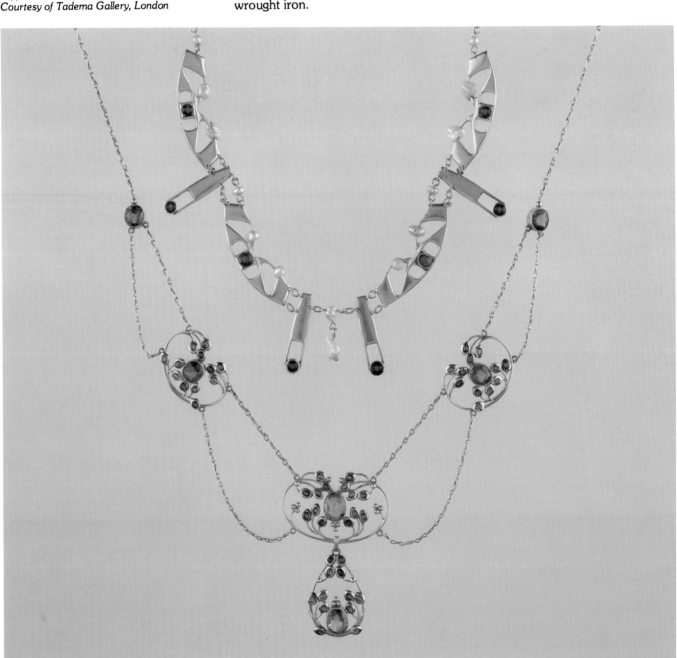

The Schools

The lack of good English design in the second half of the nineteenth century was due in part to the fact that the educational system did not acknowledge the industrial changes that had taken place in England. With the Arts and Crafts movement helping to elevate the decorative arts to the same level as the fine arts, schools in England began to address the education of the artist/craftsman and played a very important role in training and providing a meeting ground for many of the Arts and Crafts metalworkers and jewelers.

The first generation of Arts and Crafts designers was primarily self-taught but the second would have the benefit of a more formal crafts training.

The Birmingham Schools

Two major art schools were located in Birmingham, an important jewelry manufacturing city, and many noted Arts and Crafts jewelry and metalworkers passed through their doors as both students and teachers.

The Birmingham Municipal School of Art on Margaret Street

In 1887 this existing school opened workshops to train young jewelers who were apprenticing in the Birmingham trade to learn metalworking. Within a few years it was determined these students needed a school of their own.

The Vittoria Street School for Jewellers and Silversmiths

In 1890 a separate school from the Art School was opened with the idea of the technical training being under the auspices of the Birmingham Jeweller's Association and the artistic element of their training handled by the School. This system resulted in students often receiving mixed signals and in 1901 an attempt was made to correct the problems caused by two different groups supervising metalworking students.

Robert Catterson Smith was appointed the principal of the school and his students were fortunate because he was an accomplished craftsman with practical knowledge. His strong belief that art should come from nature was instilled in the students who passed through the school and he also emphasized drawing from memory.

In 1904 Catterson Smith moved over to the Margaret Street School and Arthur Gaskin took his place at the Vittoria Street School. From 1903-24 Gaskin was the headmaster until he retired to Chipping Camden and Thomas Blackband took over. (Blackband had been an apprentice to Gaskin and they made a number of items together).

The original purpose of the School was to help students planning to enter the mainstream Birmingham jewelry business to get a better feeling for good design. The reason this may have gone astray, producing a group of independent "art" jewelers and metalworkers, was because the school was headed by artisan craftsmen.

Many of the school's graduates became studio jewelers and never entered the Birmingham trade. Others proved the adage "a little knowledge is dangerous" by going to work for manufacturing jewelers and applying their knowledge of handmade jewelry to mass-produced, inferior quality products.

As Charlotte Gere and Geoffrey Munn point out in their book *Artists Jewelry: Pre-Raphaelites to Arts and Crafts*, the use of Arts and Crafts techniques was often misplaced: "enamelling is used where it is certain to get knocked, and cabochon-cut turquoise matrix is lightly cemented on to hollowware pieces that are going to have to be washed!" [32]

Camberwell School, London

This school attracted students and teachers that included Fred Partridge, Ella Naper and John Houghton Bonnor.

Central School, London

William Richard Lethaby, a well-known architect and designer, founded the Central School in 1896. He and George Frampton were joint directors, in 1902 Lethaby was appointed principal, a position he retained until he left in 1911.

The School was considered extremely unorthodox when it was opened because it was created specifically to be a school of craftsmen and it was staffed by practicing designers. By 1914 the first floor of the school was entirely dedicated to silversmithing, goldsmithing and jewelry-making classes, including diamond mounting, gem-cutting and chasing. Classes were also given in engraving, die-sinking, repoussé work, metal casting and enamel.

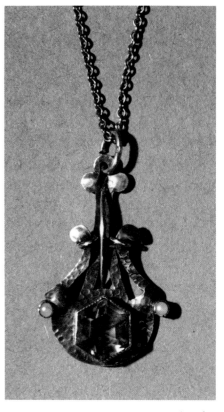

Pendant of silver and amethyst by the Birmingham jeweler Joseph Wray, c. 1905. *Collection of Gilbert Jonas, New York, New York*

Keswick School of Industrial Art, Cumberland

Founded by Canon Rawnsley as a craft and metalworking school, the Keswick School began as a night school in 1884 and four years later became a full-time school.

The jeweler Harold Stabler, and Herbert J. Maryon, a jeweler and metalworker, were directors and inspired many of the students who studied under them. The work done by the students was sold by the Home Arts and Industries Association.

Early works to come out of the school were copper vases, trays, jugs, etc. with repoussé and chased ornament. Later pieces were more elaborate often in silver or silverplate. A small amount of jewelry was made, mostly designed by Herbert J. Maryon, consisting of simple buckles and clasps of silver and turquoise.

Newlyn Industrial Class

Located in the fishing port of Newlyn in Cornwall, the Newlyn Industrial Class was intended to provide the younger fishermen with something to do in their "down time". It attracted several important craftsmen including John Pearson who taught copper repoussé work there and much of the work that came out of there is similar to his own with motifs of dolphins, squids, fish, shells and galleons.

A small amount of jewelry was also produced, most by Frances Charles Clemens who had taken some classes in enamelling and silverwork. He worked in painted enamel and silver wirework depicting sea-related subjects—shells, fish, etc.

Newtown Classes, Cambridgeshire

John Williams, who had worked for the Guild of Handicraft, ran this school for awhile, with the students producing repoussé-decorated copper and brass.

Yattendown Metalworking Class

Started in 1890 by Elizabeth Waterhouse, the wife of an architect, this Berkshire school promoted repoussé metalwork. The group's early work was made of brass but the bulk of its output was in copper, based on designs Mrs. Waterhouse derived from her plants. She provided all the materials for local men who were in the class and paid them for each piece that was sold.

The main source for sales was through exhibition at shows sponsored by the Home Arts and Industries Association and through a village shop known as "Pargeters". Some work was commissioned and other pieces were sold at Liberty & Co. When World War I broke out the class ended.

Copper repoussé commemorative plaque by the Keswick School, and a closeup of the mark. *Courtesy of Leah Roland/Split Personality, Leonia. Photo by Diane Freer*

Copper repoussé mirror by Newlyn Class. *Courtesy of Simon Tracy, London*

Epilogue

The English Arts and Crafts movement never fulfilled its promise for a variety of reasons.

While Ashbee and others believed that the jeweler should not have formal training, but should learn as he worked, this precept actually worked against the Arts and Crafts jewelers. Many of those who set out to make jewelry and metalwork had no experience at all. Their early pieces were crudely made by the "hit or miss" method and this created an image in the public mind that all Arts and Crafts jewelry was amateurish.

While theoretically, Arts and Crafts metalworkers believed in one craftsman making an entire piece from start to finish, the reality is that many of these craftsmen never learned to be proficient in all areas of production. Multiple craftsmen working on an item increased the cost, thereby undermining the concept of producing affordable jewelry and metalwork. And cost aside, although meant to be for the masses, primarily educated, artistic-minded people understood Arts and Crafts jewelry and metalwork and bought it.

It is often said that the Arts and Crafts movement ended when World War I intervened, but this is not so. It certainly slowed down, but many of the jewelers and metalworkers you'll read about in this book re-opened their studios and continued to work for many years after the war, sometimes moving into more contemporary styles.

Arts and Crafts was never a movement that appealed to everyone—but in some ways the width of its appeal during its popular period is less important than what came after it. There are direct lines running from British Arts and Crafts to the German Jugendstil style, the work of the Wiener Werkstätte, the American Arts and Crafts efforts, and the early twentieth century work done in Scandinavia which begat the modern styles of the 30's and 40's and on until today. Without the Arts and Crafts movement in Britain we would not have the work of the modern studio jeweler or the Art metalworker today.

Blue/green enamel pendant by the Newlyn Class. *Courtesy of Leah Roland/Split Personality, Leonia. Photo by Gabrielle Becker.*

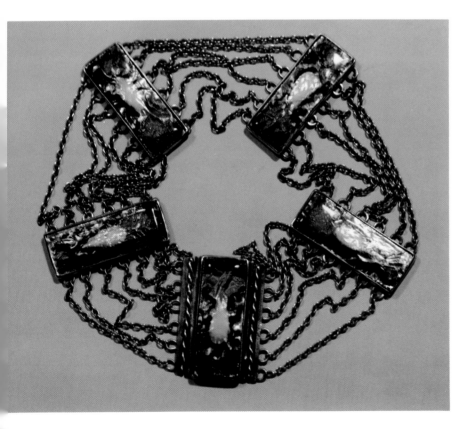

Enamel plaque necklace with silver chains linking plaques by the Newlyn Class. *Courtesy of Leah Roland/Split Personality, Leonia. Photo by Gabrielle Becker.*

English Arts And Crafts Motifs and Influences

Allegorical
Architecture (Architectonic)
Birds
Celtic
Fish
Gothic
Irises
Literature
Love/Romance
Love-In-A-Mist (a flower)
Madonna and Child
Medieval
Mythology
Nature
Oriental
Peacocks
Poppies
Pre-Raphaelite Brotherhood
Religion
Renaissance
Sailing Ships
Sea-Related
Stag
Suffragette Movement
Tree of Life
Women
Zodiac

English Arts and Crafts Materials

Abalone
Agate
Almandine garnets
Aluminum
Amazonite
Amethyst
Azurite
Base metals
Beryl
Brass
Cairngorm
Carbuncles
Carved Jade
Chalcedony
Chrysoprase
Coconut Shell
Cornelian
Copper
Crystal
Demantoid garnets
Diamonds (small)
Emeralds (flawed)
Enamel
Fire opals
Glass
Gold
Green-stained chalcedony
Horn
Ivory
Lapis Lazuli
Leather
Lumachella
Malachite
Moonstone
Mother-of-pearl
Opals
Parcel-Gilt
Paste
Pearls—baroque, blister, Mississippi River
Peridots
Pink Zircon
Pottery—Ruskin, Poole, Compton, others
Rose Quartz
Rubies
Sapphires
Serpentine (Connemara Marble)
Silver
Silver-Gilt
Shagreen
Spinel
Star rubies
Steel
Topaz
Tourmalines
Turquoise and turquoise matrix

Footnotes Chapter One

01 *By Hammer and Hand, The Arts and Crafts Movement in Birmingham*, Edited by Alan Crawford. Birmingham Museums & Gallery, Birmingham, 1984. Pgs. 97-98

02 *Peter Cormack*, Deputy Keeper, William Morris Gallery, Walthamstow, England from a lecture at the Katonah Museum, March 28, 1992.

03 Conversation with Peyton Skipwith, Fine Arts Society, London, March 13, 1991.

04 *Angels In The Studio, Women In the Arts and Crafts Movement 1870-1914*, Anthea Callen. Astragal Books, London, 1979 pg. 2

05 *Collector's Style Guide to Arts and Crafts*, Malcolm Haslam, Ballantine Books, New York, 1988, p. 60.

06 *A Silversmith's Manual, Bernard Cuzner. N.A.G. Press, Ltd., London, 1979 (6th printing), pg. 33*

07 *C.R. Ashbee, Architect, Designer & Romantic Socialist*, Alan Crawford, Yale University Presss, New Haven and London, 1985, pgs. 117, 132-33

08 *By Hammer and By Hand*, pg. 113

09 *C.R. Ashbee, Architect, Designer & Romantic Socialist*, pg. 88

10 *Omar Ramsden, 1873-1939*, Exhibition catalogue, City Museum and Art Gallery, Birmingham, England, February/March 1973, pp. 4-5.

11 *A Silversmith's Manual*, Bernard Cuzner, N.A.G. Press, London, England, 1979, p. 184.

12 *Antique and Twentieth Century Jewelry*, Exhibition Catalogue, Spink & Son, Ltd. London, England, December 1992, p. 19.

13 *Antique and Twentieth Century Jewelry*, Vivienne Becker, N.A.G. Press Ltd, Colchester, 1987 (2nd ed.), pg. 240

14 *Scottish Ceramics, Art Nouveau and Twentieth Century Decorative Arts*, Christie's, Scotland sale catalog, December 6, 1989, pgs. 47-48.

15 *Arthur and Georgie Gaskin*, Exhibition catalog, City Museum and Art Gallery, Birmingham, February 11-March 21 and Fine Arts Society, London, March 29-April 30, 1982.

16 *Metalwork and Enamelling*, Herbert Maryon, Dover Publications, Ltd., New York, 1972, 5th ed. Pg. 323

17 *C.R. Ashbee, Architect, Designer and Romantic Socialist*, pg. 88.

18 *George Hunt, Art Jeweller*, Anne Pyne, The Antique Collector, February, 1990.

19 *By Hammer and By Hand, The Arts and Crafts Movement in Birmingham*, pg. 113

20 *C.R. Ashbee, Architect, Designer and Romantic Socialist*, pg. 111

21 The Designs of Archibald Knox for Liberty & Co., A. J. Tilbrook, edited with Gordon House, Ornament Press, Ltd, London, 1976. Pg. 33, 41, 49

22 *Metalwork and Enamelling*, Herbert Maryon, Fifth Revised Edition, Dover Publications, New York, 1971, p. 275

23 *C.R. Ashbee, Architect, Designer and Romantic Socialist*, p. 113.

24 *Omar Ramsden, 1873-1939*, p. 8.

25 *By Hammer and By Hand, The Arts and Crafts Movement in Birmingham, pg. 113*

26 *Charles Ricketts and His Designs for Jewelry*, Diane Scarisbrick, Apollo Magazine, September 1982, pg. 164

27 *C. R. Ashbee, Architect, Designer and Romantic Socialist*, p. 138.

28 *Reflection: Arts and Crafts Metalwork in England and the United States*, Exhibition catalog Kurland-Zabar, Inc., New York, May 15-June 23, 1990

29 *Designer of Influence*, John Sandon, Antique Dealer and Collector's Guide, March, 1992

30 *C.R. Ashbee, Architect, Designer, Romantic Socialist*, pg. 88

31 *Antique and Twentieth Century Jewellery*, pg. 256-7

32 *Liberty Style, The Classic Years 1898-1910*, Mervyn Levy, Rizzoli, New York, 1986, pgs. 120-130.

English Arts and Crafts Techniques

Applied Ornament	Lost wax casting
Cast	Mixed metals
Chasing	Mokumé
Collet set stones	Niello
Copper-gilt	Piercing
Embossing	Punching
Filigree	Repoussé
Enamels—plique-à-jour, champlevé cloisonné, basse taille, with paillons	Saw-piercing
	Silver-gilt
Hammered metal	Wire work

Kate Allen—ALLEN

Artificer's Guild—G.D.L.D. in a shield; As. Gd. Ld. in a shield

C.R. Ashbee—CRA in a shield (mark registered in 1896)

W.A.S. Benson—BENSON; W.A.S.B.; W.A.S.B. & Co. LD; WB

Birmingham Guild of Handicraft—BGH Ltd in a diamond shape

Albert Bonner—AEB

J.H.M. Bonnor—J.H.M.B.

Frank Brangwyn—F.B.

Bromsgrove Guild of Applied Art—BG; BGAA

Alwyn Carr—AC

Child and Child—Monogram of two c's on either side of a sunflower

Collins & Co.—C & C

William Comyns—WC

John Paul Cooper—JPC in a shield , monogram or initials

Connell & Co.—clover leaf with initials WGC, one letter in each leaf. Also GLC, GBC, LGO

Bernard Cuzner—BC in a lozenge

Nelson Dawson—D on enamel, ND on metal, ND in an ivy leaf

Edith Dawson—D in a leaf (probably Edith, not Nelson)

James Dixon & Sons—JAMES DIXON & SONS; JD & S in a cartouche; JWD

Sybil Dunlop—S. Dunlop; S. Dunlop/London W.S.

Christopher Dresser—Dr. Dresser's Design; DESIGNED BY DR. C. DRESSER stamped in block capitals; Chr. Dresser stamped as a signature in a rectangular cartouche; most pieces are not marked

Dutchess of Sutherland's Cripple's Guild—DSCG

Elkington & Co.—E & Co. in a shield; Elkington & Co.

R.J. Emerson—RJE

Alexander Fisher—MADE BY ALEX FISHER; AF on the enamel; Alex Fisher fecit; Alex Fisher

Theodor Fahrner—TF in circle

William Russell Flint—WRF

Arthur Gaskin, Georgie Cave Gaskin, Gaskin workshop—G, AJG done in dots to form letters; paper label on enamel plaques: Mr. and Mrs. Arthur Gaskin, 13 Calthorpe Road, Edgbarton

Goldsmith's and Silversmith's Ltd.—G & S Co. Ld.

Guild of Handicraft—G of H Ltd. in lozenge; beginning in 1898 this was used alone and in conjunction with Ashbee's signature; G sometimes looks like C

William H. Haseler—W.H.H. in cartouche

T. Hayes—T.H. in a lozenge

Joseph Hodel—HODEL

Charles Horner—CH

Patriz Huber (on Murrle Bennett pieces)—PH attached in circle

Hukin & Heath—H & H each letter in an individual cartouche; JWH

George Hunt—G. Hunt; G.H.

William Hutton & Sons—WH&S Ltd.

Bernard Instone—signature in script and BI

Ruth A. Isaac—R. Isaac; RAI

A.E. Jones—By A. Edward Jones; AEJ in an oval; symbol of St. Dunstan Raising A Bowl; originally the mark of R. L. Rathbone

Jones & Crompton—J & C in a shield

Keswick School—KESWICK: SCH OF INDUST ARTS; K/SI/A; SKIA arranged in a circle

Archibald Knox—AK

Celia Levetus—CL

Liberty & Co.—see special insert, gold not often marked

Gilbert Marks—G. M. ; he also apprenticed at Johnson, Walker, Tollhurst and their mark is W.W.B.T.; also name written out in script

Ernestine Mills—EM monogram

L. Movio—L. Movio

Murrle Bennett—MB & Co. in cartouche; MBCo. in monogram

Moritz Gradl (Theodor Fahrner designer, may appear on Murrle Bennett pieces)—M.I.G.

H.G. Murphy—HGM in lozenge; bird in cartouche

Newlyn Industrial Class—NEWLYN; Newlyn, England

Mrs. Phillip Newman—Mrs N. in a rectangle

Fred James Partridge—PARTRIDGE; FJP;

May Hart Partridge—May Partridge

Maud Partridge—M. Partridge

John Pearson—J. Pearson; JP

A.W. N. Pugin—AWP monogram in Gothic letters

Omar Ramsden/Ramsden and Carr—Rn & Cr in cartouche for Omar Ramsden and Alywn Carr; OR; Omar Ramsden me Fecit arranged in ark; Omar Ramsden, Artist Goldsmith, London, England; Ramsden and Carr, London; Ramsden et Carr me Fecit; possibly others

R.L. Rathbone—RATHBONE

Florence M. Rimmington—FMR

George Elton Sedding—GES in circle; G. E. Sedding in a circle

Cyril Shiner—CJS reversed out in rectangle

Edgar Simpson—ES in cartouche

Edward Spencer—Edward Spencer DEL

Harold Stabler—HS in cartouche; STABLER; Harold Stabler facsimlie signature

G. J. Wainwright—G. J. Wainwright (firm's name)

Henry Wilson—HW in cartouche (note HW in monogram is not Henry Wilson but someone known as Hugh Wallis of Altrincham)

WMF—(Wurttembergische Metallwarenfabrik)—WEPCO in a lozenge; impressed diamond with a picture of an ostrich and W.M.F.G. underneath it; impressed antler in a lozenge

A and J. Zimmerman—A & JZ in a shield

Jessie M. King drawing. Ink on vellum "And gave the naked shield." *Mackintosh Collection, Hunterian Art Gallery, University of Glasgow*

Fork and spoon by Charles Rennie Mackintosh, 1903. *Mackintosh Collection, Hunterian Art Gallery, University of Glasgow*

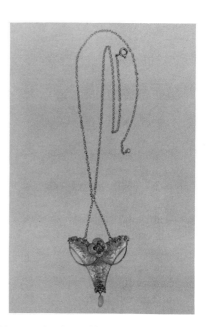

Necklace by Jessie Marion King for Liberty & Co. c. 1905. Silver, enamel and mother-of-pearl *Cheltenham Art Gallery and Museums England*

Scotland:

The Mackintosh Legacy

The English hated it. They called it Scotto/Continental art and disdained it as being an extension of that detestable "squirm" of the Art Nouveau movement. But the Scottish Arts and Crafts movement was unique, full of imagination and it had a significant influence in many countries. It has endured the test of time in a way its originators could not have imagined.

The work of two married couples had a profound effect on the crafts movement in Scotland at the turn-of-the-century. "The Glasgow Four"— Charles Rennie Mackintosh (1869-1929), Margaret MacDonald Mackintosh (1865-1933), Frances McDonald McNair (1874-1921) and Herbert McNair (1868-1955)—it all began with them. These are the players—the backdrop was the Glasgow School of Art.

Charles Rennie Mackintosh was a young assistant architect with the firm of Honeyman & Keppie in 1889 when he began attending drawing classes at the Glasgow School of Art. Herbert McNair, a friend and colleague also attended the classes, he had studied painting in France before becoming a draughtsman with Honeyman & Keppie where he met Mackintosh.

Enter the director...Fra Newbery, an Englishman, who had only recently been hired as the principal of the school when the two friends had started classes. He was known to encourage individuality and being English he was a supporter of the Arts and Crafts movement—in 1893 he sponsored a series of lectures at the School on the English movement.

Fra Newbery recognized that the early work of Mackintosh and McNair was similar to that of two day students, the MacDonald sisters, and he arranged for them to meet. The rest, as they say, is history.

They became known as "The Glasgow Four" after their first exhibition together and they worked in collaboration on various projects including furniture, illustration, metalwork, and jewelry.

The MacDonald sisters had been born in England and moved to Scotland in their teens. Their family lived in a house purchased from Talwin Morris who was himself to became an important Scottish Arts and Crafts jeweler.

By the time they began attending art school, Margaret and Frances were excellent illustrators who took inspiration from a number of sources including the work of the Englishman Aubrey Beardsley, whose drawings they had seen in *The Studio*. He had come into his own about the time they began working and he used the human figure in a symbolic way much as they would do in their own work. Beardsley had decided to become an artist after visiting the studio of the Pre-Raphaelite painter Edward Burne-Jones. In fact, the world of symbols and use of the female as a central element by the Pre-Raphaelite painters was probably another influence—the MacDonald sisters were surely familiar with the works of these artists.

The Symbolist painting "The Three Brides" by the Dutch artist Jan de Toorop (de Toorop was of Indo-Germanic heritage) was illustrated in *The Studio* and bears a similarity to their work as well.

A surge of nationalism sweeping through Scotland in the 1890's and the Celtic heritage is also encompassed in the MacDonald's work. Margaret and Frances were accused of being influenced by the Art Nouveau movement as well. As the Art Nouveau designers made use of Symbolism there was a connection, yet their style was very much their own.

At the time the MacDonalds were working there was a "spiritualist revival" movement also occurring in Europe to some extent based on Eastern religion. Theosophy and related movements such as that of the spiritualist Rudolf Steiner were popular. These influences to which artists were drawn added spiritual and poetic significance to their creations and it is easy to observe this in the MacDonald's paintings and drawings. It is also known that some of the Glasgow

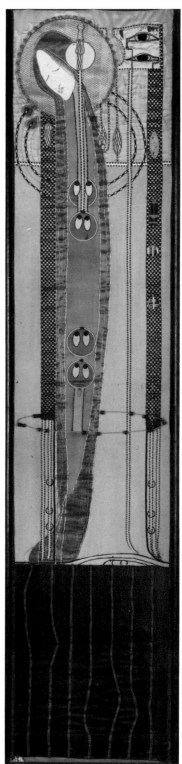

Embroidered panel by Margaret MacDonald.
Collection of the Glasgow School of Art

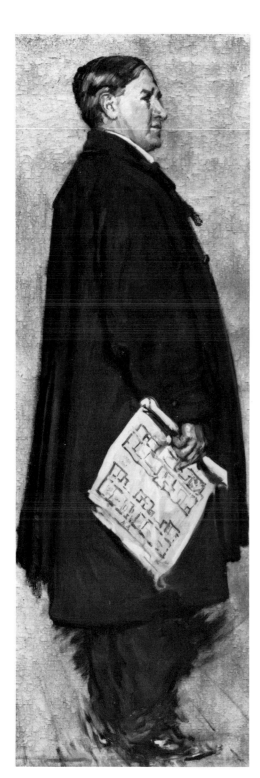

Charles Rennie Mackintosh by Francis Henry Newbery. *Scottish National Portrait Gallery, Edinburgh*

artists at this time used laudanum which is a deriavative of opium (the poet Coleridge was under the effects of laudanum when he wrote his famous poem "Kubla Khan") although no one has ever specifically suggested that any of "The Glasgow Four" partook of it.[1]

This melding of influences resulted in a dreamy, eerie style often with women as the subject (another commonality with Art Nouveau) dubbed by many "the Spook School" for its other-worldly quality. Their figures usually appeared sad or weepy and are emotionally charged. The heads, faces and hands are carefully drawn but the torsos are more abstract, almost ethereal.

Charles Rennie Mackintosh designed buildings, interiors and furniture based on organic shapes in nature that worked well with the sisters' style. Herbert McNair opened a design firm focusing on furniture, book illustration and posters also in a similar vein. After finishing school in 1896 the women opened a studio together to produce book illustrations, embroidery, gesso work, leaded glass and repoussé metalwork.

The four often worked on projects as a group until after their marriages (the McNairs wedded in 1899, the Mackintoshes in 1900); then they most often worked only as couples. Charles and Margaret's collaboration was the more successful one; she made great contributions to his work although she is generally not recognized to the full extent of her involvement.

Mackintosh eventually had a falling out with Honeyman & Keppie; perhaps it was inevitable. He hadn't been too popular with John Keppie after breaking his engagement to Keppie's sister Jessie to marry Margaret Macdonald. To "rub salt in the wound," Jessie Keppie *never* married.

Although he received a number of important architectural commissions including the design of a new building for the Glasgow School of Art, several private homes, and Mrs. Cranston's tea rooms (opened to provide a place for Glaswegians to congregate other than bars), Mackintosh was never really much appreciated in Scotland—he was too much ahead of his time. When the "Four" exhibited in London in 1896 at the Arts and Crafts Society the general reaction was shock at their "grotesque" work and they were not asked to exhibit again.

This reaction was not without precedent. Beginning in the 1860's a group of painters in Glasgow had begun to paint in the "French" Impressionist style and were dubbed "The Glasgow Boys". Failing to achieve the notice they wished, most of them left Scotland to find a place they would be better appreciated. Mackintosh, also, had too much imagination for conservative Scotland—he was seeking to create a new Scottish style but with the exception of a few visionary patrons, the Scots weren't ready for it.

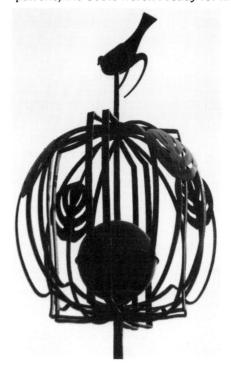

Wrought iron finial from the Glasgow School of Art designed by Charles Rennie Mackintosh. *Collection of the Glasgow School of Art*

Panel of lettering by Charles Rennie Mackintosh, 1901. *Mackintosh Collection, Hunterian Art Gallery, University of Glasgow*

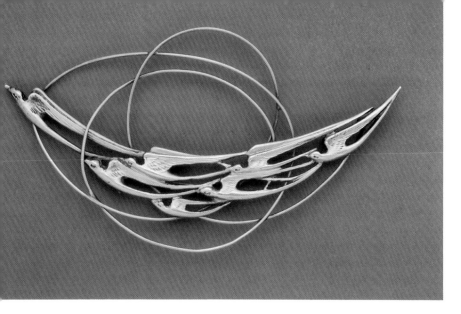

This gilt brooch by Peter Wylie Davidson strongly resembles the single necklace design attributed to Charles Rennie Mackintosh (which actually may have been designed by Frances McNair.) The stylized swallows are in wirework clouds. The brooch dates c. 1902 and is engraved "P.W.D." Davidson is known to have executed work for the Mackintoshes and the McNairs. *Courtesy of Christie's, London*

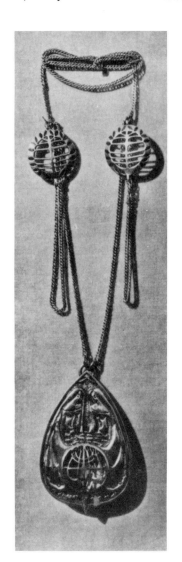

Pendant in beaten silver, pierced and enamelled to hold a crystal locket, by Frances McNair.

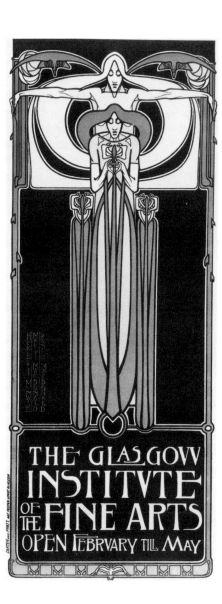

Photo of Frances McNair in an artistic dress. *Mackintosh Collection, Hunterian Art Gallery, University of Glasgow*

Glasgow Institute Poster by Herbert McNair, Margaret MacDonald and Frances Macdonald McNair, 1896. *Mackintosh Collection, Hunterian Art Gallery, University of Glasgow*

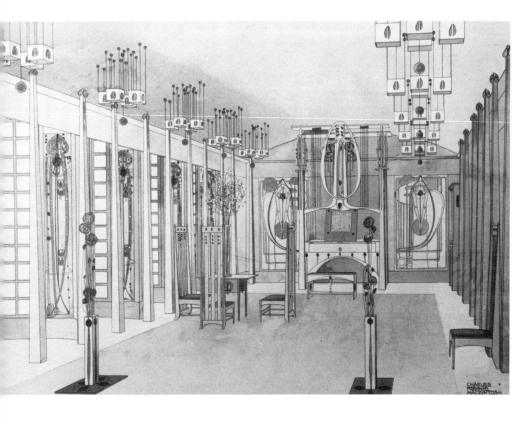

Design for a music room from the Art Lover's House by Charles Rennie Mackintosh. Panels designed by Margaret Macdonald Mackintosh. *Mackintosh Collection, Hunterian Art Gallery, University of Glasgow.*

C.R. Mackintosh Rose and Teardrop textile design, c. 1915-23, watercolor, ink, goache and pencil. *Mackintosh Collection, Hunterian Art Gallery, University of Glasgow*

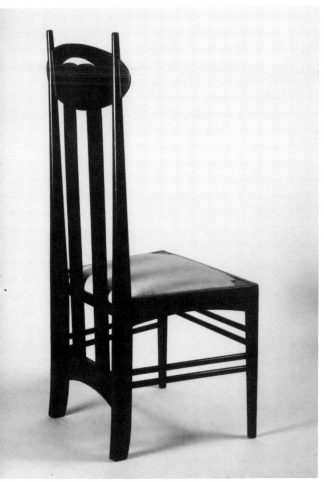

Chair by Charles Rennie Mackintosh. *Courtesy of Barry Friedman, Ltd., New York*

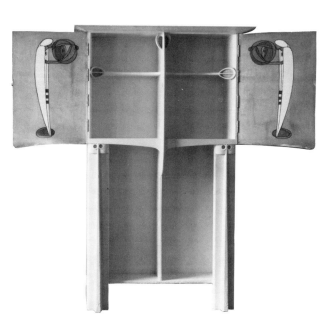

White cabinet for 120 Main St., 1902. Note the Glasgow Rose Motif.

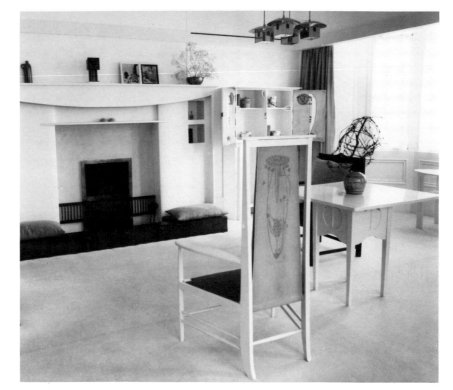

Mackintosh House drawing room. *Mackintosh Collection, Hunterian Art Gallery, University of Glasgow*

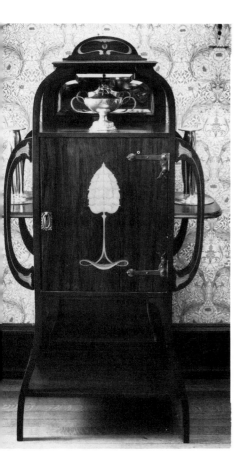

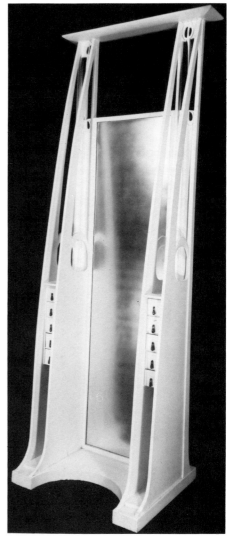

This Glasgow school cabinet c. 1900 has a graphic silhouette and very refined marquetry stylized thistle on the door, side supports and the curved top. *Courtesy of Calderwood Gallery, Philadelphia*

Charles Rennie Mackintosh Cheval Mirror for the bedroom of the Mains Street flat. Oak painted white with glass panels and metal handles. *Mackintosh Collection, Hunterian Art Gallery, University of Glasgow*

The Mackintoshes were better understood in Vienna where they were invited to exhibit their work several times and had a significant influence on the work done by the Wiener Werkstätte. One recognizable example is the black and white checked fabric Mackintosh designed and which was jokingly referred to as his "tartan"; it turns up repeatedly in the Werkstätte repetoire. The simple lines of his furniture certainly were translated into Werkstätte vocabulary, as were the slim handles and geometric designs of the silverware he designed for the Ingram Street Tearoom.

Design for advertisement for Miss Cranston's tea room by Jessie M. King. *Mackintosh Collection, Hunterian Art Gallery, University of Glasgow*

Cutlery for Miss Cranston's tea room designed by Charles Rennie Mackintosh. *Courtesy of Barry Friedman, Ltd., New York*

Tea room mural design, 1896, by Margaret Macdonald. *Mackintosh Collection, Hunterian Art Gallery, University of Glasgow*

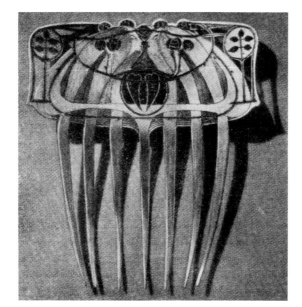

Hair comb in silver and enamel by Frances McNair.

Brooch in beaten silver and wire by Herbert McNair.

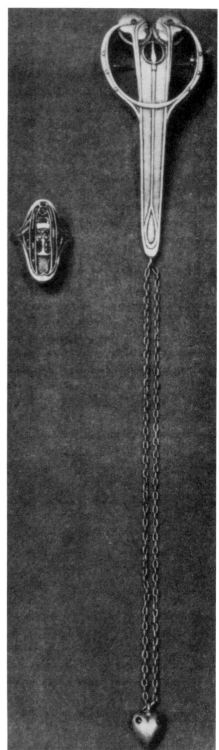

In America, the architects Frank Lloyd Wright and Greene and Greene owed a debt to Mackintosh as well. Mackintosh believed in designing a total environment with every aspect of decoration made to work together. When one enters his re-created living room in the Hunterian Museum in Glasgow it is almost a religious experience—the simple lines of the furniture and fabrics, and the almost completely white interior fills one with a feeling of serenity. Wright and the Greene brothers were also to design complete environments with the same Japanese inspired tranquility.

When he found it difficult to find financial success and recognition in his own country Mackintosh became disillusioned and eventually abandoned architecture and design. By some reports he also became a heavy drinker. He and Margaret moved to France where his spent his time doing watercolors until he became ill and the Mackintoshes then moved to England where he was to die.

Although the Mackintoshes and McNairs designed only a small amount of jewelry and metalwork, they were responsible for influencing most of the young Scottish designers of jewelry and metalwork and others in the movement in Glasgow. The majority of them attended the School of Art and could not help but be affected by them.

In the work of these craftsmen can be seen the use of motifs and techniques developed by "The Four". Best known is the Glasgow rose—a stylized rose which is a circle crosscut by several lines that denotes petals. It may have actually originated from appliqued work done by Fra Newbery's wife Jessie. Also the use of beaten and repoussé metal, a perfect medium for their highly stylized linear designs, as well as the Japanese influence, stylized female figures, birds and plant forms became popular with Glaswegian artisans.

Charles Rennie Mackintosh is believed to have designed only two pieces of jewelry, a necklace and pendant which depicts birds in flight through clouds and raindrops, and a silver ring with pearls, amethysts and rubies, but his decorative elements turned up in other artisan's jewelry. The necklace is questionable—it may have actually been designed by Frances McNair and was probably executed by the jeweler Peter Wylie Davision.

He designed a small quantity of metalwork including a brass jewel casket for Jessie Keppie and silverware for Miss Cranston's tea rooms, William Davidson's home Windy Hill, a christening set for Hermann Muthesius' son (a German architect who came to Great Britain to observe the decorative arts movement) and for the Newberys. A silver casket set with lapis lazuli and chalcedony was designed by Mackintosh and executed by Peter Wylie Davidson. It was given to Sir James Fleming by the contractors who built the Glasgow School of Art. Although Mackintosh's metalwork output was small, he used the medium in many other innovative and important ways.

Silver finger ring set with pearls, amethysts and rubies by Charles Rennie Mackintosh and a silver brooch and pendant heart set with rubies, pearls and turquoise by Margaret MacDonald Mackintosh.

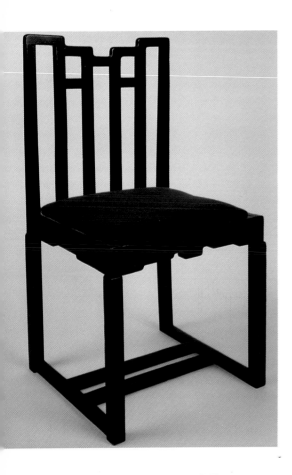

A great deal of ornamental ironwork is set in the interiors and exteriors of Mackintosh's buildings, most notably in the Glasgow School of Art. There were metal inlays and repoussé panels fitted into his furniture and he designed locks, handles and hinges. Margaret also designed metalwork which was set into his furniture and interiors.

Margaret and Frances Macdonald on their own designed a small amount of jewelry and a good deal of metalwork. Margaret also cleverly worked glass beads into some of her embroideries. The sisters made ornamental repoussé and beaten metal objects which took the form of the aforementioned panels that were placed in furniture, frames for their pictures, and domestic items. They often combined metalwork, silverwork, embroidery and gesso work all in one piece. At the 1896 Arts and Crafts Exhibition in London Frances displayed a hammered aluminum panel, "The Star of Bethlehem" and Margaret the companion piece "The Annunciation". They also exhibited a clock in beaten silver, a muffin stand and beaten brass candlesticks.

Sidechair for Chinese Room of Ingram Tea Rooms. By Charles Rennie Mackintosh, 1911. *Courtesy of Barry Friedman, Ltd., New York*

Clock face by Margaret and Frances Macdonald, 1896. Beaten tin with enamel on wood frame. *Mackintosh Collection, Hunterian Art Gallery, University of Glasgow*

Metal insert for over the mantel at 78 Southpark Avenue which was originally part of a screen exhibited in Vienna by Margaret Macdonald, 1899. *Mackintosh Collection, Hunterian Art Gallery, University of Glasgow*

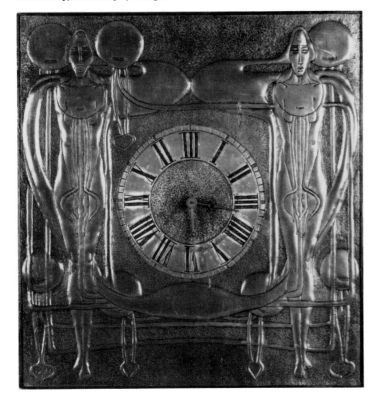

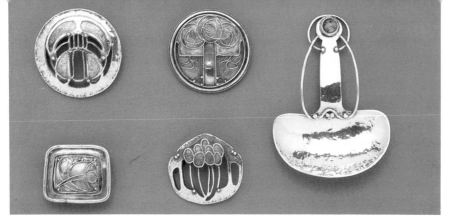

Margaret's known pieces include a silver pendant with two female heads facing each other, and a silver brooch with a pendant heart set with rubies, pearls and turquoise. Four white metal and enamel brooches, one with a Glasgow rose design, were attributed to Frances but were marked "R" at a Christie's, London auction of arts and crafts jewelry in 1992. A tea caddy spoon with enamel decoration was also attributed to Frances in that sale.

Frances and Herbert together designed a small quantity of jewelry which was probably executed by Frances. Little survives today, but it known that they made jewelry when they were living in Liverpool and exhibited in St. George's Hall there in 1901, and at the Turin International Exhibition in 1902. The existing designs for this jewelry illustrate that the jewelry made use of the Glasgow rose motif, the heart, leaves, and woman's heads, and were mainly pendants in silver with enamel and semi-precious stones. Designs for a hair comb in silver and enamel, a vinaigrette and chain, and belt buckles and brooches in beaten silver using human figures encased in wire work have been attributed to Herbert. The Kanthach Medal designed by Herbert in 1900 is of cast bronze and decorated with a nude female bust and stylized roses. There also exists a silver tea caddy and spoon designed by the McNairs for one of Herbert's sisters and sugar tongs designed for a wedding gift.

One reason that not much remains may be that as a reclusive old man living in a nursing home Herbert McNair is known to have destroyed much of the art work he and Frances produced. Perhaps he destroyed other things as well to forget the largely unhappy life they had shared.

In 1899 Herbert was offered a teaching post at the School of Architecture and Applied Art at University College in Liverpool which he accepted. After several years he resigned his post and he and Frances taught at the progressive Sandon Studios Society School which shut down in 1908. The McNairs then returned to Glasgow where Frances taught metalworking and enamelling at her alma mater (Glasgow School of Art). She taught out of neccessity to support her husband and their son Sylvan.

Herbert managed with odd jobs but did not teach again. Presumably he gave up design work as well. They continued to have financial troubles and Frances' family tried to send him off to Canada—whether their motive was to help him to look for prospects or to free their daughter of him is unclear. He did return and opened a garage. In 1921 Frances died of what was said to have been a brain hemorrhage but was rumored to have been suicide. After her death McNair is said to have drowned his sorrows in drink.

Only a small quantity of Scottish Arts and Crafts jewelry and metalwork survives today, nonetheless it was an important part of the decorative Arts and Crafts movement at the turn-of-the-century in Scotland. Equally important was embroidery which was elevated to an art by Fra Newbery's wife Jessie, head of the embroidery department at the School. The Artistic and Rational dress movement had taken root in Glasgow as well as London, and Jessie Newbery was at the forefront designing her own artistic clothes, often with embroidery, which went so well with the Art jewelry.

Many of the young women who studied at the School of Art were excellent in several areas often metalwork, jewelry and embroidery as well as other arts. It is notable that there were few males students from the School who are known today as jewelers or metalworkers.

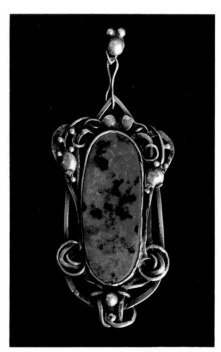

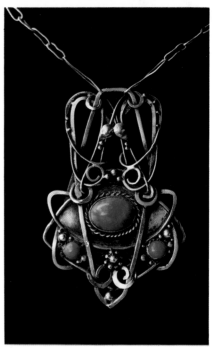

Two pendants from the Glasgow School. Silver, and opal with turquoise, c. 1900. *Courtesy of Tadema Gallery, London*

Pendants by Peter Wylie Davidson.

Mirror frame by DeCourcy Lewthwaite Dewar featured in *The Studio. Courtesy of Leah Roland/Split Personality, Leonia, New Jersey. Photo by Diane Freer.*

The best known designers from Glasgow are the following:

Janet Macdonald Aitken (1873-1941)

An artist and metalworker, Aitken studied at the Glasgow School of Art and the Atelier Colarossi in Paris. Aitken was primarily a portrait and landscape artist, but exhibited her metalwork as a student and early in her professional career. Her jewelry was sold through the Scottish Guild of Handicraft, a juried co-operative association for craftsmen to sell their wares to the public.

Peter Wylie Davidson (1870-1963)

Davidson studied drawing at the Glasgow School of Art and then worked for the silversmithing firm of James Reid and Co. in Glasgow.

While working for Reid he began teaching metalwork at the School of Art and in 1897 one of his students was DeCourcy Lewthwaite Dewar, who was to emerge as one of the most important Scottish Arts and Crafts designers.

In 1905 he left Reid's employment and went into partnership with his brother W.A. Davidson producing commissioned repoussé silver items and some jewelry as well. Their firm was located in the same building where Dewar had her studio.

When Dewar began teaching her own classes at the School of Art, Davidson helped her with the curriculum and in 1910 he co-taught with her and remained an instructor at the school until 1935. Davidson authored two books, *Applied Design in the Precious Metals* and *Educational Metalcraft*, which became important texts in Great Britain for craft classes.

Two long slender pendants in the Glasgow Style by Davidson are shown in the book *Art Nouveau Style.*[2]

In 1992 several pieces of jewelry by Davidson were sold at Christie's London. One was a white metal pendant of pierced and openwork with repoussé decoration of Hamlet and an opal set chain. It was inscribed "Alas poor Yorick". Also sold in that sale was a pendant designed by Jessie M. King and engraved "Glasgow School of Art" and a gilt brooch of a crescent of stylized birds in a fitted case dated 1902. This piece is very similar to one of the few pieces of jewelry attributed to Charles Rennie Mackintosh (but possibly designed by Frances McNair) that may have been executed by Davidson. He is known to have executed some work for Mackintosh and the McNairs that carried only his mark.

W. Armstrong Davidson

The brother of Peter Wylie Davidson, and also his business partner, Davidson was a metalworker who probably was a student at the Glasgow School of Art. A silver and enamel bowl made by W. Armstrong Davidson was designed by Dorothy Carleton Smythe and enamelled by Decourcy Lewthwaite Dewar, both important metalworkers who came out of the School.

DeCourcy Lewthwaite Dewar (1878-1959)

Dewar was born in Sri Lanka but lived most of her life in Glasgow. She attended the Glasgow School of Art and then taught metalwork and enamelling there for many years. She was also a graphic designer, painter and engraver.

Dewar made silver objects, many ornamented with repoussé work, and jewelry in the Glasgow style. Her work, frequently decorated with Limoges enamels, included plaques, mirror frames, sconces, clocks, caskets, buttons, vases, jardinières, covered cups, furniture inserts, etc.

A number of enamelled pendants, probably her earlier work, were created by her using the motifs of the "mystic eye", the Glasgow Rose, the Glasgow square, bats and butterflies.

Dewar was well-represented at international exhibitions with metalwork which was both practical and ornamental. It was created in her studio on Hope St. in Glasgow from 1900-26 and after 1926 on Woodside Terrace in that city. She was represented by the Scottish Guild of Handicraft, a juried co-operative group for artisan's to sell their work.

Influenced to some extent by her friend and colleague, Peter Wylie Davidson (see his biography) her work also shows an interest in heraldic art and Celtic design. She collaborated with Davidson on at least one piece—a commissioned trophy for the Glasgow Boys' Choir competition.

Dewar also met Alexander Fisher a number of times who may have had some impact on her enamel work. Dewar's enamelled pieces are done in strong colors with the earlier pieces in the Glasgow style and the later pieces being more geometric. Some show her interest in bright Czechoslovakian folk art, which

more than a half century later has become a popular collectible. During World War II she helped found a Scottish Czechoslovak Club in Glasgow. Her work includes repoussé and enamel picture frames. caskets, enamelled panels, tea caddies, and mirror frames.

Dewar supported the Suffragette movement and other social causes and some critics say her social conscience "diverted" her energies from her work. Her work appeared often in *The Studio*.[3]

Margaret (1860-1942) and Mary (1872-1938) Gilmour

These sisters were both metalworkers who studied at the Glasgow School of Art.

In 1893 they opened a studio on West George Street in Glasgow to teach several crafts including brass and pewter metalwork, which they maintained for almost fifty years. Although they were well-known in Glasgow, they never looked for recognition beyond the city, primarily doing local commissions for mirror frames, sconces, clocks, desk sets, jardinières and other household items.

The Gilmours, like so many Glasgow artists, were fond of Celtic motifs, and often worked in beaten brass and copper, decorating it with a jewel-like enamel.

Margaret was especially prolific and displayed her work, much of it ornamented with the Glasgow Rose motif, at the Glasgow Exhibition in 1901.

Three waist buckles by Liberty & Co. Top, c. 1910, by Jessie M. King. *Courtesy of Tadema Gallery, London*

Cloak clasp by Agnes Bankier Harvey.

Agnes Bankier Harvey (1874-1947)

Attending the Glasgow School of Art from 1894-99 where she was a student of Frances MacDonald McNair. Harvey also studied at the London School of Silversmithing. She then taught metalworking, silversmithing, goldsmithing and enamelling at the School of Art.

Harvey contributed jewelry every year to exhibitions of the Lady Artist's Club of which she was a member (Charles Rennie Mackintosh designed the doors for the club) and privately she made items in beaten and repoussé brass and a number of commissioned badges.

Harvey studied in London with a Japanese cloisonné master (possibly Kato who worked for the Stablers) and made a number of pieces of enamelled jewelry using this technique as well as applying it to other metal objects such as the altar cross of brass and cloisonné now in the Glasgow Art Gallery and Museum. A white metal and enamel pendant with small Glasgow Rose designs was attributed to Harvey in the 1992 Christie's, London sale of Arts and Crafts jewelry.

She was a member of the "Green Gate Close Coterie", a group of Glasgow artists who followed Jessie M. King to rural Kircudbright to work. Her cottage in Kircudbright had a purple door, her own brasswork on the walls and a special stove for her enamel work.[4]

Harvey exhibited internationally and won a number of awards.

David W. Hislop

Hislop was a Glasgow jeweler and metalworker who executed some work for Charles Rennie Mackintosh. His mark is on some of the cutlery Mackintosh designed for Mrs. Cranston's tearooms and one piece of a Christening set designed by Mackintosh.

Jessie Marion King (1873-1949)

One of Scotland's best-known illustrators, King grew up in the outskirts of Glasgow and then attended the Glasgow School of Art. Even in those early days as an artist, she was considered a little eccentric "dressed like a witch in a flowing black cloak, buckled shoes and a wide-brimmed hat". It was said that she sometimes claimed she was a descendant of a Major Weir who had been burned at the stake during Mary Queen of Scots' reign.[5]

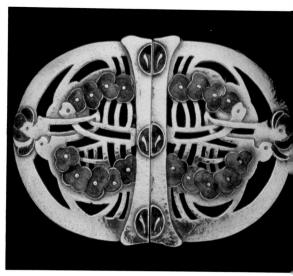

Belt buckle by Jessie M. King for Liberty & Co. c. 1900, silver and enamel. *Courtesy of Tadema Gallery, London*

Portrait of Jessie Marion King by Helen Paxton Brown. *Scottish National Portrait Gallery, Edinburgh*

After graduating from the School of Art, King was appointed lecturer in book decoration at the School of Art. Along with her illustrations, her book binding designs are quite well known, but she was also an important designer of jewelry and fabric for Liberty & Co.; she also made pottery and did batik work.

After teaching at the Glasgow School of Art for a number of years, King married the furniture designer E.A. Taylor in 1908 and moved to England for several years and then to Paris in 1911 where they opened a studio. In 1914 World War I forced them to return to Kircudbright, Scotland where she lived until her death. A number of other Glasgow artists settled in Kircudbright or stayed there frequently due to King's presence.

King's early style was influenced by the "Glasgow Four" but she evolved away from this style over the years. According to her biographer, Colin White, "in the work of 'The Four'" Jessie found images that were not unlike those of her own secret world. Hers, though were less menacing than those of the 'Spooks.'[6]

Her relationship with Liberty & Co. began with fabric designs and then continued with the jewelry designs she created for the company.

Most of her jewelry used floral designs, including roses and forget-me-knots and relate in style to work she did for a book "The Defence of Guineivere and Other Poems,", published by William Morris in 1905. There were "head and tail pieces" on each of her illustrations and these translated into the jewelry designs.

King also liked Japanese design and this can be seen in the "Ying/Yang" motifs in some of her jewelry for Liberty & Company. She liked to use swallows in some of her work, many enamelled in blue. The jewelry designed for Liberty consisted of necklaces, pendants, brooches, clasps, buckles and buttons. A toilet set with powder box, clothes brush, hair brush, hand mirror and a tortoiseshell comb of King's design were also in the Liberty line.

Silk fabric Liberty & Co. jewelry box c. 1900 designed by Jessie M. King. *Courtesy of Tadema Gallery, London*

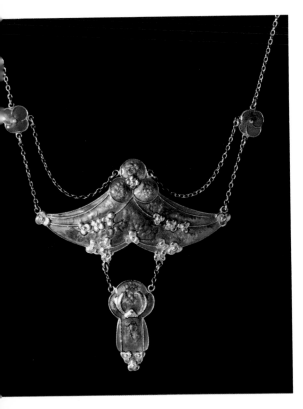

Necklace for Liberty & Co. by Jessie M. King. Silver and enamel, c. 1900. *Courtesy of Tadema Gallery, London*

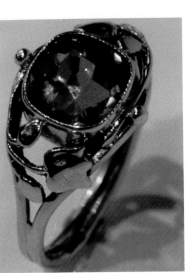

Jessie M. King designed this ring of gold and pink tourmaline c. 1900 made for Liberty & Co. This ring is illustrated on pg. 73 of Liberty's catalogue no. 4189 of 1898. *Courtesy of Tadema Gallery, London*

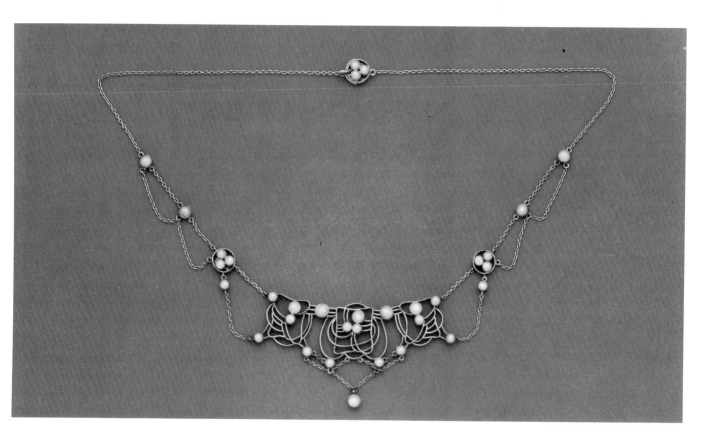

Necklace of gold and pearls designed by Jessie M. King for Liberty & Co. This was illustrated in *The Studio* in 1909. *Courtesy of Tadema Gallery, London*

George Logan

Primarily a furniture maker, George Logan designed items for the Glasgow firm of Wylie & Lockhead including some metalwork in the Glasgow style with Glasgow motifs.

Talwin (Talwyn) Morris (1865-1911)

Morris was the art director of Blackie and Sons, a Glasgow publisher, (Charles Rennie Mackintosh designed a house for Walter Mackie) and did metalwork as well.

Although never a student at the Glasgow School of Art, he was closely associated with the Macdonalds and the Newberys. In the book *The Glasgow Style* Gerald and Celia Larner say Morris "could almost be counted a fifth member of what *The Studio* called the "MacGroup." Morris had been brought up by a spinster aunt who wanted him to enter the Church, but he quit in the middle of his studies and went to work for his uncle, an architect, from whom he received his design training.

His jewelry, little of which survives, included brooches, shoe buckles and cloak clasps of hand-beaten copper, silver and aluminum. He ornamented both his jewelry and his metalwork with enamels and colored glass, and often used a heart-shaped motif on his copper mirror frames. One issue of *The Studio* featured a peacock firescreen and repoussé metal cats by Morris.

Morris made a good number of beaten metal pieces—door handles, finger plates, panels, etc.—for his own house at Dunglass Castle which he later sold to Margaret and Frances MacDonald's parents.

Buckle in beaten aluminum by Talwin Morris.

Waist-band clasp in beaten silver by Talwin Morris.

Embroidered dress by Jessie Newbery with metal closures. *Collection Glasgow School of Art*

Pendants by Isabel Spence.

Jessie Newbery (1864-1948)

Jessie Newbery was the wife of Fra Newbery, the guiding force behind the talent at the Glasgow School of Art from 1885 to 1918. She established the Department of Embroidery at the school and elevated embroidery to an art form during the Arts and Crafts period. She also designed "art" clothing compatible with the tenets of the Rational Dress movement.

Newbery taught classes in mosaics and enamels and designed several metalwork pieces including a silver repoussé chalice and paten and a repoussé alms plate. Both were executed by Kellock Brown and exhibited at the Fourth Exhibition of the Arts and Crafts Society in 1893.

Muriel Boyd Sandeman (1888-1981)

Attending the Glasgow School of Art, Sandeman became an important painter and embroiderer. She also produced enamelled pendants and belt clasps during her student years.

Dorothy and Olive Carleton Smythe (Smith)

Another sister team who attended and taught classes at the Glasgow School of Art, Dorothy and Olive were talented in many disciplines. Between them they taught no less than gesso, wood blocks, printmaking, metalwork, gold and silversmithing, repoussé work, mosaics, miniature painting, lithography, the history of costume and illumination.[7]

Dorothy's principal interest was theatre and costume design while Olive's was gesso work and other painting mediums. They designed some silver items in the Glasgow style with Limoges enamel decoration.

A silver and enamel bowl was auctioned at Sotheby's in Scotland in 1991 which was marked with D. Carleton Smythe as the designer. The maker was W. Armstrong Davidson, DeCourcy Lewthwaite Dewar the enameller, and the logo of the Glasgow School of Art was also on it. It bore the maker's mark JR in an oval, possibly for James Reid, a Glasgow firm.

Isabel Spence

Spence attended the Glasgow School of Art and designed jewelry in the Arts and Crafts style.

E.A. Taylor

A Glasgow furniture designer primarily, Taylor also designed architectural metalwork such as doorplates and fingerplates. He was married to the jewelry designer and illustrator Jessie M. King.

Mary Thew (1876-1953)

A metalworker and jeweler, Thew became friends with Jessie M. King and her husband E.A. Taylor when they all attended the Glasgow School of Art and became a member of the "Green Gate Close Coterie". This was a group of artisans who came to live year round or for extended periods of time in Kircudbright, a charming village where King and Taylor had settled after returning from living in Paris.

Thew's professional history is a bit different from most of her contemporaries as she married and had a family after school, and returned to jewelry-making later in life when she needed to earn a living. Before moving to Kircudbright she studied with Rhoda Wager (please see the fourth chapter) and was a member of the Glasgow Society of Lady Artist's Club, exhibiting with them and winning an award in 1925.

Her jewelry—brooches, rings, and necklaces—were principally of the Arts and Crafts style with Celtic influences and she also made small boxes. Thew's "trademark" was wire work surrounding semi-precious stone inserts and other materials such as abalone and enamel.

Several pieces of jewelry by Thew were auctioned by Christie's, London in 1992—a white metal openwork brooch set with abalone shell, wirework decoration and blister pearl; an openwork sailing ship with baroque pearls, citrine and amethyst; and a white metal hatpin set with agate.

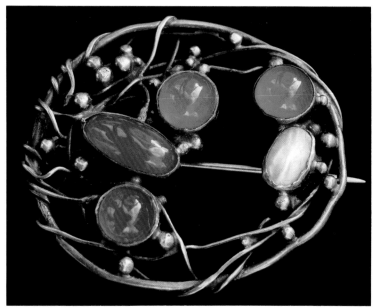

Dress by Jessie Newbery. *Manchester City Art Galleries, England*

Silver brooches by Mary Thew: one with a blister pearl and chrysoprase; another with abalone shell and a blister pearl; and a third of a sailing ship set with baroque pearls, citrine and amethyst. *Courtesy of Tadema Gallery, London*

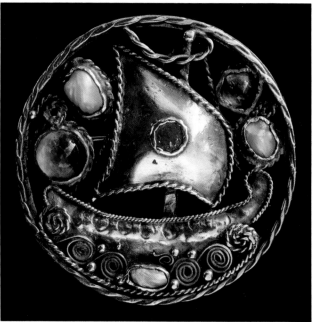

Fireplace in a billiard room, George Walton.

Snake bracelet by James Cromer Watt is of yellow metal and foiled enamel set with an opal. It has the monogram "JCW" stamped on it. *Courtesy of Christie's, London*

Pendant by James Cromer Watt. Cabochon sapphire surmount, seed pearls, large freshwater baroque pearl between a pair of entwined polychrome enamel dragons, with three oval-shaped sapphires, collet set as drops. *Courtesy of Sotheby's, London*

George Walton (1867-1933)

A Scottish interior designer and designer of metalwork including cast iron work, Walton worked in an Art Nouveau-related style and was also influenced by "The Glasgow Four". He executed some of Charles Rennie Mackintosh's designs and had his own design firm in Glasgow where he was associated with E.A. Taylor, Jessie King's husband. In 1897 he went to London where he did some designing for Liberty & Co. and designed wallpaper for Jeffrey & Co., a firm that printed wallpapers for Morris & Co. He also designed Clutha glass for James Couper & Sons of Glasgow.

James Cromer (Cromar) Watt

Cromer Watt was a student at the Glasgow School of Art in 1900 who was a trained architect and also became a jeweler. A collector of Oriental art, this influence can be seen in some of his work.

Watt had a workshop in Aberdeen on the east coast of Scotland where he worked mainly in gold, contrary to the custom of most Arts and Crafts jewelers. His pendants, brooches, and small boxes are enamelled with cloisonné and opalescent enamels with gold and silver foil (paillons), blister pearls and often a curved heart motif.

James Cromer Watt enamel and garnet set box c. 1900. *Courtesy of Van Den Bosch, Georgian Village, London*

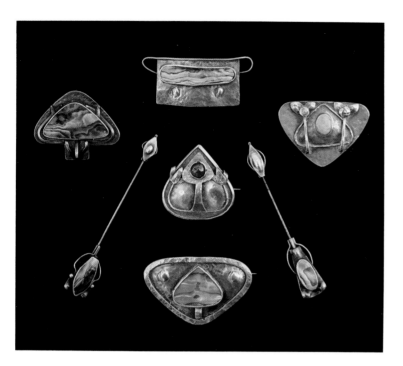

Margaret and Mary Wilson

These sisters were well-known jewelers in Glasgow at the turn-of-the century. Five white metal brooches, three set with abalone, one with opal and one with garnet by them were auctioned at Christie's, London Arts and Crafts jewelry sale in 1992.

Marion Henderson Wilson (1869-1956)

Wilson was a metalworker who attended the Glasgow School of Art for a number of years.

She worked primarily in the repoussé technique in brass, copper and tin. Her work is recognizable because she often used faces as motifs, as well as Celtic designs, the Glasgow rose and a cabbage design. Two of her pieces include a repoussé brass wall sconce designed with a female head with stars and hearts and a repoussé tin triptych of a girl seated in a rose arbor, done in 1905.

Helen Muir Wood (1864-1930)

Wood trained with Charles Rennie Mackintosh at the Glasgow School of Art and later taught enamels and wood block cutting there. Wood's work in metal, stained glass and painted ceramics received international attention and her metal work was featured in *The Studio*. She was a member of the Glasgow Society of Lady Artist's Club and exhibited with them and other places as well. A pewter mirror frame with repoussé stylized thistles was offered at auction in 1992.

Door fitting of beaten brass designed and made by John Guthrie, a student at the Glasgow School of Art c. 1900. *Nordenfjeldske Kunstindustrimuseum, Trondheim*

Embroidery by Phoebe Traquair. "The Entrance" part of the Denys series. *National Gallery of Scotland, Edinburgh*

Quaich by Hamilton and Inches, Edinburgh. Hallmarked 1906. The two-handled bowl is a traditional Scottish form of drinking vessel. The word comes from the Gaelic "cuach" which means cup. *Cheltenham Art Gallery and Museum, England*

Edinburgh

An Arts and Crafts movement also caught on in Edinburgh in the 1890's but not on the same scale as it had in Glasgow. A century later only a few Edinburgh artisans are still well-known to us whereas the work of many more Glaswegian artists have stood the test of time. At the turn-of-the-century Glasgow was known for its metalwork and Edinburgh for its enamel. In Edinburgh the education of a craftsman was usually at one of two schools. The Old Edinburgh School of Art was founded by John Duncan in 1892 to provide design classes as occupational training for students who wished to work in the areas of printing and bookbinding, embroidery, jewelry, silversmithing, and brass working. Duncan's school was considered anti-establishment and irregular in its lack of formality. He sought to create a cultural identity for young Scottish artists and promote a Celtic revival. Like the group in Glasgow, his students took ideas from what was happening on the continent *and* the English Arts and Crafts movement and combined it with their Celtic heritage to create their own unique Scottish style. Celtic Ornament was even a course taught at the school. Antithetically, the official School of Applied Art run by architect Robert Rowan Anderson took a scholarly approach to local Celtic revival by surveying the national heritage of buildings and interior decorations. The School offered classes for architects, cabinet makers and engravers. Other significant developments in Edinburgh were the formation of the Society of Scottish Artists in 1891, the Scottish Society of Art Workers and the Scottish Guild of Handicraft in 1898. These organizations were formed to help craftsmen reach the Scottish market with their work. In addition to the two schools there were also a number of private studios that sprang up throughout the city. The best known today was that of Phoebe Traquair. The biographies of Ms. Traquair and several other Edinburgh artisans follow:

Lady Gibson Carmichael

Lady Carmichael was an enamelling student of Alexander Fisher's and was also friendly with the noted Scottish jeweler Phoebe Traquair. Her husband, Lord Carmichael was a patron of the arts and commissioned several major pieces by Fisher. Carmichael and Traquair worked in Edinburgh both setting brilliant-colored translucent enamels in a Medieval style into caskets, triptychs and jewelry.

Thomas Hadden

Hadden made architectural and domestic ironwork with bird and animal motifs. He did a number of commissions for the noted architect Sir Robert Stodart Lorimer.

Hamilton and Inches (1866-still in business)

This retail and manufacturing jeweler located in Edinburgh, was founded by Robert Kirk Inches and his uncle James Hamilton.

A hammered silver quaich (a traditional Scottish cup with two handles) in the Arts and Crafts style made by the firm is in the collection of the Cheltenham Art Gallery, England and is hallmarked Edinburgh 1906.

The firm made and installed the big clock on Edinburgh's North British Station Hotel in 1902. Some of the firm's later work in the 1930's show the influence of Georg Jensen's work.

Sir Robert Stodart Lorimer

Sir Robert weas a well-known Scottish architect, who designed jewelry and enamel metalwork that was executed by Phoebe Traquair. He also designed architectural metalwork which was made by several artisans.

J.M. Talbot

Talbot was a jeweler who probably worked from his own designs as well as executing work designed by others. Three pieces of jewelry made by Talbot were offered for sale in the Arts and Crafts jewelry auction at Christie's, London in 1992. These included a silver waist clasp with a Celtic entrelac design set with amethysts, 1904; another clasp with the profiles of winged maiden's heads worked in repoussé and a third in repoussé work and with an enamel plaque of an ibis.

Phoebe Ann Traquair (1852-1936)

A true Renaissance woman, Traquair was born in Ireland, educated at the Dublin School of Art, and lived and worked in Edinburgh. She is known for her beautiful enamel work which is reminiscent of Alexander Fisher's work. There is a spiritual feeling in her enamels which are often done in plaques and then set into jewelry or on copper and silver boxes. Her work is a happy marriage of English Arts and Crafts values united with Celtic imagery.

Traquair was also an embroiderer, designer of book bindings, illuminator and a painter. She designed building interiors for the architect Sir Robert Stodart Lorimer, and also executed his designs for enamelled metalwork and jewelry.

In 1872 she married Ramsey Traquair and did not really begin to work seriously as a jeweler/enameller until her children were older.

The Victoria and Albert Museum has a number of fine pieces by Traquair in their collection which are named as were her custom. They include: a pendant depicting "Cupid the Earth Upholder", from 1902 of gold and colored foiled glass; two versions of "The Love Cup" pendant, made in 1902, painted enamels set in gold; a necklace illustrating "Eros Atlas", from 1908 of enamelled plaques in gold mounts, connected by chains. Traquair was awarded medals at several international exhibitions and exhibited with the London Arts and Crafts Society beginning in the 1890s. She was a member of the Edinburgh Arts and Crafts Club.

Phoebe Anna Traquair self-portrait. *Scottish National Portrait Gallery, Edinburgh*

Enamel pendants by Phoebe Traquair. *Courtesy of the Fine Art Society, London*

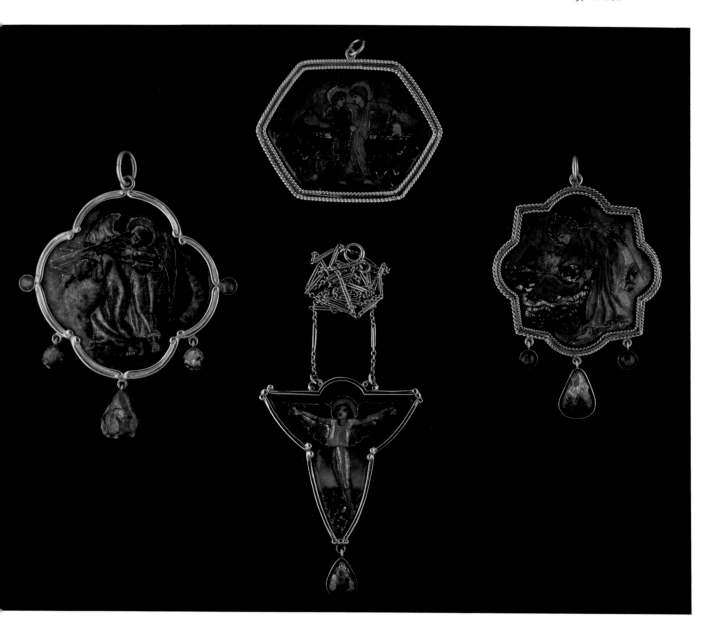

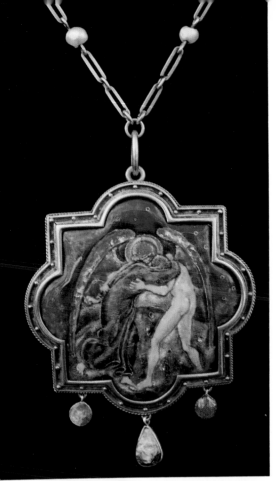

Chapter Two

01 *The Glasgow Girls, Women in Art and Design, 1880-1920*, Jude Burkhauser, ed., Canongate, Edinburgh, 1990 pp. 96-101.

02 *The Art Nouveau Style*, Roberta Waddell, ed., Dover Publications, New York, 1977 pg. 22

03 *The Glasgow Girls, Women in Art and Design, 1880-1920*, pp. 159-163

04 *The Glasgow Girls, Women in Art and Design, 1880-1920*, pg. 180

05 *The Enchanted World of Jesse Marion King*, Colin White, Canongate, Edinburgh, 1989, pg. 1

06 *The Enchanted World of Jesse Marion King*, pg. 19

07 *The Glasgow Girls, Women in Art and Design, 1880-1920*, pg. 167-8

Scottish Marks

Lady Carmichael (maybe)-JEC
Peter Wylie Davidson—P.W.D.
Margaret Macdonald Mackintosh MARGARET MACDONALD MACKINTOSH

James Reid—JR
Herbert McNair J.HERBERT McNAIR

Phoebe Anna Traquair-PAT monogram
J M Talbot—JMT
Rhoda Wager—WAGER
James Cromer Watt-JCW

Scottish Techniques

Casting
Chasing
Enamel
Cloisonné, Limoges
Hammered metal
Repoussé
Wire Work

Enamel and silver pendant by Phoebe Traquair. Reverse side shows the title "Sanctuary," 1902, and PT monogram. *Courtesy of Tadema Gallery, London*

Scottish Motifs and Influences

Art Nouveau
Aubrey Beardsley
Birds in flight
Cabbage
Celtic
Czechoslovakian
Folk art
English Arts and Crafts
Glasgow Rose
Glasgow Square
Hearts
Jan de Toorop
Japanese Design
Laudanum
Medieval
Organic Plant forms
Religion
Spiritualist Movements
Symbolists
Trees
Women

Arts and Crafts polychrome necklace with enamel double-sided plaques depicting spiritual figures on a fine link chain by Phoebe Traquair. Signed with P.T. monogram and dated 1912. *Courtesy of Christie's, New York*

"Ten Virgins Casket" by Phoebe Traquair of silver gilt, set with semi-precious stones and six enamelled plaques, c. 1907. *Mackintosh Collection, Hunterian Art Gallery, University of Glasgow*

Scottish Materials

Abalone Shells
Agate
Aluminum
Amethyst
Base Metals
Baroque Pearls
Blister Pearls
Brass
Cast Iron
Chrysoprase
Citrine
Copper
Gold
Lead
Mother-of-pearl
Opals
Paillons
Pearls
Pebble stones
Silver
Tin
Turquoise
Zinc

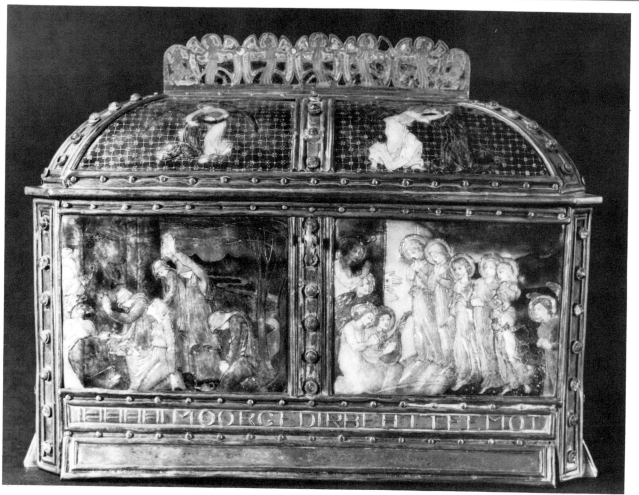

Celtic designs from the *Grammar of Ornament*
by Owen Jones published in 1851. A great
many important Celtic jewels were found in
Ireland in the mid-19th century.

Ireland:

Celtic Revival and Nationalism

The Crafts movement in Ireland had one driving force—a growing feeling of *nationalism*. From 1870-1916 this nationalist feeling fueled a Home Rule movement which lead to political upheaval and in 1921 the ending of the union with England.

As a result of this rise in nationalism a revival of all that was Irish and Celtic occurred. The Gaelic League promoted Irish culture, the Dun Emer Guild was organized by William Butler Yeat's sisters (one had been an assistant embroiderer working with May Morris) in 1902 primarily to make lace, and the founding of the Abbey Theatre in Dublin were all part of the nationalist pride that had taken hold. The early Irish revival was the equivalent to the Gothic Revival movement in England that had been spearheaded by A.W.N. Pugin. It continued from about mid-nineteenth century until the turn of the century without really evolving into something new as the Arts and Crafts movement had in England and Scotland.

The Irish crafts movement became a movement primarily reviving past designs intact rather than creating a new design style based on the past as happened England and Scotland. If work produced was not an exact copy of an old piece, it was certainly close to the original and, unlike the British movement, machine work played an important role in producing the jewelry and metalwork.

Beginning in the 1840's, there were several important archaeological discoveries made in Ireland which were to determine the direction that the jewelry and metalwork areas of the Crafts movement would head.

The Tara Brooch was discovered in 1850 in Droghead by a poor woman gathering kindling. She took it to a watchmaker who sold it to Waterhouse & Co., a Dublin jeweler. The brooch was said to be found in Tara which had a more appealing name and was eventually given to the Royal Irish Academy. The discovery helped to revive the use of metalwork techniques and motifs associated with Celtic Art. Every branch of the metalworker's art is visible in this tenth century brooch which was probably made by one man—it has modelling, casting, fine filigree, engraving, niello work, cut stones, amber and glass.

Several Irish companies began making reproductions of the brooch and English and Irish society women snapped them up, even Queen Victoria bought two at the Great Exhibition in 1851. The catalog from the exhibition illustrates several versions of the brooch by different companies.

More than forty years later, in 1892, Edmond Johnson, a prominent Dublin jeweler and goldsmith, exhibited metalwork of his own design based on Irish antiquities. He also made replicas of the Tara brooch and Ardagh Chalice which has been found along with four ancient brooches in 1868 by a boy digging potatoes. In fact, Johnson had helped restore the original chalice.

Johnson made Pennanular (almost round) brooches, a facsimile of the Shrine of St. Molaises's Gospels, and a facsimile of the Shrine of St. Patrick's bell all around 1891. Although many objects were modern works inspired by old (for example he adapted a chalice design for everyday household items) his work showed technical expertise but none of the originality of the English Arts and Crafts jewelers.

Other companies such as Hopkins and Hopkins made a buckle based on the Ardagh chalice and a casket with a hinged lid in 1909. West & Son had been making their own Tara brooch for years. In 1910 they made a two-handled bowl with Celtic interlace design, a silver rose bowl which is a replica of the Ardagh chalice and a book cover with Celtic interlace design dates from 1912.

By the 1890's there were many craft schools in Ireland just as in England and Scotland. But jewelry and metalwork does not seem to have been as important in Ireland, and little is known about Irish craftsmen who specialized in these fields. Most of the jewelry and metalwork that was done during the craft revival period was made by amateurs.

Silver book cover with Celtic interlace, 1912. Irish. *National Museum of Ireland, Dublin*

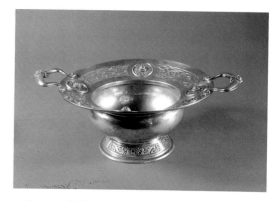

Two handled bowl with Celtic interlace. Made by West & Son, Dublin. *National Museum of Ireland, Dublin*

Group of Irish brooches shown at the Crystal Palace Exhibition in 1851.

Percy Oswald Reeves, an enameller who studied with Alexander Fisher and trained in Birmingham is best known for the enamel work he did for the tabernacle door of the Honan Hostel Chapel in Cork, built from 1914-1917. William Alphonsus Scott designed the Chapel door hinges as well as a grille, a silver incense boat, candlesticks and a monstrance. Scott was also a designer of stained glass and furniture.

Reeves' importance was both as a second-generation Arts and Crafts designer and as a teacher of other successful artisans. Utilizing symbolist imagery as several of the Glasgow School designers had done, he was one of the few to lead the movement away from the traditional designs of the Celtic Revival into a more unique style.

As an instructor of the Dublin School of Art and at the Dublin Goldsmith's Company, Reeves taught several artisans who excelled at metalwork and enamelling including Dora Allen, later to be his wife; Kathleen Fox and Kathleen Quigley. These women went on to make jewelry domestic metalwork and lamp stands.[1]

Other metalwork artisans whose work remains includes Elizabeth Davies (one of her brooches is in the collection of the Glasgow Museum and Art Galleries) and Mia Cranwell who was born in St. Louis. However, the success of these craftsmen may have been short-lived: a 1910 issue of *The Studio* states in a review of a British art school competition, specifically regarding enamel, that "in this department Dublin no longer maintains its pre-eminence. The Irish students whose enamels in some recent years ranked among the most distinguished objects in the competitions, seems to have lost the taste for those simple compositions and rich harmonies of colour that once characterized the best work from Dublin."

Embroidery, lace, stained glass, rug weaving and furniture making were the more popular craft revivals at the time, but at least one craft community focused on metalwork. Fivemiletown in County Tyron was founded by philanthropist Mary Montgomery to aid in the alleviation of widespread unemployment. It attracted Englishman John Williams who had previously been with the Guild of Handicraft and went to Ireland to supervise production of repoussé copper and brass ware at Fivemiletown.

The Arts and Crafts Society of Ireland held exhibitions in 1895, 1899, 1904, 1910, 1917, 1921 and 1925 by which time the movement was beginning to dissolve. An important Arts and Crafts exhibition also took place in 1902 at the School of Art in Cork, and jewelers Georgie Gaskin of England and Glaswegians Rhoda Wager, DeCourcy Lewthwaite Dewar and Helen Muir Wood were exhibitors. John Paul Cooper listed in his stockbook that he sold work through a Dublin Arts and Crafts Society which further suggests there was some market for jewelry and metalwork, yet Ireland is not remembered today as having had a major role in the jewelry and metalwork branches of the Arts and Crafts movement.

[1] "The Arts and Crafts Movement in Ireland," Nicola Gordon Bowe, *The Magazine Antiques*, Dec. 1992, pp. 864-875.

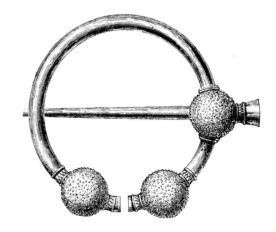

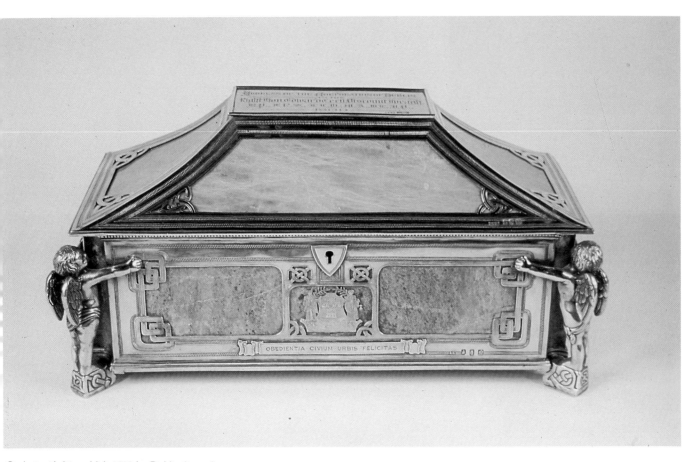

Casket with hinged lid, 1909 by Dublin firm of Hopkins and Hopkins. *National Museum of Ireland, Dublin*

Irish bracelet, late nineteenth century. *National Museum of Ireland, Dublin*

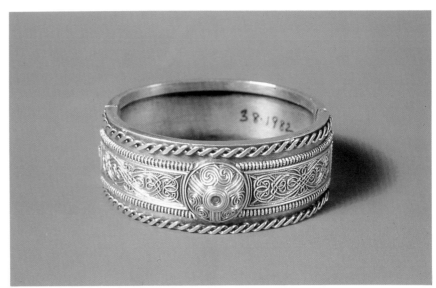

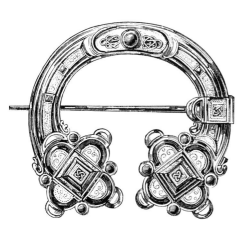

Earrings by Rhoda Wager. Silver, pearls, and faceted fire opals which are quite unusual. *Courtesy of Leah Roland/Split Personality, Leonia, New Jersey*

Australian Influences and Motifs

British Arts and Crafts
Celtic
Fish
Landscapes
Native Plants
Sailing Ships

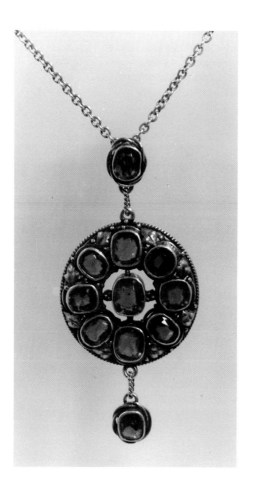

Silver and garnet pendant by Rhoda Wager c. 1920. *Courtesy of Tadema Gallery, London*

Australia:

British Training but Singularly Down Under

Rhoda Wager is probably the best-known of the Australian Arts and Crafts jewelry designers, primarily because she had made a name for herself in her native Scotland before emigrating first to Fiji and then to Sydney, Australia. She set up a workshop in Sydney where she worked from 1921-1946.

A metalworker who specialized in jewelry, Wager trained at the Bristol Art School, then moved to Glasgow and attended the School of Art. In 1900, she became art mistress at the Girls' Public School in Kilmacolm and she also taught at the Mount Florida School.

Later she returned to Bristol and taught at the Mary Redcliffe School where she took summer courses with the English Arts and Crafts jeweler and silversmith Bernard Cuzner.

Wager is thought to have studied under DeCourcy Lewthwaite Dewar and may have met the Gaskins when they visited Dewar's classes. Her jewelry and metalwork, the later pieces with enamel inserts, were exhibited in 1901 and 1902 and a copper repoussé jewelry tray in the Glasgow Art Galleries and Museum dates from 1900. She worked as a jewelry designer for over 25 years completing an astounding 12,000 pieces of jewelry all recorded in sketchbooks.

Wager emigrated to Fiji where her brother had a sugar plantation and then to Sydney, Australia, where she opened a successful production studio to make hand wrought jewelry.

She used Australian plants as design motifs in her jewelry as well as native Australian stones like opals usually mounted in silver. Her sketch books survive today in the collection of the Museum of Applied Arts and Sciences in Sydney.

Wager was a member of a number of Arts and Crafts Societies in Australia and exhibited her work frequently. She retired in 1946 and within a few years moved to Queensland where she lived until her death.

Wager's niece and assistant, Dorothy Wager Judge, established her own studio in 1939 but her work is very much in an Arts and Crafts style. She continued to work and exhibit with the Society of Arts and Crafts as late as 1971.

Several other important Australian Arts and Crafts designers like Rhoda Wager also trained outside of Australia. James W. R. Linton was born in England in 1869 and moved to Australia in 1896 after completing artistic training. After settling in Perth in Western Australia in 1907, he returned to England to visit and studied at the Sir John Cass Technical Institute under Harold Stabler.

Working at one time with partner Arthur Cross, and later with his son Jamie, Linton made many beautiful pieces of silver and gold jewelry in the Arts and Crafts style. He was also a teacher for many years and influenced a great number of craftspeople in Western Australia. He died in 1980.

Alan Cameron Walker was the founder of the Arts and Crafts Society in Tasmania and studied in London with the great enamellist Alexander Fisher after having been apprenticed as a jeweler in Australia. A trained architect, Walker taught metalwork as well as produced it until his death in 1931.

Another student of Alexander Fisher's was Ethel Barringer who created enamelled jewelry and other objects in her studio in Adelaide.

There were many Arts and Crafts Societies formed in Australia at the turn of the century, and a number of exhibitions were mounted. As in the English and Scottish movements, the artisans preferred to work with semi-precious stones, often cut en cabochon, and also with local stones.

Because of distance and a smaller number of designers, the Australian Arts and Crafts movement is not very well-known, but some lovely jewelry and metalwork can be attributed to it.[1]

Australian Materials
Amber
Amethysts
Baroque pearls
Black opals
Blister pearls
Carnelian
Coral
Enamel
Garnets
Gold
Lapis Lazuli
Moonstones
Moss agate
Mother-of-pearl
Onyx
Opals
Paste
Peridots
Paua Shell
Rose Quartz
Silver
Turquoise in matrix

[1] *Australian Jewelry, 19th and 20th Century*, Anne Schofield and Kevin Fahy. Antique Collectors' Club, Suffolk, England, 1990. pp. 83-103, 209, 216, 227, 247-9.

Tea table with tray by Hector Guimard.
Courtesy of Barry Friedman, Ltd., New York

Art Nouveau clock with peacock design.
Courtesy of Barry Friedman, Ltd., New York

Gallé Jellyfish Vase. *Courtesy of Barry
Friedman, Ltd., New York*

Table by Paris architect Leon Benouville, c.
1900. This table incorporates Benouville's most
distinctive design features in one piece. It is
executed in wild cherry and mahogany with
exotic wood marquetry and handformed brass
mounts. *Courtesy of Calderwood Gallery,
Philadelphia*

Chapter Five

France and Beyond:

The Art Nouveau

The noted British Arts and Crafts silversmith Bernard Cuzner found himself attracted to "Art Nouveau," and finding one of his teachers disdainful of it he asked why: "Its perpetrators have forgotten Shakespeare's 'o'erstep not the modesty of nature', " he was told.[1]

This then was how the English Arts and Crafts jewelry and metalcraft designers felt about Art Nouveau design. In fact, when a gift of Art Nouveau style furniture was given to the Victoria and Albert Museum in London in 1901, the English artistic community was thrown into an absolute tizzy. Art journals carried statements such as that of Beresford Pite who said Art Nouveau displayed the 'symptoms of mental disease' and George Frampton (a self-taught English Arts and Crafts sculptor and jeweler) said it was 'used by parents to frighten their naughty children.'

It is difficult to understand why the English felt so intensely against Art Nouveau but Judith A. Neiswander, in an article in *Apollo Magazine* in 1988 suggests that the strong dislike was really a matter of economic fear. England was no longer the leader in commerce and there was great concern over any foreign goods coming into the country.[2]

Yet though they might denounce it, there were many strong correlations between the work of English Arts and Crafts and Art Nouveau designers, and in fact the work of a number of British designers' works exhibit an Art Nouveau bent.

Art Nouveau, like Arts and Crafts, evolved as a reaction against the rise of industrialism and traditional Victorian design which many felt had no artistic integrity. It was strongly inspired by the Symbolist movement in French literature and art which used symbols to represent ideas. This sounds simplistic but is more complicated than it appears. Symbolist paintings were often intentionally obscure—"the superiority of the artist was matched only by that of the select few who could understand him". For example in one painting two women represent Purity and Faith climbing the staircase to Ideal.[3] From about the late 1880's the Symbolists paintings featured elongated female figures with curving paths and waves. The poppy and the woman's head are but a few of the Symbolist icons that were adopted by Art Nouveau jewelers and metalworkers.

The Art and Crafts tradition was certainly a factor in the origins of the Art Nouveau movement. The desire to create a fresh new style handcrafted by individual artisans was an ethic primary to both movements. Similarly both groups of artisans focused on the artistic value of materials rather than the intrinsic value, so horn, ivory, glass and semi-precious stones were widely used in both. Diamonds, although not a focal point, appear far more often in Art Nouveau than in Arts and Crafts jewelry. Enamel, which was so important to the Arts and Crafts designers, was equally important in Art Nouveau work, although here the two movements took divergent paths. Plique-à-jour—a transparent enamel resembling small stained glass windows is one of the most distinguishing features of Art Nouveau jewelry. It is rarely seen in Arts and Crafts jewelry where champlevé, cloisonné and Limoges enamels were more likely to be employed.

Art Nouveau Motifs

Like their British counterparts, the Art Nouveau designers focused heavily on nature for inspiration and flowers, plants, butterflies, insects, snakes and other motifs appear everywhere. The orchid, the dragonfly, and other imaginary creatures in constant movement married to the simplicity of Japanese design is characteristically Art Nouveau. In the British movement these motifs tend to be quite stylized and static whereas the French designers made them startlingly real, almost grotesque, by depicting all stages of nature including decay and death.

The whiplash motif, used entirely without restraint by Art Nouveau designers, appears abstractly in Arts and Crafts designs. It was used more figuratively in Art

Art Nouveau bronze figure by Auguste Moreau.
Courtesy of William Doyle Galleries, New York

Plique-à-jour enamel buttons, c. 1900, probably French. These are quite rare because of their fragility, and they are coveted by collectors. *Reprinted from BUTTONS by Diana Epstein and Millicent Safro. Published in 1991 by Harry N. Abrams, Inc. P: John Parnell*

Staircase railing by Louis Majorelle.

Nouveau—as part of a flower or the curl of a woman's hair. In other countries where Art Nouveau was an influence, with the exception of Belgium, designers took the more abstract route.

Women, glorified by the Pre-Raphelites, appear in English Arts and Crafts jewelry, but not to the extent that they do in Art Nouveau jewelry. The female form was a major part of the Symbolist vocabulary and was translated into jewelry...but this was a woman who was either depicted as a woeful or a "predatory" creature, quite different from the sweet, gentle English version. The Scottish work of Margaret and Frances MacDonald was closer in nature to Art Nouveau than any British work, incorporating sad female figures. In Art Nouveau jewelry and metalwork she appeared either in full figure or as a head only, but always with long flowing tresses.

Art Nouveau jewelry and metalwork departs greatly from that of the Arts and Crafts movement. In its overall mood there is a hint of the mysterious about it; it is often strange. It shows a fixation with sex and death, made in a time where men destroyed their lives over women of the demi-monde in France, while Victoria and her severity of style still ruled in England.

The Origin of the Movement

Art Nouveau jewelers in many ways adapted a movement borne of the ideals of the Arts and Crafts movement. Yet when compared to William Morris'

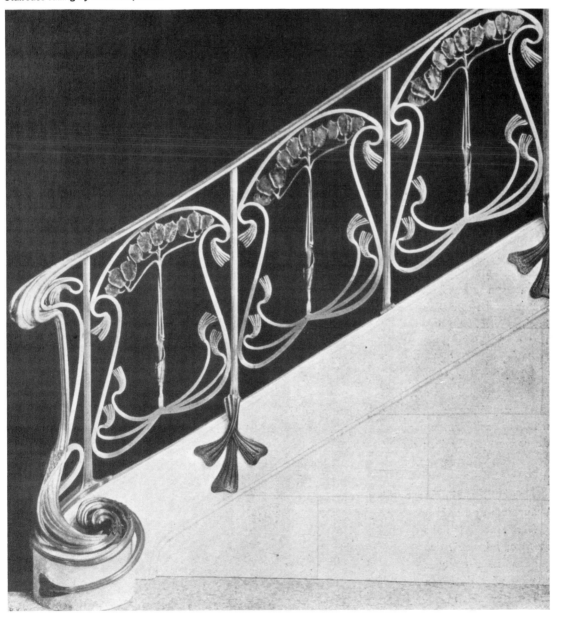

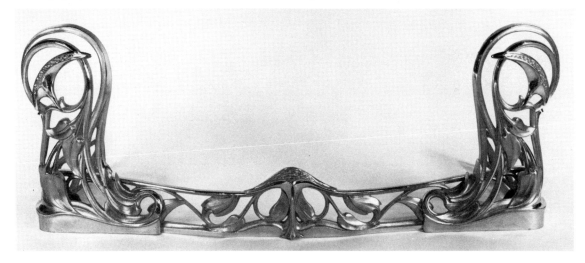

"aesthetic" for a plain lifestyle it became so degenerate in the eyes of their English cousins that they denied their kinship. The Arts and Crafts jewelers were perhaps a bit shortsighted—their own Englishness got in their way of appreciating the beauty of Art Nouveau. As Nathaniel Harris declares in his book *Art Nouveau* "In reality, Art Nouveau represents the final act in the liberation of art and craft from their Victorian fetters, a process that needs to be outlined if Art Nouveau is to be properly understood."

The Art Nouveau movement began in Belgium in the early 1890's where William Morris and other British designers had frequently exhibited, and then caught on in France, the country with which it is primarily associated with today. Victor Horta and Henry van de Velde (see chap. 5), both architects, and Gustave Serrurier-Bovy, a furniture designer were at the forefront in Belgium. Both of them designed metal furniture fittings and van de Velde designed metalwork and jewelry including jewelry designs for the German firms of Theodor Fahrner and Müller in Weimar.

Another Belgian architect, Antoine Pompe, designed metal tableware, ironwork and jewelry in the Art Nouveau style, but it was never executed. Larger firms known for having made silver objects were Fernand Dubois and Debons.

French Art Nouveau is perhaps best typified by the work of two men. The first is Hector Guimard, a follower of Victor Horta, who created swirling metalwork designs for the Paris Metro in 1900. These were completely radical for the time, and not popular with everyone in Paris by any means. Guimard also designed gilded bronze items, small metal objects, and paste jewelry for his wife.

Bronze doré fire fender by Abel Landry, c. 1900. Landry's training as a landscape painter at the Ecole des Beaux-Arts in Paris is evident in the fluid lines of this Art Nouveau work. He gained recognition as a designer for Maison Moderne. *Courtesy of Calderwood Gallery, Philadelphia*

Plate of various metals, by Lucien Bonvallet, Paris, c. 1900.

Pair of copper vases by Gustav Serrunier-Bovy of Belgium c. 1902-08. *Courtesy of Barry Friedman, Ltd., New York*

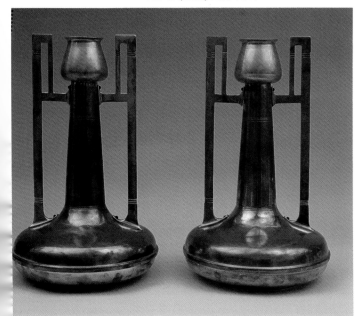

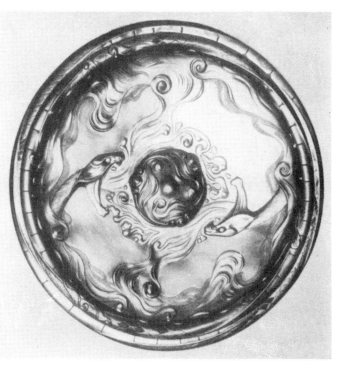

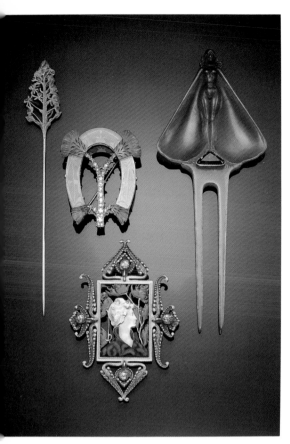

René Lalique—Genius Jeweler

The other major figure of the Art Nouveau movement was the jeweler René Lalique. He was doubtlessly the greatest of the Art Nouveau jewelers and the leader all others followed if not in style than in spirit. Unlike many art jewelers of the time he trained by working for several established jewelry firms in traditional styles before opening his own studio in 1885 and developing his unique jewelry. In 1900 he showed his jewelry at the Paris Exhibition which showed evidence that Lalique saw and revered beauty in the whole process of nature—but not the static, stylized nature depicted in Victorian jewelry. Lalique's jewelry appeared to be almost alive and full of the mystery in which nature veils itself. He is known for his use of plant forms, insects and landscapes as well as the female head and the female nude often intertwined to produce a supernatural creature. He made extensive use of plique-à-jour enamel and a variety of materials not traditionally used by jewelers including horn, glass and ivory. Some, like horn, were actually quite difficult to work, but he reveled in the simplicity of their look.

Lalique may have been influenced by the English Arts and Crafts movement to a certain extent. He had attended an art college in England from 1878-80 when the movement was still young. Although Art Nouveau jewelry was ridiculed by the English Arts and Crafts jewelers and other members of this movement, Lalique enjoyed some popularity in London outside this circle. In 1898 he participated in a show of French artists at the New Gallery on Regent Street; in 1903 he exhibited at the Grafton Gallery and in 1905 he exhibited at the Agnew Gallery. Queen Alexandra owned several Lalique pieces and may have been influenced to do so through Sarah Bernhardt. Bernhardt performed in England frequently and was a great patron of Lalique as she was of the artist Alphonse Mucha.

Lalique turned away from jewelry after only about ten years, yet close to two thousand pieces of his jewelry have been documented today. Collectors should be aware that Lalique fakes are in the marketplace—if a "signed" piece has a unwieldy look it probably is not Lalique. The most collectible pieces of Lalique's are those that are wearable—many were far too large to be worn, and his hair ornaments are generally not very wearable either. Matching sets by Lalique are extremely rare—only a few examples are known to exist. A plaque necklace, ring and earring set was auctioned in New York in 1984 by Hapsburg-Feldman.

Four pieces of jewelry by Lalique: Brooch with central portrait of a young woman with enamelled costume engraved with a foliate detail, amid enamelled leaves, further engraved, the whole framed and flanked by fern fronds enamelled green and set with pale brown and iridescent baroque pearls, signed Lalique. Carved horn and amethyst comb with female figure flanked by diaphanous wings, set with a triangular amethyst at her feet, signed on back Lalique. Brooch with inverted horseshoe shape with glass plaques intaglio-engraved with dragonflies flanking a central stem, set with brilliant cut diamonds, sprouting carved glass thistle blooms, slightly opalescent with blue enamelled detailing. Signed on mount Lalique. Hat pin in the form of a multi-stemmed plant gone to seed with pale green enamelled stems and orange flowers and areas of amber-colored plique-à-jour enamelling, signed Lalique and maker's mark and French gold standard mark. *Courtesy of Phillips, London*

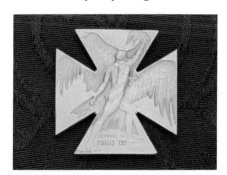

Lalique medal/brooch, gold. "The Naked Soldier". *Courtesy of N. Bloom, London*

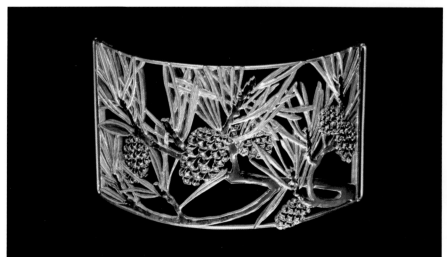

Plique-à-jour plaque de cou by Lalique. *Courtesy of John Jesse, London*

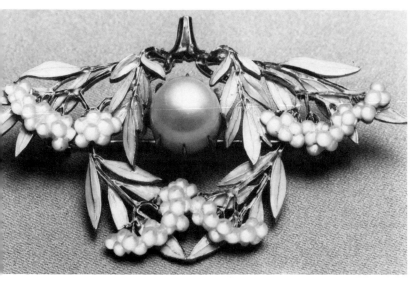

Lalique brooch with fruit clusters. Features a large pale pink pearl, enamelled brown branches, and leaves covered with thin white translucent enamel. Carved opals form the clusters of fruit. *Walters Art Gallery, Baltimore*

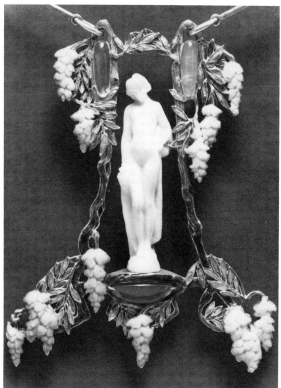

Pendant and necklace by René Lalique of a partially draped woman's figure holding a pitcher carved out of bone. The wisteria vines are enamelled with pale Mexican opals set in the vines above her head and below her feet. *Walters Art Gallery, Baltimore*

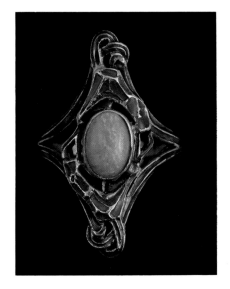

Lalique snake ring of gold, enamel and opal. *Courtesy of John Jesse, London*

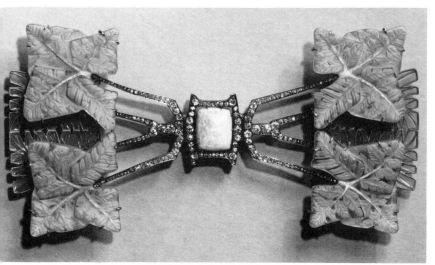

Opal and diamond brooch by Lalique which features a cushion-shaped opal in a silver-gilt frame set with small diamonds. The upper leaves are opalescent cameo glass with enamel. The lateral segments are hinged to the center to allow movement. *Walters Art Gallery, Baltimore*

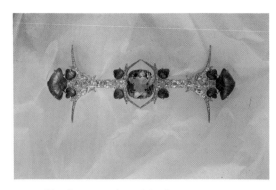

Thistle corsage brooch by René Lalique, Paris,
1905-1906. Actual size 4½″ with diamonds,
aquamarines, and enamel. *Courtesy of Asprey,
New York*

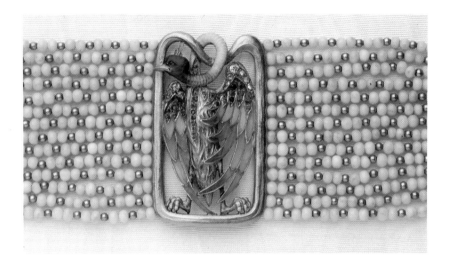

Necklace of plique-à-jour, enamel, sapphires,
diamonds and pale coral believed to be French.
Courtesy of N. Bloom, London

Lalique "Metamorphosis" cloak clasp. Blue and
green enamel and opals. This clasp was once
attached to fabric that was made to match the
clasp. *Courtesy of Asprey, New York. Photo by
Gabrielle Becker.*

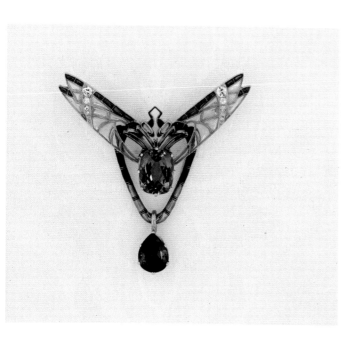

Art Nouveau brooch. pale green plique-à-jour enamel, probably tourmaline. Assumed to be French but unsigned. *Courtesy of N. Bloom, London*

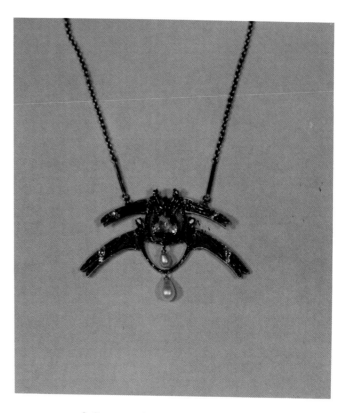

Lalique pendant of plique-à-jour enamel, aquamarines and diamonds. *Courtesy of Asprey, New York. Photo by Gabrielle Becker*

Lalique pendant depicting a wedding scene. The same plaque is on a comb in the Gulbenkian Museum in Lisbon and was copied from a Roman coin. Plique-à-jour enamel, gold, diamonds and pearls. *Courtesy of Asprey, New York. Photo by Gabrielle Becker.*

Lalique brooch of green enamel depicting a woman's head and mistletoe. There are diamonds in the woman's hair. *Courtesy of Asprey, New York. Photo by Gabrielle Becker.*

Other Important Contributors

One of the other important contributors to the movement was Samuel Bing and his shop L'art Nouveau which began by selling Japanese art and then sold the decorative arts of the new movement. In Bing's shop, jewelry by Lalique was sold as well as jewelry and metalwork items such as as flatware and purse mounts made for him by his own artists Edward Colonna and Georges de Feure (a painter from the Netherlands) and his own son Marcel. He also sold metalwork by the Englishmen W.A.S. Benson and Sir Frank Brangwyn.

Alphonse Mucha was a Czechoslovakian painter living in Paris whose fame was made by designing a poster of the exotic actress Sarah Bernhardt Bernhardt, who is said to have kept a pet panther and to have slept in a coffin, signed Mucha to a six-year contract designing posters, theater sets, costumes and personal jewelry for her.

Best known of the jewelry is the snake bracelet attached to a ring she wore on her index finger—purportedly designed to hide her arthritis. This elaborate piece of jewelry and others he designed for her were executed by the well-known French jeweler Fouquet. Mucha also designed silverware (some of which survives in the National Gallery of Prague) and published *Documents Decoratifs* with designs for furniture, lace, household objects and jewelry which became a expression of the Art Nouveau movement.

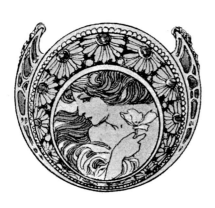

Design for watch by Alphonse Mucha.

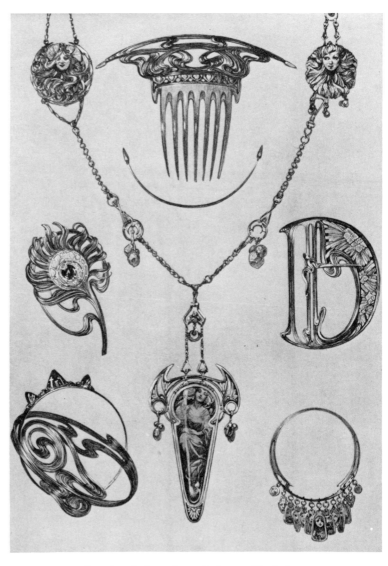

Jewelry designs from Alphonse Mucha's "Documents Décoratifs" printed in 1901. The book also includes his designs for silverware, table items, furniture, posters, wallpaper, etc. Figure and botanical studies were also represented.

A poster of Sarah Bernhardt by Alphonse Mucha.

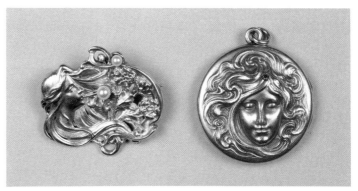

Two French Art Nouveau pendants by unknown makers. *Courtesy of John Jesse, London*

Alphonse Mucha portrait plaque, 1899, color lithograph of "La Primeve Polyanthus." *Courtesy of Skinner's Inc., Boston and Bolton*

French Art Nouveau necklace, c. 1890's. Opals and demantoid garnets, gold, opal drop. *Courtesy of N. Bloom, London*

French Art Nouveau brooch which was designed to be en tremblant. Maker unknown. *Courtesy of John Jesse, London*

Two unsigned Art Nouveau rings, probably French. 18 kt. gold and turquoise matrix *Courtesy of John Jesse, London*

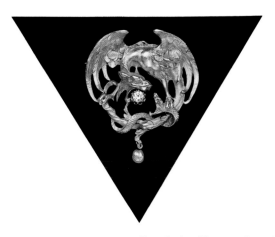

French Art Nouveau brooch of a mythical winged dragon fighting a snake of 18 kt. gold and diamond. C. 1900. *Courtesy of Didier Antiques, London*

An Art Nouveau lorgnette. *Courtesy of Nicholas Harris, London*

Gold and plique-à-jour brooch with diamonds and sapphires. Probably French. *Courtesy of N. Bloom, London*

Art Nouveau brooch, believed to be French. *Courtesy of John Jesse, London*

A Movement Led By Jewelry

Jewelry was, in fact, the most intense branch of Art Nouveau and probably the best known of the decorative arts today. Although brief in its lifespan, the Art Nouveau movement in France produced a number of excellent jewelers. Paul and Henri Vever worked in the new style with similar themes to Lalique but slightly more subdued. Perhaps their best known piece is the Sylvia pendant—a woman with wings made of gold, agate, enamel, rubies and diamonds. Other important Art Nouveau jewelry figures worked for the Vever firm including the enameller Tourette, and the engraver Lucien Gautrait about whom not much is known. Gautrait primarily designed pendants and brooches imitating Lalique's style. Eugéne Grasset was a Swiss-born painter and decorative artist who also designed jewelry for the firm.

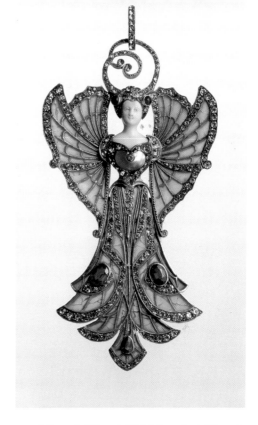

A "copy" of Vever's "Sylvia" pendant. Plique-à-jour, enamel, garnets, silver, paste. The original "Sylvia" is gold, agate, rubies and diamonds, c. 1900. *Courtesy of John Jesse, London*

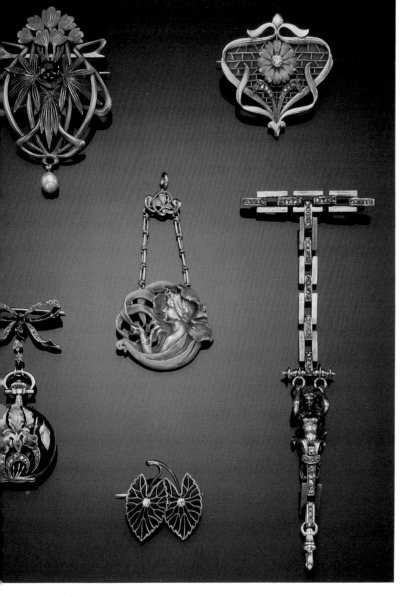

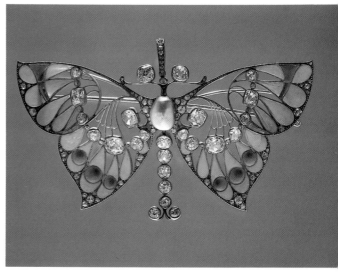

A gold, diamond, pearl and plique-à-jour enamel butterfly brooch by Vever, circa 1900. *Photo Courtesy of A La Vieille Russie, New York*

Top left: Gold, enamel and ruby brooch with a diamond and pearl drop signed Vever, Paris, numbered 2301. Top right: Almost heart-shaped brooch/pendant with central pink enamelled floret with an old-cut diamond center, leaves below set with rose cut diamonds, background of green translucent enamel, unmarked. Center: Enamelled gold pendant with the profile of head and shoulders of a femme-fleur emerging from an iris and green foliage, on chain with foliate link, makers mark for Andre Rambour and JP monogram, possibly for Joseph Pasteyer. Watch with case embellished with an iris bloom picked out in colored enamels, the leaves set with rose-cut diamonds, against a matte black background. Maker's marks for Borel and engraved inside "Borel Neuchatel Cylindre 10 rubis", numbered 61301. Suspended from a diamond and ruby bow brooch. *Courtesy of Phillip's, London*

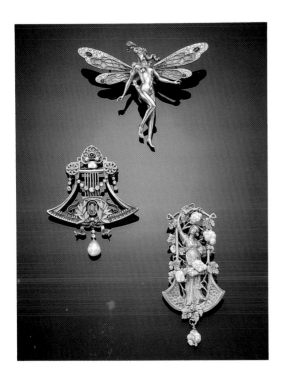

Top: Pale green and blue plique-à-jour, gold, diamond and ruby brooch by C. Duguine. Center: Necklace signed by Lucien Gautrait consisting of a gold fan-shaped pendant decorated with palmettes, enamelled and set with diamonds. The lower section holds a sapphire flanked by enamelled laurel leaves and ribbons with diamond and pearl drop, with original chain. Bottom: Brooch/Pendant/Buckle in the form of a clothed maiden reaching to pick a grape. The vine leaves are decorated with green and yellow enamel, the grapes are baroque freshwater pearls. Removable brooch, necklace and buckle fittings. In the style of Louis Aucoc, and marked D.J., possibly for D. Jouannet. *Courtesy of Phillips, London*

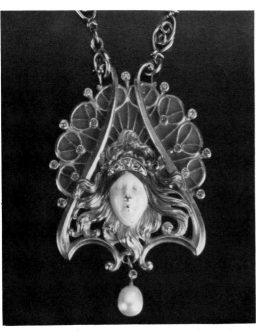

Art Nouveau pendant and necklace in the style of Aucoc. *Courtesy of Lawerence Fine Art, Crewkerne, England*

A strong Japanese influence pervades the work of Lucien Gaillard, who like Lalique worked often in horn, and plique-à-jour enamel. Beginning to make jewelry around 1900, he used insect and flower forms in his silver work and although he was influenced by Lalique, he created his own style.

Louis Aucoc, who had been Lalique's employer, made beautiful jewels in the Art Nouveau style, primarily of chased gold, some set with gem stones. George Fouquet, born into a family of jewelers, made an extensive line of important Art Nouveau jewels until about 1910. He collaborated for a time with Charles Desrosiers, a freelance designer who had studied with Grasset, and then later for two years with Alphonse Mucha. Fouquet's work tended to focus on floral motifs yet the facade of his store in 1900 featured a relief panel of a woman with a flowing mane and swirling clothing.

Mellerio was a Paris jewelry firm that produced a more subdued form of Art Nouveau jewelry and often used the peacock feather, frequently set with precious stones, as a motif. Eugene Feuillâtre, a sculptor apprenticed as a goldsmith and enameller, worked for Lalique, and then worked independently. He was inspired by Lalique but did not imitate his work. In addition to jewelry, he made hollow-ware of translucent enamel, glass and silver.

René Foy worked in Lalique's style, Antoine Bricteux collaborated with the designer G. Landois to produce Art Nouveau jewels, and Gerard Sandoz was a painter who worked for his father's firm designing in the Art Nouveau style. Charles Boutet de Monvel made jewelry of animal and bird forms that had almost human faces, as well as sea horses, crabs and spiders. Jean Dunand, a Swiss sculptor and admirer of John Ruskin, also worked in an Art Nouveau style making jewelry and metalwork.

In France, unlike in Britain, for the most part the Art Nouveau movement was not an attempt to bring art jewelry to the masses. It was primarily popular with the demi-monde and the "artsy" crowd such as Sarah Bernhardt and her coterie. Basically Art Nouveau jewelry was purchased by a few wealthy patrons. Even for its time Art Nouveau jewelry was expensive and was affordable by only a small group of people, much of it bought by museums. There were a few exceptions—most notably work from the firm of Piels Frères. This company substituted celluloid for ivory, copper and silver for gold, and used rolled gold and enamelling to make high quality "imitation" Art Nouveau jewels. Their work often featured a female face with long flowing hair. Many Piels Frères pieces were exported, and belt buckles seem to have been their most popular item. They were also known for jewelry made in the Egyptian revival style around 1900.

The female body and woman's head motifs so popular in the expensive Art Nouveau jewelry was just as popular in what we would today call costume jewelry. In the catalog *Jewels of Fantasy*, Vivienne Becker states that several firms were known for making inexpensive copies of Sarah Bernhardt's jewelry and other Art Nouveau jewelry including Maison Gripeaux, Elizabeth Bonté who worked in horn and Georges Pierre, her competitor who later became her partner. She also mentions the firms of Rouzè, Mascaraud, Victor Prat and Maison Savard.

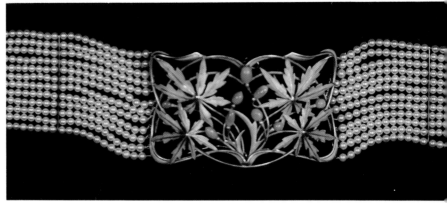

Dog collar by Alex Falize. Plaque is green enamelled on gold, with conch pearls and pearl necklace. *Courtesy of Asprey, New York. Photo by Gabrielle Becker.*

The more established jewelry firms in Paris—Boucheron, Chaumet and Cartier—did make some jewelry in the Art Nouveau style, but with the precious stones that would appeal to their clientele. Lucien Hirtz, who had been an assistant to Lucien Falize designed many silver objects for Boucheron including vases, clocks, cups, ashtrays, etc. Very little of the jewelry survives since its high intrinsic value means the pieces were probably re-worked to use the valuable stones.

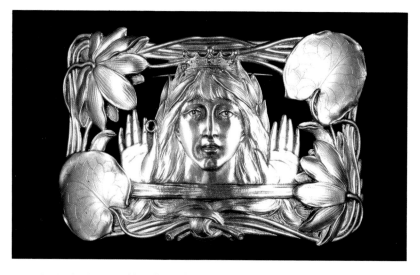

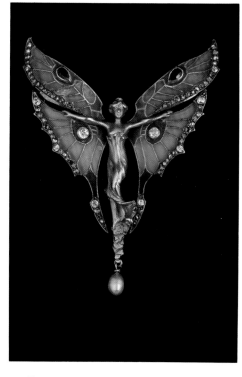

A belt buckle by the firm of *Piels Frère*. This firm was one of the few in France to make affordable Art Nouveau jewelry of a high quality. They substituted celluloid for ivory and rolled gold and silver for gold. *Courtesy of John Jesse, London*

Brooch by Gaston Lafitte c. 1900. Plique-à-jour enamel on 18 kt. gold, diamond, ruby, and pearl. *Courtesy of Cobra and Bellamy, London*

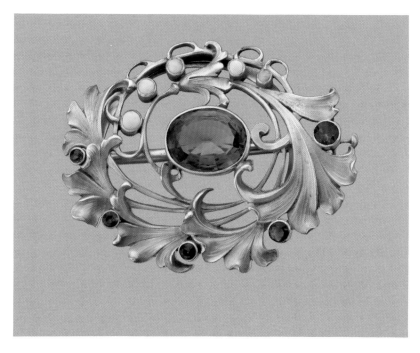

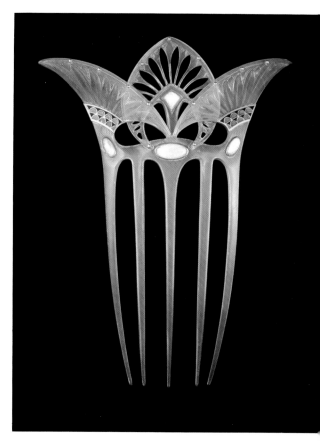

Silver gilt, amethyst and opal buckle designed by Emile James and made by René Beauclair, c. 1900. *Courtesy of Tadema Gallery, London*

Hair comb by Fouquet. *Courtesy of John Jesse, London*

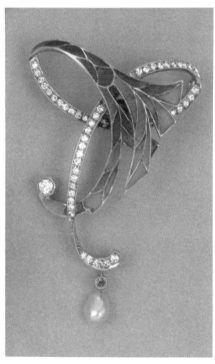

Art Nouveau brooches. *Courtesy of Nicholas Harris, London*

Group of charming Art Nouveau brooches in the medal style. All gold, the one on the top left by "Kohler" and the others by Edmond-Henri Becker. Becker was a well-known medal designer in the Art Nouveau style. *Courtesy of Nicholas Harris, London*

Medal Work

A small offshoot of French Art Nouveau jewelry was medal work. A renewed interest in medal engraving in France coincided with the Art Nouveau movement resulting in many medals executed in this style. The medals of silver and gold were worn as jewels and used as prizes in competitions. Designers who were known for this art, include Oscar Roty, Russian-born Felix Rasmusny, Charles Rivaud, Paul Richard among others.[4]

Lalique also executed some medal work. A silver medal cast with the profile of Sarah Bernhardt was auctioned by Hapsburg-Feldman, New York in 1989. A small number of these medals had been given to selected guests at a luncheon given in Bernhardt's honor. Another medal by Lalique of bronze depicting a woman's head was used as an invitation to a Lalique exhibit.

There were many other lesser known individual jewelers and jewelry firms working in the Art Nouveau style, some doing quality work and others making poor imitations of work of the better known jewelers.

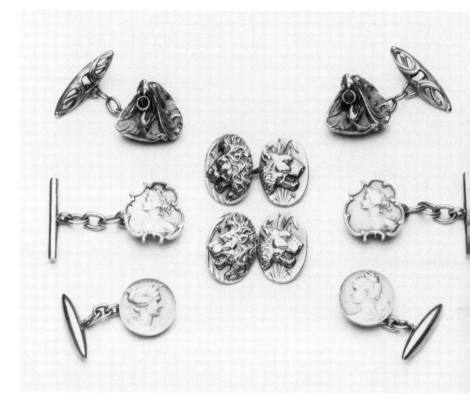

These cufflinks are an example of Art Nouveau medal jewelry. *Courtesy of Nicholas Harris, London*

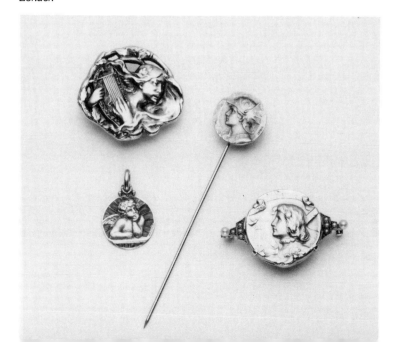

Art Nouveau Metal Work

Although metalwork played a smaller role in the French Art Nouveau movement than jewelry, a number of designers and craftsman produced items, many created in silver. As with jewelry silver items were mainly produced for the luxury trade—also a departure from the English Arts and Crafts movement.

Feuillâtre made large scale enamel pieces—for example, a dish with a bizarre-looking fish in a silver frame. Ernest Cardeilhac's firm, led by designer Lucien Bonvallet, created Art Nouveau mounts for vases with silver and silver gilt carved wood with ivory handles. Even Lalique made silver perfume bottles and heads for walking sticks.

The jeweler Lucien Gaillard produced items such as parasol handles, hair pins and hand mirrors, and Jean Dunand designed a variety of objects in non-precious metals although he became better known during the Art Deco period for his lacquer work. Artists like the sculptor Alexander Charpentier designed door handles, lock plates and medals.

Art Nouveau in Belgium

Although Art Nouveau may have originated in Belgium, it came full circle in jewelry design with the work of the jeweler and goldsmith Philipe Wolfers. While designing more traditional jewelry for the family business, Wolfers became influenced by French Art Nouveau jewelry designs and began to do his own work "on the side." Wolfers' workshop also made a small number of silver, pewter and bronze objects with enamel, ivory and stones decorating them, and vases of ivory and crystal.

Although bearing a similarity to French design, Wolfer's jewelry is heavier, more symmetrical and even more obviously related to the Symbolist movement. His work is often compared with that of Wilhelm Lucas Von Cranach, a German jewelry designer. Some of Von Cranach's jewelry was executed by Felix Friedlander, a Berlin jeweler who had once been apprenticed to Wolfers. Von Cranach and Wolfers were also friends who both loved using images with an air of mystery. Wolfers work featured sensual orchids, insects, exotic bird motifs, and peacocks, with enamel work often including paillons.

Other Belgian designers who are lesser known today include the sculptor Paul DuBois, who made buckles and clasps, and Leopold van Strydonck, who made jewelry finished with an oxidation process.

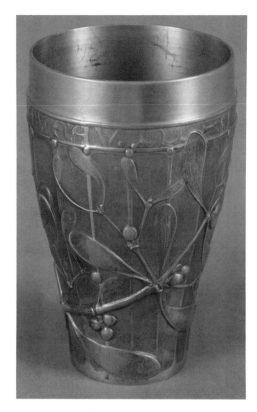

Pewter beaker by Jules Brateau, Paris, c. 1900. *Nordenfjeldske Kunstindustrimuseum, Trondheim*

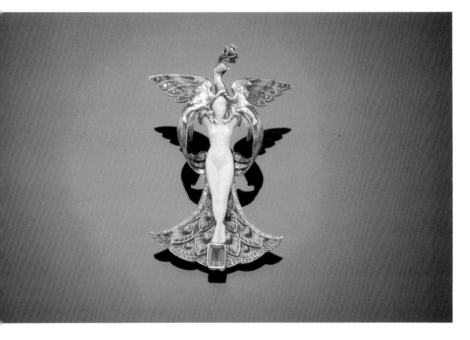

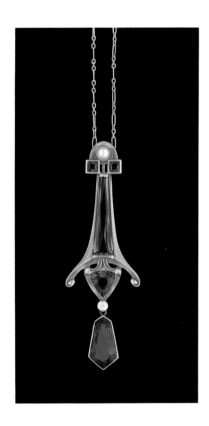

"Metamorphse", a Symbolist brooch by Phillipe Wolfers of Belgium. The central naked woman figure is of carved ivory surmounted with a peacock having outspread wings, in pale plique à-jour enamels, the tail feathers spreading below her feet, blue and green "eyes" and edged with rose cut diamonds and set with an emerald. Signed with the PW monogram and "Ex Unique"- used by Wolfers to distinguish his crafts jewelry from the more traditional jewelry he designed for his family's firm. *Courtesy of Phillips, London*

Art Nouveau pendant believed to be made in Belgium. 18 kt. gold, amethyst, pearl and diamond, c. 1900. *Courtesy of Cobra and Bellamy, London*

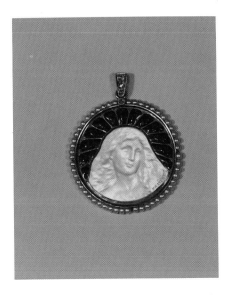

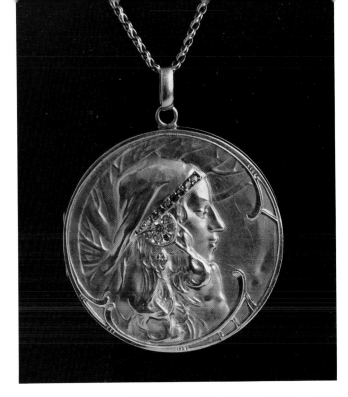

French Art Nouveau religious medal of the Virgin, "L'immaculee" c. 1900. Cabochonné enamel (meant to look like a cabochon stone) which resembles sapphires, seed pearls, mounted in gold. Signed by Russian born medalist Felix Rasumny who worked in France. Another medal by Rasumny is in the British Museum. *Courtesy of Asprey, New York. Photo by Gabrielle Becker.*

Art Nouveau gold and diamond locket, c. 1900. *Courtesy of Tadema Gallery, London*

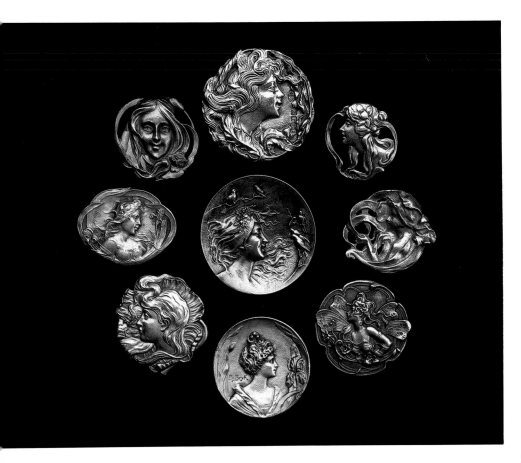

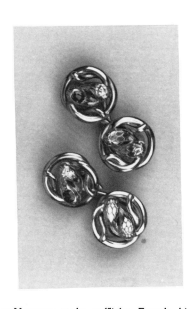

Silver buttons in the Art Nouveau style, c. 1900-1910. *Reprinted from BUTTONS by Diana Epstein and Millicent Safro. Published in 1991 by Harry N. Abrams, Inc. P: John Parnell.*

Art Nouveau snake cufflinks, French, highlighted by round rubies, sapphires and diamonds. 18 kt. gold with 14 kt. gold crossbars. Hallmarked. *Courtesy of Skinner's, Inc., Boston and Bolton*

Bronze Art Nouveau inkwell. Inscribed on base Oct. 12th, 1903. *Skinner's, Inc. Boston and Bolton*

Silver cream and sugar bowl by the Italian silversmith Carlo Bugatti.

Candlesticks by Dutch designer Georges de Feure.

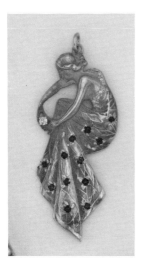

Seated lady Art Nouveau pendant, unsigned. *Courtesy of N. Bloom, London*

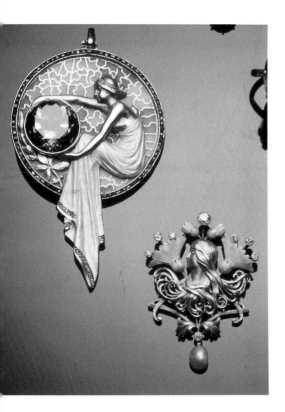

Circa 1900 maiden with matte yellow enamelled gown edged in diamonds holding a large circular mixed-cut amethyst landscape edged with calibré cut sapphires and decorated with plique à-jour enamelled naturalistic cagework background. Attributed to Masriera. Circa 1890 female head in profile with elaborate long flowing tresses. Three pale salmon-pink and yellow enamel floral cusps with diamond trefoil sprays and a central pearl and diamond drop. *Courtesy of Phillips, London*

Hair slide by Lucien Gaillard of horn, pearl and citrine, c. 1900. *Courtesy of Tadema Gallery, London*

Art Nouveau in Other European Countries

Primarily known as a French and Belgian movement, Art Nouveau took hold for a short time in other countries as well. In Spain, where it was known as "El Modernisme" and was primarily an architectural movement, Luis Masriera was the main proponent of Art Nouveau jewelry. Masriera was a goldsmith and designer who was born into a jewelry family, studied in Geneva and returned home to design Art Nouveau jewelry. Antonio Gaudi, the son of a coppersmith, was known for his wrought iron work which pushed the metal to its limits.

In Italy, it was known as Stile Floreale or Stile Liberty (because the jewelry of Liberty and Co., exhibiting Art Nouveau-like motifs, was so well-known). Furniture, not jewelry and metalwork, in the Art Nouveau style was favored by Italian craftsmen with the exception of Carlo Bugatti who became a master of Art Nouveau style silver, gold and jewelry work.

Starting as a furniture maker, Bugatti sold his business in 1904 and began making jewelry and metalwork using the same strange motifs he had decorated his furniture with earlier. A familiar motif was a surrealistic dragonfly which appeared on many pieces. He used other creatures such as crocodiles, wart hogs, ostriches, and partial animal motifs like elephant trunks. Hybrid creatures of mixed animal parts also appear on his trays, flatware, tea and coffee services.

In Austria, the early Secession style is identified as Art Nouveau-influenced, and other independent jewelers worked in the style as well. (see Chapter Six)

Russian Art Nouveau appeared mostly in crafts other than jewelry and metalwork, but a small portion of the work by renowned jeweler **Fabergé** was in an Art Nouveau style with flower, dragonfly and snake motifs. One example is a bloodstone box with applied gold leaves and diamond berries in the Art Nouveau style which has four different colors of gold, in the collection of the Hillwood Museum, Washington, D.C. Other examples by lesser known jewelers exist as well, but this Art Nouveau is a much tighter, more constrained design.

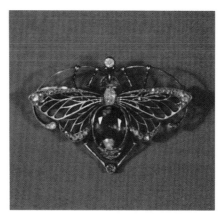

Russian brooch c. 1910 by Friederich Kochli of St. Petersburg., with diamonds. *Courtesy of Asprey, New York. Photo by Gabrielle Becker*

Fabergé butterfly c. 1890-1900. Burma rubies, Siberian emeralds, Burma sapphires, pearl may not be original. *Courtesy of Hirsh, London*

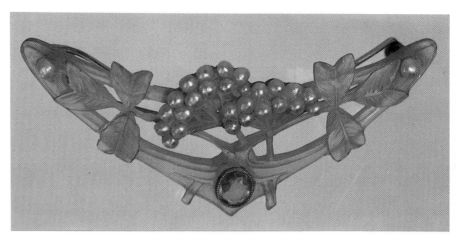

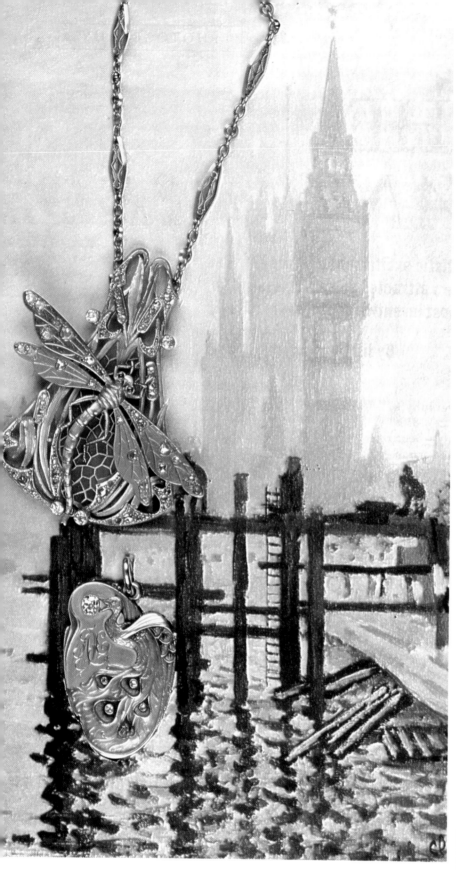

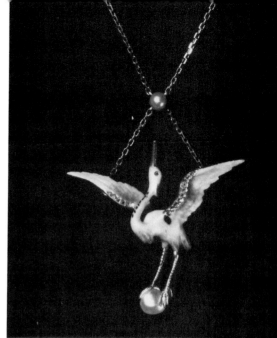

Art nouveau pendant, natural pearl, rose diamonds, pink enamel and platinum chain. Maker unknown. *Courtesy of N. Bloom, London*

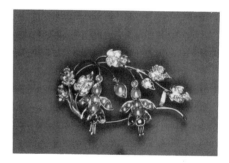

Pearl and sapphire Art Nouveau brooch, maker unknown. *Courtesy of N. Bloom, London*

Top: Art Nouveau 18 kt. gold necklace, a dragonfly and bullrushes with plique-à-jour enamel and diamonds. French hallmark, c. 1900. Bottom: Russian Art Nouveau peacock pendant, enamel, two colors of gold and diamonds. Hinged back with two photo frames. *Courtesy of N. Bloom, London*

Art Nouveau carved orchid. Maker unknown. *Courtesy of John Jesse, London*

Enamel pendant by Frans Zwollo Sr. (1872-1945), c. 1910. This Dutch artisan was a theosophist and a follower of Rudolph Steiner which is evident in his work, the colors of this brooch represent the highest spiritual aura. (Rudolf Steiner was an Austrian trained scientist who lived in Germany and preached a relationship between scientific study and spiritual knowledge.) This is a rare piece by this silversmith and jeweler who also taught in Haarlem and briefly in Germany. Inset shows his mark. *Courtesy of Tadema Gallery, London*

Art Nouveau in Holland took on other influences such as that of Indonesian architecture (Holland had ties with Indonesia through the spice trade) as well as well known Dutch forms such as clogs. It was also inspired by the Symbolists including the Dutch painter Jan de Toorop. Several silversmiths were part of the "Amsterdam School," including Jan Eisenlöffel, who worked in a geometric style similar to the linear faction of German Art Nouveau, and Frans Zwollo, Sr., who was a jeweler and silversmith as well as teacher of metalwork in Haarlem. Zwollo believed in less machine involvement in silver work and spent a short time teaching in Germany.

Another artist who taught in Haarlem was Lambert Nienhaus. He was an enamellist and designer who worked in an Art Nouveau-related style designing silverware and jewelry from 1905-18. The silversmithing firms of C.J. Begeer, Uthrecht and J.M. Van Kempen & Zn. were also producing domestic items of silver in the Art Nouveau and Arts and Crafts styles.

In Germany Jugendstil (Young Style) became its own distinct version of Art Nouveau (which is covered in Chapter Five). Still, some German firms, including Zerrenner, Louis Flessler & Co., and Robert Koch, made good quality jewelry in the French Art Nouveau manner.

Eight-day clock believed to be Dutch, with Delft-like enamel. *Courtesy of Leah Roland/Split Personality, Leonia. Photo by Diane Freer*

Late Art Nouveau silver and chyrsoprase brooch. Amsterdam School, 1920. *Courtesy of Tadema Gallery, London*

Hungarian Art Nouveau was blended into a popular historic style to make another unique manifestation. It is known that Hungarian Art Nouveau jewelry was produced; however, it is frequently difficult to identify. Much of the Budapest-made jewelry that survives today is actually marked Viennese, particularly pieces with garnets and low-quality opals.

Other European countries including Czechoslovakia and Finland had their own forms of Art Nouveau as well but little of it manifested itself as metalwork and jewelry.

Flagon by Sandrik Silverware Manufacturers, Budapest, c. 1900.

A silver gilt necklace believed to be Austro-Hungarian, c. 1900, set with amethysts and green paste and decorated with black and white enamelled florets. The backplate of each panel is pierced with scrolling foliage and leaf designs. *Courtesy of Spink & Son, Ltd., London*

Mirror frame of copper by Professor Paul Horti and F. Sárváry, Budapest, c. 1900.

Jewelry casket of enamel and silver, by Professor Paul Horti, Budapest, c. 1900.

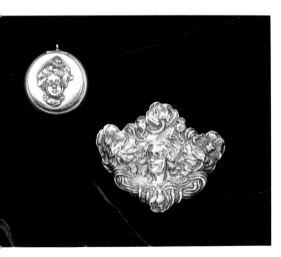

A group of Unger Bothers Art Nouveau brooches in sterling silver. This Newark, New Jersey firm manufactured quite a large quantity of these at the turn of the century. *Courtsey of Carole Berk, Inc., Bethesda. Photo by Luisa DiPietro*

Metal Art Nouveau box, probably American. Marked B & W on bottom.

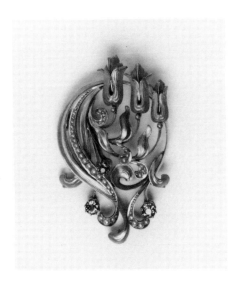

Art Nouveau brooch, believed to be American. Half pearls, diamonds and translucent enamels. *Courtesy of N. Bloom, London*

Marcus & Co. Art Nouveau brooch, circa 1900 of pink and green enamel, diamonds and conch pearls. *Courtesy of N. Bloom, London*

Art Nouveau in America

Americans adapted Art Nouveau to jewelry and metalwork fairly extensively. Prominent jewelers such as J.E. Caldwell, Black Starr and Frost, Raymond C. Yard, Theodore Dreicer, Krementz and Co., and Riker Bros. made fine jewelry that exhibited a restrained version of Art Nouveau. Marcus & Co. and Tiffany & Co. made jewelry with strong-colored stones and enamels that are somewhere betwixt and between the Art Nouveau and Arts and Crafts styles with a charm of their own. And L.C. Tiffany made wonderful jewels in his own "art style," often incorporating his famed Favrile glass.

Most notably in the United States, the Gorham Company, a successful silver manufacturer, created a special line of Art Nouveau style silver and silver gilt domestic items known as Martelé (French for hammered) which it introduced the same year Liberty & Co. introduced the Cymric line. (The Gorham Company was founded in 1852 and was one of the first silver manufacturers to use machines although the Martelé line was handmade). Also included in the line was jewelry of silver and some copper, set with pearls, quartz and mother-of-pearl.

William Christmas Codman, an Englishman who had joined Gorham in 1891 was in charge of the Martelé line. The silversmith for the line was Joseph Edward Straker, another Englishman and the chaser was Robert Bain, a Glaswegian. In the manner of the Arts and Crafts movement only a hammer and chase was used to produce Martelé items. Although most of what was produced was clearly Art Nouveau in style, Codman was influenced by the beliefs of William Morris and the English Arts and Crafts movement and some pieces are more geometric than the French Art Nouveau and closer to Arts and Crafts in style with boxes, bowls, cups, ewers and other objects being made. C. R. Ashbee visited the plant in 1900, the same year an all silver Martelé dressing table and Lalique's jewelry was shown at the Paris Exhibition and both were a tremendous success. Gorham also later hired the Danish designer Erik Magnussen, a contemporary of Georg Jensen.

Edward Colonna was another noted jeweler who worked in the Art Nouveau style in the United States and Europe. Colonna was born in Germany and trained in Brussels, then he went to work for Tiffany in New York. After New York he went to Paris working for Samuel Bing for awhile and then returned to the United States again.

Another aspect of the Art Nouveau influence on American jewelry and metalwork was a quantity of inexpensive, mass-produced silver jewelry, and other small items made primarily by Unger Bros. and Kerr & Co. both of Newark, New Jersey. (Kerr also made larger items including a coffee service.) Their work was similar and taken from French motifs—flowers, leaves, and woman's heads with curling hair are most common. The Whiting Mfg. Co. of New York also made silver items in the Art Nouveau style such as bowls and desk items.

The firm of George Shiebler & Co. in business from about 1876-1915 began by making flatware and then other silver items, some of which were in the Art Nouveau style.

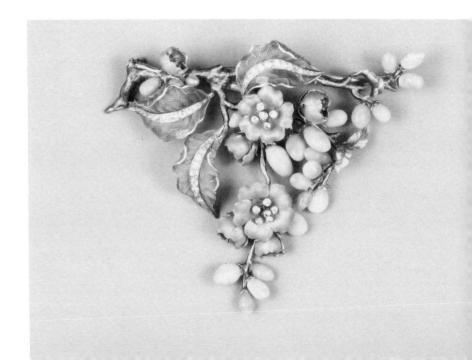

An amusing anecdote relating Art Nouveau in America to the French movement was recently reported in a newsletter issued by Faceré Jewelry Art of Seattle, Washington. According to the newsletter, the American dancer Löie Fuller put aluminum wands in her skirts to create waves of light and movement which echoed the sensuality and energy of the Art Nouveau line. Further research shows Fuller was known to dance with a long trailing scarf and wore costumes of gossamer silk. She appeared at the Folies Bergére in 1893 and at the 1900 Paris Exhibition where she was declared the personification of Art Nouveau. A number of bronze statues and other items were fashioned after her.

According to Vivienne Becker in her book *Art Nouveau Jewelry*, it was the copyists of the Art Nouveau master jewelers who brought about the downfall of the movement. She suggests they brought the movement to its "saturation" point by overdoing all of the motifs which served a purpose to the original designers but were used in excess by its imitators.

As Gabriel Mourey said in 1902 in the publication *Art Nouveau Jewellery and Fans*, "It's intensity, as one sees, is so great as to be almost alarming. Some of it's excesses are dangerous; what will be the result?"[5]

The Beginning of the End

By 1908, the fire of Art Nouveau creativity was in embers and dying. In contrast, the British Arts and Crafts work had slowed down during World War I, but a number of jewelers and metalworkers re-opened their studios after the war and continued working well past the mid-century. Some of their students are still working today. One of the important differences between the movements is that Art Nouveau jewelry was created by artists who worked for themselves and rich patrons, while much of the Arts and Crafts jewelry was produced by artisans who spent a great deal of time teaching, thereby leaving a legacy that has lived on.

Chapter Four

[1] *A Silversmith's Manual*, pg. 185
[2] *'Fantastic Malady' or Competitive Edge? English Outrage at Art Nouveau in 1901*, Judith A. Neiswander, Apollo Magazine, 1988
[3] *George de Feure, A Turn-of-the-Century Universal Artist*, Ian Millman, Apollo Magazine, 1988
[4] *Important Jewelry of Rene Lalique*, auction catalogue, Hapsburg-Feldman, New York, NY, June 7, 1981
[5] *Art Nouveau Jewellery and Fans*, Gabriel Mourey and Aymer Vallence, reproduced by Dover Publications, New York, NY, 1973, pg. 7

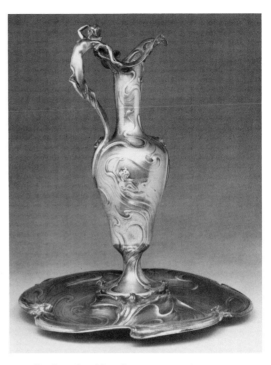

Sterling silver Martelé ewer on stand, c. 1900 by Gorham Co. of Providence, Rhode Island. *Courtesy of William Doyle Galleries, New York*

Art Nouveau Motifs and Influences

Bats
Birds
Butterflies
Chameleons
Curvilinear
Death and Dying
Dragonflies
English Arts and Crafts
Flowers
Fruit
Foliage
Holly
Insects
Irises
Japonisme
Landscapes
Leaves
Mermaids
Metamorphis
Mistletoe
Mythological creatures
Nature
Orchids
Peacocks
Poppies
Serpents
Scarabs
Snakes
Symbolism
Thistle
Wheat
Women's heads with flowing tresses
Women with full body

Art Nouveau Materials

Amethyst	Gold
Aquamarine	Horn
Base metals	Ivory
Brass	Opals
Bronze	Paste
Celluloid	Pate de verre
Chalcedony	Pearls
Conch pearls	Platinum
Copper	Rubies
Coral	Sapphires
Diamonds	Silver
Emeralds	Silver-gilt
Glass	Turquoise

Art Nouveau Techniques

Carving
Chasing
Cabochonné enamel
Champlevé enamel
Cloisonné enamel
Engraving
Plique-à-jour enamel
Repoussé

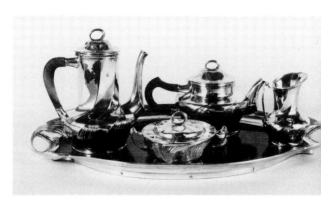

Jugendstil tea service, early twentieth century.
Courtesy of Barry Friedman, Ltd., New York

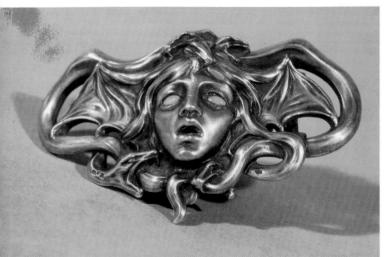

Silver buckle of a Medusa head on bat's wings.
Opal eyes, silver, by Albert Holbein. Stamped
on back BRGM 1900. This piece was shown at
the Paris exhibition of 1900. *Courtesy of Barry
Friedman, Ltd., New York*

Germany:

The Jugendstil Movement

"Is it or isn't it?" might be a fitting theme for the new art movement that began at the end of the nineteenth century in Germany.

Both the English Arts and Crafts movement and the French Art Nouveau style were strong influences on what was to happen in the field of decorative arts in Germany, although the Jugendstil movement (Young Style) is often referred to as "German Art Nouveau". (The name Jugendstil is derived from the art journal *Jugend* which began publication in Munich in 1896.)

The so-called English version of Jugendstil had been promoted by the architect Hermann Muthesius who had been sent to England from 1896-1903 to report back to Germany on English design. The articles he wrote, his book *The English House*, and his admiration for a number of British designers he met including Charles Robert Ashbee and the Mackintoshes helped feed an interest in English style. His wife Anna wrote a book on the Artistic Dress Movement in 1903 which included designs from Glasgow and a painting of her by Fra Newbery, principal of the Glasgow School of Art, was featured on the cover of the magazine *Jugend* with a Glasgow rose motif on her dress and on the wallpaper behind her.[1]

Munich and the New Art

It is said by most historians that the early Jugendstil style (before 1900) was more figurative and influenced by William Morris. After the turn-of-the-century the style became more abstract like the French Art Nouveau.

Other historians suggest that at least in Munich, the hub of the "new art" movement, the two styles of Jugendstil actually happened simultaneously, not one after the other.

In any case Munich became the focus of the new art movement in Germany beginning in 1894 when Hermann Obrist, a sculptor and designer, exhibited tapestries with organic designs. The following year he introduced the "whiplash" motif which was related to Art Nouveau, Celtic and Japanese design, causing quite a sensation. These designs appeared again later as metal decorative fittings and inlays for furniture he designed.

To understand why this new style caused excitement, one must go back and look at the political situation in Germany at this time. In 1871, after a war with France, the loosely-related independent states of Germany became a unified power. The strongest state, Prussia, became an important industrial power. By the 1880's a wide assemblage of manufactured metal products was available, but the integrity of style had been jeopardized in the name of progress.

With the unification came a new sense of nationalism; one aspect of this nationalistic feeling was a search for a German artistic identity. Much as it happened elsewhere on the Continent and in Great Britain, in searching for this new style the past was reconsidered and revivals were initiated. Before the Jugendstil began to emerge Germany had been steeped in a classical revival, with all the ornateness and heaviness of other countries' late Victorian periods. The Jugendstil movement was different from the British Arts and Crafts movement; it was a search for good German design of both handmade *and* machine-made objects.

Munich Leaders

An important figure in the Jugendstil movement was the architect August Endell who studied under Obrist. Using whiplash motifs influenced by Japanese and Celtic ornamentation he designed the Art Nouveau Hof-Atelier Elvira in 1898, a building with a relief ornamentation on its facade that was a melding of all three. Although known best for architecture, Endell designed jewelry which was shown at the Munich Secession Exhibition and metal fittings for his own furniture. A wooden chest now in the collection of the Munich State Museum was part of a suite of library furniture and is ornamented with an organic looking shapes of galvanized iron covering much of the front of the chest. A matching bookshelf carries the same embellishment on a smaller scale.

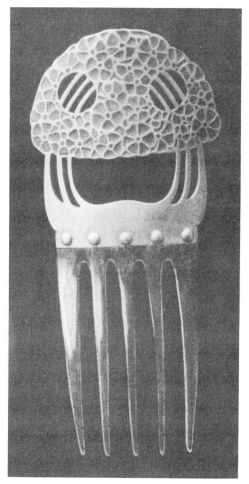

A comb in silver and horn by J. Hofstetter.

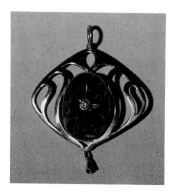

Pendant that is believed to be German. Gold, carved garnet and diamond. *Collection of Joyce Jonas, New York. Photo by Diane Freer.*

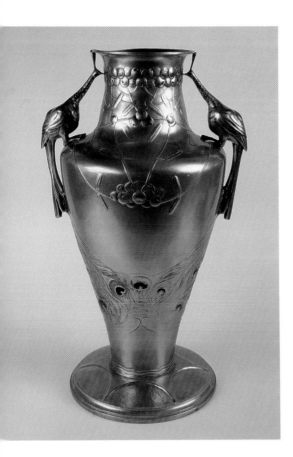

Jugendstil tureen by Osiris Werke. Executed by a group of artisans of the LGA Bayern, 1901.
Courtesy of Barry Friedman, Ltd., New York

Otto Eckman, one of the first recognized leaders of the Jugendstil movement, made strong use of naturalistic motifs in his designs, which were replicated by many of his contemporaries. Well known for his tapestries, he also designed jewelry, hammered copper, silver and wrought iron objects, some of which were commercially manufactured by Josef Zimmerman & Co.

Frederich Adler was another of Obrist's students. He designed silver and pewter objects which resembled the work being done in Vienna. His designs were executed by companies such as Orion and Walter Scherf & Co. (which manufactured the Isis and Osiris lines), Reineman & Lichtinger, and the Bruckman silver manufacturing company. He also made one-of-a-kind jewelry in both gold and silver, mostly for his family and friends. Several pieces (designed by Adler but executed by others) have survived. Adler, a Jew, tragically was killed in the concentration camp at Auschwitz.

Ludwig Viethaler is a good example of an artisan who joined the machine made arena of the Jugendstil movement. This Munich designer worked for a number of the city's metalworking firms, then left Germany for New York where he worked in the metalwork department of Tiffany & Co. for a period of time. He later returned to Germany and a former position with Wenhart & Co. designing domestic wares in a Jugendstil style. Viethaler's designs incorporated underwater plant and animal forms which were processed with patination. These pieces often set with semi-precious stones were marketed under the trade name "EOSIN". In later years Viethaler worked for a number of firms designing household objects, lighting fixtures and jewelry and he also took up sculpting in bronze.[2]

Vereingte Werkstätten

In 1897 The Vereinigte Werkstätten (United Workshops) was founded in Munich by Obrist, Bernard Panhok, Paul Schultze-Naumburg, Richard Riemmerschmid and Bruno Paul. Other workshops were soon to follow in Dresden, Berlin and Hanover. The workshop was inspired by Arts and Crafts ideals, yet the members of the Werkstätten showed no preference for hand crafted work over machine work (although they mostly made commissions by hand.) Their charter was to create quality work at an affordable price by whatever means would achieve that end and with no concern for whether a craftsman would design *and* execute his own work. By 1900 most of the original group had moved on to do other things but the Werkstätten moved further into industrial design and still exists today.

Perhaps best known of that Munich group was the architect, designer and artist Richard Riemmerschimid who was part of the linear (or rational) faction of the Munich Jugendstil movement. He designed a small quantity of brass and copper items as well as lighting fixtures and silver tableware that were simple and functional. He also made furniture that was clearly related to the Arts and Craft movement. In the book *Art Nouveau and Art Deco Silver*, author Annelies Krehel Aalberse says that he was the first German artist to "create a completely new functional model for flatware. In designing the knife handle Riemerschmid took account of the fact that one cuts with an index finger extended."

Bruno Paul, an illustrator and furniture designer was one of the two founders of the Vereingte Werkstätten who designed metal objects including an impressive twelve branch candelabra and pierced ornamental radiator screens. Only a small quantity of jewelry was to come out of the Werkstätten.

Peter Behrens was another decorative artist who followed the Jugendstil style and became one of the early members of the Vereingte Werkstätten. In addition to designing furniture and stained glass windows, Behrens made drawings for jewelry and designed flatware including some for his own home using geometric motifs. In 1899 he joined the Darmdstadt Colony and later worked for a number of large corporations.

The Darmstadt Colony

Since we have just mentioned the Darmstadt Colony, let us digress for a moment to explore its contribution to the crafts movement. The Darmstadt Colony was important because it provided artists with a place to live and work. Grande Duke Ernst Ludwig of Hesse (one of Queen Victoria's grandsons) was only twenty-three when he organized the colony to support the fundamental beliefs of the English Arts and Crafts movement. He believed in the English idea

Gold brooch designed by Theodor Von Gosen and executed by "Vereingte Werkstatten", Munich.

of an object being made completely by an individual craftsman, and was opposed to the Vereingte Werkstätten's acceptance of machine techniques.

The connection to the British Arts and Crafts movement was more than just speculation at Darmstadt—the Duke had been to England and while there he hired M.H. Baillie Scott to design some of the interiors and furnishings in his home. Scott commissioned the Guild of Handicraft to make some of those furnishings.

The Duke recruited the Austrian architect and designer Joseph Maria Olbrich to start the colony, and even had him design the buildings. Olbrich's silver designs from Darmstadt, executed by P. Bruckman & Sohne of Heilbronn, were not terribly successful—only a few have survived.

Patriz Huber designed jewelry and silver objects such as parasol handles, boxes and bottle stoppers, Paul Bürch, Peter Behrens, and others who were to make jewelry and metalwork also joined the colony. Hans Christiansen, a painter and graphic artist, made a number of designs for silver while at Darmdstadt in a style more like French Art Nouveau which were executed by Martin Mayer of Mainz and E. L. Vietor. Some of his work was imported into Austria as well.

Albin Müller became the Darmstadt's leading architect after Olbrich's death. He had worked as an architect and as a teacher, and had designed a number of silver objects and flatware sets.

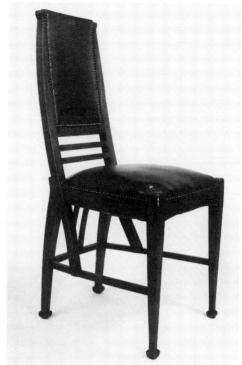

Patriz Huber chair. *Courtesy of Barry Friedman, Ltd., New York*

Coffee and tea service and samovar designed by Peter Behrens, c. 1901. *Courtesy of Barry Friedman, Ltd., New York*

Pewter tea service designed by Joseph Maria Olbrich while he was at the Darmstadt colony. Exhibited at the Universal Exposition in St. Louis in 1904. *Courtesy of Barry Friedman, Ltd., New York*

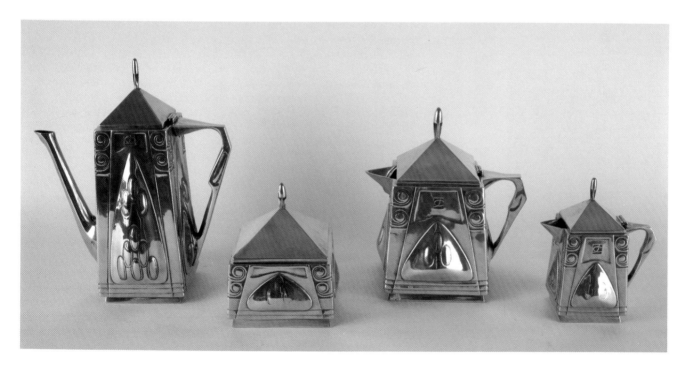

Silver flatware and fish fork and knives by Peter Behrens. *Courtesy of Barry Friedman, Ltd., New York*

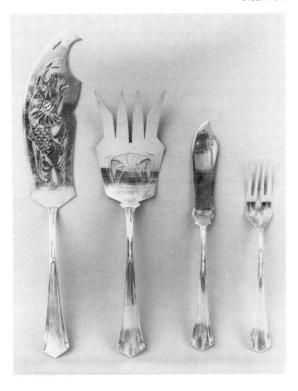

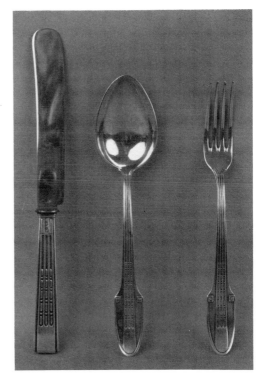

Cast bronze and enamelled table clock by Albin Müller. Blue enamel, polychrome enamelled eagle decoration. *Courtesy of Barry Friedman, Ltd., New York*

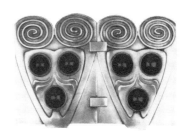

Sterling silver belt buckle designed by Patriz Huber and made by Theodor Fahrner Company, 1901. Chrysoprase accents gold wash. Marked with designer's and marker's monograms and "900 deposé." *Courtesy of Skinner's, Inc., Boston and Bolton*

The Deutsche Werkbund

In 1907 the Deutsche Werkbund was formed, a Secessionist group with many important designers such as Henri Van de Velde and Bernard Panhok as members. It brought together both artisans and industrialists in an attempt to further pursue the ideal of "quality" work whether produced by hand or machine. Some of the former members of the Vereingte Werkstätten such as Peter Behrens and Richard Riemmerschid joined the Werkbund which was to became a far more successful organization than the DIA (Design Industries Association) in England founded in 1915.

Although Van de Velde was a Belgian, he became an important figure in the German applied arts. As a member of the Werkbund, his focus was to champion the individual artisan. He was trained as an architect and studied painting in Belgium and in Paris, joining a Brussels Secessionist group in 1899. He gave up painting to devote himself to decorative arts and was so intense about his work that he even designed clothing to match his interiors. He was brought to Germany to run a craft work school in Berlin; in later years he was to recommend Walter Gropius as his successor at this school, which became the basis for the Bauhaus.

Van de Velde designed a quantity of metalwork, much of it in silver, including objects such as tea sets and samovars, candelabras and flatware. Of the silver jewelry he designed, belt buckles were among the best known pieces. His style was somewhat geometric yet curvilinear and bears some resemblance to early Georg Jensen work.

Munich and Beyond

Wilhelm Lucas Von Cranach was an important Berlin jewelry designer who was friendly with another Belgian—Art Nouveau jeweler Phillipe Wolfers. Von Cranach was a painter, interior designer as well as a jewelry designer. His work was executed by Louis Werner and other jewelers and was Art Nouveau influenced but with a dissolute quality similar to Wolfers work. Like Wolfers', his jewels consisted of fantastic creatures and mythical subjects such as Medusa's heads. Prolific around the turn-of-the-century, he designed a silver dinner service for the Duke of Saxe-Weimar's wedding consisting of three hundred and thirty-five pieces. He also collaborated with the two sons of the court jeweller, Theodor Muller, on important silver work.

Other important Munich designers included Paul Haustein, who designed a series of mounted copper enamelled vessels with relief decoration in the Jugendstil style, as well as Arts and Crafts-inspired jewelry for the Vereinigte Werkstätten. From 1907 on, he designed silver for the firm of P. Bruckman & Sohne of Heilbronn. Wilhelm Von Debschitz was a painter and interior decorator who founded what became known as the Debschitz School in 1902 with Obrist. Both jewelry and metalwork classes were taught at the school with students coming from all over Europe to study. One of the important materials used at the school was cast and patinated bronze.

Brass handle by Henri Van de Velde. *Nordenfjeldske Kunstindustrimuseum, Trondheim*

Tourmaline and gold ring by Henry van de Velde c. 1898, Brussels. One of his first designs made at his Uccle workshop before he moved to Germany. *Courtesy of Didier Antiques, London*

Belt buckle of silver, moonstones and diamonds by Henri Van de Velde. *Nordenfjeldske Kunstindustrimuseum, Trondheim*

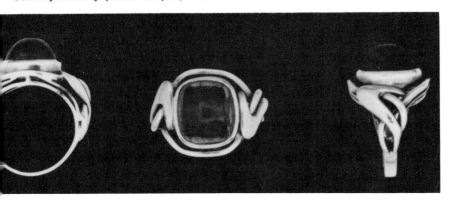

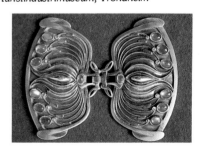

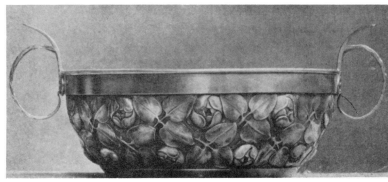

Silver fruit dish and steel casket designed and
executed by Ernst Riegel, 1908

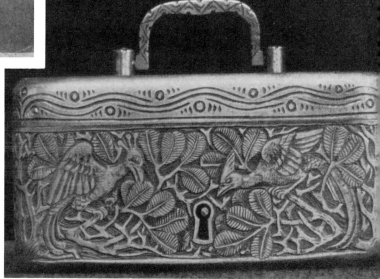

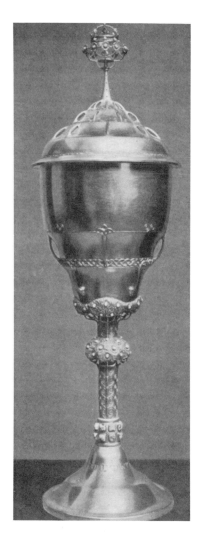

Silver cup designed and executed by Ernst
Riegel

One of van Debschitz's students became one of the few eminent female
Jugendstil designers. Gertrude von Schnellenbühel designed both jewelry and
metalwork in an organic and ornamental style. One of her best known pieces is a
silver candelabra which holds twenty-four candles; other known pieces include a
champagne cup and a coffee service. She executed her jewelry designs of silver
and gold herself.

Hans Eduard von Berlepsch-Valendas, like William Morris, wanted to improve
his life through art. Swiss born, he had met the English artisan Walter Crane and
had visited Charles Robert Ashbee at Chipping Camden in 1906. Trained as an
architect, Berlepsch-Valendas designed jewelry for Theodor Fahrner (who will be
discussed more fully later in this chapter), as well as silver items, furniture with
metal fittings, copper and bronze items and metal window grilles and gates,
textiles, ceramics, and furniture.

Fritz von Müller had apprenticed in England as a goldsmith with Roskell and
Hunt before studying enamelling and modelmaking in Paris. He opened his own
studio in Munich where he made gold and silverwork with his earlier pieces being
historically-influenced by the Renaissance and Gothic periods; his later pieces
are stylized natural forms.

One of the most important of the gold and silversmiths was Ernst Riegel, who
had apprenticed to von Müller. He had his own shop for six years and then joined
the Darmstadt Colony. There he designed and executed "vessels" of semi-
precious stones with chased settings for the Grand Duke including a cocoa-nut
cup with silver mounting and gilding and a fruit dish with gilding. He also made
jewelry and other objects for wealthy patrons and liturgical metalwork. One of
the best known examples of his work is a silver duck set with semi-precious
stones c. 1910.

Several larger retail jewelry firms in Munich also worked in the more floral
Jugendstil style including Karl Rothmüller, Nicholas Thallmayr and Erich Erler.[3]

Not all of the important Jugendstil jewelers and metalsmiths were in Munich;
Emile Lettre was a silversmith and jeweler who was born in Germany and then
worked in Budapest and Paris. After returning to Germany he opened a shop in
Berlin; there, the English Arts and Crafts jewelers Bernard Instone and H. G.
Murphy worked with him. Also in Berlin were the manufacturing jewelers Louis
Werner and J. H. Werner both of which made jewels in the Jugendstil style.

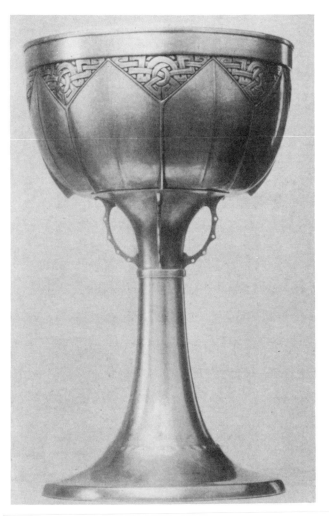

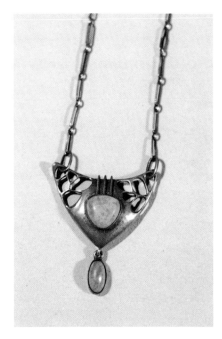

Necklace by Theodor Fahrner of silver and chrysoprase. Signed TF, 925, Deposé. *Collection of Gilbert Jonas, New York. Photo by Diane Freer.*

Silver cup designed and executed by Ernst Riegel

Theodor Fahrner

Perhaps the best-recognized name today for producing Jugendstil-style jewelry is the firm of Theodor Fahrner. Fahrner was a manufacturing jeweler who produced "affordable art jewelry". He was able to do this by making his jewelry partly by machine, yet he maintained good design quality by using the top designers of his time. The Fahrner firm was founded in Pforzheim in 1855 and upon the death of Theodor Fahrner, Sr. in 1883 his 24-year old son took over the company. Around 1900 Fahrner began to hire important German and Austrian designers who worked in the Jugendstil style to design for him. In 1900 this new jewelry was exhibited at the Paris Exhibition, where it was well-received, winning a silver medal.

The success of the jewelry by Fahrner's first designer Max Gradl, a free-lance artist, led him to approach members of the Darmstadt Colony including Patriz Huber, Joseph Maria Olbrich, Paul Bürck, a graphic artist, Rudolph and Ludwig Hubig and other important designers such as Hans Eduard von Berlepsch-Valendas, Emil Riester and his nephew Egon Riester. Lesser known artists who also designed for Fahrner include the architect Max Benirschke, Frederich Eugen Berner, a painter; Adolf Hildebrand, a painter; Franz Boeres; Vera and Bert Joho, Fahrner's daughter and son-in-law; and Christian Ferdinand Morawe, a writer and painter.

In 1901 he began to mark his jewelry with the TF trademark which allowed him to begin exporting to Great Britain and other countries. Most notably, Murrle Bennett & Co. sold Fahrner jewelry in England and these pieces are often marked with the names of both companies.

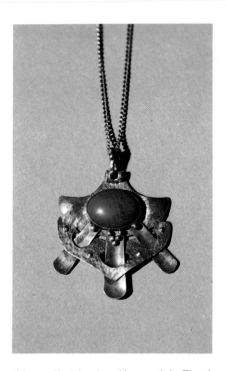

Silver and lapis lazuli necklace made by Theodor Fahrner for Murrle Bennett. *Collection of Gilbert Jonas, New York. Photo by Diane Freer.*

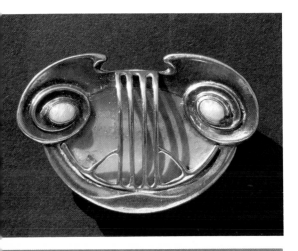

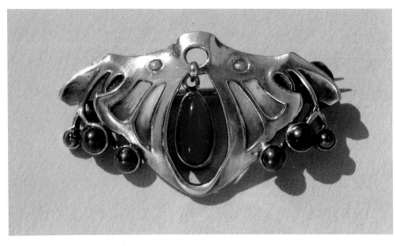

Theodor Fahrner brooch. Silver, enamel, carnelian, and hematite, c. 1900. *Courtesy of Tadema Gallery, London*

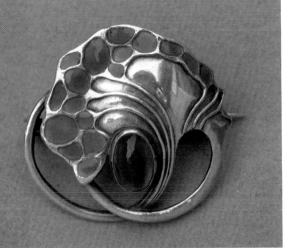

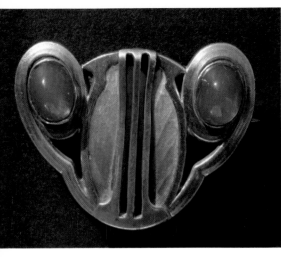

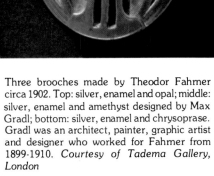

Three brooches made by Theodor Fahrner circa 1902. Top: silver, enamel and opal; middle: silver, enamel and amethyst designed by Max Gradl; bottom: silver, enamel and chrysoprase. Gradl was an architect, painter, graphic artist and designer who worked for Fahrner from 1899-1910. *Courtesy of Tadema Gallery, London*

Silver and enamel choker designed by Franz Boeres for Theodor Fahrner, c. 1905. Boeres was a painter and sculptor who began designing for Fahrner in the year this necklace was made and he continued to design for him until Fahrner's death. *Courtesy of Tadema Gallery, London*

In 1905 Fahrner wound down his production in the Jugendstil style and moved into the new prevailing trend of functionalism. He had also branched off somewhat from the Jugendstil/Darmdstadt style while it was still popular, and pieces may be found with filigree work which is based on German folk jewelry, floral motifs in enamel which are similar to the "Neo-Biedermeier" jewelry made by the Wiener Werkstätte, or a "Neo-Empire" style of silver and gold relief pieces which imitate cameos. Also, in 1908 a line of cloisonné jewelry was designed by Herman Häussler who was on Fahrner's staff. Jewelry with a leaf pattern was probably patterned after Otto Czecha's jewelry. A small group exhibit a Moorish influence.[4]

Unfortunately Fahrner lived only until 1919 and upon his death the firm was sold to Gustav Braendle who discontinued Fahrner's policy of allowing designers to sign their pieces. At this point stylistically the jewelry began to be Art Deco.

Jewelry For Everyone

Although Fahrner's jewelry was compatible with the artistic movement's "reform" clothing it was also quite wearable by a larger audience. He had seen jewelry made in Germany in the French Art Nouveau style fail to reach a wide audience and he was the wiser for it, focusing on wearable necklaces and pendants, brooches, belt buckles, tie, hat and coat pins.

Fahrner jewelry was executed in both gold and silver, set with semi-precious stones; the gold was almost completely handcrafted. His earlier jewelry retained some of the influence of Art Nouveau symbolism but soon took on a more geometric appearance, often featuring dangling parts. A small quantity of jewelry had precious stones in it.

Fahrner had a number of competitors who worked in a similar style, most significantly the firm of Heinrich Levinger. Known as Levinger & Bissinger from 1903-09, the firm then reverted to the name of Heinrich Levinger. This company featured jewelry by the Austrian designer Otto Prutscher. Other Pforzheim companies included Carl Hermann (at least one designer, George Kleeman, did work for Hermann and Fahrner) Gebrüder Falck, Bohnenberger & Böhmler, Wilhelm Feucht, A. Hauber, Julius Wimmer and O. Zahn.

Firms such as F. Zerenner manufactured jewelry in the French Art Nouveau Style and the jeweler Robert Koch of Baden-Baden and Frankfurt made very good quality jewelry in the French style as did a number of other German jewelers. Koch also executed some jewelry that was designed by Joseph Maria Olbrich.

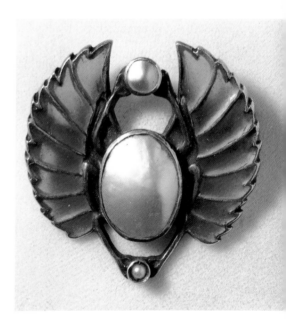

Brooch designed by Otto Prutscher and made by Heinrich Levinger., c. 1900. Silver, plique-à-jour enamel and pearls. *Courtesy of Tadema Gallery, London*

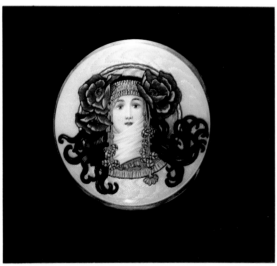

Box by Heinrich Levenger with a woman's head. Signed HL but with a Birmingham, England assay mark, 1899. *Leah Roland/Split Personality, Leonia. Photo by Diane Freer.*

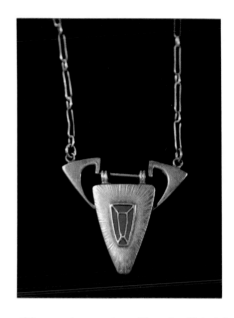

Silver and enamel necklace by Heinrich Levenger. *Collection of Gilbert Jonas, New York. Photo by Diane Freer.*

Two enamel boxes by Heinrich Levenger. Both have Birmingham, England assay marks, the poppy design from 1900 and the thistle from 1901. *Leah Roland/Split Personality, Leonia. Photo by Diane Freer.*

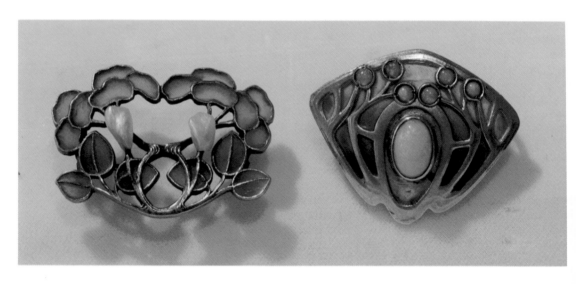

Two brooches by Heinrich Levenger of silver, plique à jour, opal and pearl, both c. 1900. *Courtesy of Tadema Gallery, London*

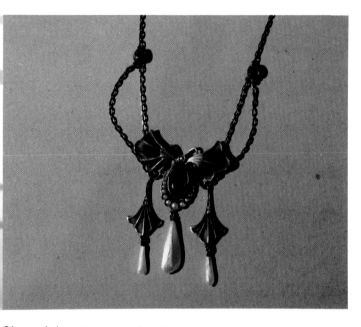

Silver and plique-à-jour enamel necklace in the Jugendstil style. With amethysts, split pearls, and river pearls. Hallmarked Carl Hermann, Pforzheim. *Courtesy of Skinner's Inc., Boston and Bolton*

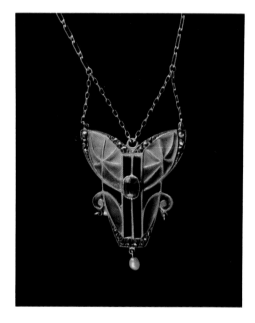

Plique-à-jour pendant, probably from Pforzheim. *Courtesy of Leah Roland/Split Personality, Leonia. Photo by Gabrielle Becker.*

WMF

As Fahrner made a success of taking Jugendstil jewelry to a commercial level, so too did a number of German firms do the same with domestic metalwork. The firm of WMF (Württembergische metallwaren Fabrik) is one of the best known today, partially because it exported a great quantity of items to England, where many were sold through Liberty & Co. Their vast array of domestic ware was manufactured in both pewter and nickel-silver and ranged stylistically from swirling Art Nouveau to "High Jugendstil" geometric designs. WMF goods were designed by well-known artists including the sculptor Albert Mayer, Richard Riemerschmid and Paul Haustein.

A small example of what could be found in their catalog includes jardinières, vases, pickle jars, card trays, candelabras, biscuit barrels, wine coolers, cigar boxes, claret jugs, and coffee services.

Other successful firms included that of H. Feith and A. Floch of Cologne, which made pewter ware under the name of "Electra," and Kunstgewerblick MetallwarenFabrick Orion, owned by Nuremberg's G. F. Schmidt and Freiderich Adler, which also made pewter goods. Staatliche Fachschule für Edeltmetall in Pforzheim made pewter ware as did Metallwaren Fabrick Eduard Hueck of Lüdenschied with Behrens, Joseph Maria Olbrich and Albin Müller designing for them. In Mainz, Martin Mayer worked.

Another well-known firm was J.P. Kayser Söhne, Krefeld which began making domestic wares of a pewter alloy in 1890 in the firm's Cologne "art workshop." Under the name of Kayser-Zinn, they produced goods with natural motifs including plants and insects which they sold to Liberty & Co. A number of other firms also made Art Nouveau silver and silver plate items in the French style including M.H. Wilkens & Söhne, Koch & Bergfeld (both of Bremen), and P. Bruckmann & Söhne (of Heilbronn). Koch & Bergfeld used designs by Hugo Leven and Albin Müller.

As the new art style had come to Germany late relative to Great Britain and France, it had a rather short life. But it was perhaps, the most successful of all the 'new art" movements as it naturally segued into one of quality industrial design. The next generation of designers, those associated with the Bauhaus, proved that good design and machines could co-exist.

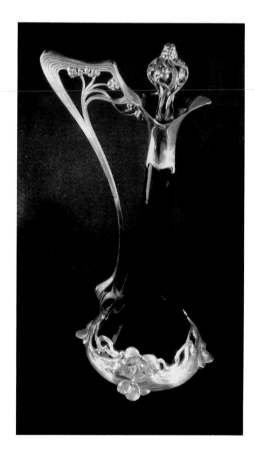

Silverplate and glass cordial bottle made by WMF. *Courtesy of Leah Roland/Split Personality, Leonia. Photo by Diane Freer.*

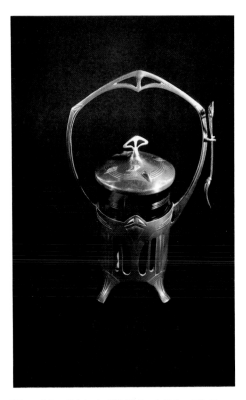

Silverplate relish jar by WMF. *Leah Roland/Split Personality, Leonia. Photo by Diane Freer.*

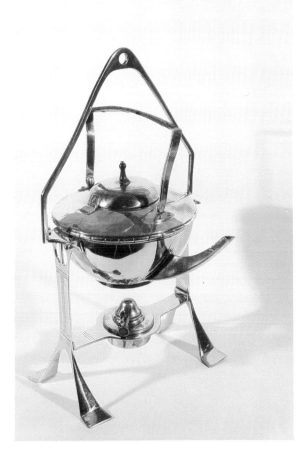

Brass samovar made by WMF. *Courtesy of Barry Friedman, Ltd., New York*

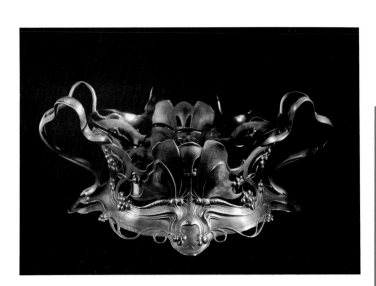

Jardinière by WMF. *Courtesy of Leah Roland/Split Personality, Leonia. Photo by Diane Freer*

Jugendstil Materials

Agates	Kayser-Zinn
Alpacca (a silver-colored metal)	(a pewter alloy)
Amazonite	Lapis Lazuli
Amethyst	Malachite
Brass	Mother-of-Pearl
Chrysoprase	Olivine
Citrine	Opals
Coral	Pearls
Copper	Pewter
Garnet	Rubies
German Silver	Sapphires
Gilded brass	Silver
Gilded silver	Spinels
Glass	Swiss Lapis (glass)
Gold	Tin alloys
Green chalcedony	Tourmaline
Hematite	Turquoise
Ivory	Zircon

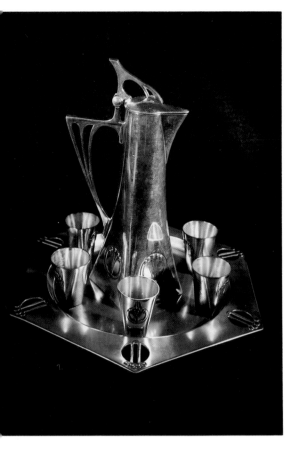

Candlesticks in the "Secessionist style" by WMF. *Leah Roland/Split Personality, Leonia. Photo by Diane Freer.*

WMF cordial set in the geometric Jugendstil style. *Leah Roland/Split Personality, Leonia. Photo by Diane Freer.*

Jugendstil Techniques
Casting
Enamel work
Gilding
Machine work
Patination
Plating

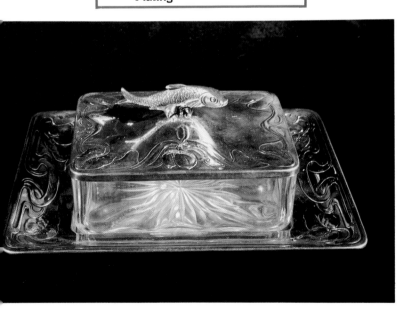

Honey jar by WMF. *Leah Roland/Split Personality, Leonia. Photo by Diane Freer.*

WMF sardine dish. *Leah Roland/Split Personality, Leonia. Photo by Diane Freer.*

Chapter Five

01 *The Glasgow Girls, Women in Art and Design, 1880-1920*, pg. 54
02 *Art Nouveau and Art Deco Silver*, Annelies Krekel-Aalberse, Harry N. Abrams, Inc.
 New York, NY, 1989, pg. 129
03 *Art Nouveau in Munich, Masters of Jugendstil*, Kathryn Bloom Hiesinger, ed.
 Prestel/Philadelphia Museum of Art, Munich, 1988, pg. 164-65
04 *Theodor Fahrner Jewelry, Between Avantgarde and Tradition*, Ulrike van Hase
 Schmundt, Christianne Weber, Ingeborg Becker, Schiffer Publishing, Atglen
 Pennsylvania 1991, pg. 44-67

Kayzer-Zinn dish with butterfly design. The Kayser-Zinn company used their own alloy. *Leah Roland/Split Personality, Leonia. Photo by Diane Freer.*

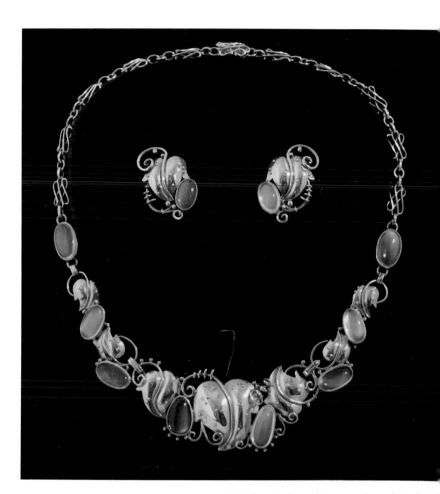

This jewelry by a German artisan dates later than the Jugendstil period but shows a relationship to the earlier movement. The necklace by F.R. Greeven, a jeweler from Dortmund, can be assembled into earrings and a brooch, c. 1930. *Courtesy of Tadema Gallery, London*

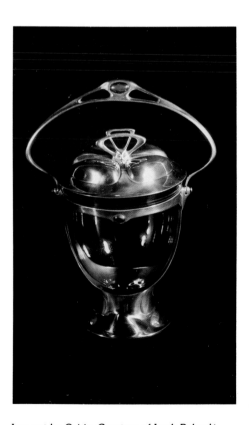

Jam pot by Osiris. *Courtesy of Leah Roland/ Split Personality, Leonia. Photo by Diane Freer*

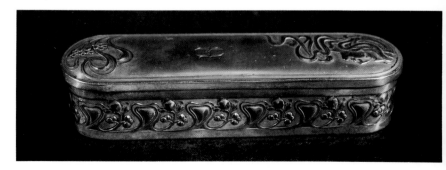

WMF silverplate toothbrush box. *Leah Roland/ Split Personality, Leonia. Photo by Diane Freer.*

Fabrics by Richard Riemmerschmid. *Bayrisches Museum, Munich, Germany*

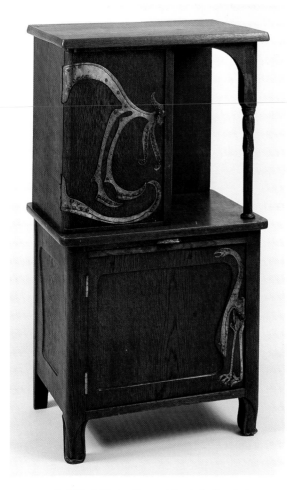

Bedside table by Bernard Panhok. *Bayrisches Museum, Munich*

Jugendstil Motifs and Influences

Animals	Japanese
Birds	Medusa head
British Arts & Crafts	Organic shapes
Celtic	Plants
Flowers	Undersea creatures
French Art Nouveau	Vienna Secessionist
Geometric figures	Whiplash
Insects	Women

Poster for Frommes Kalender, 1898 by Koloman Moser. *Courtesy of The Galerie St. Etienne, New York*

Poster for the Second and Third Secession Exhibits 1898-99 by Joseph Maria Olbrich. *The Galerie St. Etienne, New York*

Silver and opal pendant by Koloman Moser in 1903 for the Wiener Werkstätte. *Courtesy of Osterrichisches Museum, Vienna*

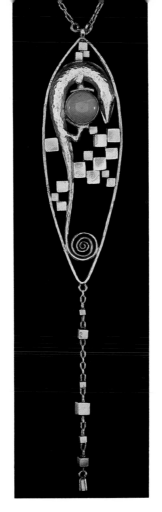

Gold and opal brooch by Carl Otto Czecha for the Wiener Werkstätte, c. 1913. Inv. # W.I.1298. *Courtesy of the Osterrichisches Museum, Vienna*

Silver and enamel cigarette case c. 1900 designed by Koloman Moser and made by Georg Anton Scheid. *Courtesy of Tadema Gallery, London*

Austria:

The Vienna Secessionists and the Wiener Werkstätte

The French Art Nouveau style was welcomed by Viennese artisans in the 1890s, but they were late in adopting the style.

A number of the established Viennese jewelers adopted the style, including Franz Hauptmann and Gustav Fischmeister, who had been a student of Lalique. The floral and Japanese-oriented motifs were those most often used by these jewelers, and for the most part they worked with traditional materials, including precious stones.

The Vienna Secessionists

Even though a quantity of Art Nouveau-influenced jewelry was produced in Austria, it was not made until the movement had almost ended in France, at the end of the century. Thus it rather quickly evolved into a singularly Austrian style. The foundations of this new style were the Vienna art exhibitions run by a private exhibition society known as the Kuenstherhaus. In 1897 a group of artists who had exhibited under this system broke away because of ongoing policy disputes. They called their new organization the "Secession," and named the artist Gustav Klimt as their president.

Other members of the Secession group included the architects Josef Hoffman, Joseph Maria Olbrich and the designer/artist Koloman Moser. All three of these men were to become important jewelry and metalwork designers, and excelled in other areas of the decorative arts.

The Secession built its own exhibition hall in an Art Nouveau style, sponsored its own events and published the magazine *Ver Sacrum*. At its eighth exhibition in 1900, Charles Robert Ashbee, Charles Rennie Mackintosh and Margaret Macdonald exhibited their work, and their influence was to have a profound effect on the Viennese movement.

The Wiener Werkstätte

The Secessionists soon found themselves falling into two factions—the "stylists" who were craft-oriented and favored the Art Nouveau style (although it was evolving into a more geometric style), and the more traditional painters known as the "naturalists". In 1903 the "stylist" faction broke away from the Secession and formed the Wiener Werkstätte (Vienna Workshop), aiming to create "unity in the arts" and to follow the teachings of John Ruskin and William Morris.

The Wiener Werkstätte was modeled after the Guild of the Handicraft, but had one important component the Guild lacked: a patron. The workshop's seed money was provided by Fritz Warndorfer, a businessman with a strong interest in the British Arts and Crafts movement (he had even commissioned Charles Rennie Mackintosh to design a music room). Warndorfer travelled to England frequently, providing additional exposure for the Werkstätte to English ideas, though from a design standpoint they were more influenced by Mackintosh and the Glasgow school. The Werkstätte adopted the British ideals of looking back in time for inspiration, and of giving equal importance to all the arts.

Josef Hoffman had visited several English craft guilds in 1902 and was no doubt influenced by their ethics. But one difference in the attitude of the workshop members from their English counterparts was that they were not against the use of machinery in the manufacturing process.

The Werkstätte and Jewelry

The Wiener Werkstätte was prolific in its output of all areas of the decorative arts, but we will focus only on the jewelry and metalwork in this book. Metal and silversmith shops were staffed early on by a number of silversmiths including Alfred Mayer, Josef Wagner and others. They executed Hoffman and Moser's designs, though not all work was executed on site. Gerda Buxbaum states in the book *Jewels of Fantasy* that various members of the Werkstätte used outside firms to execute their jewelry, including Georg Anton Scheid, Rozet and Fischmeister, and Oscar Dietrich.

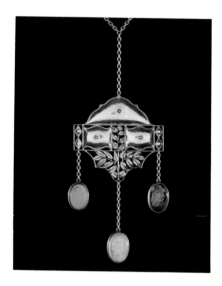

Pendant by Josef Hoffman for the Wiener Werkstätte of gold and opal, 1912. Inv. # W.I. 1113. *Courtesy of Osterrichisches Museum, Vienna*

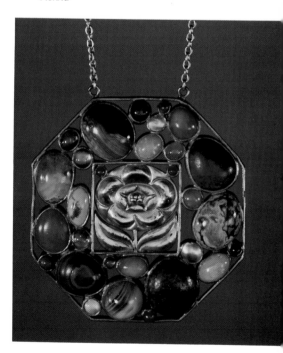

Pendant by Josef Hoffman for the Wiener Werkstätte of silver and semi-precious stones, 1907. Inv. #Bi 1471 *Courtesy of the Osterreichsches Museum, Vienna*

Belt buckle designed by Koloman Moser of silver and enamel. Executed by Georg Anton Schied c. 1900. *Courtesy of Tadema Gallery, London*

Georg Anton Scheid was a Viennese silversmith working in the modern style. In addition to executing work for Hoffman and Moser, he made pieces for designers now mostly forgotten, including Franz Delavilla, Milla Weltman and Hans Bolet. These designers also had work executed by such firms as A. Sturm, Bruder Frank, Eduard Friedmann and others.[1]

Hoffman and Moser approached jewelry as they did other design projects—good craftsmanship and design were more important than the materials. They tended to work with silver more than gold and used semi-precious stones, often taking advantage of the colored patterning of variegated stones.

Two other important designers of metal and jewelry joined the workshop in the early years. Otto Prutscher, who was a pupil of Josef Hoffman, joined the Werkstätte for a while in 1903. In addition to producing designs for textiles, glass, book bindings, leather, clock cases and furniture, he designed metal and silverwork, jewelry with enamel, and platinum jewelry. Prutscher also designed jewelry for Theodor Fahrner in Germany, and like Koloman Moser he provided designs for jewelry made by Rozet and Fischmeister.

When Carl Otto Czecha, a painter, graphic designer and craftsman joined the Wiener Werkstätte in 1905, he brought a more decorative and floral look to the jewelry. Although he left in 1907 to teach in Hamburg, he continued to design for the workshop.

The Werkstätte's jewels—pendants, belt buckles, hair combs, necklaces and hat pins—were often rather intricate structures, though even the early pieces were more geometric and restrained than French Art Nouveau. The workshop also made gilded leather purses, beaded bags and shoe buckles.

Other designers who made jewelry for the Wiener Werkstätte before 1914 included Berthold Loffler, who also designed costumes and graphics, and Arnold Wechansky, a designer of ceramics, silver, wallpaper and textiles. Eduard Josef Wimmer designed textiles, ivory and silver pieces as well as jewelry; he later taught at the University of Chicago. Karl Witzman was one of the few to design jewelry only, while Josef Wimmer-Wisgrill ran the fashion department but also designed some silver pieces. Mathilde Flögl and Max Snischek also designed some jewelry.

In 1907 Koloman Moser left the Wiener Werkstätte; as new artists joined the group, the style of the work changed. The look of the jewelry began to soften.

The Later Years

In later years the Werkstätte's style became more ornate, and jewelry was one of the first areas in which this was reflected. Dagobert Peche's jewelry was of a fanciful nature, often quite fantastic-looking, and his output of jewelry designs was significant. Peche enjoyed working with ivory, as in the ivory and gold tiara he designed in 1920, and he was instrumental in the hiring of Friedrich Nerold, an ivory carver. The hiring of Nerold led to the opening of the ivory workshop in 1916. During World War I ivory became a favored material due to the shortages of other materials. In later years wooden and enamelled costume jewelry was also produced.

Austrian Jugendstil brooch. Plique-à-jour enamel sun rising with forget-me-nots. Gold, diamond and pearl. *Couresy of Asprey, New York. Photo by Gabrielle Becker.*

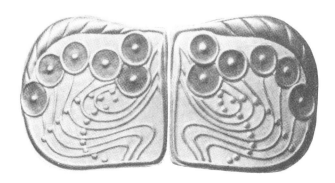

Silver clasp by Anna Wagner, a silversmith and enamellist trained at the Vienna Kunstgewerbeschule and working in Vienna.

The jewelry produced by the Wiener Werkstätte was created in conjunction with artistic clothing styles much as it had been in Britain. The corset and the late Victorian fashions were as distasteful in Viennese artistic circles as they had been in English creative society. The "reform" dress (sometimes called the flour sack) was not very flattering. It was primarily designed and promoted becasue a number of the members were friendly with Gustav Klimt's lover, the fashion designer Emilie Flöge, and they wore the clothes he designed for her. Flöge was featured in Klimt's paintings wearing art clothes and jewelry.

Under the direction of Eduard Josef Wimmer, a designer and craftsman who joined in 1907 and designed some jewelry for the Wiener Werkstätte, the fashion department was opened. They designed fabrics and clothing, and ultimately became one of their most profitable divisions.

The Werkstätte and Metalwork

In addition to jewelry the Wiener Werkstätte produced a large quantity of metalwork in a wide variety of styles. Using silver, gilded silver, silverplate (Alpacca), enameled metal, gilded copper and brass, they created domestic items such as candle holders, planters, inkwells, flower baskets, cruet stands, tea services and flatware. Many of these objects were decorated with enamel, lapis, coral, opals, turquoise, garnets, moonstones, carnelian, malachite, citrines, ivory and a variety of other non-precious materials.

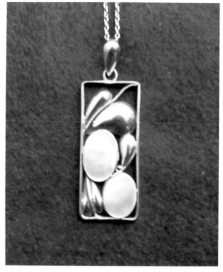

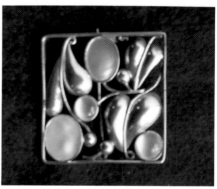

Pendant and a brooch by the Wiener Werkstätte. *Courtesy of John Jesse, London*

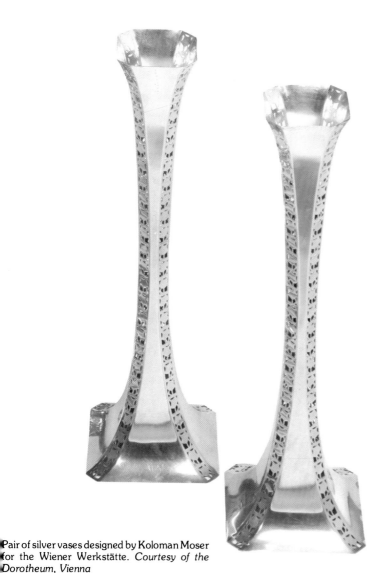

Pair of silver vases designed by Koloman Moser for the Wiener Werkstätte. *Courtesy of the Dorotheum, Vienna*

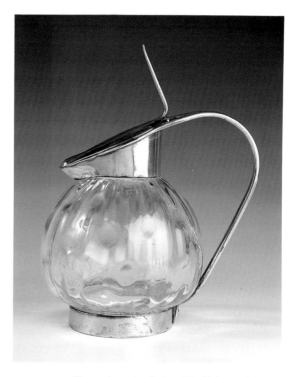

Sherry decanter designed by Koloman Moser, c. 1900. *Courtesy of Didier Antiques, London*

Sterling silver and enamel brooch, Vienna, early twentieth century. Diagonally tooled leather design in pale blue enamel, paper label Wiener Kunsthandwerk, Elfi Muller & Co., Wien/Karntnerstr 53, hallmarked on catch. *Courtesy of Skinner's, Inc., Boston and Bolton.*

Scarf pin by V. Schonthoner, an Austrian painter and designer who also designed small colored pins.

Blue-green Loetz vase. *Courtesy of Barry Friedman, Ltd., New York*

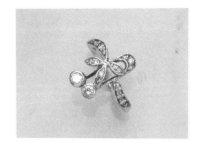

Gold and diamond ring in the Jugendstil style. *Courtesy of the Dorotheum, Vienna*

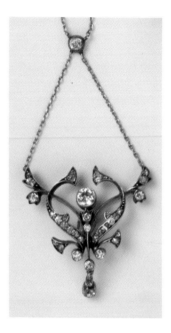

Platinum necklace in the Jugendstil style. *Courtesy of the Dorotheum, Vienna*

A number of items were made from sheet metal with a pattern of squares cut into it; this was known as "gitterwork". There is a strong correlation between gitterwork and Charles Rennie Mackintosh's use of black and white checkered fabric. Flatware was designed by Josef Hoffman, Carl Otto Czecha, Otto Prutscher, Eduard Joseph Wimmer and others. Some designs were initially made as commissions for clients and were later mass-produced. A series of silver boxes was also important in the metalwork line.

The Wiener Werkstätte finally closed its doors in 1939. Fortified with wealthy patrons, it had never really been meant to be self-sufficient, and World War II sounded its death knell. The old social structure with its well-to-do patrons was crumbling. To make matters worse, many of the important designers had died.

The Wiener Werkstätte influence is still seen today—in the United States, the well-known firm Reed and Barton is now manufacturing silver-plated flatware designed by architect Richard Meier which is clearly Wiener Werkstätte-influenced.

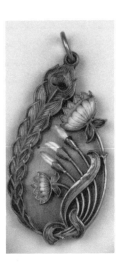

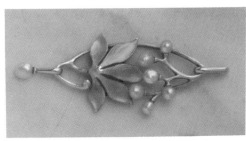

Jugendstil gilt enamel locket. Floral design set with a freshwater pearl and two imitation pearls. Hallmarked Austria. *Courtesy of Skinner's, Inc., Boston and Bolton*

Jugendstil-style brooch. *Courtesy of the Dorotheum, Vienna*

Seven-ball chair designed in 1906 by Josef Hoffman and made by J & J Kohn of beechwood and stained mahagony. *Barry Friedman, Ltd., New York*

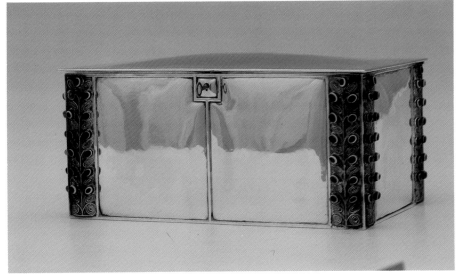

Silver box designed by Koloman Moser for the Wiener Werkstätte, 1903-7. Decorated with stylized trees and set with cabochon cut glass in black and white simulating onyx. Interior lined with ebony. Marked Koloman Moser, Adolf Erbrich, silversmith, Wiener Werkstätte monogram and Austrian assay mark. Also Hungarian and Swedish import marks. *Courtesy of Bukowski's, Stockholm*

Fine Loetz silver-overlaid glass vase. *Courtesy of William Doyle Galleries, New York*

Silver tea service with ebony handles. Designed by Josef Hoffman. *Courtesy of Barry Friedman, Ltd., New York*

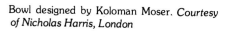

Bowl designed by Koloman Moser. *Courtesy of Nicholas Harris, London*

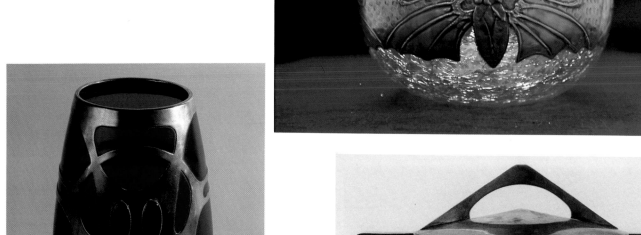

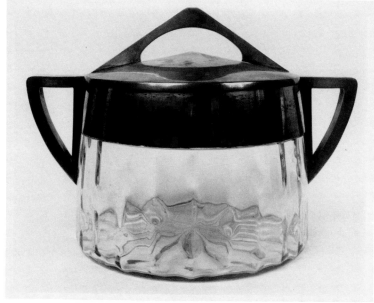

Purple vase with jewels designed by Koloman Moser. *Courtesy of Barry Friedman, Ltd., New York*

Large tureen designed by Koloman Moser. *Courtesy of Barry Friedman, Ltd., New York*

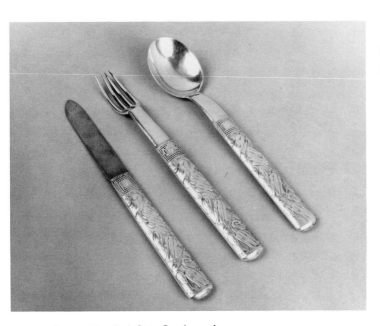

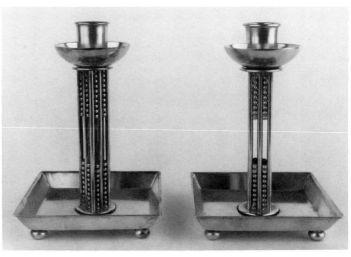

Candlesticks designed by Hans Ofner, Vienna, 1906. *Courtesy of Barry Friedman, Ltd., New York*

Flatware designed by Carl Otto Czecha and executed by the Wiener Werkstätte, c. 1908. *Courtesy of Barry Friedman, Ltd., New York*

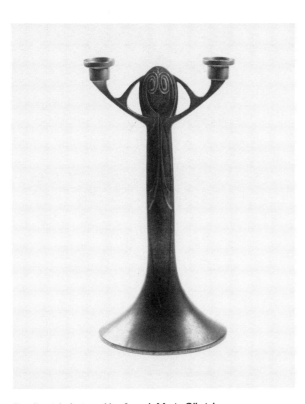

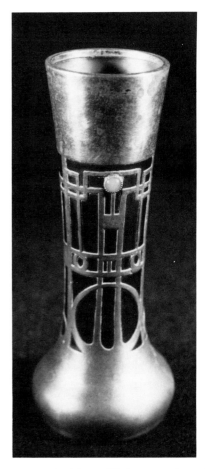

Vase in the Wiener Werkstätte style, maker unknown. *Courtesy of Leah Roland/Split Personality, Leonia. Photo by Diane Freer.*

Candlestick designed by Joseph Maria Olbrich in 1902. 14½" high. *Courtesy of Barry Friedman, Ltd., New York*

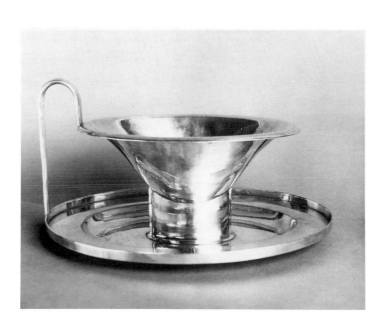

Nickel-plated sauce boat designed by Josef Hoffman. *Courtesy of Barry Friedman, Ltd., New York*

Clock designed by Josef Hoffman of hammered sheet copper and corals with alabaster columns. Signed WW, JH, CK (Carl Kallert), registered trademark, 1903-4. *Courtesy of Barry Friedman, Ltd., New York*

Knife and fork designed by Josef Hoffman. *Courtesy of Barry Friedman, Ltd., New York*

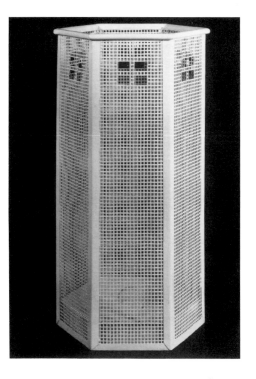

Perforated iron white painted umbrella stand 1906/08 executed by Wiener Werkstätte from a Josef Hoffman design. *Courtesy of Barry Friedman, Ltd., New York*

White painted metal baskets designed by Josef Hoffman. *Courtesy of Barry Friedman, Ltd., New York*

Austrian Art Nouveau ceramic plaque by Ernest Wahliss showing a young couple holding a musical score. *Courtesy of Skinner's, Inc., Boston and Bolton*

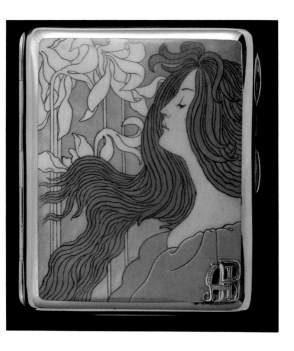

Cigarette case by Georg Anton Scheid. Scheid, who did enamel work, was in business in Vienna from 1862-1903, part of that time in partnership with M. Markowitz. A bracelet by the partnership and a brooch by Scheid are in the British Museum's collection. "GAS" is his mark. *Courtesy of John Jesse, London*

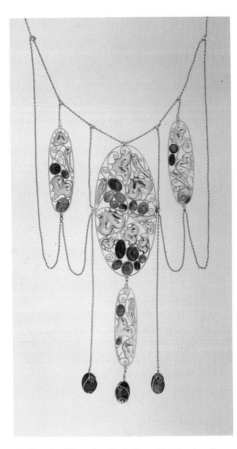

Collar/necklace by Carl Otto Czecha for the Wiener Werkstätte of gold and opal, 1901. Inv. # W.I. 1061. *Courtesy of the Osterreichsches Museum, Vienna*

In the book *Wiener Jugendstilsiber, Original, Falschung (Forgery) or Pasticcio* published in 1980, Waltraud Neuwirth cautions that there are faked Wiener Werkstätte metalwork pieces on the marketplace today. He says they are often a marriage of some original piece of the correct time period which is melded with a forgery to make it appear authentic.

Neuwirth says the items usually include parts of hammered silver, often combined with other materials such as glass or ceramic, are geometric in shape and are everyday objects. Additionally they have either incomplete marks or marks in the wrong places. Overall, the work is somewhat sloppy and if examined closely does not have the "right" feeling.[2]

[1] *Jewels of Fantasy, Costume Jewelry of the 20th Century*, Deanna Farneti Cera, ed., Harry N. Abrams, Inc., New York, NY, 1991, pg. 86.
[2] *Wiener Jugendstilsieber, Original, Fälschung Oder Pasticcio?*, Dr. Waltraud Neuwirth, Vienna, 1990

Wallpaper designed by Prof. C.O. Czecha, 1914 and executed by Max Schmidt.

Wiener Werkstätte Techniques

Beaten silver
Cabochon cut stones
Collet set stones
Repoussé work
Wire work

Suede clutch purse with sterling and chyrsoprase accents. Austrian, early 20th century. Gold wash accents and Austria standard mark "A.F." on sterling. Retailers stamp "Spaulding & Co." on inside suede. *Courtesy of Skinner's Inc., Boston*

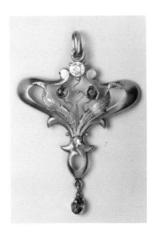

Gold Jugendstil pendant. *Couresty of the Dorotheum, Vienna*

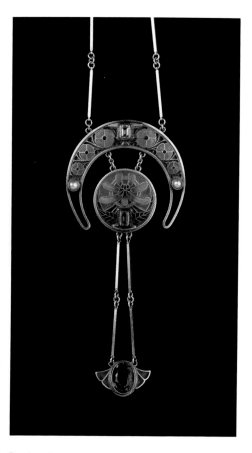

Pendant by unknown designer, believed to be
Austrian. *Courtesy of John Jesse, London.*

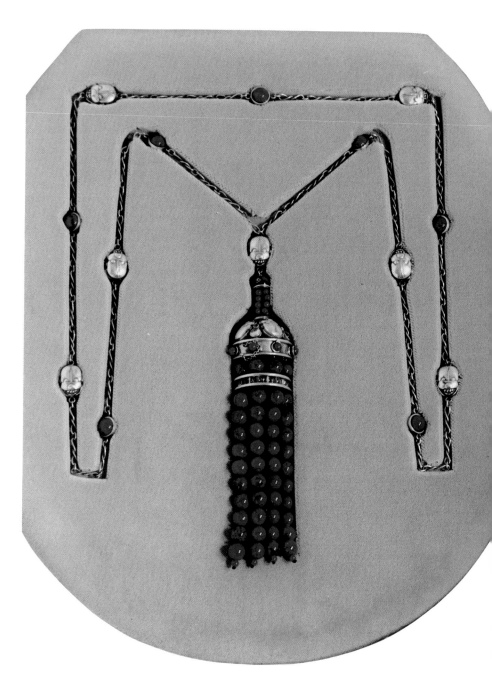

Lapis lazuli, moonstone, sapphire, diamond and
silver pendant with internal watch. Probably
Austrian, c. 1920. The geometric style verges on
Art Deco in this piece. *Courtesy of Tadema
Gallery, London*

Wiener Werkstätte
Materials

Agate
Almandine garnet
Brass
Chrysoprase
Copper
Coral
Gold
Lapis
Malachite
Moonstone
Mother-of-pearl
Opal
Pearls
Silver
Tin
Tortoise shell
Turquoise
Wood

Watercolor by Carl Larsson "When the Children Have Gone to Bed". Note the Arts and Crafts style interior. *Courtesy of the National Swedish Art Museum, Stockholm*

Two hair combs by Harald Slott-Møller.

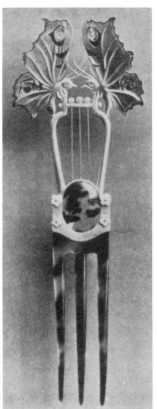
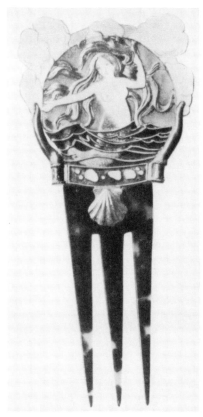

Scandinavia:

A Search for National Identity

What is the first name that comes to mind when one thinks of "art jewelry" from Scandinavia?...Thorvald Bindesbøll, right! No? Perhaps you thought of Harald Slott-Møller? Of course, you probably thought of Georg Jensen first, but the two craftsmen just mentioned were actually the first to be influenced by the new crafts movement in Europe and to begin making distinctive jewelry of their own. Without their lead, Georg Jensen would not be a name known around the world today.

Born in 1846, Bindesbøll was an architect who was influenced by the work of William Morris as well as by Eastern art, Japanese metalwork and Celtic ornament. He was a multi-talented artist, as were so many artisans of the British Arts and Crafts movement, designing jewelry and silver, ceramics, bookbindings, lighting fixtures, furniture, and glass. His early jewelry (in the 1880's) called on designs from the past, primarily Viking and Old Nordic designs. But by the 1890's Bindesbøll began to design for two silversmiths and a new and bold design emerged unlike any jewelry that had been made in Denmark until this time. Most other art jewelers to follow would be influenced by his work.

Not being a silversmith himself, Bindesbøll's designs were often hard for silversmiths to follow; they were unused to working with the very organic looking sketches he provided. Fortunately, in the last four years of his life he teamed up with a silversmith named Holger Kyster which turned out to be a perfect partnership—Kyster understood exactly how to execute his jewelry. Some of his work was also produced by the firm of Peter Hertz.[1]

Silver brooch by Thorvald Bindesbøll

Harald Slott-Møller

Harald Slott-Møller was also an artist turned jewelry designer. Møller had travelled in Europe and had communication with several artisans of the English Arts and Crafts movement, and these influences can be seen in his work. Some of his work has been described as similar to Henry Wilson's, and at the very least he believed in the Arts and Crafts ethic of a single craftsman doing all of the work on a piece of jewelry from start to finish.

Slott-Møller's jewelry was pictorial rather than abstract, unlike most of the Danish jewelers who were to follow him. One of his most famous pieces is the "Helen of Troy" necklace, now in the Museum of Decorative Arts in Copenhagen. The necklace illustrates a nude figure of Helen carved in ivory standing in front of a backdrop of a burning Troy. The other strongly colored-enamelled plaques in the necklace have soldiers on them and the piece is made of silver, gold and semi-precious stones. Some of his work was shown at the Paris Exhibition in 1900 by the Danish firm of A. Michelson.

Skønvirke Influences

The period in the history of Danish decorative arts that corresponds with the Arts and Crafts and Art Nouveau periods was known as the skønvirke period— roughly from 1900-1925. Denmark's artistic community, like their counterparts in Europe, were reacting against the growth of industrialism and against the style movement then in favor, historicism. The skønvirke period was characterized by quality craft work and new styles that didn't rely on the past. As mentioned, Bindesbøll and Slott-Møller were two of the driving forces who gave the movement impetus. Patrons like Pietro Kron and Emil Hanover helped to support the crafts movement and were also organizers for a number of exhibitions which brought foreign artists and craftsmen to Denmark including C.R. Ashbee and Lalique. The fact that Queen Victoria's son Prince Edward married the Danish Princess Alexandra may partly explain why the British Arts and Crafts movement had influence in Denmark; the Continental influence was thrown into the mix when many Danish goldsmiths attended German schools.

The Danish movement's response to English Arts and Crafts influence was varied; some aspects were enthusiastically adopted, while others were not so

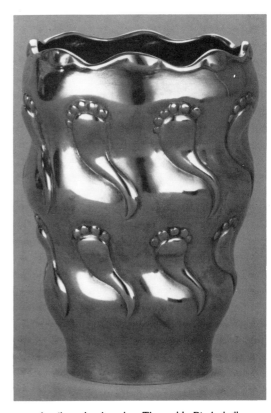

A silver beaker by Thorvald Bindesbøll. *Courtesy of Museum of Decorative Arts, Copenhagen*

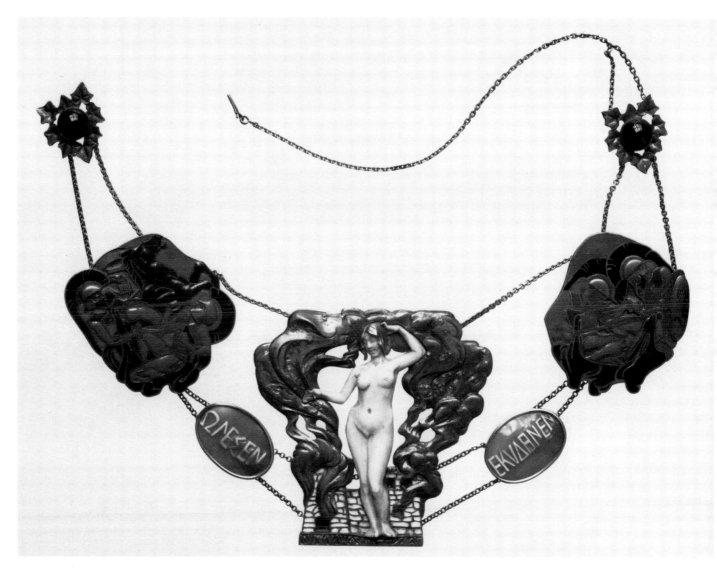

Helen of Troy necklace by Harald Slott-Møller,
c. 1899. The necklace is gold with ivory, enamel
and semi-precious stones. *Courtesy of the
Museum of Decorative Arts, Copenhagen.*

well-received. The Danish movement imitated the English in its desire to create quality jewelry that would be available to many people. Most of the Danish jewellers used less enamel than the English Arts and Crafts or Art Nouveau designers. Another point of difference was that many Danish jewelry designers had trained as sculptors and brought those skills into their jewelry making. Designers like Just Anderson and F. Kastor Hansen were sculptors turned silversmiths, and Mogens Ballin, Georg Jensen's mentor, was influenced by the work of Siegfried Wagner, another sculptor. The use of hammer marks as decorative elements was a technique the Danes adopted directly from the English Arts and Crafts movement, defying the past standards of Danish silverwork, which had traditionally used all planished surfaces. However, the Danish jewelers of the skónvirke period sometimes tooled their jewelry by machine, unlike the purists of the English Arts and Crafts community.

Another influence on the new Danish artistic movements came from the east—from Japan. Shades of traditional Japanese naturalism can be seen in Danish skønvirke jewelry and metalwork, much as it appeared in the work of other contemporary movements worldwide.

Organic shaped brooches by Thorvald Bindesbøll.

Mogens Ballin

Mogens Ballin is another important name in the history of skønvirke jewelry and metalwork for two reasons. He was instrumental in moving Danish jewelry from being only for the rich to being available to a wide audience; he was also the man who hired young Georg Jensen and trained him to be a silversmith.

Ballin had taken a rather circuitous route to his career. Trained as a painter, he studied in Paris where he became acquainted with the Symbolist painters. Born and raised a Jew, Ballin had an "epiphany" that caused him to convert to Catholicism and become a monk. His life as a monk did not fulfill him though, and life as a painter did not support him financially after he married in 1899. Looking for financial security he decided to open a workshop to make beautiful, everyday objects of affordable metal (bronze, silver, pewter, copper, etc.) based on the ideals of William Morris and John Ruskin.

Though untrained as a craftsman he worked alongside his metalsmiths. Ballin's work was quite simple and influenced by that of Thorvald Bindesbøll, Siegfried Wagner (who designed for him) and German silversmiths of the time. His designs were somewhat abstract and organic in nature, incorporating semi-precious stones. The Ballin workshop produced lamps, jewelry—including brooches, clasps, and combs—writing sets and household items. None of the pieces produced in his workshop are signed and it is quite difficult to say if Ballin, Wagner or one of a number of other designers created a specific piece.

"Butterfly" clasp in bronze and silver in three parts by Mogens Ballin.

An unusual silver and lapis lazuli brooch by Mogens Ballin, made in 1900. This brooch was given by Ballin to his wife to commemorate the birth of their son. *Courtesy of Museum of Decorative Arts, Copenhagen.*

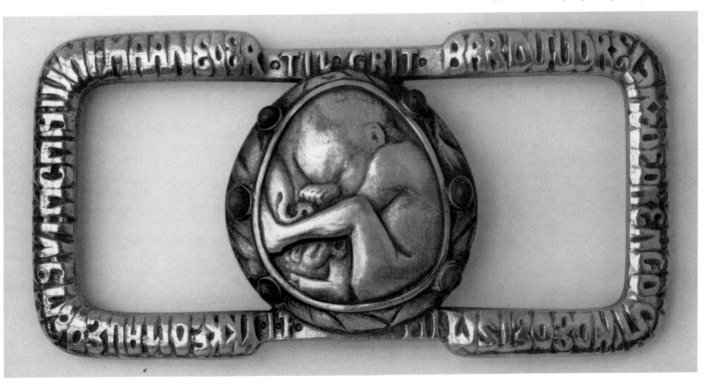

Georg Jensen

Around 1901-2 Georg Jensen was hired as a journeyman in Ballin's workshop. He had previously been apprenticed to a goldsmith and then trained as a sculptor in France before joining Ballin. While sculpting was his great love, in 1897 Jensen—who had been left a widower by his first wife—turned to a more practical way to support his small children. He soon exhibited some of his own pieces of jewelry at a local art gallery where he had previously shown his sculpture. The well-known "Adam and Eve buckle," now in the Museum of Decorative Arts in Copenhagen, dates from this period.

In 1904 Jensen left Ballin to open his own workshop and was soon exhibiting at home and abroad with considerable success. In fact at one point in the early days of his workshop Jensen had to put up a sign that said "closed for repairs" to give himself time to replenish his sold out stock. [2]

In the first few years Jensen made only jewelry—the famous silverware and silver objects were yet to come. This was primarily a question of economics—jewelry represented a smaller cost of goods and Jensen did not yet have a cash reserve. A number of designs for rings, earrings, brooches, bracelets and necklaces were executed, and hatpins were extremely successful. In fact the hatpins were so popular that Jensen's workshop made and sold over one hundred different styles.

Although certainly revealing some Art Nouveau influence, Jensen's jewelry is more sculptural and three-dimensional. Some early pieces show obvious Lalique influence—Jensen had studied in France and was familiar with Lalique's work. The dragonfly belt clasp now in the Georg Jensen Museum is a good example. Others have what may be considered a Jugendstil feeling. Familiar motifs from these movements such as the dove, flowers, and flowing tendrils also appear in Jensen's early pieces. His designs were more symmetrical than Art Nouveau and in that sense have a stronger relationship to English Arts and Craft design, yet are a style that is uniquely Jensen. He also collaborated with the artist Christian Møhl-Hansen on a number of pieces—the best known is probably the dove brooch. The motif was also used on bracelets, necklaces and earrings as well.

Jensen's Early Years

Jensen worked mostly in silver, and infrequently in 18 kt. gold. Silver seemed to have more appeal to him, probably because of its sculptural qualities and also because it helped him to keep his prices reasonable. Jensen combined silver with semi-precious stones and materials in "warm" colors. His work is somewhere between a stylized and naturalistic treatment and often has drops of various materials hanging from it.

In 1904 he had begun limited production of hollow-ware with his first piece, a teapot being shown at an exhibition. It was the first in what was to become the "Magnolia" line of tea and coffee services. In 1905 he had begun a collaboration with the architect and designer Johan Rohde, with Rohde designing cutlery and silver items with minimal ornamentation. The "Acorn" pattern, one of the most famous Jensen patterns today was one of Rohde's designs (1913) as was pitcher no. 432, which was thought to be so audacious when it was designed in 1920 that it was not put into production until 1925. In 1906 Jensen made his first complete line of cutlery, "Antique" which is still an important seller in the line today. One of the motifs that often turns up on Jensen's hollow-ware is small clusters of fruit.

Rohde, who was a painter, also designed gold jewelry with filigree work, pearls and precious stones. His use of the acanthus leaf, a neoclassical Danish jewelry element was quite different from Jensen's work.

Jensen Expands

Continually hiring skilled workers, Jensen expanded his shop to sixty workers by 1910. The Jensen business was so successful by 1909 a shop was opened in Berlin to sell Jensen jewelry and silverwork. Others were to follow in London, Paris, Barcelona and other cities.

Another important name in the history of the Jensen company is that of Harald Nielsen, Jensen's brother-in-law. Beginning as a chaser, he evolved into a talented draughtsman and designer who played a significant role in the company. Other important designers who worked for Jensen over the years include the Danish sculptor Gundorph Albertus, who married one of Jensen's sisters-in-law and Henning Koppel who learned his craft under Harald Nielson's tutelage and

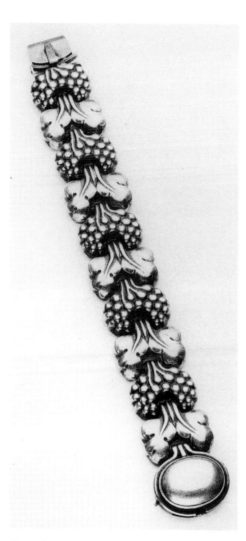

Georg Jensen sterling silver bracelet. *Courtesy of Butterfield and Butterfield, Los Angeles*

was known for his irregular, abstract shapes. Count Sigvard Bernadotte joined the firm in 1935 and contributed a severe but highly contemporary look.

By 1960 there were 14,000 Jensen patterns in production (there are less today). The company still flourishes, more than five decades after Jensen's death with many of the early designs of jewelry and silverwork still in production. Jensen jewelry was and is sold worldwide and also had some influence on work in other countries. The work of the American Arts and Crafts Kalo workshop in Chicago in the early twentieth century often bears resemblance to Jensen's work and in fact had several Danish craftsmen on staff.

Jensen's genius was in being a sound buinessman and in using the machines to augment the handwork of his artistic jewelry and silverwork. He proved that high-quality artistry and level-headed business sense could go hand-in-hand—which is why his business remains functioning today. Jensen continued to design until his death, when a new generation of designers took over, including Jensen's son Jorgen Jensen.

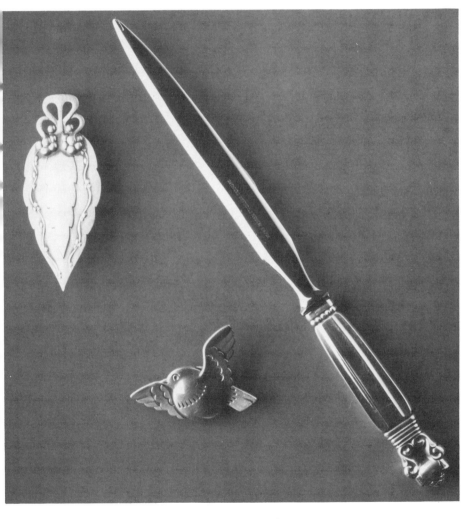

Three Georg Jensen sterling items still being made today. Letter opener is in the acorn pattern which was first introduced in 1916. *Courtesy of Georg Jensen, Royal Copenhagen Co., New York*

Georg Jensen brooch with amber, green agate, moonstone, amethyst and sapphire. Designed in 1908. *Courtesy of Georg Jensen, Royal Copenhagen Co., New York*

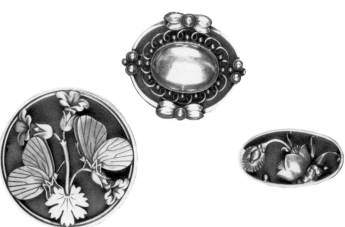

Three early twentieth century Georg Jensen sterling silver pins. *Courtesy of Skinner's Inc., Boston and Bolton.*

Two Danish brooches and two pendants, all sterling circa 1900. The round pendant or brooch is by Georg Jensen. *Courtesy of Bukowski's, Stockholm.*

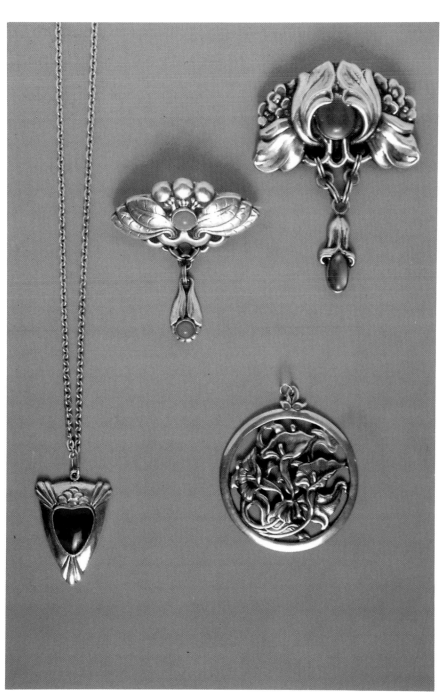

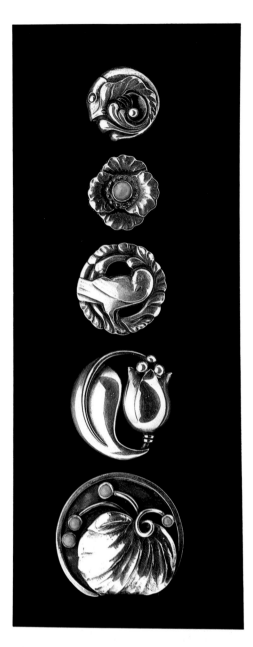

Top three buttons are rare examples of early twentieth century Georg Jensen buttons. The bottom two buttons were made in the United States in the 1940's based on Georg Jensen designs. *Reprinted from Buttons by Diana Epstein and Millicent Safro. Published in 1991 by Harry N. Abrams, Inc. P: John Parnell.*

Georg Jensen brooch still being made today. This one has moonstones, a 1914 version in the book *Georg Jensen, the Danish Silversmith* illustrates it with amber. *Courtesy of Georg Jensen, Royal Copenhagen Co., New York*

Sterling bracelet by Georg Jensen. Believed to be made around 1950. Marked Georg Jensen sterling, USA, JoPol 00288. *Collection of Joyce Jonas, New York*

Sterling silver necklace, bracelet, brooch and earrings, hallmarked. Earrings converted to French wires. *Courtesy of Skinner's, Inc., Boston and Bolton*

On the right, a Jensen sterling brooch with amber and green agate first made in 1909. On the left a brooch with carnelian and green agate first made in 1913. *Courtesy of Georg Jensen/Royal Copenhagen Co., New York*

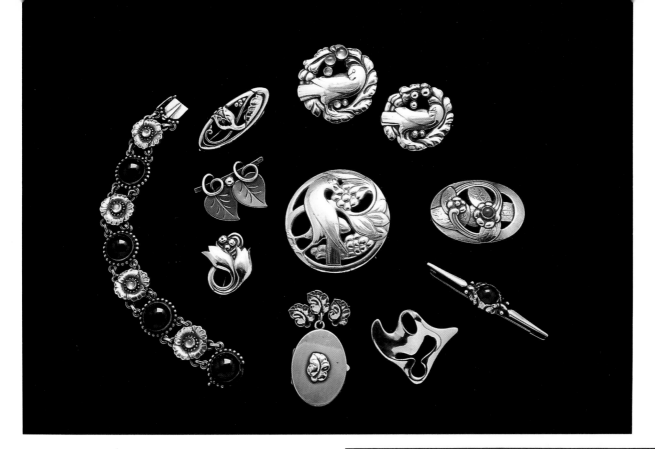

Selection of George Jensen jewelry all marked "GJ", sterling, Denmark except where noted. Starting from the top and moving clockwise: Large bird pin with cabochon moonstones and small version in all silver, first put into production in 1914; sterling pin with carnelian, bar pin with green chrysoprase, free form sterling pin of more recent design; locket; intertwined tulip pin; double leaf marked New York; bracelet with moonstones and blue glass cabochons; oval pin. *Courtesy of Carole Berk, Bethesda. Photo by Luisa DiPietro*

Georg Jensen jewelry still being made today.
Courtesy of Georg Jensen, Royal Copenhagen Co., New York

Georg Jensen sterling silver items. Salt and peppers and toast rack designed by Sorensen, c. 1930. Sugar castor by Harold Nielsen, c. 1930.
Courtesy of Didier Antiques, London

Six piece silver tea set by Georg Jensen.
William Doyle Galleries, New York

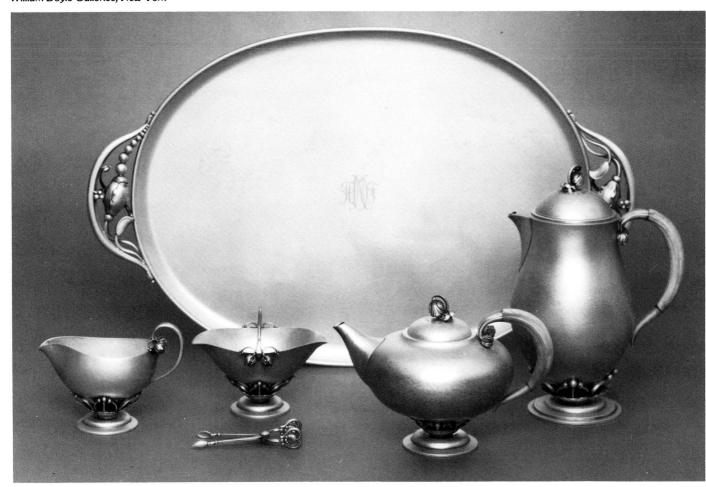

Jewelry by modern Georg Jensen designers. Two jewels with watch faces are by Torun Bülow-Hübe, a native of Sweden who lived in France and then Java. Bülow-Hübe began working for Jensen in 1967. The ring is by Nanna Ditzel, who attended the Danish School of Arts, Crafts and Design and opened her own studio in 1946, beginning to design for Jensen in 1954. The bracelet was designed by Erik Herlow, who studied at the Royal Danish Academy of Fine Arts and has had many exhibitions of his work. Bent Gabrielsen, designer of the pendant, attended the Danish College of Jewelry; as a silversmith and commercial designer he has won many awards. *Courtesy of Tadema Gallery, London*

Enamelled silver fish clasp
by Erik Magnussen

Erik Magnussen "Grasshopper on Mistletoe" brooch. Partly gilded silver with amber and emeralds, 1907. *Courtesy of Museum of Decorative Arts, Copenhagen.*

Scandinavian Materials
Agate
Amber
Amethyst
Brass
Bronze
Carnelian
Chrysoprase
Cordierite
Disko
Enamel
Freshwater pearls
Garnet
Gold
Ivory
Labradorite
Lapis Lazuli
Moonstones
Mother-of-pearl
Quartz
Sapphires
Silver

Two hair combs of horn by Marie Christiansen. One is decorated with pearls, the other with mother-of-pearl and shows an Art Nouveau influence. *Courtesy of Museum of Decorative Arts, Copenhagen*

Skønvirke Jewelers and Metalworkers

Other important jewelers of the skønvirke movement included Erik Magnussen, who was a self-taught jeweler, goldsmith, silversmith and enameller and used naturalistic motifs—bees, butterflies, grasshoppers, beetles, etc. In 1925 he emigrated to America and became the artistic director for the Gorham Company where he was quite successful until he left during the Depression. He then opened a workshop, first in Chicago and then in Los Angeles, making expensive jewelry for movie stars. After 1939 he returned to Denmark and produced jewelry in a Nordic style.

Evald Nielsen, who had travelled in Germany and Paris, opened his workshop for silversmithing in 1900 and the German influence can be seen in his designs. He was extremely successful, primarily working in silver with amber, malachite and turquoise and selling his jewelry throughout Scandinavia and Germany.

Other important jewelers were F. Kaston Hanson, who created jewelry resembling silver sculptures, primarily animals, and Just Anderson, who was discovered by Mogens Ballin. Anderson ran a successful business with his wife Alba, a chaser, creating mainly one-of-a-kind jewelry of gold and precious stones. In order to expand his business he moved on to work in pewter, silver and Disko, an alloy he invented, making vases, bowls and small sculptures.

Christian Thomsen designed buckles for the Royal Copenhagen porcelain company along with sculptor Bertha Nathanielson around 1901. A limited quantity of these porcelain plaques mounted in silver guilt buckles were made—the British Museum has one by Thomsen in their collection.

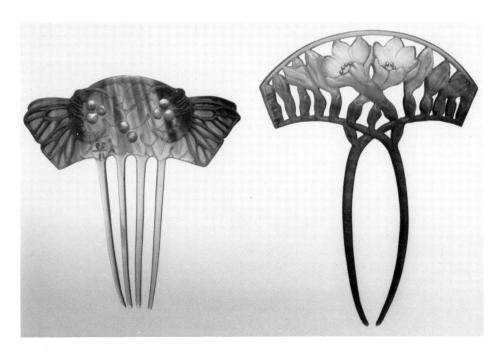

Women Artisans

As in England, women metalwork designers emerged for the first time during the skønvirke period. Part of this may be due to the fact that Jensen took apprentices from a woman's art school and a number were daughters of artists of the time. One of the best known women silversmiths was Inger Møller who worked for Jensen from 1909-21 and then had her own shop. Her early work was in the skønvirke style and she won many exhibition awards in Denmark and abroad. Thyra Marie Vieth, the daughter of a sculptor, worked for several silversmiths before opening her own workshop and also ran her own chasing school. She worked from her own designs as well as those she commissioned from others.

Marie Christiansen, the daughter of a painter studied horn and ivory carving in France, made jewelry and combs which were the closest to Lalique of all the Danish work. Elise Thomsen and Ingeborg Mølsted were both daughter's of painters and Tabita Nielsen Schwenn was Georg Jensen's sister-in-law who trained with Mogens Ballin and then worked for Jensen. Her husband, Danish artist Carl Schwenn painted a portrait of Georg Jensen which hangs in the workshops today. There were a number of other important designers from the skønvirke period including: Axel Hou, Georg Thylstrup. Bertha Nathanielsen, and Svend Hammershøj.

Similar movements to the Danish skønvirke took place in the other Scandinavian countries at the turn-of-the-century although not many designers from these countries are well-known today; metalwork was less important than textiles and ceramics and some of the other decorative arts.

A number of crafts societies were formed in Scandinavian countries in an effort to elevate crafts to the level of fine arts and in an effort to mold national styles.

Two pieces of modern Danish sterling silver, marked AxS. The relationship to early Georg Jensen pieces and the work of his contemporaries is evident. *Courtesy of D. & J. Ritchie, Inc., Toronto*

| **Scandinavian Influences/Motifs** |
| Art Nouveau |
| Birds |
| Birch leaves |
| English Arts and Crafts |
| Flowers |
| Nationalism |
| Nature |
| Pine twigs |
| Vikings |

The Art Movement in Sweden and Finland

In Sweden the Swedish Society of Industrial Design was founded in the mid-nineteenth century. In 1897 at an Industrial Exhibition held in Stockholm the artist Carl Larsson showed watercolors of house interiors which adapted the British Arts and Crafts style to Swedish habitats. The best known silversmith to be influenced by English Arts and Crafts was Javob Angmann, who began working around 1900 in a "new art" style.

In Finland the Central School of Arts and Crafts was founded in Helsinki in 1871, the Finnish Society of Craft and Design in 1875, and the Friends of Finnish Handicrafts in 1879. Under Russia's rule there had been a growing feeling of nationalism which led to a Finn revival, had the upper classes speaking Swedish and also influenced the decorative arts. The styles of the past were popular along with Art Nouveau inspired designs in tapestries and jewelry. Architects such as Herman Gesullius, Armas Lindgren and Eliel Saarinen created a unique Finnish style of architecture. (Eliel Saarinen later designed flatware for the International Silver Company in the United States.)

By the 1890's the ideas of William Morris and John Ruskin reached Finland. Axel Gallen, a painter, believed in Morris' tenet that the artist/craftsman should create an entire piece of work himself and he designed and made many decorative objects including jewelry. His pupil Erik Ehrström became an important silversmith whose work foreshadowed the Art Deco style that was yet to come. Carl Wilhelm Vallgern worked in bronze to design domestic items, while Walle Rosenberg designed metalwork pieces.

The Art Movement in Norway

Norway broke away from Sweden in 1905 and this freedom brought about a Viking revival—particularly the use of dragon heads that appeared on Viking ships, and the entrelac motif similar to Celtic design. Frieda Hansen opened the Norwegian Tapestry Weaving Studio in Oslo and the painter Gerhard Munthe designed weavings and furniture, the two areas on which the Norwegian crafts movement primarily focused.

The Norwegian jeweler and silversmith firm best known from this period is David Anderson, still an important Oslo firm today. David Anderson made jewelry in an "Art" style at the turn-of-the century as well as silver and gold objects. Enamelled goods became an important portion of their output and still is quite popular in their line of goods today. Another important Norwegian jeweler at this time was the firm of J. Tostrup which made a number of items with plique-à-jour enamel, some of them exhibited at the Paris Exhibition in 1900. Marius Hammer and Thorvald Olsen of Bergen also made silver items in the Art Nouveau style.

In Scandinavian art jewelry and metalwork, silver was the preferred material as it was affordable for young craftsmen and also because it went well with semi-precious stones and materials like amber and coral. Amber, known as "Nordic Gold" was found in Denmark along the beaches where it had been carried by the rivers and was referred to as "the tears of the sun goddess." Finnish jewelry used local stones including quartz, garnets, labradorite, smoky quartz and cordierite. Unlike the exotic flowers used in French Art Nouveau, native plants—including birch leaves, and pine twigs—were used by Scandinavian designers.

In the 1920's the skønvirke style in Denmark began to fade and as in much of Europe functionalism was "in". Jewelry and metalwork of that time had little decoration and more machine work was done.

The work of the turn-of-the-century Scandinavian jewelers and metalworkers had clearly been a departure from what had come before it. These new techniques and attitudes allowed it to evolve into the sleek, modern style associated with Scandinavian craftsmanship today.

01 *Danish Jewelry*, Jacob Thage, Komma & Clausen, Denmark, 1990, pg. 73
02 *Georg Jensen, The Danish Silversmith*, E.R. Jorgen Møller, Georg Jensen and Wendel Als, Copenhagen, Denmark, 1984

Brooch of 18 kt. gold with Swedish freshwater pearls and four brilliant cut diamonds, c. 1910. Of Swedish origin in a design that has both Art Nouveau and Edwardian feeling about it. *Courtesy of Bukowski's, Stockholm*

Early twentieth century enamel on brass brooch from Norway.

United States:

Cousins Across the Ocean

There is little doubt that the Arts and Crafts movement in the United States was a direct result of the British movement. It had long been fashionable for American jewelry and metalwork to follow England's lead. American Arts and Crafts jewelry which began to be made around the 1890's happened to coincide with the time frame in which American jewelry began to be made in any great quantity at all.

Christopher Dresser had lectured in Philadelphia in 1876, and Charles Robert Ashbee visited Chicago twice. All of this interaction helped expose American artisans to British work. Likewise, Americans such as Gustav Stickley, Elbert Hubbard and Elizabeth Copeland, all of whom were to become important to the American Arts and Crafts movement, went to England to study. Jane Addams, who was to found Hull House in Chicago, visited the Guild of Handicraft in the 1880s. William Morris products were imported to the States, while Owen Jones' *Grammar of Ornament* and British art magazines like *The Studio* made their way to American shores.

A number of important British designers and craftsmen came to live and work in the United States, with Archibald Knox figuring prominently, so it cannot be doubted the strong influence the British Arts and Crafts proponents had on their American cousins.

In the United States, as in Great Britain, there was a movement to provide more sensible clothing for women—in America it was known at the "Free Dress League." Kimono-style dresses were popular was well as the mannish skirt, blouse and belt while the magazine *The Craftsman* carried articles on plain, simple clothes. As in Great Britain, this new style of clothing was well-suited to Arts and Crafts jewelry.

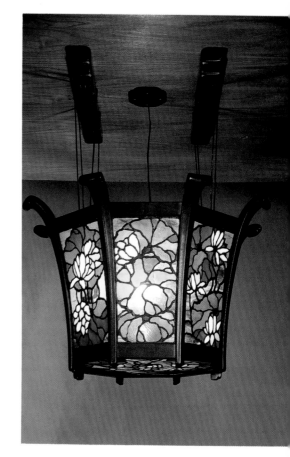

Greene and Greene ceiling light for the Robert R. Black House, Pasadena, California. Mahogany and stained glass, 1907-9. *Courtesy of Hirschl and Adler Galleries, New York*

Early Limbert cut-out chair; Limbert table lamp; Limbert double oval library table with over-hanging table top; Dirk Van Erp boudoir lamp in hammered copper and mica; Gustav Stickley five light chandelier in hand-wrought copper and amber glass shades. *Courtesy of David Rago, Trenton*

Great Britain: Similarities and Differences

Despite all the similarities between the American and British movements, there were also a number of significant differences, giving the American movement a life and style of its own. In the exhibition catalog *Art With a Mission* several important differences are highlighted:

—Because the American Arts and Crafts movement had no national spokesman like England's William Morris or John Ruskin, it became a movement that was regional in nature. The important centers were the East Coast (New York, Philadelphia, Boston), Chicago, and California.

—Americans were not as adamant as the British that the machine be ignored.

—There was no history of medieval or Gothic past to draw upon so American artisans were influenced by their own history—the metalwork that had been made by colonial craftsman, the designs of the Shakers, the pioneering history and the winning of the West which incorporated the strong relationship of the American Indian with nature. They were also influenced by the Spanish missions of the Southwest.[1]

It has been said by several historians that jewelry was not an important part of the American Arts and Crafts movement. While it is true that furniture, pottery and metalwork were probably the most prolific areas of the decorative arts, with textiles, graphic arts, and printing all being significant, it would be wrong to say that jewelry was unimportant.

As in England a number of guilds were formed in the United States and only a few produced jewelry and metalwork, but this did not mean there was a lack of interest in jewelry. The individual craftsman was a more important factor in this area of the decorative arts, with a few noted workshops being the exception. Many of these independent designers, jewelers, and metalworkers were women, who like their sisters in Great Britain became an important part of the Arts and Crafts jewelry and metalcraft movement.

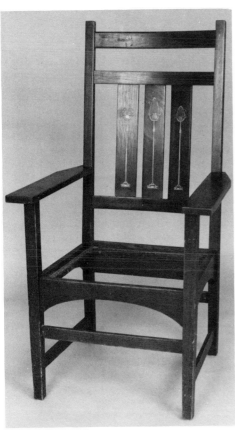

Gustav Stickley high-back armchair by Harvey Ellis c. 1904 inlaid with a stylized flower in copper, nickel and wood. *Courtesy of David Rago, Trenton*

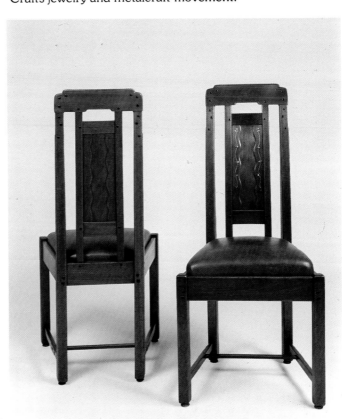

Pair of Greene and Greene side chairs from the Robert R. Blacker House, 1907-9. Mahogany and ebony with copper, pewter, and mother-of-pearl inlay. *Courtesy of Hirschl & Adler Galleries, New York*

Four Tiffany lamps: Brass and Favrile glass lotus bell lamp, bronze and Favrile blue dragonfly lamp, bronze and Favrile glass wild rose lamp, and Favrile glass and bronze Nautilus lamp. *Courtesy of Skinner's, Inc., Boston and Bolton, and William Doyle Galleries, New York*

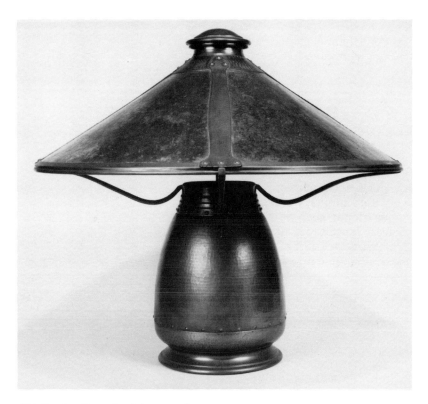

Old Russian Kopperkraft hammered copper and mica table lamp. *Courtesy of David Rago, Trenton*

Roycroft drop front desk and rocker. *Courtesy of David Rago, Trenton*

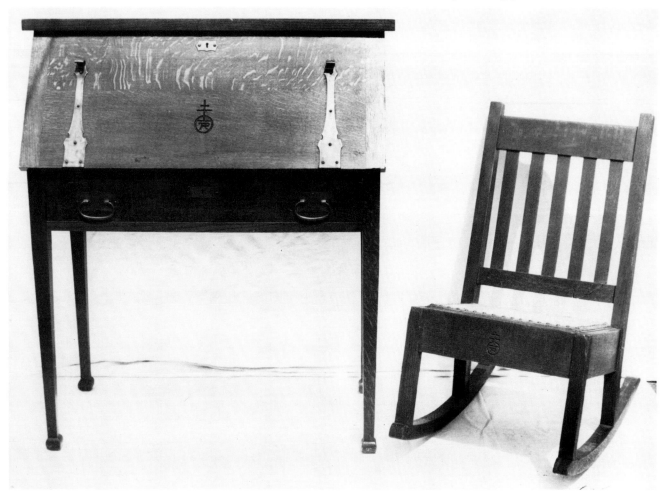

American Arts and Crafts Jewelry

The Arts and Crafts Societies that sprung up around the country, most notably in Boston and Chicago, were also to play a significant role as they focused heavily on jewelry and metalwork.

Some of the early American Arts and Crafts jewelry shows an awareness of the Art Nouveau movement, and the Japanese influence of the Aesthetic period also lingered. While more stylized and abstract than the work of artisans in Great Britain, American Arts and Crafts design is still more closely related to the English than to any other European style. American designers usually favored architectonic and simple shapes, with quiet coloration. They worked in both gold and silver, although this tended to be a regional choice and stones were often collet set with semi-precious stones including opals, moonstones, coral and amethyst among others, valued for their color not their intrinsic worth and were usually cabochon cut. Blister pearls and native stones such as turquoise, Mississippi river pearls and Montana sapphires were especially favored.

A beading effect was commonly used on the metal, as well as the "paper clip" chain for necklaces and pendants and a t-bar that hooked into rings for closures. Necklaces, pendants and brooches were the most common items made by Arts and Crafts jewelers, with bracelets and rings less common and earrings somewhat rare. Buckles and cufflinks were also made, but again, less frequently. American artisans tended to favor enamel work and naturalistic motifs such as curling vines and tendrils, flowers and fruits.

Much of the body of American jewelry is unsigned and it is difficult to track down the makers. Rosalie Berberian, an expert in American Arts and Crafts jewelry and metalwork, has done extensive research in the archives of the Boston Arts and Crafts Society which has yielded some good results; Sharon Darling, for her book *Chicago Metalsmiths*, searched directories for the city of Chicago during the early part of the twentieth century to turn up previously unknown jewelers. Yet, there is still a great deal less information available on American designer/craftsman than on their British contemporaries. Compounding this problem is the fact that there is work by many amateur jewelers and metalworkers surviving which is unsigned.

The East coast craftsmen were located primarily in New York City, upstate New York, Boston and Philadelphia with Boston the starting point for the Arts and Crafts movement to take hold in the East.

Large Mabé pearl pendant set in sterling silver with handwrought chain. *Collection of John Toomey/Dinah Thompson, Oak Park*

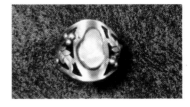

An American Arts and Crafts silver ring with a blister pearl. Signed with back to back interlocking "C's" which is similar but not the same as the mark for a Chicago firm, Carence Crafters about which little is known.

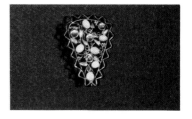

A gold Arts and Crafts brooch, probably American. Opals, moonstones, with foliate motif.

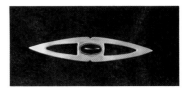

An American Arts and Crafts brooch with a carbuncle. Unsigned and has an amateur look.

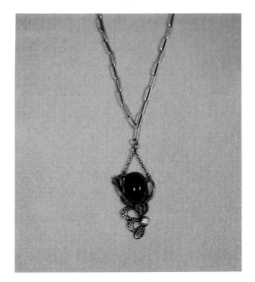

An American Arts and Crafts brooch of silver, cabochon carnelian and pearl, unsigned. The chain is a reproduction being made today by Roycroft Associates of East Aurora, New York. It is clearly marked with a Roycroft tag on the catch.

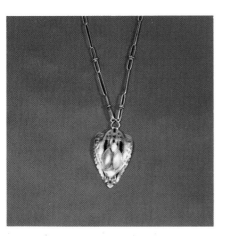

An American Arts and Crafts pendant with grey and white blister pearls and a paperclip chain, unsigned.

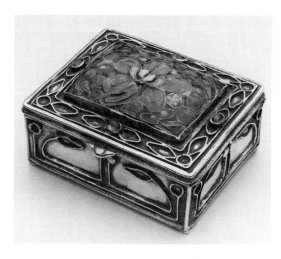

Elizabeth E. Copeland, Boston, Massachusetts, 1866-1957, Coffer, silver with cloisonné panel, 1908.37, 2¾ x 5½ x 4 in., Laura S. Matthews Fund, 1982.1291 ©1992 *The Art Institute of Chicago. All rights reserved.*

Boston Jewelry and Metalwork

Charles Eliot Norton, professor of fine arts in Boston, became friendly with John Ruskin in 1874 and started Boston's first organization to provide lectures and classes for the crafts. Then, in 1897 the Boston Arts and Crafts Society was formed, and then the Arts and Crafts Institute, which taught handicrafts with a focus on jewelry. Other schools in various parts of the country soon followed.

Boston jewelry designers tended to work in gold and produced more finely worked jewelry than that made in Chicago and on the West Coast. They even used precious stones in many of their pieces. Elizabeth Copeland is one of the best known of the Boston jeweler/silversmiths. She was born in Boston but studied in London before working in the Arts and Crafts style. She also studied under Laurin Martin, a British-trained enamellist teaching at the Cowles Art School in Boston. Copeland is known for her enamel and silverwork in simple nature-inspired motifs. She exhibited throughout the United States. Other notables among the Boston community were Margaret Rogers, Margaret Vant and Frank Gardiner Hale, who often worked in two-color metals. Josephine Hartwell Shaw is known for her use of Oriental motifs and carved jade in her jewelry. Edward Everett Oakes was a student of both Hale and Shaw, and became an important jeweler in his own right. He was strongly inspired by nature, and his jewelry was known for its leaf work. He worked his metal (often gold) in a variety of ways, including carving, chasing and wire working; he set his pieces with both precious and semi-precious stones (as did Hale) and always made his jewelry with well-finished backs. His son Gilbert Oakes followed in his footsteps as a jeweler.

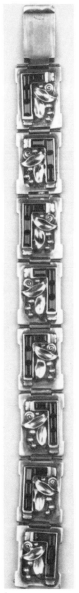

Arts and crafts bracelet, garnet, silver and gold links. Each rectangular panel is set with four-baguette-cut garnets, channel set, with a gold leaf motif. Signed: Oakes. *Courtesy of Skinner's, Inc. Boston.*

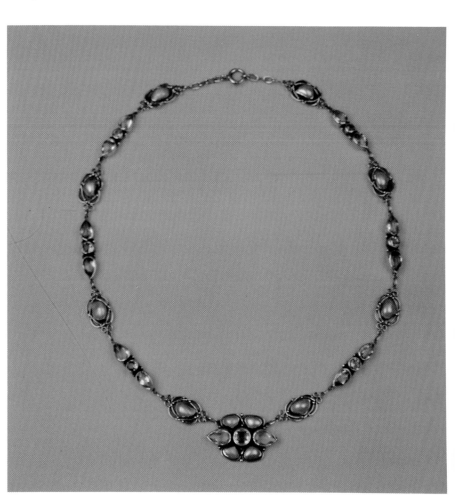

Gold necklace with amethysts, aquamarines, and baroque pearls attributed to Margaret Rogers, Boston. Early twentieth century, 16" in length. *Courtesy of Skinner's Inc., Boston and Bolton*

Arthur Stone born in England, apprenticed as a silversmith and worked there for 23 years. In 1901 he set up his workshop in Gardner, Massachusetts, where he became one of the most outstanding silversmiths of the Arts and Crafts movement. Stone was a skilled chaser who made flatware and hollow-ware, often with stylized leaves used for ornamentation. He was both a designer and a consummate craftsman, equally comfortable using repoussé, chasing, piercing and fluting techniques. His work had a highly polished finish, sometimes contained gold inlay, and evidenced many influences including Celtic, Moorish, Renaissance, and Colonial Revival. He also was fond of depicting New England flowers. Stone's shop was successful enough to support a staff that included Earle Underwood and Arthur L. Hartwell. He was in business for 36 years and was a medalist of the highest level of the prestigious Boston Arts and Crafts Society.

In 1902, Arthur Astor Corey, one of the founders of the Boston Arts and Crafts Society, hired Mary C. Knight, an enamellist and metalworker who had been a designer for Gorham and Co., to run a new enterprise known as the Handicraft Shop. Karl F. Leionen, a silversmith who had spent ten years working at his craft in Finland before coming to the United States, went to work for the Handicraft Shop, as did Frans J. P. Gyllenberg, a silversmith who had been apprenticed in Sweden. George Christian Gebelein was also a silversmith with the shop for six years, and went on later to have his own business designing and making Colonial inspired silver. Katherine Pratt, a student of both Leinonen and Gebelein, also became an important silversmith who worked until the 1960's.

Other Boston Arts and Crafts metalworkers included James T. Wooley, a silversmith and member of the Arts and Crafts Society and George J. Hart, who apprenticed in England and then had his own shop in Boston. He taught silversmithing and jewelry making at several schools and was a member of the Arts and Crafts Society. Rebecca Cauman worked in silver, copper and pewter with enamels and semi-precious stones. German-born George Ernest Germer, another member of the Arts and Crafts Society, was known for his ecclesiastic silver with Gothic motifs.

Philadelphia Plays a Supporting Role

Although Philadelphia played a lesser role in the American Arts and Crafts Movement, the city helped lay the groundwork for the movement's success when it hosted the 1876 Exposition, where the new European trends were first presented to the American public. Two important publications came out of Philadelphia, the well-established *Ladies' Home Journal* and *House and Garden*, which began publishing in 1901. Both of these publications helped to create awareness of new ideas for home furnishings and crafts.

The Rose Valley commune established near Philadelphia was based on the English guild system, although it produced mainly furniture, not metalwork. The undisputed master of metalwork in the United States, Samuel Yellin, lived in Philadelphia, where he also was a teacher of his craft. In 1905 he had come to the United States from Poland, where he had learned to work with copper, nickel and other metals, but his love was for wrought iron. Working only from his own designs, Yellin made gateways, window grilles, hinges and other iron items. He also crafted repoussé brass doors, chests and boxes, vases, lamps and executed a number of important commissions.

Upstate New York and the Roycroft Shop

New York had two geographically separate centers for crafts—the upstate area near Syracuse and Buffalo, and New York City. In upstate New York several important men in the Arts and Crafts movement established themselves and opened workshops.

Charles Rohlfs, a former successful stage actor with the hobby of woodworking, opened a studio for making custom-designed furniture. He was so successful that he was even commissioned to make a number of pieces for Buckingham Palace. Although Rohlfs himself did not make metalwork, Paul J. Wilhelm, a fellow craftsman who lived nearby, made objects of copper, silver and enamels.

Iron and mica lantern by wrought iron master Samuel Yellin, early twentieth century. *James R. Bakker Antiques, Cambridge*

Arthur Stone Workshop, Gardner, Massachusetts, twentieth century. Loving cup, Arthur Stone, design and repoussé decoration, Herbert Taylor, craftsman, silver, 1919, ht. 6½ in., Gift of the Antiquarian Society through Mr. and Mrs. Edwin A. Seipp Fund, 1979.326.

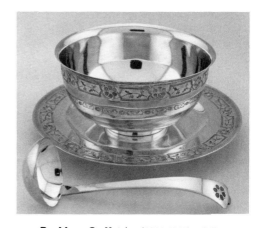

By Mary C. Knight (1876-1940) of Boston, Massachussetts, a plate, bowl and ladle, 1904-7. Silver plate ht. ½ in., diam. 5½"; bowl ht. 2 in., diam. 4 1/16 in.; ladle ht. 5 in., diam. bowl 1½ in.; Americana Fund, 1982.205a

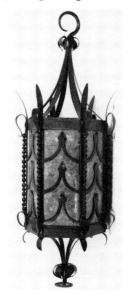

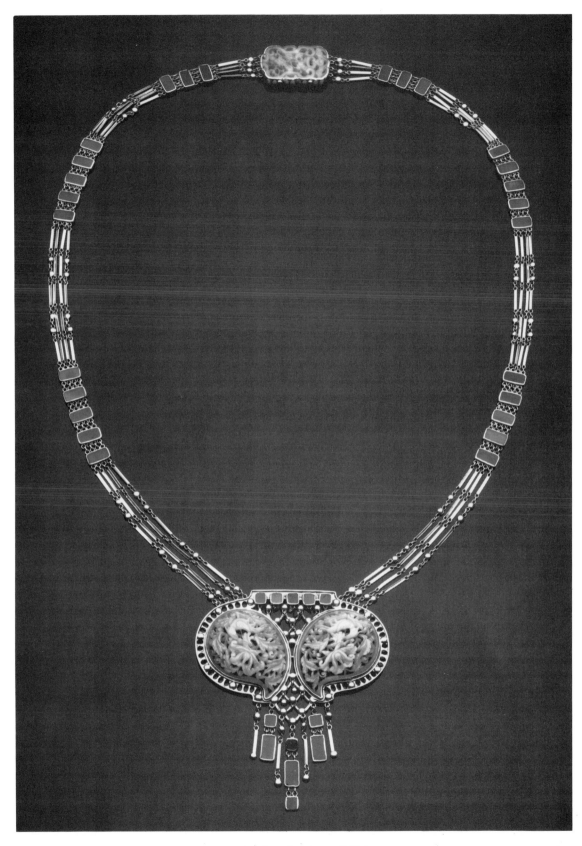

Necklace of gold, jade and glass. c. 1915, by
Josephine Hartwell Shaw. Shaw was from
Duxbury, Massachusetts and was active from
1900-35. The necklace is 20″ long. *Courtesy of
Museum of Fine Arts, Boston*

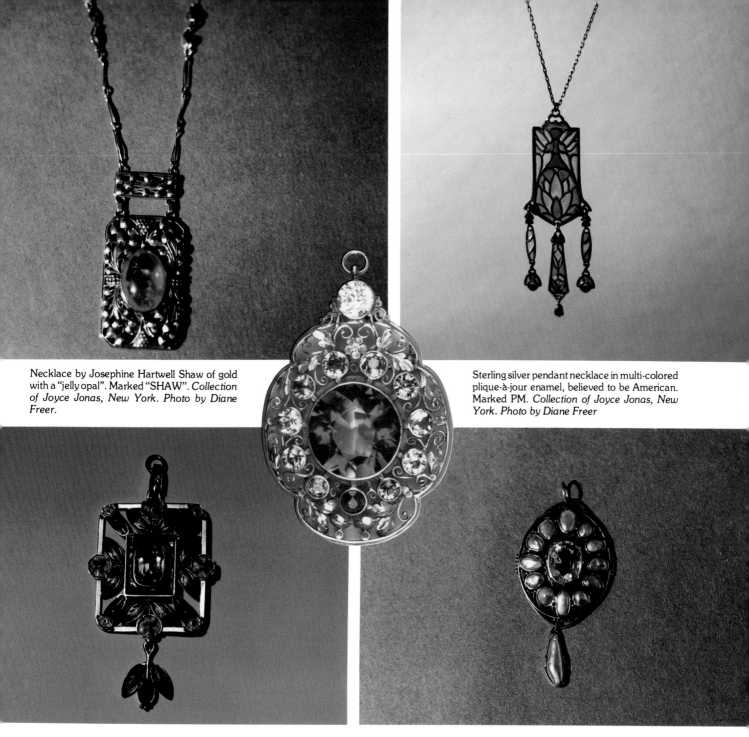

Necklace by Josephine Hartwell Shaw of gold with a "jelly opal". Marked "SHAW". *Collection of Joyce Jonas, New York. Photo by Diane Freer.*

Sterling silver pendant necklace in multi-colored plique-à-jour enamel, believed to be American. Marked PM. *Collection of Joyce Jonas, New York. Photo by Diane Freer*

Pendant that is believed to be American Arts and Crafts. Of 14 kt. gold, enamel, tourmaline and amethyst. Signed with a script "F". *Collection of Joyce Jonas, New York. Photo by Diane Freer.*

Pendant by Josephine Hartwell Shaw of blister pearls and yellow sapphire. Marked J. H. Shaw. *Collection of Joyce Jonas, New York. Photo by Diane Freer.*

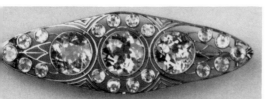

American Arts and Crafts gold pin with bronze, tourmaline, and pearls marked 18 kt. *Courtesy of Skinner's, Inc., Boston and Bolton*

Multi-colored stone brooch with pendant, early twentieth century. Gold, zircon, central large amethyst surrounded by demantoid garnets, aquamarine, citrines and tourmalines. *Courtesy of Skinner, Inc., Boston and Bolton*

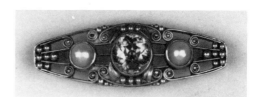

An American Arts and Crafts jewel. Gold pin with bronze tourmaline & pearls marked 18 kt. *Courtesy of Skinner's Inc., Boston and Bolton*

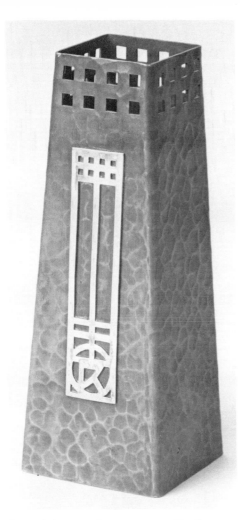

Roycroft hammered copper vase with silver overlay, probably designed by Dard Hunter. *Courtesy of David Rago, Trenton*

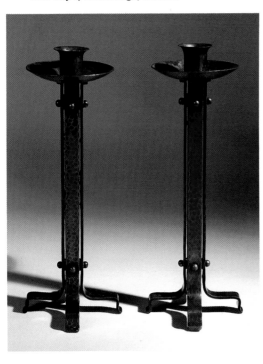

Pair of Roycroft candlesticks, from about 1915-20 of hammered copper. 11¾" high. *Courtesy of Hirschl and Adler Galleries, New York and Struve Gallery, Chicago*

A former soap salesman and manufacturer, Elbert Hubbard settled in East Aurora, New York near Buffalo in 1893. The following year he went to England and met William Morris and was seduced by Morris' Kelmscott Press. He returned to New York and began producing books patterned after the Kelmscott books. From bookmaking he moved easily into leather work and then into very simple furniture and copper work. He founded Roycroft, a crafts community with an apprentice system, to produce his work. It was run very much like a guild, at one time having 500 members.

Karl Kipp, a former banker, took charge of the Roycroft copper shop where a number of items including bookends, inkwells, smoking sets, trays, candlesticks, vases, planters, spoons and other domestic items were produced. Some carried brass trim and various colors of patinas. A small output of copper jewelry was also made by the Roycrofters including hat pins, bracelets and brooches. Kipp left the Roycrofters after several years and opened his own business, The Tookay Shop.

Another important copperwork designer for the Roycrofters was Dard Hunter. This young man designed a number of pieces for Hubbard and then had his own workshop backed by Hubbard to make metalwork, furniture and other items. Hunter visited Vienna several times and injected some of the Viennese style of Art Nouveau into his work.

Elbert Hubbard and his wife died tragically when the Lusitania sank in 1915 and their son Ben took over the business. As with many other firms, the Great Depression hit the business hard and it was sold by the family in 1938. The Roycrofters is still a thriving business today under its current ownership and is making reproduction Arts and Crafts jewelry of sterling silver and semi-precious stones. Most of the jewelry is made from Dard Hunter designs of 1909 but some are from the Tookay shop, the Kalo shop in Chicago and other turn-of-the century Arts and Crafts metal shops. They have been adapted to modern use by converting buckles to brooches and creating matching earrings for pendants.

Heintz Art Metal and Gustav Stickley

Another important metalwork firm was the Heintz Art Metal Shop located in Buffalo. The firm specialized in sterling decorated bronzeware and undecorated bronzeware, well-made and finished in a variety of different patinas—red (royal), green (verde), and bronze. There was also a gold-toned patina; nickel silver plating on bronze was used, but less frequently. Items of copper and custom work were also produced. The Heintz Art Metal Shop specialized in domestic items including picture frames, lamps, desk sets, bowls, trophies, ashtrays, vases, boxes, humidors, book ends, book trays and smoking sets. The company remained in business until about 1929. Another small company in competition with Heintz was Smith Metal Arts started by a former Heintz salesman and a Heintz craftsman in 1919.

Perhaps best known of the upstate craftsmen was Gustav Stickley. He is remembered above all for his furniture, which featured simple lines and materials, but his firm also produced a fair quantity of metalwork.

In 1898 Stickley visited C.F.A. Voysey and other Arts and Crafts artisans in England, the same year he formed his company near Syracuse, New York. In 1901 he began publishing the magazine *The Craftsman* and dedicated the first issue to William Morris.

In 1903 Stickley held an exhibition at his business and displayed metalwork by the Art Fittings Co. of Birmingham, among other British-made goods. He imported some of their pieces and sold them under his own name but he also produced metalwork of his own including copper candlesticks, hammered copper wall plaques, andirons, lamps, dinner gongs, etc. with much of his metal work patinated. The real heyday of the company was from 1905-1913 but by 1915 Stickley was bankrupt. He died a man whose work had been discounted in his day, but today his work demands high prices from collectors. Gustav Stickley's furniture and accessories are being reproduced again today to fill the demand created by a renewed interest in the Arts and Crafts period in the United States.

Stickley's brothers, L & J. G. Stickley were also in the furniture business and produced metalwork items including copper candlesticks and hammered copper ashtrays.

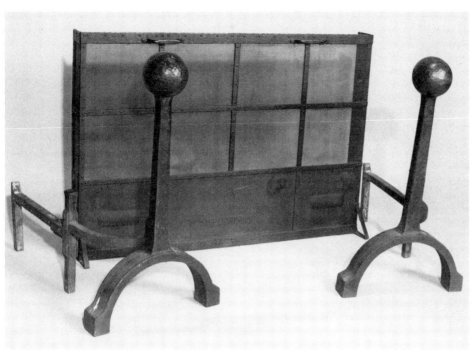

Gustav Stickley andirons and firescreen.
Courtesy of David Rago, Trenton

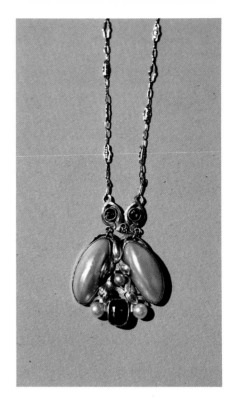

Necklace of gold, green, tourmaline and pearl
by the Elverhoj community. This is an unusual
piece since this utopian/crafts community on
the Hudson River in upstate New York was not
known for making jewelry. Signed. *Collection of
Joyce Jonas, New York. Photo by Diane Freer*

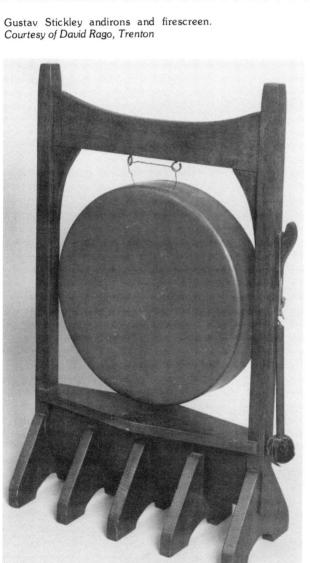

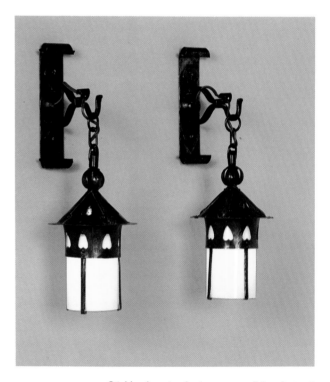

Stickley hanging lanterns on wall brackets of
glass and iron. Circa 1906. *Courtesy of Hirschl
and Adler Galleries, New York*

Gustav Stickley dinner gong c. 1903. *Courtesy
of David Rago, Trenton*

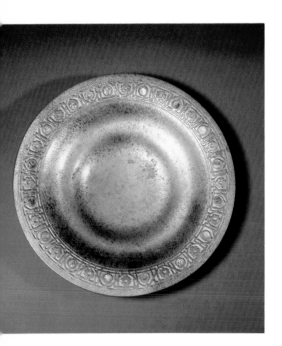

Tiffany Studios bronze plate with mother-of-pearl inlays.

From the Tiffany studio, bronze and Favrile glass candlestick; desk set items; picture frame and pen tray. *Courtesy of Skinner's, Inc., Boston and Bolton*

New York City and Louis Comfort Tiffany

New York City was home to a different genre of work in the Arts and Crafts Movement. It was dominated by one man—Louis Comfort Tiffany. Tiffany was the son of the founder of the elite Tiffany & Co. jewelry store. Rather than join the family business he went to Paris to study painting in 1876 where he no doubt got a sense of the changes to come in the world of decorative arts. Although he lived the life of a humble artist during his early years in New York as a painter (boarding in the YMCA) he was to inherit $13,000,000 when his father died.

In 1876 L.C. Tiffany began making stained glass which put him in direct competition with the artist John La Farge. Ironically their work hangs side-by-side in the Metropolitan Museum of Art in New York City today. Tiffany went on to found the firm of Associated Artists in 1879 with Candace Wheeler, a textile designer, Lockwood de Forest and Samuel Coleman. The firm provided interior decorating services much as Morris and Co. did in England. Also like Morris and Co., they worked for wealthy clients.

In 1894 Tiffany discovered the process for making his famed Favrile glass and in 1902 the business became Tiffany Studios. Tiffany Studios produced stained glass lamps, windows, ceramic items, metalwork and art jewelry. The work was Arts and Crafts in soul, and was described as Art Nouveau in appearance—but no matter how it was categorized, his work always had a unique look that was easily recognizable as L.C. Tiffany. Janet Zapata, whose biography of Louis Comfort Tiffany is forthcoming, believes that he had such an enormous ego he would never have "copied" any existing style but rather quite deliberately strove for something that was his own.

A line of cast bronze desk items inlaid with glass or mother-of-pearl were also a part of the studio's output, as were other small metalwork items such as cigar boxes and picture frames, smoking stands, lamps, candlesticks and vases. The bronze work was sometimes gilded and additionally some items of copper were also made. The metalwork was overseen by studio manager Julia Munson who was responsible for some of the designs as well.

Tiffany was an eccentric man who always dressed in white and lived a quite decadent lifestyle after receiving his inheritance. His firm went bankrupt in 1932 after he had already retired. Today the work of the Tiffany Studios, most notably the lamps, are highly coveted by collectors.

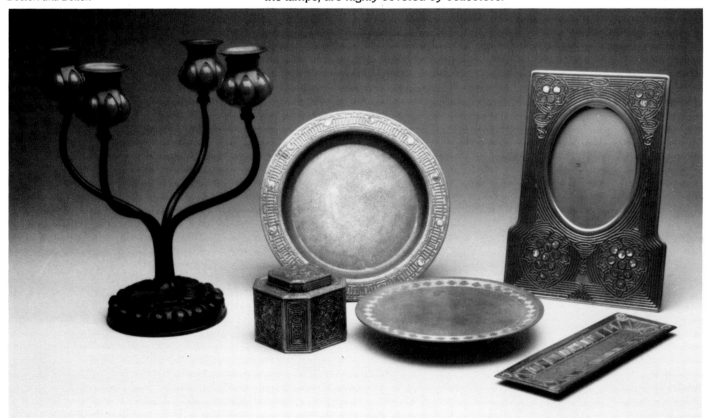

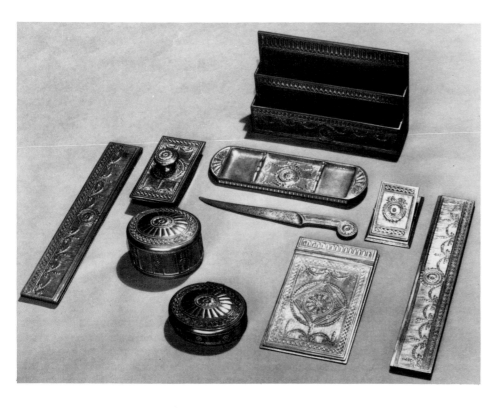

A group of gilt-bronze desk set items in the Adam pattern by Tiffany Studio. *Courtesy of William Doyle Galleries, New York*

Tiffany & Co. opal boulder pendant necklace which shows an Art Nouveau influence. 18 kt. green gold with a double strand delicate link chain. The chain is punctuated with clusters of leaves and circular cut emeralds and sapphires. Signed Tiffany & Co. *Courtesy of William Doyle Galleries, New York*

Tiffany's Jewelry

The jewelry produced by the Studios was quite exotic and very expensive. It is usually reported that only a small quantity of jewelry was made in the Studios, which reflects what has been documented, but Zapata says this incorrect. Her book should shed more light on this subject. Tiffany worked with both gold and silver, and later pieces may be made of platinum. He also favored mixed metals and was known to carry around a piece of Japanese mixed metal work in his pocket.[1]

Tiffany's jewelry also incorporated enamels, precious and semi-precious stones, Favrile glass, and misshapen pearls. He chose stones primarily that were either opaque or translucent (such as opals or moonstones) or dense (such as lapis lazuli and turquoise). Influences reflected in his jewelry range from Japanese design to Egyptian motifs, as well Celtic, Medieval, Byzantine, American Indian and naturalistic motifs such as dragonflies and exotic flowers. Ms. Zapata says that his work in enamel resembles his paintings in coloration and tonality.[2] A recent newsletter from Christie's, London described six paintings by Tiffany by saying "his exploration of light, color and form is suggestive of his later inspired experiences with glass...the paintings demonstrate the play of light and jewel-like color that are hallmarks of Tiffany's most innovative design work."

In 1904 at the St. Louis Exposition Tiffany exhibited a collection of American wildflower jewelry and a dragonfly brooch of black opals, demantoid garnets, platinum and gold which had been designed by him but was executed by Tiffany & Co. Three years later Tiffany & Co. purchased the jewelry portion of his company. It became the "Art Jewelry" department of Tiffany & Co., and remained open until 1933. All of L.C. Tiffany's jewelry made after this date is stamped Tiffany & Co.

Tiffany brooch c. 1900 of gold and turquoise. *Courtesy of Nicholas Harris, London*

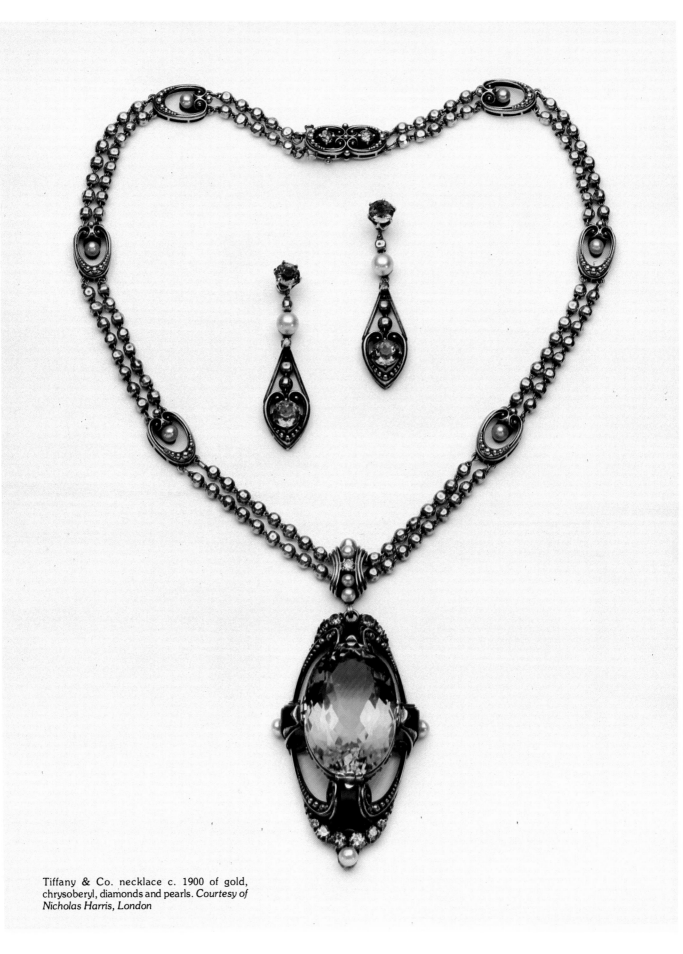

Tiffany & Co. necklace c. 1900 of gold,
chrysoberyl, diamonds and pearls. *Courtesy of
Nicholas Harris, London*

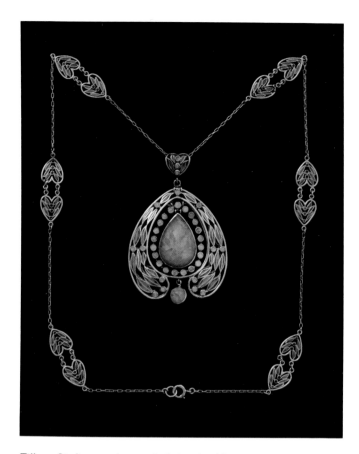

Tiffany Studios pendant and chain of gold,
plique-à-jour enamel set with opals c. 1902.
Courtesy of Tadema Gallery, London

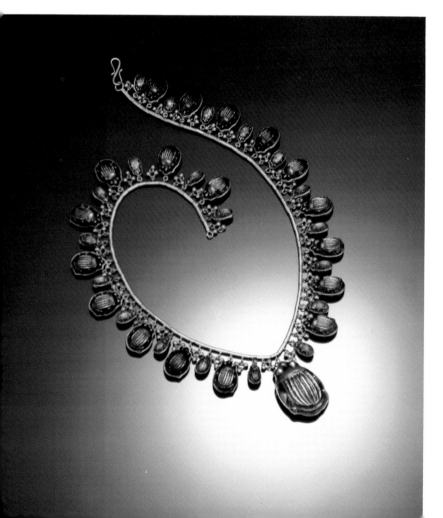

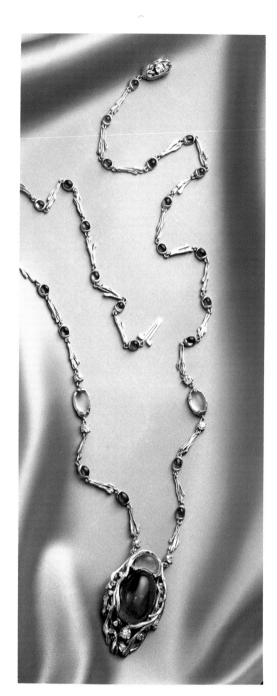

Tiffany & Co. necklace of platinum, sapphires,
old mine-cut diamonds. *Courtesy of William
Doyle Galleries, New York*

L.C. Tiffany Favrile glass scarab and 18 kt. gold
necklace. The large scarab is surrounded by a
fringe of thirty-eight smaller scarabs of blue and
purple Favrile glass. The necklace is approxi-
mately 19 inches and is signed L.C.T. *Courtesy
of Butterfield and Butterfield, Los Angeles*

Silver and turquoise matrix lily pad brooch by American craftswoman Mary Gage. Gage was born in Indiana at the turn-of-the century. With no formal training in jewelry making she learned her craft by working with Armenian and Yemenite Jews in Greenwich Village. In 1924 she had a workshop in Greenwich Village and later one in Soho. Her jewelry was sold by retail stores and as of 1989 she was still teaching silversmithing in Portland, Maine.

Not all of the "art jewelry" and metalwork that came out of Tiffany & Co. was designed by L.C. Tiffany. The famed life-like enamelled orchid brooches exhibited at the Paris Exposition of 1889 were designed by Paulding Farnham. They were individual works of art more closely allied to Art Nouveau than to the Arts and Crafts because of their use of exotic flowers.

Farnham was not only an important designer for Tiffany & Co. but also head of its jewelry department around the turn-of-the-century. He eventually took over the silver department as well, and was named as the firm's art director.

Farnham designed silver objects with enamel and gem stones set into them in the 1890s. Although many of the items he designed had a late Victorian or classic revival identity, several known pieces were in the Arts and Crafts movement mode. Shown at the Paris Exhibition of 1900 were three silver bowls inlaid with metals and gemstones which approximate American Indian woven baskets through the patternwork of the metal. A vase in the collection of the Brooklyn Museum, made of silver, enamels and opals with an overall Arts and Crafts feeling, includes a few Art Nouveau curved lines as well. Farnham left the firm under strange circumstances, presumably after problems with Charles Tiffany, owner of the firm.

Tiffany & Co. favored the use of native gemstones, hence they used Montana sapphires, Mississippi River pearls and American turquoise. The company had purchased the first lot of Montana sapphires ever mined; they had been sold to Tiffany in a cigar box.

Another New York firm that bears mention is Marcus and Co. Still in business today, the firm produced lovely jewelry in the early years of the twentieth century which can be classified as both Arts and Crafts and Art Nouveau. The jewelry is often similar to work by Tiffany & Co., and like Tiffany & Co. the firm often used native materials. Their belt buckles are among the stronger Arts and Crafts examples.

Marcus and Co. jewelry is known for its enamel work, undulating lines and the use of moonstones, sapphires and blister pearls. Many of the firm's designs were the creations of George E. Marcus and a number of his pieces were exhibited in the late 1890's at the Boston Arts and Crafts Society.

Black, Starr and Frost, an established jewelry firm, produced some "art" jewelry. A 14 kt. gold and emerald cross pendant with interlaced motifs in the Celtic style made by this company was recently offered at auction in New York.

There were also several independent artisans working in New York, including Marie Zimmerman who made jewelry and metalwork in silver, copper, bronze, gold and iron finished with a variety of patinas. She worked from the turn-of-the-century until the 1930's. Janet Payne Bowles had her own silversmith workshop in New York as well, making jewelry that has been sometimes described as "bizarre."[3]

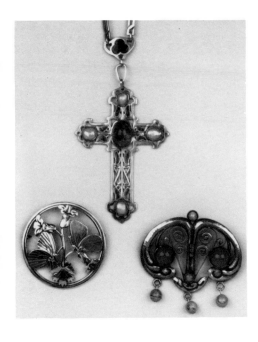

Marcus & Co., bracelet with opals, diamonds, sapphires, blue and green enamel and gold. *Courtesy of Asprey, New York. Photo by Gabrielle Becker*

Jensen circle brooch and a cross pendant and chain in the Arts and Crafts style. The cross is centered by an oval cabochon-cut amethyst, highlighted by purple enamel and blister pearls with matching chain and amethyst beads. The brooch below is early twentieth century of scrolled leaf and tendril openwork design set with moonstone, coral and agate cabochons with blue enamel detail. The pendant is marked "830S, JKD" *Courtesy of Skinner's, Inc., Boston and Bolton*

A pair of Mary Gage silver and carbuncle floral pins.

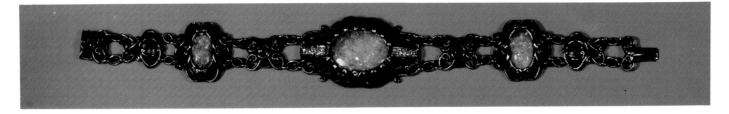

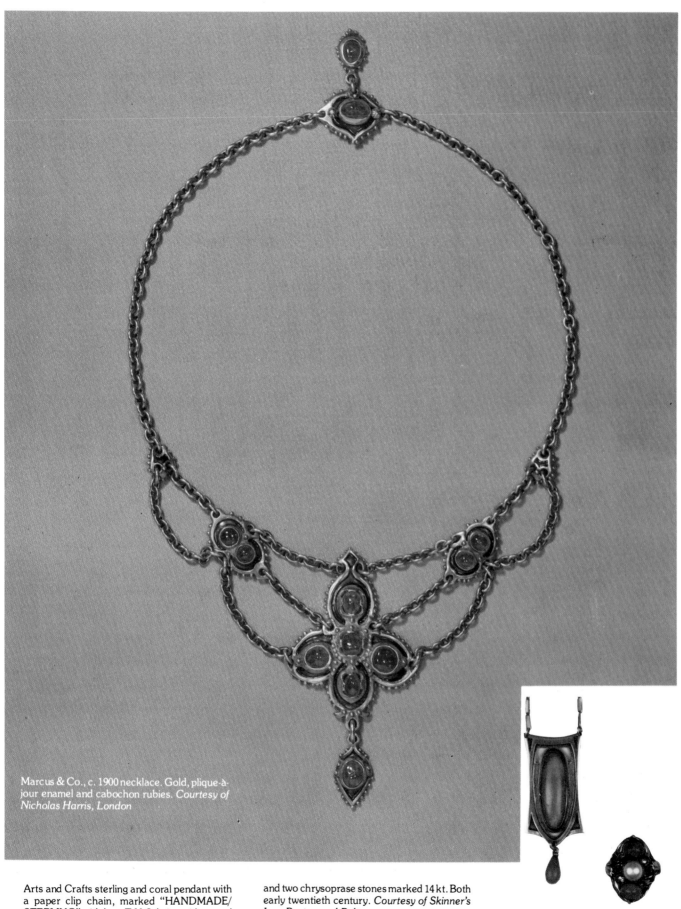

Marcus & Co., c. 1900 necklace. Gold, plique-à-jour enamel and cabochon rubies. *Courtesy of Nicholas Harris, London*

Arts and Crafts sterling and coral pendant with a paper clip chain, marked "HANDMADE/STERLING" with logo T.H.S.A ring with a pearl and two chrysoprase stones marked 14 kt. Both early twentieth century. *Courtesy of Skinner's Inc., Boston and Bolton*

Free form mother-of-pearl pin with diamonds and pearls in 18 kt. gold by Marcus & Co. Garnet, pearl and enamel 14 kt. gold necklace by Marcus & Co. Centered by a gold trefoil set with round garnets and pearls highlighted by green enamel with matching pendants and matching chain and clasp. *Courtesy of Skinner's Inc., Boston and Bolton*

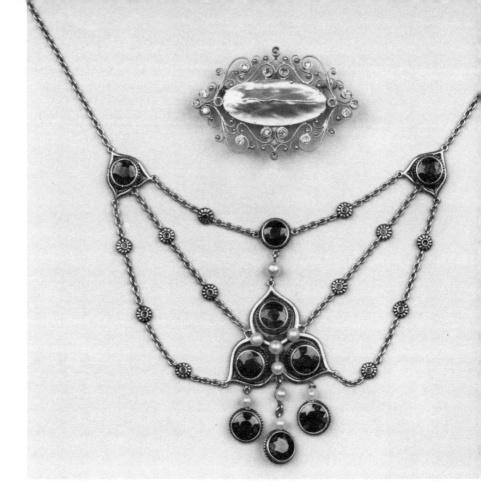

Kalo pendant of 14 kt. gold with faceted citrine. Inscribed on the back, "Marie Forbes", stamped KALO 14 kt. *Collection of John Toomey/Dinah Thompson, Oak Park*

A signed sterling silver Kalo brooch.

Pin, Kalo Shop, Chicago, Illinois, silver mount with enamel setting, 1922, 2 x 1⅜ in., Gift of Mrs. Burton W. Hales, 1978.302 front view. ©1992 *The Art Institute of Chicago. All rights reserved.*

The Kalo Shop, Chicago

In Chicago, a number of talented jewelers and metalsmiths were quite successful working in the Arts and Crafts style. The firm with the greatest longevity as makers of jewelry and silver items was the Kalo (the Greek word for beautiful) Shop run by Clara Barck Welles and her husband George S. Welles, an amateur metalworker. Kalo was both a school and a craft workshop that became so successful it remained in business until 1970.

Welles had been a student at the Art Institute of Chicago in 1900 when Charles Robert Ashbee came to lecture so it is probably not accidental that some of the early silver to come out of her shop resembles some of Ashbee's work. The Kalo Shop, founded that year (originally to make leather goods) was known for producing very simple, handcrafted pieces usually of unornamented silver but sometimes with semi-precious stones set into it. Commonly used motifs were flowers, fruits and leaves with soft curves and hammer marks often were visible.

Welles retired in 1940 and sold the business to four of her employees. The Kalo Shop had many Danish artisans working for it over the years which explains why its work sometimes bore a similarity to Georg Jensen's. When Daniel Pederson and Yngre Olsson, two of the silversmiths until almost the end died the company was disbanded.

Several well known silversmiths were Kalo alumni, including Emery Todd, Esther Meacham and Julius Randall from Sweden who all went on to have their own businesses in Chicago. **Russian immigrant Falick** Novick who trained as a silversmith as a teenager came to Chicago via New York and opened his own business. Jessie Preston was another jeweler and metalworker who used bronze and other metals in his lamps and candlesticks.

Other Chicago Artisans

Frances Koelher, a Chicago socialite, spent time in England where she studied with the English enamelling titan Alexander Fisher and her jewelry is closely related to British Arts and Crafts. She often worked in 22 kt. gold and precious stones which was a reflection of her wealthy clientele.

There were a number of other important independent jewelers and silversmiths working in Chicago as well. Robert Riddle Jarvie, of Scottish heritage, began as an amateur metalworker in copper and brass and then opened his own shop branching out into silver and gold. He is best known for the simple but elegant candlesticks he made in sixteen different designs in brass and copper with patinated finishes. He also made lanterns, copper bowls, bookends, sconces, vases, trays and smoking items.

Jarvie became a fine silversmith who exhibited at the Art Institute of Chicago and many of his silver pieces have a permanent home there today. He closed his business around 1920 and went to work for the Chicago jeweler C.D. Peacock, a firm that also made some Arts and Crafts/Art Nouveau style jewelry around the turn-of-the-century.

Jon Pontus Petterson, a Norwegian-born silversmith was employed both by Tiffany & Co. and Robert Jarvie prior to opening his own shop in Chicago. Some of his work shows a strong Ashbee influence.

Madeline Yale Wynne was the daughter of the man who invented the Yale lock. She was a founding member of the Chicago Arts and Crafts society and had her own workshop making jewelry in gold, silver, enamel, semi-precious stones and unpolished pebbles; she also made silver tableware. Little of her jewelry survives today.

Frank Lloyd Wright came to prominence as an architect in Chicago after working for Adler and Sullivan (the firm of Louis H. Sullivan), when he opened his own business in Oak Park. Much like Charles Rennie Mackintosh, Wright designed houses with totally integrated interior furnishings. His work is derivative of the Arts and Crafts movement, and incorporates a strong Japanese influence. His simple houses were furnished with complementary furniture, often built-in, and items he designed including vases, lamps and candlesticks made of copper, brass and bronze. He also designed a number of wrought iron gates for his buildings.

George Grant Elmslie, a Scottish-born architect, was also a student of Louis H. Sullivan. Like Wright, he struck out on his own, eventually designing "prairie-style" houses, as well. A friend of Robert Jarvie, Elmslie designed a number of silver items for him and for his own projects he designed ornamental iron work and metalwork in the Arts and Crafts style.

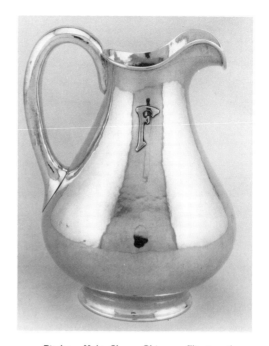

Pitcher, Kalo Shop, Chicago, Illinois, silver, 1914-18, ht: 8⅝ in., Gift of the Antiquarian Society through Mrs. Nelson Edward Smyth Fund in memory of Nelson Edward Smyth, 1984.1134 ©1992 The Art Institute of Chicago. All rights reserved.

Robert Riddle Jarvie, Chicago, Illinois, 1865-1941, punch bowl, ladle and tray, silver, punch bowl ht.: 10⅛ in., w. 25½ in.; d.:7⅛ in., ladle l.: 18 in.; tray ht.: ¾ in., diam.: 20¾ in., Gift of Mr. and Mrs. John R. Hattstaedt, 1974.293a-c. ©1992 The Art Institute of Chicago. All rights reserved.

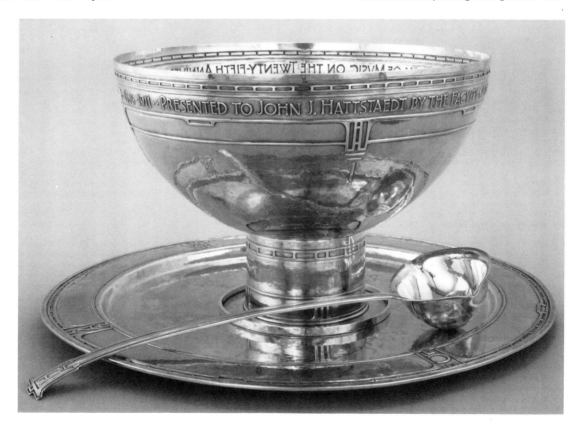

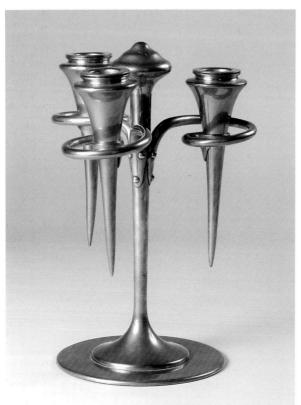

Robert Riddle Jarvie three-branch candelabra of brass, 10 1/3″ high. *Courtesy of Hirschl and Adler Galleries, New York.*

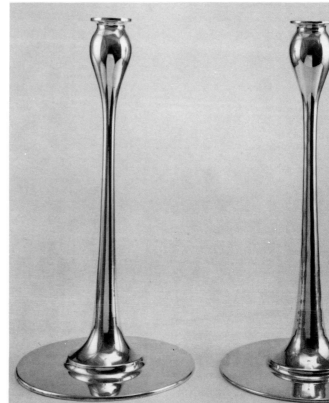

Robert Riddle Jarvie, Chicago, Illinois, 1865-1941, Pair of candlesticks, silver, 1903-15, ht.: 14 in.; base diam.: 7¼ in., Gift of the Bessie Bennett and Mrs. Herbert Stern funds, 1973.377-378. ©1992 The Art Institute of Chicago, All Rights Reserved.

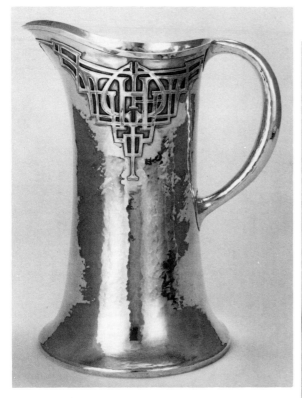

Robert Riddle Jarvie, Chicago, Illinois, 1865-1941, Pitcher, silver, 1911, 10¼ in.; base diam.: 6 7/16 in., Gift of Raymond W. Sheets, 1973.357. ©1992 The Art Institute of Chicago. All rights reserved.

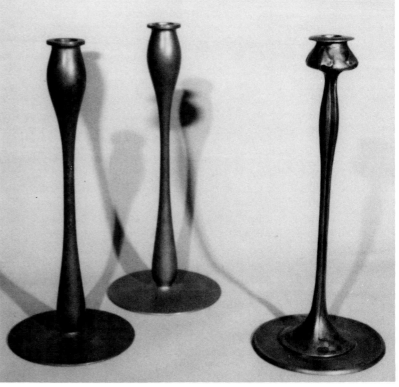

Bronze candlesticks by Robert Riddle Jarvie. *Courtesy of David Rago, Trenton*

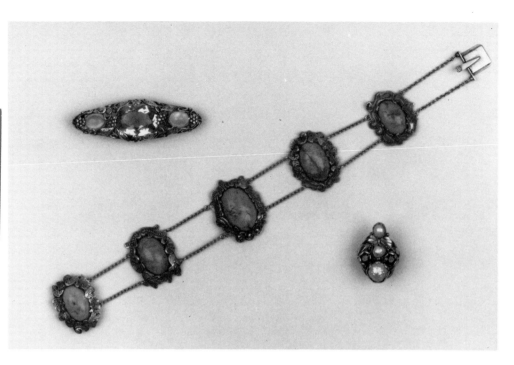

Chicago Commercial Shops

The well-known commercial workshops in Chicago were Lebolt and Co. and Marshall Field and Co. Lebolt and Co. was founded by jeweler J. Myer Lebolt and offered handwrought necklaces, pendants and bracelets, silverware and domestic silver items such as napkin rings, condiment dishes, place card holders, etc. The Marshall Fields and Co. Workshop produced both machine and handmade silver, bronze, and brass jewelry, including hatpins, brooches and bracelets. They also made objects for the home such as tea sets, flatware, porringers and candy dishes, using acid-etched techniques to create a patina. The workshop remained open until 1950.

Little is known about the firm of Carence Crafters outside of the surviving work by them. They created objects and jewelry with Celtic designs in copper, brass, silver and German silver, using the acid etching technique for the finish.

The rest of the Midwest was not without talent in the areas of jewelry making and metalwork with the state of Ohio being the home of several craftsman. Horace E. Potter of Cleveland had studied at the Guild of Handicraft and worked with Wilhelmina Stephan, a pupil of Alexander Fisher. His jewelry shows his British Arts and Crafts connection. Mildred Watkins, also of Cleveland, was both a jeweler and metalworker who decorated her pieces with enamel. E.T. Hurley, a Rookwood pottery artist made several bronze candelabras with sea horse designs.

In Baltimore, Maryland Theodore Stanford Pond, made simple silver items and in North Carolina William Waldo Dodge Jr. had a silversmithing shop in the 1920's and 1930's. Cyril Colnik in Milwaukee was known for wrought iron work and Ernest Batchelder opened the Handicraft Guild of Minneapolis as a craft school that made repoussé decorated copper items set with semi-precious stones. The Guild's goods were sold nationwide.

Early twentieth century jewelry: top brooch of sterling silver with citrine and moonstones, Bracelet by LeBolt & Co., 14 kt. gold and turquoise, gold ring with sapphires and baroque pearls. *Courtesy of Skinner's, Inc., Boston and Bolton*

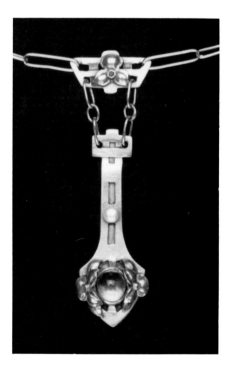

Matthias William Hanck, Park Ridge, Illinois, 1883-1955. Lavaliere, silver, amethyst and pearl, 1911-15; ht. 9 in.. Gift of James J. and Marshall Field, 1988.60 front. ©1992 The Art institute of Chicago. All rights reserved

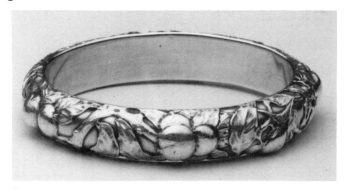

Horace E. Potter, Cleveland, Ohio, 1873-1948, bracelet, silver, 1911-30 diam. inside 2⅝ inc., Gift of the Antiquarian Society, 1989.146. ©1992 The Art Institute of Chicago. All rights reserved.

Greene and Greene hanging lantern from the Jennie Reeve House, Long Beach, California c. 1904. Copper and leaded glass. *Courtesy of Hirschl and Adler Galleries, New York.*

Oscar J.W. Hansen, American, 1892-1962, pin, silver and glass, 1945-62, 3 3/16 x 2⅜ in., Gift of the Antiquarian Society through the Mrs. Eric Oldberg Fund, 1987.273. ©1992 The Art Institute of Chicago. All rights reserved.

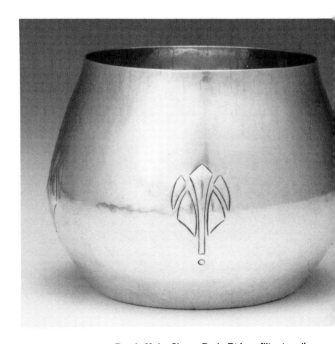

Bowl, Kalo Shop, Park Ridge, Illinois, silver, 1905-14.: 3¼ in.; diam. top.: 3¼ in., Restricted gift of Mr. and Mrs. Robert A. Kubicek, 1988.443. ©1992 The Art Institute of Chicago. All rights reserved

California Arts & Crafts

On the West Coast in Pasadena, California, the architectural team of brothers Charles and Henry Greene created a category of Arts and Crafts decoration with their own stamp on it. In 1901 Charles had married an English woman and went with her to England on their honeymoon where he became influenced by William Morris. In later years he was to meet Ashbee as well, but this was after the Guild of Handicraft had already gone into liquidation.

Charles came back from England with new design ideas that were to point the way to the brothers' style in architecture, furniture, art glass and metal lighting fixtures. They successfully and magnificently melded a powerful Japanese influence with an Arts and Crafts style.

Dirk Van Erp was another important craftsman of the West Coast Arts and Crafts genre. He had arrived in the United States in 1886 from Holland and worked in the shipyards in San Francisco as a coppersmith. His hobby was making decorative items from shell casings for which he built up a following. In 1908 he opened his own shop, originally with a Canadian metalworker, Eleanor D'arcy Gaw (who trained with C. R. Ashbee) as a partner, and then alone. He is primarily known for lamps of hammered copper with mica shades, but also made objects such as vases, inkwells and desk accessories. Harry St. Dixon worked for Van Erp and then had his own copper ware workshop.

Another lamp maker in the Arts and Crafts style was Lillian McNeil Palmer who ran the Palmer Copper Shop from 1910-1918 and then worked alone for a number of years. She also designed lamps for Gump's Department Store and collaborated with Harry St. John Dixon who had worked for Dirk Van Erp.

Hans W. Jouchen, a German, and Fred T. Brosi, an Italian, were partners in the Old Mission Kopper Kraft Shops in San Jose and San Francisco. They were known for lamps that look similar to those made by Dirk Van Erp. In *American Arts & Crafts, Virtue in Design* Leslie Bowman mentions an interesting note about their work—many of the items they produced were decorated with local eucalyptus leaves which were metallized.

Other noted West Coast metalworkers included Frederick Eaton who had a metalwork shop in Santa Barbara and the Albert Berry shop in Seattle that made copper ware. Clemens Friedell, who had apprenticed as a silversmith in Vienna and worked for Gorham on the Martelé line, had his own shop making silver jewelry and sterling silver items. He worked in a style similar to the Martelé style using the chasing technique and a patinated finish. His work often featured native California flowers. Allen Adler in Corona Del Mar made sterling items as did the staff at the Craftsman Studios in Laguna Beach. In the retail business Shreve and Co. of San Francisco made and sold a limited quantity of silver pieces in the Arts and Crafts style. John O. Bellis was a Shreve and Co. silversmith until he left to open his own shop in 1906.

Porter Blanchard, the silversmith, taught at the Batchelder's School of Design and Handicraft in Pasadena. He learned his craft in Boston from his silversmith father and moved to California in 1923 where he opened his own business. Blanchard worked in both a Colonial revival style as well as others using a combination of hand and machine crafting. Yet another artisan, Douglas Donaldson, made silver and copper items with enamel and precious stones.

In the United States, the Arts and Crafts movement in metalwork and jewelry was clearly embraced as enthusiastically as it had been in Great Britain. Yet owing to a different historical background, as well as regional differences within the country, once again the result was a product unique to its own branch of the movement.

Dirk Van Erp hammered copper and mica floor lamp. *Courtesy of David Rago, Trenton*

[01] *Art with a Mission, Objects of the Arts and Crafts Movement*, Patricia Tidier, Exhibit March 31-May 26, 1991, Spencer Museum of Art, University of Kansas
[02] Conversation with Janet Zapata, April 1992

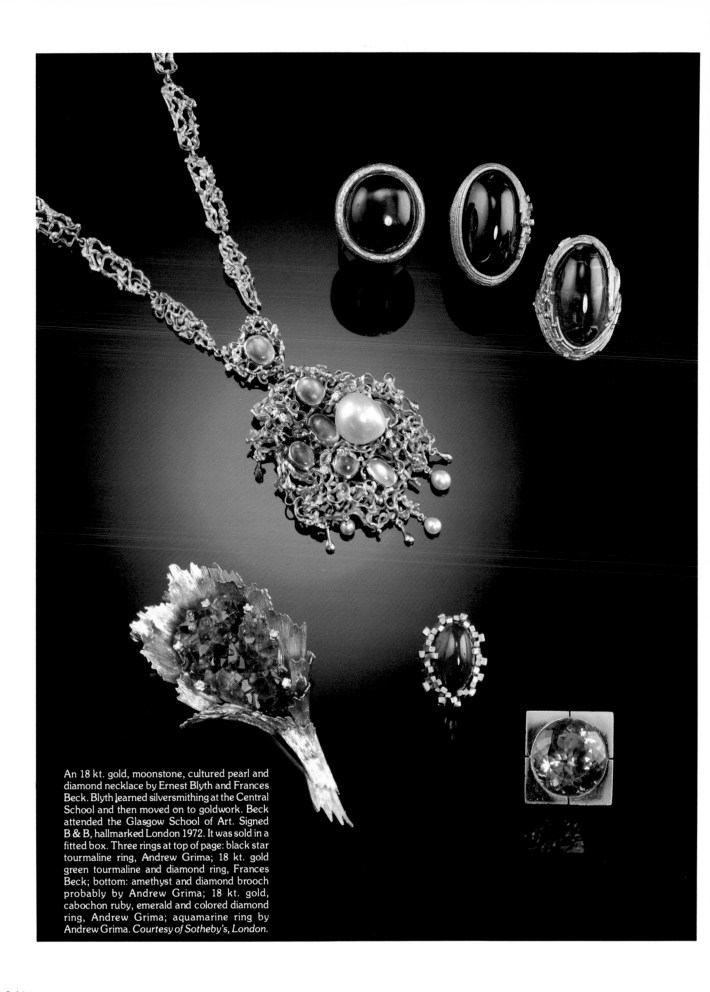

An 18 kt. gold, moonstone, cultured pearl and diamond necklace by Ernest Blyth and Frances Beck. Blyth learned silversmithing at the Central School and then moved on to goldwork. Beck attended the Glasgow School of Art. Signed B & B, hallmarked London 1972. It was sold in a fitted box. Three rings at top of page: black star tourmaline ring, Andrew Grima; 18 kt. gold green tourmaline and diamond ring, Frances Beck; bottom: amethyst and diamond brooch probably by Andrew Grima; 18 kt. gold, cabochon ruby, emerald and colored diamond ring, Andrew Grima; aquamarine ring by Andrew Grima. *Courtesy of Sotheby's, London.*

Modern Studio Jewelers

The Arts and Crafts jewelry and metalwork movement in Europe lost momentum when it was interrupted by World War I. In England many artists re-opened their studios after the war, often working in more contemporary styles but working nonetheless as late as the 1960s and 1970s.

Whether the movement in its original form survives today seems almost irrelevant. The Arts and Crafts jewelers and metalworkers started a tradition that continues to flourish today, in a world so dependent on mass production and machinery that the men and women of the Arts and Crafts movement could never have imagined how pervasive industrialization would become. Yet independent artisan/jewelers and metalworkers are still working today, many following the paths cleared by those who came before them.

On the next few pages we offer a selection of jewels by jewelers who either are working now or were working in the second half of this century. Many of these artisans attended the schools you have read about in this book, including the Central School in London and the Glasgow School of Art. Some work employs the same techniques that were used back in 1900, such as cloisonné and other enameling techniques.

A number of these artisans trained as artists and sculptors, and became self-taught jewelers, another parallel to the jewelers of the Arts and Crafts movement.

These artists have exhibited at craft shows and depended on craft publications to make their work known to the public as did the original Arts and Crafts jewelers. The audience for their jewelry has often been of some means because handmade jewelry and metalwork today is quite expensive, just as it has always been relative to its time.

Amethyst and gold earrings by Jean Stark in the form of oak leaves set with bullet shaped stones and highlighted with granulation of 18 and 22 kt. gold. Ms. Stark is a well-known American jeweler who has been a pioneer in working in the ancient technique of granulation and has been a teacher as well as a distinguished craftsman. *Courtesy of Skinner's, Inc., Boston and Bolton*

Arthur King gold, emerald, and diamond ring and bracelet, 1960. King, a self-taught jeweler, was born in 1921 and grew up in New Jersey. He opened a shop on Madison Avenue and exhibited internationally including at the Fortnum and Mason department store in London. *Courtesy of Tadema Gallery, London*

Ring by Arthur King. *Courtesy of Tadema Gallery, London*

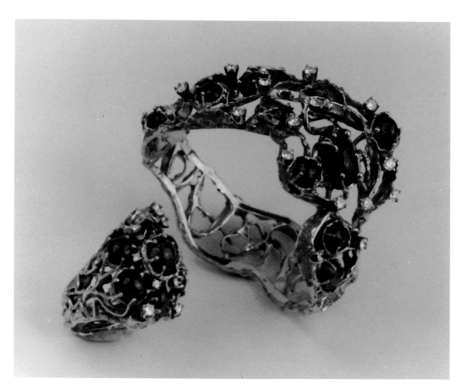

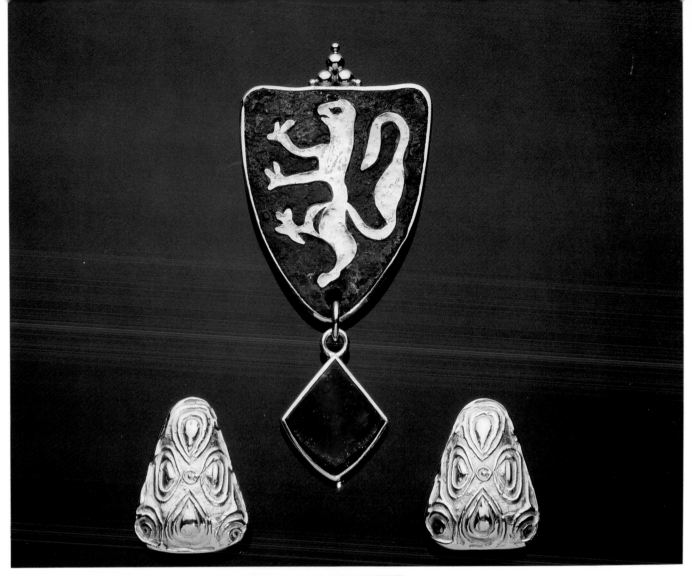

Three pieces of jewelry by the well-known British goldsmith Elizabeth Gage. Ms. Gage creates contemporary pieces that are clearly steeped in the influence of art from earlier centuries, much as the turn-of-the-century Arts and Crafts artisans did. In the center, an 18 kt. gold pin with a gold lion on a bronze shield with a bi-colored tourmaline drop. This piece is based on a bronze shield over 100 years old that itself was a copy of a medieval shield. Below a pair of 18 kt. carved gold earrings. The "Icarus Pin" was originally a cast piece that came out incorrectly but Miss Gage loved the shape and kept it for almost eight years. She then found a bronze Roman head (approximately 300 A.D.) which she knew would go with it; to this she then added a Roman coin minted in 290 A.D. and finally gave him a ruby heart. *Courtesy of Elizabeth Gage, London. Icarus photo by Eileen Tweedy*

Space age jewelry: Top left: Gubelin, gold, tourmaline, enamel, 1958. Bottom left—planets brooch, white and yellow gold with diamonds and emerald, c. 1960. On the right: a Pierre Cardin gold citrine necklace, c. 1960. *Courtesy of Tadema Gallery, London*

Georges Braque, Hades IV, December 1962.
Gold brooch set with diamonds and emeralds.
Courtesy of Tadema Gallery, London

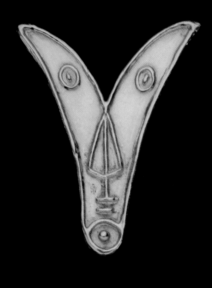

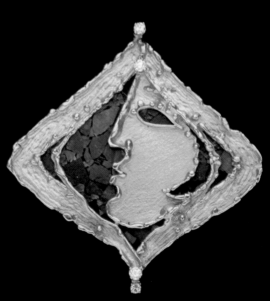

Artist-designed jewelry from 1960: Top: Pablo
Picasso pendant. Left: Jean Cocteau gold
brooch. Bottom: Georges Weils brooch of gold,
opal and diamonds. More turn-of-the-century
Arts and Crafts designers began as artists than
not, and this is another example of the tradition
continuing. *Courtesy of Tadema Gallery,
London*

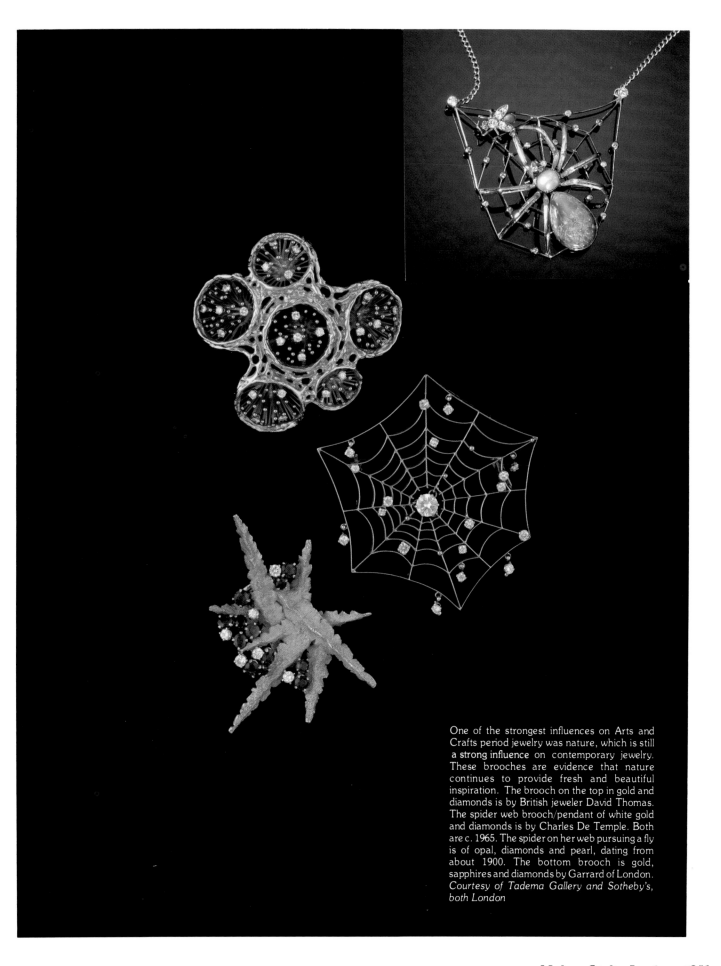

One of the strongest influences on Arts and Crafts period jewelry was nature, which is still a strong influence on contemporary jewelry. These brooches are evidence that nature continues to provide fresh and beautiful inspiration. The brooch on the top in gold and diamonds is by British jeweler David Thomas. The spider web brooch/pendant of white gold and diamonds is by Charles De Temple. Both are c. 1965. The spider on her web pursuing a fly is of opal, diamonds and pearl, dating from about 1900. The bottom brooch is gold, sapphires and diamonds by Garrard of London. *Courtesy of Tadema Gallery and Sotheby's, both London*

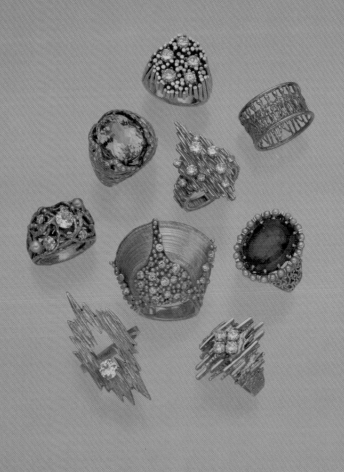

British designed rings in gold c. 1965. Top:
Gilian Packard, Row One: Frances Beck,
Georges Weil, Stuart Devlin, Row Two: Charles
De Temple, Jacqueline Mina, David Thomas,
Bottom: Andrew Grima and Georges Weil.
Courtesy of Tadema Gallery, London

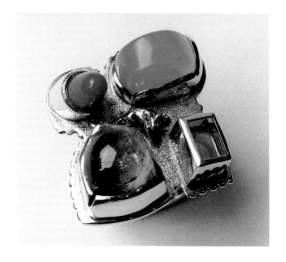

Norah Pierson "The Mouse in the City" Ring c.
1968 of gold, green tourmaline, rubelite,
chrysoprase, quartz and chalcedony. Pierson
has exhibited internationally and at "The Golden
Eye" gallery in Santa Fe, New Mexico. *Tadema
Gallery, London*

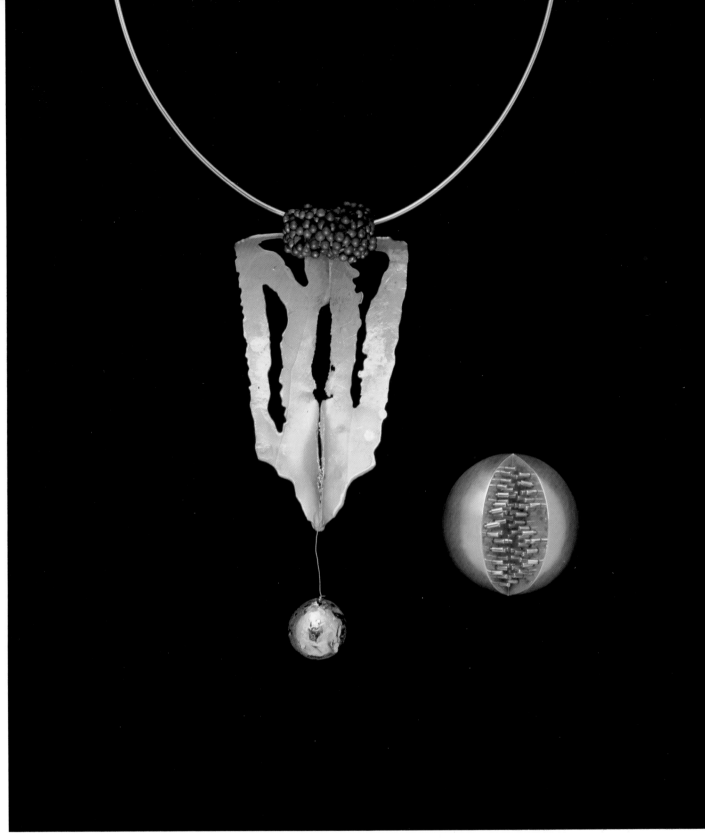

Two views of a gold necklace with magnetic beads by Takis, a Greek artist, c. 1965, and a gold brooch with mobile rods by Belgian artist Pol Bury. These internationally known kinetic sculptors design jewelry in the way that many turn-of-the-century Arts and Crafts sculptors such as Sir Frank Brangwyn, Sir Alfred Gilbert, Georg Jensen and others in Denmark did. *Courtesy of Tadema Gallery, London*

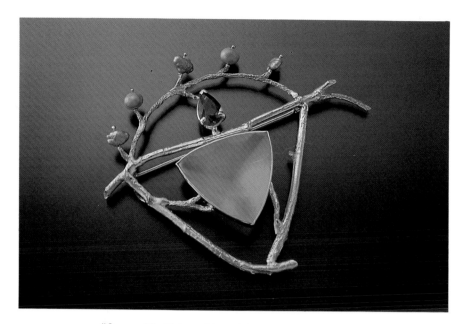

"Queen of the Universe" brooch by Roz Balkin of 14 and 22 kt. gold. Rose quartz, amethyst, pearls, cast and fabricated. Balkin of Woodstock, New York has been designing jewelry since 1973. *Courtesy of Roz Balkin, Woodstock. Photo by Allen Bryan*

"Construction" brooch by Rebekah Laskin, enamel on copper. She is known for her "cool" abstract designs and has some of her work in the collection of New York's Cooper-Hewitt Museum. *Courtesy of Aaron Faber Gallery, New York*

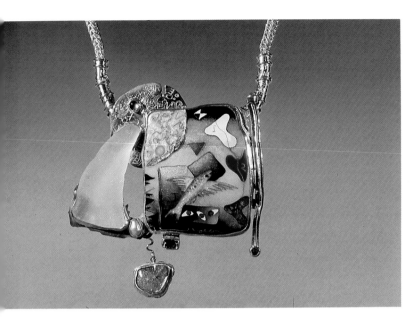

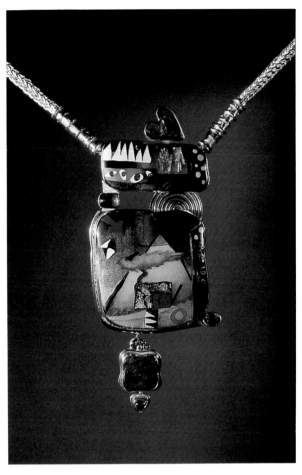

Two necklaces by self-taught artisan Colette. On the left, "Pectoral #10", "From the Deep". Fine silver, 18, 22, 24 kt. golds, tanzanite, boulder opal, tourmaline, purple garnet, river glass, rainbow moonstone and Chinese pearl. On the right, "Pectoral #8", fine silver, 22, 23, 24 kt. golds, fine silver chain, garnet, aquamarine, sapphire and tourmaline. *Courtesy of Aaron Faber Gallery, New York*

Pendant by Larissa Rosenstock, "Peacock #5", Limoges enamel on copper, set in 18 kt. gold with boulder opal. She is known for realistic detail painted directly on metal. The peacock was one of the most common motifs of the turn-of-the-century "art" jewelry movement. *Courtesy of Aaron Faber Gallery, New York*

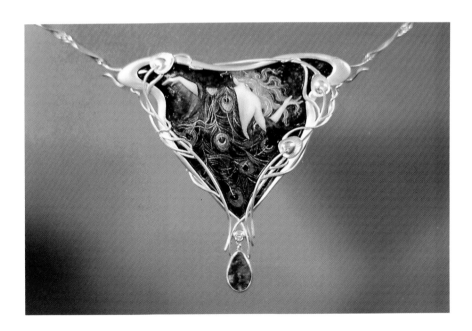

Glossary

Agate—A variety of chalcedony; this stone is found in all colors.

Aluminum—This silver-colored metal is very light and very malleable and was first used in jewelry during the Victorian era. Several Art and Crafts jewelers specialized in working with it.

Amazonite—An opaque green form of feldspar.

Amber—The fossilized resin of prehistoric pine trees, found in a variety of colors ranging from golden to orange-red inside.

Amethyst—A variety of quartz with a deep purple to bluish-violet color.

Annealing—The process used to make metal more malleable by heating it.

Aquamarine—This form of beryl can be found in a pale green blue or a clear blue form.

Baroque Pearls—Pearls that form in odd and organic shapes rather than almost round shapes.

Cabochon—An unfaceted stone with a rounded, smooth surface with a high polish.

Casting (Sand)—This method of moulding utilizes metal molds that are filled with sand.

Champlevé enamel—This method of enamelling is done by digging out part of the metal and filling it with enamel and then firing the piece of jewelry.

Chasing—A metalwork technique in which the metal is pushed away but not removed to raise it into a design. The tools of the chaser are a hammer and punch.

Chrysoberyl—A semi-precious stone of transparent golden yellow, green-yellow or brown. The two most-valued varieties are alexandrite and chyrsoberyl cat's eye.

Chrysolite—Both peridot and olivine are alternative names for chrysolites. It can range in color from yellow-green to olive green to brownish.

Chrysoprase—A variety of chalcedony, chrysoprase is found in a clear green or an "apple-green" color. It is usually used en cabochon or for ornamentation.

Citrine—This variety of quartz is found in a range of colors from to light yellow to red-orange to an almost brown.

Cloisonné Enamel—In this method of enamelling a thin wall of metal or wire is used to separate different color enamels.

Clutha Glass—A pale green, yellow or amber glass with bubbles or streaks. Made by James Couper & Sons of Glasgow.

Collet Set—A setting in which a round band of metal fits around a stone.

Coral—The skeleton of small marine animals that is found in colors ranging from almost white, pink, to red.

Festoon—A garland.

Filigree—Patterns made from fine wire work.

Engraving—In this technique metal is cut away with a tool known as a "graver" to form a design. This can also be done by a machine.

Garnet—This semi-precious stone can be found in several different colors. The blood-red type is the Bohemian type often found in Victorian jewelry, the almandine variety ranges from a red to a deep purple color; hessonite garnets are a brown-orange and the much rarer demantoid garnet is found in several shades of green and was quite popular in Victorian jewelry.

German silver—This is a misnomer, German silver is an alloy of copper, zinc, and nickel.

Gilding—Fire gilding was the early process used to put a coat of gold on an object. Today the electrogilding method is used.

Guilloché enamel—This form of enamel work is done by working the metal with an engine-turned lathe to form a patterned design and then enamelling over the pattern.

Hematite—This mineral is an iron oxide which is opaque. It has a deep gray to black metallic appearance.

Horn—Used as a substitute for tortoiseshell.

Ivory—African ivory is from the tusk of a male or female elephant, Indian ivory is from the male only.

Lapis Lazuli—This stone is composed of a mix of lazurite and haunite, pyrite, and calcite. It is found a variety of blue colors with gold veins running through it.

Limoges enamel—This is a method of enamelling where is the enamel is painted on the surface of an object.

Lost Wax Method (Cire Perdu)—This method of casting metal uses a rubber mold which is filled with wax to form a pattern from which a plaster mold is made. The plaster is then heated and the wax melts away or is "lost".

Lumachella—From Hungary, this material is composed of fossilized shells embedded in a black matrix.

Matrix—A stone that is used still partially in the rock in which it is found is said to be in matrix.

Mississipi River Pearls—Irregular shaped pearls, usually elongated, found in the Mississippi River.

Modelling—Using clay, wood, plasticine, etc. to make patterns from which to create casts for metalwork.

Mokumé—A Japanese method of working metal which is used to add color. Various thin sheets of metal are rolled out very thin and treated with a solution, then tied together with wire and soldered together. It is then beaten from the back or drilled or filed to make designs in the various sheets of metal. The whole piece is finally hammered or scraped flat to one thickness which has a mottled effect. John Paul Cooper was a great proponent of this type of metalwork and some contemporary jewelers today are using it.

Moonstone—A semi-translucent variety of feldspar which has adularescence.

Mother-of-Pearl—The hard, smooth iridescent interior lining of the shells of certain mollusks.

Niello—Metal is first engraved and then filled with a dark enamel in the niello method.

Opal—A semi-precious stone with rainbow-like iridescence. It is divided into three groups—the opalescent precious opals, the yellow-red fire opals and the common opal.

Paillons—Tiny pieces of metallic foil used underneath enamel work by a number of Arts and Crafts jewelers.

Paste—Glass that is used in imitation of real stones.

Piercing—The use of a piercing saw to cut parts of metal away to produce a utilatarian or decorative effect.

Planishing—A hammering process done to give a smoother finish to a piece of metal.

Plique-à-jour enamel—Primarily used in Art Nouveau jewelry, this method is similar to the cloissoné method of enamel except that the back of the enamel sections are left open to allow light to pass through. This is achieved by creating the jewelry with a backing to which the enamel will not adhere when it is fired, and which is then removable.

Polishing—Sanding and polishing metal on a wheel removes hammer marks.

Repoussé—This three-dimensional technique is used for decorating metal. Working from the inside out the metal is raised outward to create a design, the finishing is done from the outside.

Shagreen—the skin of a ray from the waters around China which is very granular. It is usually dyed green. This "lost art" was revived during the Arts and Crafts period by John Paul Cooper and others.

Soldering—Heat and metal solder is used to join pieces of metal.

Stamping—A mechanical process for producing metalwork. The item is literally stamped out of a piece of metal.

Turquoise—A bluish-greenish, blue, or greyish green gemstone. The name came from Turkey, due to the trade route it once travelled.

Wire work—Twisting and fashioning metal wire to make jewelry and other items.

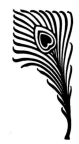

Hallmarks

The British Hallmarking System

English gold and silver pieces carry some or all of the following marks:

—**Standard Mark**, for silver: **The Lion Passant** (a lion in full profile wearing a crown, with his right paw raised)

and for gold: a crown and 18 or 22 kt.,
> or 14 ∗ 585 for 14 kt. gold,
> or 9 ∗ 375 for 9 kt. gold

—**Maker's mark** (or sponsor's mark)

—**City of origin mark**
Birmingham: an anchor
Chester: city coat of arms—three wheatsheaves and a sword
Dublin: Hibernia
Edinburgh: castle with three towers on a rock
Glasgow: coat of arms: a tree with bird sitting on top, bell, fish with a ring in its
> mount (until 1964)
London: Leopard's head (King's mark)

—**Assay mark**: letter in a shield indicating year made. Consult published hallmarks lists because the shield shape and the alphabet script changes periodically.

From 1876 to 1904, an "F" indicated goods of foreign origin.

Liberty & Co.
Any combinations of the following might appear:

Silver:
1. town mark—anchor for Birmingham, Leopard's head for London
2. silver mark—Lion Passant
3. date letter
4. LY & Co. before 1900; L & Co.
5. Cymric

Pewter:—some combination of the following:
1. "Tudric" with a number; usually in a sunken rectangle with raised letters; sometime impressed in quotes
2. Made in England
3. "Solkets"—a Haseler mark; crossed acorn motif
4. "English Pewter"
5. "Made by Liberty & Co."
6. registration numbers; series of numbers after RD. (registered)

Design or mold numbers do not always appear; the lower numbers are earlier pieces. if a "0" is not before a number the piece probably is from 1920 or later. Bear in mind designs were repeated and changed over the years. The 0500 number series includes designs by Archbibald Knox.[1]

[1] Tilbrook, Adrien J., with Gorden House, *The Designs of Archibald Knox for Liberty & Co.,* London, Ornament Press Ltd. 1976.

Hallmarks in Other Countries

Austria
—Head of Apollo facing left: for gold
—Head of Diana: for silver
—Crossed AA: gold imported to Austria from 1898 to 1901
—Crossed AA and Imperial eagle: gold imported to Austria from 1901 to 1921
—Crown and crescent: silver .800 or .850 (used after 1888)

France
—Eagle's head, minimum of 18 kt. gold
—Owl in an oval: gold imported to France
—Winged head of Mercury: gold made for export
—Wild boar's head: indicates silver of .950 fineness
—Wild boar's head and eagle together: mixed metal (used from 1905)

Republic of Ireland
—Crowned harp: sterling and 22 kt. gold

Germany
—.950: sterling silver (after 1907)
—karat mark: gold (after 1907)

Belgium
—Silver is optional for assaying since 1868. It carries maker's mark and standard .0826 or higher. If assayed from 1863-1904 it carries the mark of the assay master S. Groth which looks like intertwined "S"'s in an oval. From 1904-32 the initials CFH appear in an oval. There is also a control mark which is three towers with the year written underneath it.

Finland
—Silver is marked with standard either 813H, 875H, 914H in rectangle; the state mark of a crown in a heart; if imported a crown in an oval. Also has a city mark, maker's mark, and a date letter.

Holland (Netherlands)
—Two standards for silver: 0.934 is shown as Lion Rampant (standing on his hind legs, facing sidewards) with the number "1"; 0.833 is represented by a Lion Passant (on all fours facing sideways) with "2" underneath it. Head of Minerva facing left with a letter indicates the assay office; maker's mark, date letter. A "V" under a crown under a triangle indicates imports from 1893-1906.

Norway
—Silver does not have to be assayed. Since 1843 a crowned Lion Rampant indicates at least a .0830 standard; marked with maker's mark and standard from 830 S to 9255.

Sweden
—All silver has state mark—three crowns in a lozenge and "S" in a hexagon; maker's mark and date letter.

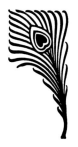

Dealers

in Arts and Crafts/Art Nouveau Jewelry and/or Metalwork

Aalto Gallery (Georg Jensen Jewelry), 8 Ganton Street, London WIV 1LR, England

After Noah (English Arts and Crafts Jewelry and Metalwork), 121 Upper St., Islington N1 1Qp, England

A La Vieille Russie (Art Nouveau Jewelry and Fabergé), 781 Fifth Avenue, New York, New York 10022

Ark Antiques (American Arts and Crafts Jewelry and Metalwork), Box 3133, New Haven, Connecticut 16515

Asprey (Art Nouveau Jewelry, and European Arts and Crafts Jewelry and Metalwork), 725 Fifth Avenue, New York, New York 10022

Carole A. Berk, Ltd. (American and European Arts and Crafts Jewelry), 8020 Norfolk Avenue, Bethesda, Maryland 20814

N. Bloom & Son Ltd. (Art Nouveau Jewelry), 40 Conduit Street, London W England

Calderwood Gallery (European Arts and Crafts Metalwork), 221 South 17thStreet, Philadelphia, Pennsylvania 19103

Cobra and Bellamy (British Arts and Crafts, Art Nouveau, Contemporary Artist's Jewelry), 149 Sloan Street, London SW1, England

Didier Antiques (British Arts and Crafts Jewelry and Metalwork), 58-60 Kensington Church St., London W8 4DB, England

Fine Art Society (British Arts and Crafts Jewelry and Metalwork), 148 New Bond Street, London W1Y OJT, England

Barry Friedman, Ltd. (American, European, Jugendstil, and Wiener Werkstätte metalwork), 851 Madison Avenue, New York, New York 10021

Nicholas Harris Gallery (British Arts and Crafts Jewelry and Metalwork), 564 King's Road, London SW6 2DY, England

Hirschl and Adler Galleries (American Arts and Crafts Metalwork), 21 E. 70th Street, New York, New York 10021

JAG (British Arts and Crafts metalwork), Unit 6, 58-60 Kensington Church Street, London W8 4DB, England

John Jesse Ltd. (British Arts and Crafts and Art Nouveau Jewelry and Metalwork), 160 Kensington Church Street, London W8 4BN, England

Kurland-Zabar (American and British Arts and Crafts jewelry and metalwork), 19 E. 71st Street, New York, New York 10021

M. McAleer (Irish and Scottish Silver and Jewelry), Portobello Road, London N1, England

David Rago (American metalwork), Box 3592 Station E, Trenton, NJ 08629

Spink & Son, Ltd. 56 & 7 King Street, St. James, London SW1Y 6QS, England

Style (British and European metalwork), Camden Passage, London N1, England

Silber-Keller (European Arts and Crafts Metalwork), Stievestrasse 98000, Munich 19, West Germany

Leah Roland/Split Personality (British and Continental Arts and Crafts jewelry and metalwork), Box 419, Leonia, New Jersey 07605

Tadema Gallery (British, Continental Arts and Crafts Jewelry and Contemporary Artist's Jewelry), 10 Charlton Place Camden Passage, London N1, England

The Antique Trader (British Arts and Crafts metalwork), 357 Upper Street, Camden Passage, London N1, England

John Toomey Gallery (American and European Arts and Crafts jewelry), 818 North Boulevard, Oak Park, Illinois 60301

Simon Tracy (British Arts and Crafts metalwork), 18 Church Street, London NW8, England

Van Den Bosch (British Arts and Crafts Jewelry and Metalwork), Shop 1, Georgian Village, Camden Passage, London N1, England

Woodsbridge Antiques (American Arts and Crafts metalwork), Box 239, Yonkers, New York 10705

Auction Houses

That Offer Arts and Crafts Jewelry and/or Metalwork

James R. Bakker Antiques, Inc., 370 Broadway, Cambridge, MA 02139

Bukowski's, Wahrendorffsgatan 8, S-111 47, Stockholm, Sweden

Butterfield and Butterfield, 761 Sunset Boulevard, Los Angeles, CA 90046

Christie's, 164-166 Bath Road, Glasgow G2 4TG, Scotland

Christie, Manson & Woods, Ltd., 8 King Street, St. James, London SW1Y 6QT, England

Christie's, 502 Park Avenue at 59th Street, New York, New York 10022

Dorotheum, Haupthaus, Dorotheergasse 17, Wein 1, Austria

William Doyle Galleries, 175 E. 87th Street, New York, New York 10128

Lawrence Fine Art Auctioneers, South Street, Crewkerne, Somerset TA18 8AB, England

Phillips Son & Neal Auctions, 101 New Bond Street, London W1Y OAS, England

Phillips Son & Neal Auctions, 406 East 79th Street, New York, New York 10021

Carl Schulter, Alsterufer 12 2000 Hamburg 36, Germany

Sotheby Parke-Bernet Auctions, 1334 York Avenue, New York, New York 10021

Sotheby Parke-Bernet Auctions, 34-35 New Bond Street, London W1A 2AA England

Skinner's Auctions, 2 Newbery Street, Boston, Massachusetts 02116

Skinner's Auctions, 357 Main Street (Route 117), Bolton, Massachusetts 01740

Museums

With Arts and Crafts Movement Jewelry and/or Metalwork

Art Institute of Chicago
Michigan Avenue at Adams Street
Chicago, Illinois 60603
(American Arts and Crafts metalwork)

Austrian Museum of Applied Art
A-1010 Wien
Stubenring 5, Austria
(European Arts and Crafts Jewelry and Metalwork)

Bayrisches National Museum
Prinzregentensrabe 3
8000 Munchen 22, Germany
(European Arts and Crafts Jewelry and Metalwork)

Birmingham Museums and Art Gallery
Chamberlain Square
Birmingham, West Midlands B3 3DH, England
(English Arts and Crafts Jewelry and Metalwork)

Cheltenham Gallery and Museums
Clarence Street
Cheltenham, Glos GL50 3JT, England
(English Arts and Crafts jewelry and metalwork)

Delaware Art Museum
2301 Kentmere Parkway
Wilmington, Delaware 19806
(Extensive Pre-Raphaelite collection including Jewelry)

Fitzwilliam Museum
Cambridge CB2 1RB England
(English Arts and Crafts Jewelry)

Georg Jensen Museum
Bredgade 11
DK-1260 Copenhagen K, Denmark
(Georg Jensen jewelry and metalwork)

Glasgow Museums and Art Galleries
2060 Pollokshaws Road
Glasgow G43 1AT, Scotland
(English and Scottish Jewelry and Metalwork)

Calouste Gulbenkian Museum
Avenida de Berna
Lisbon, Spain
(Lalique jewelry)

Glasgow School of Art
167 Renfrew Street
Glasgow G3 6RQ, Scotland
(Ornamental iron work in this C.R. Mackintosh structure)

High Museum of Art
1280 Peachtree St. NE
Atlanta, Georgia 30309
(American Arts and Crafts Metalwork)

Hunterian Art Gallery
University of Glasgow
G12 8QQ Glasgow, Scotland
(objects by Charles Rennie Mackintosh and Margare
Macdonald Mackintosh including some metalwork)

Manchester City Art Galleries
Mosley Street
Manchester M2 3JL, England
(clothing from the English Arts and Crafts period)

Metropolitan Museum
5th Avenue at 82nd Street
New York, New York 10028
(Art Nouveau and Tiffany Jewelry)

Museé des Arts Decoratifs
107, Rue de Rivoil
75001 Paris, France
(Art Nouveau jewelry and metalwork)

Museum of Decorative Arts
68, Bredgarde
1280 Copenhagen L, Denmark
(Danish Jewelry and Metalwork)

Museum of Fine Arts
465 Huntington Avenue
Boston, Massachusetts 02115
(Jewelry from the American Arts and Crafts period)

Museum of Modern Art
11 W. 53rd Street
New York, New York 10029
(a few examples of European Arts and Crafts metalwork)

National Museum of Wales
Cathays Park
Cardiff CF1 3NP, Wales
(English Arts and Crafts Jewelry)

Austrian Museum for Applied Arts
A-1010 Wien
Stubenring 5, Austria
(European Arts and Crafts Jewelry and Metalwork)

Schmuckmuseum
JahnstraBe 42,
D7530 Pforzheim, Germany
(Arts and Crafts, Jugendstil, Art Nouveau jewelry)

Victoria and Albert Museum
South Kensington
London SW7 2RL, England
(English, Scottish Arts and Crafts jewelry and metalwork; Ar
Nouveau jewelry, Georg Jensen jewelry, Arts and Crafts
clothing, embroidery)

Walter's Art Gallery
600 North Charles Street
Baltimore, Maryland 21201
(Art Nouveau Jewelry)

Bibliography

Books:

Adams, Steven, *The Arts and Crafts Movement*, Seacaucus, New Jersey: Chartwell Books, Inc., 1987.

Anscombe, Isabelle, *Arts and Crafts Style*, New York, New York: Rizzoli, 1991.

Anscombe, Isabelle, *A Woman's Touch*, New York, New York: Chartwell Books, 1985.

Anscombe, Isabelle and Charlotte Gere, *Arts and Crafts in Britain and America*, New York, New York and London, England: Van Nostrand Reinhold, 1983.

Art Nouveau Domestic Metalwork from Württembergische metallwaren Fabrik, 1906, Antique Collectors' Club: Suffolk, England, 1988.

Ashbee, C. R., *Modern English Silverwork*, New Edition, London: Antique Collectors' Club 1974.

Aslin, Elizabeth, *The Aesthetic Movement, Prelude to Art Nouveau*, London, England: Ferndale Editions, 1981.

Baker, Lillian, *Art Nouveau and Art Deco Jewelry*, Paducah, Kentucky: Collector's Books, 1981.

Becker, Vivienne, *Art Nouveau Jewelry*, New York, New York: E.P. Dutton, 1985.

Becker, Vivienne, *Antique and Twentieth Century Jewelry*, Colchester, England: N.A.G. Press Ltd., 1987.

Beerbohm, Max, *Rosetti and His Circle*, New Haven, Connecticut and London, England: Yale University Press, 1987.

Bennett, David and Daniela Mascietti, *Understanding Jewelry*, Suffolk, England: Antique Collector's Club, 1989.

Bergmaier, Senta, *Schmuck von 1900 bis 1980*, Stuttgart, Germany: Ruhle, Diebener-Verlag, 1982.

Bishop, Margaret and Dan Klein, *Decorative Art 1880-1980*, Oxford, England: Phaidon, 1986.

Black, J. Anderson, *A History of Jewelry Five Thousand Years*, New York, New York: Park Lane, 1981.

Bloomingdale Bros., *Bloomingdale's Illustrated 1886 Catalogue*, Mineola, New York: Dover Books, 1988.

Blum, Stella, *Fashions and Costumes from Godey's Lady's Book*, Mineola, New York: Dover Publications, 1985.

Bly, John *Discovering Hallmarks on English Silver*, Aylesbury, England: Shire Publications, 1992.

Bowman, Leslie Greene, *American Arts and Crafts, Virtue in Design*, Boston, Toronto, London: Bulfinch Press/Little Brown & Co, 1990.

Boymans Van-Beunigen Museum, *Silver of a New Era*, Rotterdam, Netherlands: Museum Boymans Van Beunigen and Museum Voor Sierkunst, 1992.

Burkhauser, Jude, *Glasgow Girls, Women in Art and Design 1880-1920*, Edinburgh, Scotland: Cannongate, 1990.

Bury, Shirley *Jewellry 1789-1910 Vol.I*, Sussex, England: Collector's Club, 1991.

Bury, Shirley *Jewellery Gallery Summary Catalogue*, London, England: Victoria and Albert Museum, 1982. Callen, Anthea, *Angel in the Studio*, London, England: Astragal Books, 1979.

Calloway, Stephen, *The House of Liberty, Masters of Style & Decoration*, London, England: Thames and Hudson, 1992.

Carpenter, Charles H., Sr., *Gorham's Martelé Silver* Chapter in Encyclopedia of Collectibles, Alexandria, Virginia: Time-Life Books, 1979.

Cartlidge, Barbara *Twentieth Century Jewelry*, New York, New York: Harry N. Abrams, Inc. 1985.

Clark, Robert Judson *The Arts and Crafts Movement In America 1876-1916*, Princeton, New Jersey: University of Princeton, 1992.

Crawford, Alan, *C.R. Asbhee, Architect, Designs and Romantic Socialist*, New Haven, Connecticut and London England: Yale University Press, 1985.

Crawford, Alan, *By Hammer and Hand, The Arts and Crafts Movement in Birmingham*, Birmingham, England: Birmingham Museums and Art Gallery, 1984.

Crowley, David, *In the Victorian Style*, New York: Mallard Press, 1990.

Cummings, Elizabeth and Wendy Kaplan, *The Arts and Crafts Movement*, London, England: Thames and Hudson, 1991.

Cuzner, Bernard *A Silversmith's Manual*, London, England: N.A.G. Press Ltd., 1979.

Dagleish, George R. and Rosalind K. Marshall, ed., *The Art of Jewelry in Scotland*, Edinburgh, Scotland: Scottish National Portrait Gallery, 1991.

Darling, Sharon *Chicago Metalsmiths*, Chicago, Illinois: Chicago Historical Society, 1977.

Duncan, Alastair and Martin Eidelberg, Neil Harris, *Masterworks of Louis Comfort Tiffany,* New York, New York: Harry N. Abrams, Inc., 1989.

Duncan, Alastair, *Louis Comfort Tiffany*, New York, New York: Harry N. Abrams, Inc., 1992.

Fahy, Kevin and Anne Schofield, *The Jewelry of Australia*, Suffolk: Antique Collector's Club, 1991.

Flower, Margaret, *Victorian Jewelry*, New York, New York: A.S. Barnes & Co., Inc., 1967.

Garner, Philippe, *Phaidon Encyclopedia of Decorative Arts 1890-1940*, Oxford, England: Phaidon Press Limited, 1982.

Garside, Anne (ed.), *Jewelry Ancient to Modern*, New York, New York: The Viking Press, 1979.

Gere, Charlotte, *Victorian Jewelry Design*, London, England: William Kimber, 1972.

Gere, Charlotte, *American and European Jewelry 1830-1914* New York, New York: Crown Publishers, 1975.

Gere, Charlotte and Geoffrey C. Munn, *Artist's Jewelry Pre-Raphaelite to Arts and Crafts*, Suffolk, England: Antique Collector's Club, 1989.

Gernsheim, Alison, *Victorian and Edwardian Fashion, A Photographic Survey*, New York, New York: Dover Publications, 1963.

Gillon, Edmund V. Jr. *Art Nouveau An Anthology of Design and Illustration from The Studio*, Mineola, New York: Dover Publications, 1969.

Hackney, Fiona and Isla Hackney, *Charles Rennie Mackintosh*, Seacaucus, New Jersey: Chartwell Books, 1989.

Hageney, Wolfgang, *German Jewellry—Variations of Jewellry Designs—Liberty Style*, Rome and Milan, Italy: Belvedere, 1985.

Halen, Widar, *Christopher Dresser*, Oxford: Phaidon/Christie's, Ltd., 1990.

Harris, Nathaniel, *Art Nouveau*, Twickenham, England: Hamlyn Publishing Group, 1987.

Haslam, Malcolm, *Collectors Style Guide Arts and Crafts*, New York, New York: Ballantine Books, 1988.

Healy, Debra and Penny Proddow, *American Jewelry Glamour and Tradition*, New York, New York: Rizzoli, 1987.

Heskett, John, *German Design 1870-1918*, New York, New York: Taplinger Publishing Co., 1986.

Hiesinger, Kathryn Bloom, ed., *Art Nouveau in Munich Masters of Jugendstil*, Munich, Germany: Prestel-Verlag and Philadelphia Museum of Art, 1988.

Hinks, Peter *Twentieth Century British Jewelry 1900-1980*, London, New York and Boston, Massachusetts: Faber and Faber, 1983.

Howarth, Thomas *Charles Rennie Mackintosh and the Modern Movement*, London, England and New York, New York: Routledge, Ltd., 1990.

Hughes, Graham, *Jewelry*, New York, New York and London, England: Studio Vista Limited and E.P. Dutton & Co., Inc., 1966.

Hughes, Graham, *Modern Silver Throughout the World 1880-1967*, New York, New York: Crown Publishers, 1967.

Hughes, Graham, *Modern Jewelry An International Survey 1880-1963*, New York, New York: Crown Publishers, 1963.

Jones, Kenneth Crisp, ed., *The Silversmiths of Birmingham and Their Marks: 1750-1980*, London, England: N.A.G. Press, Ltd., 1981.

Jones, Owen, *The Grammar of Ornament*, Mineola, New York: Dover Publicatons, 1987.

Kallir, Jane, *Viennese Design and the Wiener Werkstätte*, New York, New York: Galerie St. Etienne/George Braziller, 1986.

Kaplan, Wendy, ed., *The Encyclopedia of Arts and Crafts*, New York, New York: E.P. Dutton, 1989.

Kaplan, Wendy, ed., *Scottish Art and Design 5,000 Years*, New York, New York: Harry N. Abrams, Inc., 1990.

Koch, Michael and others, *The Belle Epoque of French Jewellry 1850-1910*, London, England: Thomas Heneage & Co., Ltd., 1990.

Karl, Kreuser, *Gurtelschlieben des Jugendstil*, Munich, Germany: Prestel-Verlag, 1990.

Krekel-Aalberse, Annelies, *Art Nouveau and Art Deco Silver*, New York: Harry N. Abrams, Inc. 1989.

Laing, Jennifer and Lloyd *Art of the Celts*, New York and London: Thames and Hudson, 1992.

Levy, Mervyn, *Liberty Style The Classic Years 1898-1910*, New York: Rizzoli International Publications, 1986.

Loring, John, *Tiffany's 150 Years*, Garden City, New York: Doubleday & Co., Inc., 1987.

Lucie-Smith, Edward *The Story of Craft—The Craftman's Role in Society*, New York, New York: Van Nostrand Reinhold Co., 1984.

Marsh, Jan, *Pre-Raphaelite Woman: Images of Femininity*, New York, New York: Harmony Books, 1987.

Maryon, Herbert, *Metalwork and Enamelling*, New York, New York: Dover Publications, 1971.

McFadden, David Revere, ed., *Scandinavian Modern Design, 1880-1980*, New York, New York: Harry N. Abrams, 1982.

Møller, Jorgen E.R., *Georg Jensen The Danish Silversmith*, Copenhagen, Denmark: Georg Jensen and Wendel A/S, 1984.

Morris, Barbara, *Liberty Design*, Secaucus, New Jersey: Chartwell Books, 1989.

Mourey, Gabriel and Aymer Vallance, *Art Nouveau Jewellry and Fans*, New York, New York: Dover Publications, 1973.

Naylor, Gillian, *The Arts and Crafts Movement*, London, England: Trefoil Publications, 1990.

Neuwirth, Waltraud, *Wiener Jugendstilsilber Orginal Falschung Oder Pasticcio*, Vienna, Austria: ?, 1980.

Partell, Joseph, *The Tiffany Touch*, New York, New York: Random House, 1971.

Peters, Mary, *Collecting Victorian Jewellery*, New York, New York, Emerson Books, 1970.

Proddow, Penny and Peter Schneirla, *Tiffany 150 Years of Gems and Jewelry*, New York, New York: Tiffany & Co., 1987.

Pullee, Caroline, *20th Century Jewelry*, New York, New York, 1990.

Sataloff, Joseph, *Art Nouveau Jewelry*, Bryn Mawr, Pennsylvania: Dorrance & Co., Inc., 1984.

Schiffer, Nancy, *Handbook of Fine Jewelry*, Atglen, Pennsylvania: Schiffer Publishing, 1991.

Schmundt, Ulrike von Hase, Christine Weber, Ingeborg Becker, *Theodor Fahrner Jewelry*, Atglen, Pennsylvania: Schiffer Publishing, 1991.

Schweiger, Werner, *Wiener Werkstätte: Design in Vienna 1903-1932*, New York, New York: Abbeville Press, 1984.

Sembach, Klaus Jürgen, Art Nouveau, *Utopia: Reconciling the Irreconcilable*, Cologne, Germany: Benedikt Taschen Verlag, 1991.

Slesson, Catherine, *The Art of Aubrey Beardsley*, London: Quintet Publishing, Ltd,, 1989.

Snowman, Kenneth A., *Carl Fabregé*, New York, New York: Greenwich House, 1983.

Spink & Son, Ltd. *Antique and Twentieth Century Jewelry Exhibition*, December, 1992, London, England.

Thage, Jacob, *Danish Jewelry*, Komma & Clausens Boger, 1990.

Tilbrook, A.J. with Gordon House, *The Designs of Archibald Knox for Liberty & Co.*, London, England: Ornament Press Ltd., 1976.

Waddell, Roberta, ed., *The Art Nouveau Style*, Mineola, New York: Dover Books, 1977.

Waters, William, *Burne-Jones*, Aylesbury, England: Shire Publications, 1989.

White, Colin, *The Enchanted World of Jessie M. King*, Edinburgh, Scotland: Cannongate, 1989.

Wickmann, Siegfried, *Jugendstil Art Nouveau Floral and Functional Forms*, Boston, Massachusetts: Little, Brown & Co., 1984.

Wintersgill, Donald, *Scottish Antiques*, London, England and Edinburg, Scotland: Johnston & Bacon, 1977.

Catalogs and Exhibition Catalogs:

Berberian, Rosalie, *Fine Early 20th Century American Craftsman, Silver, Jewelry & Metal*, Ark Antiques, New Haven, Catalog Number 92-1

Berberian, Rosalie, *Fine Handwrought Early 20th Century American Silver*, Ark Antiques, New Haven, Catalog No. 1987, Supplement No. 1

Birmingham Gold and Silver, 1773-1973, July-Sept. 1973 at the City Museum and Art Gallery, Birmingham.

Burke, Doreen, Bolger and others, *In Pursuit of Beauty: Americans and the Aesthetic Movement*, Metropolitan Museum of Art/Rizzoli, 1986, New York.

Cannon-Brookes, Peter. Exhibition catalogue "Omar Ramsden, 1873-1939," City Museum and Art Gallery, Birmingham, 1973.

Carruther, Annette, *Ashbee to Wilson, Catalogue of the Hull Grundy Gift to the Cheltenham Art Gallery and Museums, Part. 2*, 1985, Cheltenham, England.

Cera, Deanna Farnetia, *Jewels of Fantasy, Costume Jewelry of the 20th Century*, Harry N. Abrams & Daniel Swarovski Co., Inc., New York, 1991.

Christie's, *Fine Jewels*, New York June 10, 1992 auction catalog

Christie's, *British Decorative Arts from 1860 to the Present Day, and the Larner Collection of Jewelry*, London, Oct. 9, 1992.

Crystal Palace Exhibtion Illustrated Catalogue, Dover Publications, Mineola, NY, 1970

Decorative & Novelty Silver Exhibit from October-November 1984 at the Nicholas Harris Gallery, London.

Ferreira, Dr. Maria Teresa Gomes, *Art Nouveau Jewelry by Lalique*, International Exhibitions Foundation, 1985, Washington, D.C.

From Architecture to Object, Hirschl and Adler Galleries, 1989, New York.

Arthur and Georgina Gaskin Exhibition, City Museum and Art Gallery, Birmingham, England Feb. 11-March 21, 1982 and at the Fine Arts Society, London, March 29-April 30, 1982.

Hapsburg-Feldman, *Important Jewelry of Rene Lalique*, New York, June 7, 1981.

Jewellry and Jewellry Design 1850-1930 and John Paul Cooper 1869-1933, The Fine Art Society/Adelaide Festival of Arts and John Jessie Exhibition November 1975, London.

Kaplan, Wendy, *The Art That Is Life The Arts and Crafts Movement in America 1875-1920*, 1982 Museum of Fine Arts, Boston.

Reflections: Arts and Crafts Metalwork in England and the United States, Exhibition at Kurland-Zabar, New York, New York, 1990.

Muriel and Archiblad Sanderson, Glasgow Museums and Art Galleries Exhibit Aug.-Sept. 1987, Glasgow.

Skinner's, Sale 1287, Arts & Crafts: Decorative Arts & Furniture, Bolton, October 21, 1989.

Sotheby's, *Silver and Jewels, Weymss Ware, Scottish and Sporting Paintings, Drawings and Watercolors, Gleneagles Hotel*, Aug. 26-27, 1991 and Aug. 27-28, 1990, Aug. 31-Sept. 1, 1992

Tidier, Patricia, *Art With A Mission, Objects of the Arts and Crafts Movement*, Exhibit March 31-May 26, 1991, Spencer Museum of Art, The University of Kansas.

Gertje Utley and others, *Vienna 1900*, Exhibition at the Museum of Modern Art, July 3-Oct. 21 1986, New York.

Varnedoe, Kirk, *Vienna 1900 Art Architecture Design*, Museum of Modern Art, New York, 1986.

Articles:

Akkerman, Klaas, *Phillipe Wolfers: Master of Art Nouveau*, Heritage, August 1989.

Allen, Craig, *Functional Design*, The Antique Collector, September, 1992.

Baker, Keith, *British Arts and Crafts Jewelry*, Antique Collector's Club.

Berberian, Rosalie, *The Society of Arts and Crafts of Boston and its Master Silversmiths*, Arts and Crafts Quarterly, Vol. IV. No. 1.

Bickerdike, Rhoda, *The Dawsons: An Equal Partnership of Artists*, Apollo Magazine, November, 1988.

Bowe, Nicola Gordon, "The Arts and Crafts Movement in Ireland," *The Magazine Antiques*, Dec. 1992, pp. 864-875.

Dèpas, Rosalind, *The Bensons: A Family in the Arts and Crafts Movement*, Journal of Pre-Raphaelites and Aesthetic Studies.

Duncan, J. Alastair, *The Silver of Carlo Bugatti*, Antiques Magazine, December 1989.

Gordon, Leah, *Georg Jensen: Making Silver Shine*, Heritage, May 1989.

Gorvey, Brett, *Wiener Werkstätte—Pioneers of Modern Furniture,*, The Antique Collector, March 1991.

Harlow, Frederica Todd, *Mostly Morris*, Art and Auction, November 1989.

Halen, Widar, *Christopher Dresser and the Aesthetic Interior*, Antiques Magazine, Jan. 1991.

Harrington, TY *The Wizardry of Samuel Yellen, Artist in Metals*, Smithsonian Magazine, March, 1982.

Healy, Debra and Penny Proddow, *Tiffany's Orchids of 1889*, Antiques Magazine, April 1988.

Helliwell, Stephen, *Comyns—A Living Tradition*, Antique Collecting, June 1992.

Jeronack, Paul, *Ahead of His Time*, Art and Auction, April 1991.

Kurland, Catherine and Lori Zabar, *Metalwork Reflections on English and American Contributions*, Arts and Crafts Quarterly.

Kurland, Catherine and Lori Zabar, *Atlantic Accents*, Antiques and Fine Arts, Jan./Feb. 1992.

Lieberman, Gloria, *Artistic Adornment Arts and Crafts Jewelry*, Art and Antiques Magazine Millman, Ian, *George de Feurë A Turn-of-the-Century Universal Artist*, Apollo Magazine, November, 1988.

Neiswander, Judith *Fantastic Malady or Competitive Edge? English Outrage of Art Nouveau in 1901*, Apollo Magazine, November, 1988.

Pynne, Ann, *George Hunt, Art Jeweller*, The Antique Collector, Feb. 1990.

Reed, Christopher, *Nearsighted and Visionary*, New York Times Book Review of Gertrude Jekyll by Sally Festing, May 24, 1992.

Sandon, John, *Designer of Influence*, Antique Dealer & Collector's Guide, 1992.

Scarisbrick, Diana, *Charles Ricketts and His Designs for Jewelry*, Apollo Magazine, Setember, 1982.

Speel, Erika, *The Art Enamellers*, The Antique Collector, February, 1987.

Weir, Juliet, *A Tale of Two Jewellers*, Irish Arts Review.

Zapata, Janet, *The Rediscovering of Paulding Famham, Tiffany's Designer Extraordinaire, Parts I and II,*, Antiques Magazine, March and April, 1991.

Values Reference

The following is intended to be a guide to the prices Arts and Crafts jewelry and metalwork has brought at auction in the last five years, a fairly good indicator of where the market is going. Please bear in mind that auction prices may vary from dealer prices and private sale prices. Additionally, prices can vary by country and even from one city versus another in the same country. Prices are obviously also predicated on condition, whether a piece is signed and outside influences such as the economy.

We give prices in the currency of the countries in which they were sold because to convert them to today's value in U.S. dollars would be inaccurate. Those references with specific page numbers are prices for the actual pieces illustrated in this book, the remainder are prices for other works by the same artisans discussed in this book.

Chapter One

p. 31	Sterling and leather purse, London 1903, $550, Skinner's, Boston, 1990
38	Crowned cockerel brooch designed by C.R. Ashbee, £7700, Christie's, London, 1992
39	Waist clasp by C. R. Ashbee, a clasp like this sold for £825, Christie's, London, 1992
43	Pendant by Frank Brangwyn: £2,200, Christie's, London, 1992
48	Necklace attributed to John Paul Cooper, £1155, Christie's, London, 1989
51	Blister pearl bracelet by Nelson and Edith Dawson, £1870, Christie's, London, 1992
53	Toast rack by Christopher Dresser, a similar piece sold for £330, Christie's, London 1992
59	Tristan and Isolde buckle by Alexander Fisher, £3960, Christie's, London, 1992
72	Enamel butterfly brooch by George Hunt, £660, Christie's, London, 1992
73	George Hunt Medusa brooch of blue-green enamel, £2200, Christie's, London, 1992
86	Similar animal rings by the Oveds, a ring with a stag and a ring with swans, silver with gold ornament and jewel eyes, £935, Christie's, London, 1992
87	Hair ornaments by Fred Partridge, £770, £1650, £1100, Christie's, London, 1992
106	Three silver and enamel picture frames by William Hutton & Sons, left £1210; middle, £1650; Christie's, London, 1992

W.A.S. Benson pair of copper and brass chamber sticks, £220, Christie's, London, 1992

Sir Edward Burne-Jones gold, enamel and gem set brooch/pendant executed by Carlo Giuliano, 1890, £18,700, Sotheby's, London 1990

Christopher Dresser soup tureen and cover, electroplated metal and ebony, designed for Hukin and Heath in 1880, £2640, Sotheby's, London, 1991

A Joseph Hodel yellow and silver pendant on chain with a black opal and baroque pearls, £1760, Christie's, London, 1992

H.G. Murphy, three pierced silver brooches, £495, Christie's, London, 1992

Omar Ramsden and Alwyn Carr, pair of silver menu holders, £330, Christie's, London, 1992

Omar Ramsden silver mounted shagreen box, 1930, £2420, Christie's, London, 1992

Edgar Simpson white metal pendant set with opals, £1650, Christie's, London, 1992

Harold Stabler silver twin-branch candelabrum, 1935, £880, Christie's, London, 1992

Henry Wilson white metal brooch with turquoise enamel, £286, Christie's, London, 1992

Keswick School of Industrial Art brass tray, $300, sold privately in New York, 1993

G.L. Connell Ltd. silver bowl, 1903, £3300, Christie's, London, 1992

James Dixon & Sons silver candlesticks, 1907, £1320, Christie's, London, 1992

Charles Horner, three Liberty style silver pins, $350, Skinner's, Boston and Bolton, 1990

W.H. Haseler for G. L Connell, six silver and enamel coffee spoons in original fitted case, 1906, £935, Sotheby's, London, 1991

Liberty & Co. yellow metal ring with enamel designed by Archibald Knox, £2200, Christie's, London 1992

Liberty & Co. Cymric mantel clock, silver and enamel, 1903, £4620, Sotheby's, London, 1991

Liberty Clock of pewter and enamel designed by Archibald Knox, c. 1903, £2090, Sotheby's, London, 1991

Murrle Bennett, enamel and sterling silver pendant, c. 1905, $250, Skinner's, Boston and Bolton, 1990

Theodor Fahrner bird pin, silver, enamel and chalcedony c. 1900 for Murrle, Bennett Co., £550, Sotheby's, London, 1991

Wakely and Wheeler Loving Cup, c. 1900 8 3/4" h, $1540, Sotheby's, New York, 1992

Artificer's Guild hammered brass bowl designed by Edward Spencer, £715, Christie's, London, 1992

Chapter Two

p. 134	A spoon for Mrs. Cranston's tea room like those pictured sold for $1100, Sotheby's, New York, 1992
137	Four brooches attributed to Frances McNair along with white metal caddy spoon, £495, Christie's, London, 1992
139	(top) A similar belt buckle by Jessie M. King, £1650, Christie's, London, 1992
144	Snake bracelet by James Cromer Watt, £2200, Christie's, London, 1992
144	Pendant by James Cromer Watt, £3850, Sotheby's, London, 1992
149	An Arts and Crafts polychrome enamel pendant necklace by Phoebe Traquair, 1912, £990, Christie's, London, 1992

Glasgow style wall clock reputed to have been a wedding gift from Charles Rennie Mackintosh to a friend, £1760, Christie's, London, 1992

Glasgow style copper wall sconce, £275, Christie's, London, 1992

Charles Rennie Mackintosh poster, $105,000, Christie's, New York, 1993

Helen Muir Wood pewter mirror frame, £440, Christie's, London, 1992

Chapters Three and Four--no recent examples available

Chapter Five

p. 167	Gold, enamel and ruby brooch by Vever, SF27,600; Art Nouveau gold, plique-a-jour and diamond pendant, SF 4670; enamelled gold pendant by Andre Rambour, SF7150; Art Nouveau watch case with iris bloom design, SF6050, Phillips, Geneva, 1991
168	Brooch by C. Duguine, SF46,200; necklace by L. Gautrait, SF 28,600; brooch, necklace and buckle possibly by D. Jouannet, SF41,800; Phillips, Geneva, 1991
171	Metamorphose by Phillippe Wolfers, SF99,000, Phillips, Geneva, 1991
172	Art Nouveau cufflinks, French, $1100, Skinner's, Boston and Bolton, 1991
173	Bronze Art Nouveau inkwell, 1903, $990, Skinner's, Boston and Bolton, 1991

Marcus & Co. mother of pearl, pearl and diamond pin, 18 kt. gold, Art Nouveau style, $2750, Skinner's, Boston and Bolton, 1991

Marcus & Co. Art Nouveau enamel, pearl, diamond, and opal necklace, $16,500, Christie's, New York, 1989

Tiffany & Co., moonstone and sapphire necklace c. 1914, $27,000, Skinner's, Boston and Bolton, 1990

Chapter Six

Peter Behrens brass tea kettle, 1908, $880, Sotheby's, New York, 1992

Theodor Fahrner silver, enamel necklace set with aquamarine, pearls, peridot, $825, Skinner's, Boston and Bolton, 1991

Theodor Fahrner sterling silver belt buckle designed by Patriz Huber, 1901, $2100, Skinner's, Boston and Bolton 1990

Hugo Leven electroplated metal tazza c. 1900, £825, Sotheby's, London, 1991

Orvit pewter three-piece tea service, 1902, $1430, Sotheby's, New York, 1992

Plique-a-jour necklace, probably Pforzheim, glass stone, sterling, $700, Skinner's, Boston and Bolton, 1989

WMF silver-plated center piece c. 1900, 27 1/2 in. long, 12 1/2in. high, $2475, Sotheby's, New York, 1992

WMF silver-plated fish service for twelve, c. 1910, $400, Skinner's, Boston and Bolton, l991

WMF copper and brass tea kettle, c. 1910, $660, Sotheby's, New York, 1992

WMF brass coffee set, 1910, teapot,water kettle on stand with burner, milk jug, covered sugar bowl, two-handled tray, $400, Skinner's, Boston and Bolton, 1991

WMF silver pin with amber, early 20th century, $400, Skinner's, Boston and Bolton, 1990

Chapter Seven

p. 200 Sterling silver and enamel pin, Vienna, Elfi Muller, $150, Skinner's, Boston and Bolton, 1990
201 Art Nouveau gilt enamel locket with floral design, $495, Skinner's, Boston and Bolton, 1991
206 Suede clutch purse with sterling mounts, $250, Skinner's, Boston and Bolton, 1990

Josef Hoffman white painted metal basket c. 1905, 9 1/2 in. high, missing glass liner, $1870, Sotheby's, New York, 1992

Joseph Maria Olbrich, three silverplated dessert forks and spoons executed by Christofle, 1903, $550, Sotheby's, New York, 1992

Joseph Maria Olbrich, pewter two-branch candelabrum executed by E. Hueck, 1902, 14 1/2 in. high, $4950, Sotheby's, New York, 1992

Dagobert Peche oval pill box of silver-colored metal and ivory for the Wiener Werkstatte, c. 1910, £2200, Sotheby's, London, 1991

Wiener Werkstatte three-piece table garniture, two vases and square centerpiece designed by Josef Hoffman, 1910, $12,100, Sotheby's, New York, 1992

Chapter Eight

Georg Jensen sterling silver and lapis lazuli pendant, early 20th century, $1,400, Skinner's, Boston and Bolton, 1990

Georg Jensen sterling silver and green onyx pin, early 20th century, $425, Skinner's, Boston and Bolton, 1990

Georg Jensen hammered silver inkwell, c. 1920, 9 1/2 in. length, 6 3/4 in. width, $2,000, Skinner's, Boston and Bolton, 1991

Georg Jensen early 20th century silver brooch with stylized bird, $175, Skinner's, Boston and Bolton, 1990

Georg Jensen silver three compartment serving bowl, 9 in. dial. 1925-32, $2,200, Sotheby's, New York, 1992

Georg Jensen sterling silver necklace,with moonstones, early 20th century, $900, Skinner's, Boston and Bolton, 1989

Georg Jensen silver cigarette box, 1919, 7 in. length, $1,650, Sotheby's, New York, 1992

Georg Jensen silver centerpiece bowl, c. 1923, 7 3/4 in. dia., $2,200, Sotheby's, New York, 1992

Evald Nielsen silver bowl 5 1/4 in. dia. and dish 9 1/8 in. dia., c.1929, $150, Skinner's, Bolton and Boston, 1990

Chapter Nine

p. 233 A similar Gustav Stickley dinner gong, copper, $1400, Skinner's, Boston and Bolton,1990
234 (related to bottom picture) Tiffany Studio enameled bronze tray and bookend, $3300, and Zodiac eight-piece Tiffany bronze desk set (perpetual calendar, letter file, inkwell, note pad, blotter ends, blotter rocker) $990, both Skinner's, Boston and Bolton, 1991
239 A related necklace by Marcus & Co., pearl and enamel, 14 kt. gold with garnets, sold for $3600, Skinner's, Boston and Bolton, 1991
238 Mary Gage sterling silver and turquoise pin, early 20th century, $355, Skinner's, Boston and Bolton, 1990
227 Silver and pearl pendant, $350, Skinner's, Boston and Bolton, 1989
242 Similar Robert Jarvie cast brass candlesticks, 1910, $3300, Sotheby's, New York, 1992

Allen Adler sterling silver fork and spoon, 10 1/2 in. length, $175, Skinner's, Boston and Bolton, 1990

Albert Berry hammered copper and horn bowl/ashtray, 6 in. dia., $400, Skinner's, Boston and Bolton, 1990

Arts and Crafts gold and opal pendant, $2200, Skinner's, Boston and Bolton, 1989

Arts and Crafts gold and tourmaline pin, $900, Skinner's, Boston and Bolton, 1991

Porter Blanchard sterling silver tray, 11 in. dia., $250, Skinner's, Boston and Bolton, 1990

Rebecca Cauman basse taille enamel and sterling silver condiment service, with sterling ladle and green glass bowl, 4 1/2 in. dia., 1925, $600, Skinner's, Boston and Bolton, 1991

Elizabeth Copeland early 20th century silver and enamel box, $650, Skinner's, Boston and Bolton, 1990

Kalo sterling silver water pitcher, 9 in. height, $1,800, Skinner's, Boston and Bolton, 1991

Kalo 14 kt. gold bracelet, $3,100, Skinner's, Boston and Bolton, 1989

Lebolt and Co. 14 kt. gold and turquoise bracelet, 7 3/4 in. length, early 20th century, $2,000, Skinner's, Boston and Bolton, 1990

Margaret Rogers 14 kt. gold and tourmaline pin, 1927, $800, Skinner's, Boston and Bolton, 1990

Roycroft silver-washed vase with Steuben glass insert, 6 in. height, $250, Skinner's, Boston and Bolton, 1990

Gustav Stickley hammered copper jardiniere c.1905, with repousse decoration, $4,950, Sotheby's, New York, 1992

Arthur Stone sterling silver pen tray, early 20th century, $600; sterling salad fork & spoon set, $850, Skinner's, Boston and Bolton, 1990

Tiffany & Co. sapphire and moonstone brooch, $11,000; sapphire and moonstone bracelet, $22,000, Christie's, New York, 1992

Chapter Ten

p. 246 Ernest Blyth and Frances Beck 18 kt. gold, moonstone, cultured pearl and diamond necklace, £1760; black star tourmaline Andrew Grima ring, £1210; 18 kt. gold, green tourmaline and diamond ring, Frances Beck, £1320; 18 kt. Frances Beck gold, pink tourmaline and diamond ring, £1320; amethyst and diamond brooch probably by Andrew Grima, £1430; 18 kt. gold, cabochon ruby, emerald, and colored diamond ring, Andrew Grima, £2420; aquamarine ring, Andrew Grima, L2750; all Sotheby's, London, 1990.
247 Amethyst and gold earrings by Jean Stark, $1100, Skinner's, Boston and Bolton, 1990

Georges Braque ring in gold, £1000, Christie's, London, 1992

Pol Bury 18 kt. gold ring, 1972, kinetic number 16 of an edition of 30, $330, Skinner's, Boston and Bolton, 1991

Index

"SO NOW 'TIS ENDED LIKE AN OLD WIFE'S STORY"